PARAPOLITICS

CONSPIRACY
IN
CONTEMPORY
AMERICA

PARAPOLITICS:
CONSPIRACY IN CONTEMPORY AMERICA

© 2006 by Kenn Thomas

All Rights Reserved

ISBN: 1-931882-55-X

Published by
Adventures Unlimited Press

www.adventuresunlimitedpress.com

Printed in the United States of America

PARAPOLITICS

CONSPIRACY
IN
CONTEMPORY
AMERICA

By

Kenn Thomas

Dedicated to Skylaire...

PARAPOLITICS
Conspiracy in
Contemporary America

By Kenn Thomas

CONTENTS

Parapolitics!
By Kenn Thomas

This volume pulls together many of the articles I have written for publications outside of my regular venue, *Steamshovel Press*, plus some things from the web site and lectures I have done on the Octopus and the Maury Island UFO. I hope it reflects the particularized information wrought from a study of parapolitics.

The word "parapolitics" doesn't originate with me but I often champion it as an alternative to the distorted media handle of "conspiracy theory". Like Wilhelm Reich's "orgone" – a term for atmospheric energy – the word "parapolitics" appears in some dictionaries but not most.

Peter Dale Scott defined parapolitics as "a system or practice of politics in which accountability is consciously diminished" Scott defined the term as "an intervening layer of the irrationality under our political culture's rational surface" but called it too self-conscious. He ultimately exchanged it for another self-conscious term, "deep politics" defined as "all those political practices and arrangements, deliberate or not, which are usually repressed rather than acknowledged". Although Scott is the pre-eminent scholar of conspiracy in American politics, I would suggest to readers that they do not move with haste to an abandonment of the term.

The prefix "para" means "alongside" -- an activity that happens concurrently with visible politics, just as paranormal events happen alongside normal ones. A scientific definition exists involving atoms spinning in different directions, providing an apt metaphor for a free society versus one dominated by secret rule. Even the etymological roots of the word "paranoia" suggest a consciousness additional to sanity, not sanity's absence. The term "metapolitics", often offered as an alternative, suggests that the phenomenon is a more evolved form of politics. It is not. The parapolitical runs

1

alongside normal politics but in the opposite direction. It is a de-evolution toward manipulation and control.

Little need exists, of course, to dress up a study of conspiracy with a quasi-academic term, outside of the need to resist that phony sobriquet, "conspiracy theory". Anyone in America who thinks independently about current affairs, from a perspective other than as defined by authority, is called a "conspiracy theorist". In fact, parapoliticos (intelligence community media assets) concocted the term as a tool of disinformation. In this way, while the media does its well-known job of lulling viewers into a passive state of consumption, woofing down Pentagon press releases along with everything else, it accomplishes three propaganda objectives: 1. it robs alternative points of view of credibility; 2. it suggests that conspiracies don't really exist; 3. and it creates a surprisingly lucrative ideational/ entertainment commodity. "Conspiracy theory" as a theme in movies, talk shows and TV dramas has become a big industry.

Perhaps it is too obvious to point out, but a modicum of any factual knowledge about anything exposes the paucity of actual information found in the mainstream media. An egregious example discussed elsewhere in this book concerns the comic book artist Jack Kirby. Kirby's creations became responsible for an enormous chunk of the revenues generated by the megabuck comic book entertainment industry. In the wake of blockbuster movies like *The Hulk*, *X-Men* and *Spiderman*, however, based on characters Kirby created, the media gives all credit to Stan Lee, the editor at Marvel who made contributions to the scripts of the 1960s comic books. In the publicity surrounding the release of the recent movies, the media often credited Lee as the artist, a trade he did not ply, and gave him far more for creating the Marvel properties than was his due.

The money involved, and the fact that Jack Kirby remains an unrecognized genius of American art, should quiet any suggestion that this is a trivial example. With it, the

media demonstrates not only a profound deficiency but a deliberate intent to obfuscate and distort historical reality. Kirby was a workaday comics artist laboring under work-for-hire contracts. While an enormous (and still growing) entertainment bureaucracy grew up around his creations, he received only his page rate and even had trouble getting back his original artwork. While comfortably middle-class and certainly a success in the eyes of his fans and fellow professionals, Jack Kirby remains in relative obscurity compared to the popularity of his characters, all licensed and exploited for enormous and ongoing corporate profits. The true story of Kirby's career and the question of creator rights obviously does not serve corporate media bosses.

This exposes a parapolitical agenda. It disinforms. A more widely understood example among "conspiracy theorists" (that is, students of the parapolitical) concerns the JFK assassination. More than the dumb show of lone nutters versus conspiracy nutters presented annually around November, the lessons of that important historical event illuminate a wide range of contemporary issues leading away from the media's pre-ordained false dialogue. Had this not been the case, the JFK parapolitical research community would not have had the staying power it still does after forty years and the pathway to the research the reader will find in this book would not exist. Understanding Lee Harvey Oswald's spy career means understanding how spies operate transnationally, having more allegiances than even they understand, like the terrorists of mujahadeen/al Qaeda. Seeing how put options sold on the day of the JFK assassination helps the student of parapolitics see the same process as it happened after 9/11. Knowing about David Ferrie's secret biowarfare laboratory illuminates the subjects of anthrax and AIDS as they have been happening in today's daily news.

These topics emerged in books I produced on the JFK assassination, *NASA, Nazis and JFK* (Oswald-as-spy) and *Mind Control Oswald & JFK* (put options), although the

lessons of Ferrie's lab are discussed in Ed Haslam's brilliant book, *Mary, Ferrie and the Monkey Virus. NASA, Nazis & JFK* was the first annotated book edition of the Torbitt Memorandum, an underground document that had long circulated in photocopy form among parapolitical researchers. Its many revelations included the possible role in the assassination of a man named Fred Crisman, identified in the Torbitt as one of the tramps arrested in the railyard behind the grassy knoll on November 22. Proceeding backward in time from that, the reader will find Crisman's presence at the first post-World War II UFO event, the Maury Island case. Proceed forward and Crisman's presence can be found in the parapolitical research and work of Danny Casolaro, the infamous Octopus conspiracy.

Although I produce a magazine that covers all aspects of the conspiracy culture, few fail to understand why this parapolitical nexus defines the parameters of the majority of my particular research. It goes to the core of every odd dimension of recent American history, from JFK to biowarfare to mind control and UFOs, things that still constitute the preoccupation of America's mass culture. It concerns real people involved in multi-generational links to the covert world and the ufological subculture. It also involves American samizdat literature — not only the Torbitt, but the Gemstone File, the Kiwi Gemstone, the COM 12 papers — that not only reflect a remarkably consistent alternative view of world events compiled by widely disparate sources, but that would be lost as literature if not for their appearance in the parapolitical landscape.

In recent internet correspondence, the author of a well-known encyclopedia of UFO history challenged my credentials as a scholar after I pointed out errors of fact he made about the Maury Island case. The correspondence included a third party only dimly aware of Crisman's JFK-UFO connection, a sad and amazing fact only too true of many people. Although both admitted to never having read

the only book ever written on Maury Island (mine), the author's contention that it never really happened and that anyone with interest was "free to believe whatever, er, eccentric notion to which he is attracted" made him imagine that he had the authority to squelch the discussion. Complaining that I was a conspiracy theorist, he took refuge from his errors in pointing out awards he had received from the American Library Association and the Publishers Marketing Association.

I responded that my academic credentials included a twenty year career as an archivist and historian at a major midwestern university. My most recent academic work at the time appeared in a biographical volume published by Harvard and in an encyclopedia on conspiracy published by the University of Manchester in England. I was not interested in bragging or getting into a pissing match with this writer, but I had to underscore that his awards came only from marketing and commercial book publishing associations. Such awards are public relations tools for their respective industries and not imprimaturs of proven, solid research. Moreover, the writer's arrogance, in trying to belittle parapolitical research while getting his facts wrong and discouraging the third party from looking into it more at all, shocked me. Was this a deliberate attempt at disinforming? Or did it fall into Peter Dale Scott's definition of "deep politics" – parapolitics as usual, conscious or not.

The writer also had used Gerald Posner as the source for his understanding of the JFK assassination. Posner's three year lone-nut thesis "study" of the JFK assassination was offered up in the mainstream as some kind counter-balance to the decades long body of parapolitical research by hundreds of others proving conspiracy. To support that weak intellectual pylon, the writer offered reviews of Posner in various daily papers.

No appeal to authority, commercial or academic, will supplant a direct observation of the facts. This is the biggest

resistance I have to the term "conspiracy theory", that it attempts to deprive the notion of parapolitics of its basis in fact. This is a book of commentary but the reader will learn from it a ride range of historical facts, although some of it quite arcane. As the *Steamshovel Press* motto goes: All conspiracy. No theory. The various rants, screeds, samizdat, Freedom of Information files and oral histories discussed here are offered as artifacts of study. They contain dead end leads, false information, a variety of biases and many authentic revelations. They are not, however, theories. They open a doorway to a realm of facts and perspectives that the newspapers, the media and the academy deliberately ignore.

Notes from the Underground
Fortean Times 176, November 2003

Conspiracy believers—those furtive, shifty-eyed people in trench coats obsessed by conspiracy suffer more from schizophrenia than paranoia. They patronize an extremely popular topic that at the same time is vilified and accursed by their friends and neighbors. Like *Star Trek* fans, they have a need to congregate and share their interests. Unlike the Trekkies, however, the outside world does not find those interests goofy yet relatively benign. They fear them and their enthusiasts. These are the "conspiracy theorists". They run a gamut from serious political dissidents to the clinically paranoid. Also unlike the awkward teenage Trek heads, they rarely find huge commercialized conventions to pursue the topic that fascinates them. Instead, they sit in the dark and watch *X-Files* reruns.

In fact, the producers of *Trekkies 2*, a follow-up to a documentary on *Star Trek* conventions, looked at the possibility of including a conspiracy theorist in the new film. *Star Trek* creator Gene Roddenberry was a Mason, after all, and the *Star Trek* program includes many plots about its

United Federation of Planets being overtaken by conspiratorial aliens. *Trekkies 2* decided against it, though, for the sake of "trying to stay with the positive side of things."

Instead, the conspiracy underground meets in a variety of venues, often undercover and disguised as aficionados of something else. They become ufologists, patrons of the alternative media, popular culture academics and the New Age crowd. Their numbers include coffee shop bohemians, historians, civic-minded, speech attending citizens and mind control victims. Each of these constituencies regularly organizes conferences and public events that attract crowds and speakers to examine assassinations, secret political manipulations and hidden history, often as a corollary to the central topic under discussion.

The late psychedelicist Terrence McKenna, for instance, offered his views of the internet's "alien presence" at the same Whole Life Expo, a New Age gathering in Chicago, where *Communion* author Whitley Streiber lectured on the grey creatures outside his cabin. Although diametrically opposite views of extraterrestrialism, they came together on the conspiracy theory that mainstream culture deliberately wraps the idea of aliens on earth in a curtain of derision and cover it up.

UFO conferences in general provide a bedrock of conspiracy gatherings. Their underlying assumption, that flying saucers and other unusual space craft frequently visit the earth and yet are virtually unacknowledged by human societal institutions, of necessity includes a conspiracy component. The disinterest and outright ridicule of the subject from the mainstream involves cover-ups by governments around the world. These governments seek to protect the technological secrets gleaned from back-engineering crashed extraterrestrial craft. Or they are protecting the citizenry from panic. Or even worse, they disguise their own involvement with alien plots to enslave humanity.

One such gathering, the International UFO Congress, meets regularly in the American southwest, in Las Vegas or at a small town to its south, Laughlin, Nevada. While its main program features many of the well-known speakers on the UFO circuit, like David Icke - who presents his own bizarre world view about shape-shifting reptilians conspiring with world leaders for power dominance throughout history - the lectures that appear further down the program list deal seriously with some quite spooky real life conspiracy mysteries. At one recent Laughlin gathering, the subject was the mysterious death list attendant to ufological community itself. The speaker, Cope Shellhorn, presented a long list of UFO researchers who met their fates in unusual accidents, bizarre murders, suspicious suicides and fast-acting cancers. According to Shellhorn, "many in this field fail to reach their full four-score."

Presumably, a conspiracy is behind this. These researchers went too far investigating and exposing the UFO-government connection and had to be eliminated. Even though that proposition may be difficult for some, the UFO conventions also provide a public forum for the discussion of indisputably real mysterious death lists that get little attention in any other venue. At the book dealer tables of these gatherings fans get excited with conspiracy talk and share arcane information. After the Shellhorn talk, for instance, the focus at one table concerned the list of deaths from the late 1980s involving Star Wars defense contractors. Over a dozen scientists working on the Star Wars defense initiative, SDI, all highly trained technicians on super computers and the most advanced military hardware, either could not drive cars well enough to avoid lethal wrecks or were so depressed by their high-paying, high profile lifestyles that they committed suicide.

The mysterious death list more recently under discussion involved microbiologists. Specialists in virology, bacteriology and biowarfare have fallen off bridges, been

bludgeoned to death or, in one case, accidentally got locked into a refrigeration chamber. The most noted person on this list, of course, is microbiologist David Kelly, the UK's Ministry of Defense's chief scientific advisor, found this past July, with a wrist slit near his home in Southmoor, near Abingdon in Oxfordshire, the victim of an apparent suicide. Kelly's role in Unscom's investigation of Iraq prior to the war, and his potential as a whistleblower against UK and US intentions there now, make him a ripe cause for conspiracy theorizing. Previously, Kelly once had aided MI6 in debriefing the Soviet defector Vladimir Pasechnik, another prominent microbiologist on the death list.

So it goes at the UFO conferences. More than just people with fanciful imaginations in tinfoil hats, these events draw together common citizens with a normal concern about the machinations of their governors, specifically in the area of advanced technology. The mysterious death connections, well-known to this crowd, never appear on the nightly news. Web sites and Art Bell-type radio shows refer to them, but nowhere else are they more openly discussed and debated in the flesh than at these conferences. For this reason, many feel that attendees include information gathering spies.

In history some suggestion exists that this may be the case in some instances. The best example goes back to the beginning of the modern UFO era, in the figure of a man named Fred Crisman. In 1947, Crisman claimed to have seen a UFO in the skies over Maury Island at Puget Sound in the state of Washington, three days prior to Kenneth Arnold's famous sightings. Arnold, in fact, later investigated the case and it came to be dismissed as a great hoax. Crisman's earlier appearance in the historic record, however - before Maury Island - came in the form of an extensive quote in *Harper's Magazine* in September 1946, in an article about the first world convention of science fiction fans earlier that year in New York.

In 1967 correspondence with UFO researcher Gary Leslie reflects that Crisman had become a regular speaker at UFO conventions himself, on the Maury Island case. Amazingly enough, the following year, Fred Crisman was subpoenaed by New Orleans district attorney Jim Garrison for possible involvement with the JFK assassination. Some researchers, in fact, have identified Crisman as one of the railyard hoboes behind the grassy knoll. The existence of such a person, with one foot in the covert conspiracy world and another in the ufological subculture, remains one of the great mysteries of the Maury Island case, and a great cause today of conspiracy speculation.

Conferences devoted exclusively to the topic of conspiracy have been ancillary to the UFO gatherings, and only a recent development. Prominent among them is the Conspiracy Conference held in the northern California area, near San Jose. The promoters also organize the annual Bay Area UFO conference in San Francisco. "How can we even begin to address the possibility of life and intelligent civilizations on other worlds if we don't even know who we are and what is happening right under our noses?, says Conspiracy Con promoter Brian Hall. "There are forces working very hard to not only suppress esoteric knowledge, but to maintain a population of taxpaying zombies stuck in survival mode." Hall and his partner Victoria Jack produced the Bay Area UFO conferences for over decade before beginning the Conspiracy Con in 2001.

It proved tremendously popular, attracting international, capacity crowds. "People called and said they were canceling their vacations to attend," says Hall. Almost half of those in attendance traveled from outside California, testifying to the global nature of the conspiracy-minded culture. Hall acknowledges that his audience is comprised of people from a variety of different subcultures. "There are many types of conferences that briefly touch on the issues that we're addressing here. UFOs, New Age, spirituality,

10

alternative healing, preparedness. But in my opinion, they fall short because they don't address the issues that we face right now."

Those issues include mind control. Chief among Hall's early speakers at the Conspiracy conference was Cathy O'Brien, self professed former sex slave for the CIA. According to her talk, O'Brien took the lead in claiming victim hood by MKULTRA, the historically real CIA program to develop mind-altering and drugs as potential weapons dating back to the 1950s.

O'Brien partners with Mark Phillips, who claims credit in his former capacity as an intelligence operative for the 1983 rescue of O'Brien and her daughter from the brainwashing program. Phillips and O'Brien co-authored *Trance-Formation of America*, an immensely popular book peopled with celebrities the pair claim also are involved with the sex-slave operation of MKULTRA, from the current US vice president Dick Cheney to the late singing hobo, Boxcar Willy. *Trance Formation* also ostensibly documents the US government's involvement in white slavery operations, international child porn, and drugs.

Fanciful or not, O'Brien and Phillips opened the door for other such victim/lecturers as Bryce Taylor and Arizona Wilder to come forward, to near celebrity status on this new-found lecture circuit. By August 2003, no less than eight former subjects of MKULTRA spoke at the Sixth Annual Ritual Abuse, Secretive Organizations and Mind Control Conference in Windsor Locks, Connecticut in the US.

But the political roots of the conspiracy convention can be found in the conferences and public events first put on by an activist community that formed over public dissatisfaction with the conclusions of the blue-ribbon Warren Commission over the JFK assassination. In fact, many of these early conferences looked like amateur Warren Commissions, with participants solemnly delivering their own conclusions on the real individuals, organizations and

political forces behind history's most famous murder. Academic as some of these presentations were, they usually ended in a call for civic action against the government cover up.

With funding from the wealthy and well-known, people such as writer Norman Mailer, the conferences coalesced into what even today is known as the JFK research community. In the absence of any real movement to address the wrongs of the Commission, conference goers became paper tigers, content to refine their conclusions for in specialized conferences for the informed. Oliver Stone's *JFK* movie bolstered their efforts by renewing attention to this unresolved sore spot in American history. Stone's effort led to the creation of the Assassinations Material Review Board under the first President, and it's life was extended under Bill Clinton. The Board identified and releases many thousands of files pertaining to the assassination that the JFK research community still continues to pour over.

Chief among the current JFK conference organizers is the Coalition On Political Assassinations, headed by Washington, DC conspiracy writer John Judge. Judge works tirelessly both as a classically cast 1960s political activist and as the organizer and promoter of conferences. Sometimes as many as three year, observing the anniversaries not only of JFK but of the 1968 assassinations of Robert F. Kennedy and Martin Luther King, in as many cities (Dallas, Los Angeles and Memphis, respectively), the COPA conferences now attract both the distanced academics and those that clamor for political reform.

For many years, a competition of conferences developed for the attention of the assassinations audience. A gathering called the Assassination Symposium on Kennedy (an awkward phrase construction done for the benefit of a memorable acronym, ASK) conducted what amounted to the closest thing the conspiracy community had to its own Star Trek convention. Held at the Hyatt Regency Hotel adjacent to

Dealey Plaza in Dallas, ASK paid major celebrities as its keynote speakers, including Norman Mailer (at the time of his fictionalized account of the life of Lee Harvey Oswald) and included a large room of dealers hawking books, videos and other collectible JFK merchandise, such as toy versions of Lee Harvey Oswald's famous Manlicher Carcano rifle. ASK was put together by commercial concerns for the sake of profit. The promoters also regularly organized South by Southwest, an annual music event in Austin, Texas showcasing the up and coming new rock stars. The dealer rooms at the ASK symposiums were enormous and paid table space was at a premium.

The Coalition on Political Assassinations stood in stark contrast to ASK. Comprised primarily of the cognoscenti remnants of the JFK research community, and headed by the zealous social conscience Judge, COPA staged smaller conferences in Dallas at the same time as ASK. The COPA conferences appealed to the hardcore researcher with detailed examinations of the medical evidence, the documentary paper trail of mafia figures and intelligence agencies connected to the JFK hit and lesser known celebrities such as the comedian-turned activist Dick Gregory. COPA made only enough money to sustain the group, sometimes less. ASK drew away from it many more potential attendees, enthralled like many fan groups with the dealers sensationalistic books and other paraphernalia afforded by the bigger event. Oddly enough, however -- and even though a conference similar to ASK but smaller remains called JFK Lancer -- only the true-hearted researcher group, COPA, survived the competition. ASK went out of business in 1997 and its promoters returned to the rock music scene.

Today, COPA still organizes its conferences for the research community, over JFK as well as the other well-known assassinations of the 1960s. Although still small, it has reached a new level of technological sophistication. The plans for its November conference in Dallas this year include a

video conference link to another meeting in Philadelphia. While the Dallas crowd listens to such speakers as Paris Flammonde - interestingly, a JFK/UFO crossover author - it will also avails itself to a video debate between Arlen Spector, creator of the oft-ridicule "Magic Bullet" JFK theory and Cyril Wecht, the famed pathologist convinced of conspiracy by the forensic evidence. The live debate will be beamed into Dallas from Duquesne University in Pittsburgh, Pennsylvania.

Not all political conspiracy gatherings have been so noble, however. An environmentalist group called Earth First has long held forth the view that its founder, Judi Bari, was gravely wounded in a car bombing by a conspiracy of the FBI in 1990. Rather than gatherings to promote the environmental cuase, Earth First!'s event became single issue conspiracy conferences about the Bari bombing. In 2002, the group even won a lawsuit settlement of four million dollars over the claim. All evidence suggests, however, that Bari was bombed by her angry ex-husband. Evidence for this was collected and presented in the conspiracy-oriented magazine *Flatland*. When *Flatland* publisher Jim Martin attended an Earth First rally in San Francisco just before the settlement, he too was accused of working for the FBI and was shoved by members of the crowd in distain.

Often such conflicts reflect only honest differences of opinions. At a recent Midwest symposium on political assassinations, Chicago's conspiracy gadfly, the wheelchair bound Sherman Skolnick, raised a ruckus by asking one speaker about the possible funding of the 1960s political dissidents through CIA front foundations. The speaker, Carl Oglesby, author of a well-known treatise on American conspiracy politics called Yankee-Cowboy War, also was once a high profile figure in the Students for A Democratic Society, one of the suspect groups according to Skolnick. Not a right-winger by anyone's assessment, Skolnick himself led a campaign to clean up the corrupt Chicago courts in the 1960s,

an effort that ultimately led to the resignation of federal court judge and former Illinois governor Otto Kerner. For his inquiries at this conference, however, Skolnick was escorted to the exit.

Accustomed to disagreement and replete with conference-goers possessed of individualistic points of view needing protection, such factional fighting is not uncommon in the world of conspiracy conferencing. At one UFO event where the topic turned to conspiracy in religious culture, grandstanding on the part of one speaker led to cancellation of a talk by another. Scheduled to present her thesis that Jesus Christ is not historically real but rather a conspiratorial by-product of ancient imperial Rome, author Acharya S (*The Christ Conspiracy*) abruptly had her appearance canceled by the promoters. Another speaker, Laurence Gardiner, whose theories about royal bloodlines stand or fall on Jesus being historically real refused to appear at the same conference. Despite the clamor of fans and critics alike for a far more interesting speaker, Acharya S was removed from the speaker schedule, a victim not so much of a pro-Jesus conspiracy but of the promoters' strong desire not be stiffed on Gardiner's non-refundable airfare.

Although conspiracy conferences as such have been recent and rare, their origins lie in the past of a fandom that is neither fish nor fowl when it comes to conspiracy and the more science-fictional elements of developing society. This is the marginals publishing milieu, populated by small presses devoted to a wide variety of subcultures and specialty interests, including Satanism, erotica, Reichian orgone, Marxism, the Situationists, the anarchists and the nihilists as well as ufology and conspiracy. The most historically well known of such conferences is the 1992 Phenomicon held in Atlanta, Georgia. This brought together a number of young writers who later became big fish in the small conspiracy pond. These included Jim Keith, renown as the author of a series of conspiracy books, including *Black Helicopters Over*

America and *Casebook on Alternative Three*; Len Bracken, who recently wrote a comprehensive overview of conspiracy questions related to the 9/11 disasters called *The Shadow Government*; and Adam Parfrey, whose Feral House press has grown today into one of the premiere alternative presses in the US. Such convergences of the literary and artistic boho element, although percolating perpetually in coffeehouses and bookstores, do not happen often. One such conference, the Disinfo Con in New York in 2001, became a media event and the subject of a book and DVD documentary. Amid stage shows that included an entourage called the Wall of Vaginas and a perfomers blowing off explosives from his cheat, Disinfo included two speakers from the Phenomicon of a decade before: Adam Parfrey; and the perennial conspiracy satirist, *Illuminatus* author Robert Anton Wilson.

Otherwise, the topic of conspiracy presents itself to the great unwashed - untainted, that is, by actual belief in conspiracy or creative resonance with the idea - in the form of academic investigation. In January, the alumni associations of the Medill and Syracuse Universities in New York presented a panel discussion entitled "Media Monotone", to discuss the lack of diversity in the mainstream news media, i.e., a conspiracy of suppression by corporate media of alternative points of view. The panel included only one representative from the mainstream, a columnist for *CBS Financial Watch*. The other panelists included a Satanist, a Marxist, a conspiracy theorist and a representative from Fairness and Accuracy in Media, a watchdog group. In October, the Midwest Popular Culture Association plans an entire conspiracy panel for its convention in Minneapolis. Speakers will deliver papers on such topics as a psychoanalytic interpretation of *The Manchurian Candidate*; the similarities of radical Islam and the US militia movement; and the conspiracy behind the story that US troops used sarin gas in Laos.

The level of interest in conspiracy (the illuminated call it "parapolitics") in the popular culture has been noticeably prominent in recent times, primarily in thriller TV shows like *X Files* where it functions as a siphon for the waning credibility of government and media. As a part of public discourse, however, it emerges frequently and in a wide variety of forums, from starry eyed ufologists to serious intellectuals. Perhaps its ubiquity has prevented it from being the subject of too many conferences focused exclusively on the topic. While it may look like a schizophrenic part of many paranoid subcultures, the variety of conspiracy experience may actually be the multiple personality disorder of the larger world.

ELECTION 2000

Conspiracy Is A Vice
Fortean Times 140, December 2000

The elections began on a note of conspiracy with the selection of the son of former president and CIA chief George Bush as the Republican party candidate. Here was a candidate cloned in CIA labs, or a member of a family of shape shifting Reptilians - like the British royals - according to more extreme elements in the conspiracy research and rumor community. At the very least, Bush Jr's familial ties linked him to the Kennedy assassination by those who see JFK as the victim of a Yankee-Cowboy war in which Bush's father was top cowboy. Many conspiracy screeds implicate the senior Bush in some involvement in the JFK murder - eg "The Role of Richard Nixon and George Bush in the Assassination of John F. Kennedy" by Paul Kangas in the book *Popular Alienation*. Even the CIA admits that someone in its employ named George Bush received a debriefing following JFK's death.

Bush Jr's choice of running mate, former Wyoming congressman Richard Cheney, came pre-wrapped in the machinations of the Iran-Contra conspiracies. In fact, Cheney attended a 1987 White House intelligence committee meeting with Colonel Oliver North (military fall guy for the illegal funding of Nicaraguan rebels), in which North told lies about the affair that he later admitted to. Cheney continued to support, encourage and promote North after that but now avoids all discussion of Iran-Contra with the quip: "This race is about the future..."

An early possible vice-presidential choice of Al Gore (Bush's opponent in the Democratic party), energy secretary Bill Richardson, was touted in mainstream media as a

charismatic and effective leader until tainted by a scandal involving the mysterious theft of computer hard drives at the nuclear facility in Los Alamos, New Mexico. This happened after bizarre wildfires drew attention to the area.

But Al Gore moved conspiracy to the center stage of American politics by selecting Connecticut senator Joseph Lieberman as his running partner. Lieberman is Jewish, and conspiracy theories about Jews have long constituted a large component of parapolitical study, from debate about the 'secret' world domination plan called the *Protocols of the Elders of Zion* to the notorious doubters of the Nazi Holocaust. With the planned declaration of a Palestinian state in September, the idea of the second closest heartbeat to the American presidency being Jewish raised "I told you so" eyebrows among far right theorists and opened old tensions among black Americans. Within a week of the selection, the president of the Dallas, Texas, branch of the NAACP, the African American civil rights group, was forced to resign after calling Lieberman "very suspicious" and saying of Jews that "their interest primarily has to do with [...] money and these kinds of things."

The vice presidency is the highest American political office ever sought by a Jew. That distinction, previously, had been held by Judah Philip Benjamin (1811-1884), a US senator from Louisiana who served from 1853 until 1861, when Louisiana seceded and joined the southern Confederacy. Benjamin then served as attorney general to the Confederacy under its president, Jefferson Davis, and went on to become its secretary of war and secretary of state. Not surprisingly, Judah Benjamin's life is steeped in conspiracy. Even standard biographies refer to the great deception that enabled him to sneak to Great Britain after the capture of Jefferson Davis in 1865.

In the UK Benjamin had a successful legal career; he was appointed Queen's Counsel for Lancashire in 1872 after writing a treatise on personal property law and retired in

1883. Conspiracy history has it, however, that Benjamin bled the South of its assets during the US Civil War, transferring much of it to British banks, thus ensuring its defeat.

He was the only member of the Confederate government never to return to the US, and he died in Paris in 1884.

Benjamin is a suspect in the assassination of Abraham Lincoln. The theory goes that Lincoln assassin John Wilkes Booth worked as an agent for the Confederate secret service with a group that intended to kidnap Lincoln and blow up the White House, all at the behest of the defeated Confederate leaders - who, at that time, included Judah Benjamin. Lincoln became a target in this scenario because of a failed raid on the city of Richmond by a Union colonel named Ulrich Dahlgren. When Dahlgren was killed, documents were found on him suggesting that
Lincoln had approved plans to assassinate Jefferson Davis and his cabinet, and resulted in Benjamin formulating plans to kill Lincoln.

Joseph Lieberman supported the Cuban exile community of Miami, Florida, in opposing the return of the Cuban boy Elian Gonzales by the Clinton administration. It was a constituency that otherwise might have been lost to the president's successor, Al Gore. It is also one with roots going back to the anti-Castro mob that may have had a hand in JFK's assassination.

The governor of Florida is the brother of George W Bush, who is the governor of Texas, the state where Kennedy was shot. These hard wired connections only add to what is already out there, making conspiracy chatter a certainty in the US presidential elections this fall.

The Bush Era Beckons
From Steamshovelpress.com

Now that George Bush Jr. has been installed as president "elect", *Steamshovel* readers can safely say they saw it coming. I wrote a column about conspiracy connections of the vice-presidential candidates for *Fortean Times* that predicted the Florida trouble spot; and my comments to the BBC last June that Bush would "win" impressed it such that they will have some additional prominence in the Beeb's upcoming series on conspiracy theories.

The new issue of *Steamshovel,* although dedicated to "Conspiracy As Usual in Florida", actually refrains from discussion about the election, focusing instead back on Diana and the Octopus, which does not obviously connect with the incoming administration. Not obviously.

The new issue also includes a farewell look at Clinton's place in conspiracy history, and a boatload of other topics of interest to those who knew how election 2000 was going to turn out long ago. Check out the order form on the front page for a contents list, and subscribe today.

My comments about Bush merely followed the logic of parapolitical manipulation-successful extra-electoral power politicking by Dubya's father that leaves a trail back from Iran-contra, to the Reagan assassination attempt, the October Surprise, on back to the Kennedy assassination, back further even to the Nazis. The real prophet about the election was Sean David Morton, who made uncannily specific remarks detailing the election squabble and the Bush ascendancy to Art Bell several years ago. In this context, even Bill Clinton's presidency resulted from a Bush, Sr. so tuckered from four years in the public limelight he gave the presidency away by special arrangement, to a player squirrelly enough to ignore the drug-running in Mena, Arkansas. How could anyone expect that deal to last forever?

In response to the befuddling support by the militia groups of George Bush, Jr., who clearly represents the same NWO forces the militias have always opposed, especially under George Bush Sr., I offer the following from Repairman Jack in the book *Conspiracies* by F. Paul Wilson (**www.repairmanjack.com**). Repairman Jack is a violent anti-hero who appears in the kind of trash-fiction novels often found at airport bookstores. The author is a crony of horror writer Stephen King. The latest installment of the Repairman Jack series takes place at a conference of conspiracy theorists--The Society for the Exposure of Secret Organizations and Unacknowledged Phenomena. In it, Repairman Jack opines:

"I can't help wondering why these New World Order types should bother with an armed takeover. I mean, considering how nowadays people are slugging away at two and three jobs to make ends meet, how Mr. and Mrs. Average American are working until mid-May every year just to pay their federal income tax, and then on top of that they pay state and city income taxes, and then after those they've got to fork over sales taxes, property taxes, excise taxes, and surcharges, not to mention all the hidden expenses passed on in day-to-day prices jacked up by license fees and endless streams of regulations from OSHA and all the other two-bit government regulatory agencies."

"By the time Mr. and Mrs. Citizen are through they've surrendered seventy-five percent of their earnings to the bureaucracy. Seems to me like the NWO boys have already got you right where they want you."

Add the military budget, and subtract the dishonest talk of tax cuts and smaller government coming from the new administration, and the result is the new Bush era that the militia right would surrender to if it indeed holds Bush out as hero. Ralph Nader called it the permanent corporate government. (The scoop on Nader found in the Gemstone file features prominently in the new issue of *Steamshovel*).

So what difference did the election make? As Acharya S recently put it more succinctly, "Who cares which reptile is in charge?" At *Steamshovel*, the 2000 election results are an occasion to revisit a great deal of recent parapolitical history in its next issue, currently planned as an all-Bush issue.

Perhaps *Steamshovel* readers can move closer to some closure about various Bush family scandals, or at least obtain a more detailed review as it watches the puppet show in progress.

Embarrassment, shame, outrage and all of the other emotions attendant to the latest assault on the supposedly cherished American values of democracy stopped nothing this election season; only a reasoned understanding and a healthy dose of satire and nose-thumbing remain to make the next four years (or whatever truncated term develops) bearable.

The Shallow Government -- Nobody In Charge
Intro to Len Bracken's *The Shadow Government*

Nobody won the election of 2001 and everybody knows this. Al Gore didn't win or he'd be president. George Bush, whose reported latest gaffe (that the French have no word for "entrepreneur") adds to his legend as America's most stupid pretender to the presidency (1), was appointed to that post by the Supreme Court in a bad decision cast along very narrow ideological lines. (2)

History already has filed away the short version of that election: Gore got the popular vote and the shadows-- Bush family and cronies--shanghaied the electoral vote in Florida. Never before had conspiracy politics been pushed so into the face of American citizens. Extra-electoral power politicking with a trail going back to the Bush build up and break down of Saddam Hussein, back to Iran-contra, back further to the Reagan assassination attempt, to the October

Surprise, on back to the Kennedy assassination, back further even to the Nazis. Same players. Same shadow government. (3) Nobody was the real winner.

The concept of the "shadow government", in fact, played a public relations role in the activities of the new ersatz administration just after 9/11. It publicly acknowledged the underground bunkers that members of an alternate administration would occupy in case the "real" one was wiped out by some terrorist attack. The only irony acknowledged by the compliant press was that the computers in these secret bunkers needed upgrading. The bigger irony remained, that the notion of hidden underground bunkers housing the true manipulators of the world, a long-held concept by students of conspiracy and parapolitics, had long been laughed at as the product of crazy, paranoid minds.

9/11 granted a new legitimacy to that idea, to the idea of sleeper agents, mind-controlled assassins, the terror mirror of interlocking state spy bureaucracies and global killer terrorist networks, to the whole gamut of conspiracy theory ideas that before had seemed so far-fetched. Many had previously argued that "conspiracy theory" (more properly called, for the sake of clarity, the study of parapolitics) sought falsely to impose order on a chaotic universe. It seemed more clear to more people after 9/11 that the chaos was coming from somewhere and that it's discernible roots stretched outside the instantly declared enemies of the state. (4) It could not be the fault of the elected officials because, after all, Nobody had won the previous election.

Few people understand this better than the Baltimore Psychogeographic Society, whose diligent research work pieced together this remarkable amassing of the theories, facts and the history of culpabilities in the 9/11 disaster. The book's author, Len Bracken, and co-horts Andrew Smith and Carla Platter launched the Campaign for Nobody in Baltimore's Inner Harbor as early as 1999. With little more than some leafleting of Baltimore, Washington and Philadelphia, the

group led the charge that culminated in their candidate taking over America in the fall of 2001, when Nobody won. Late night talk show talker Conan O'Brien even mentioned the group in his monologue as "anarchists who look like everyone else."

Of all the conspiracy theories put forth since 9/11, the state terror thesis is the simplest, most elegant and most easily followed. The basic notion is that whether or not it actually participates in any given mass crime event, like 9/11 or the Oklahoma City bomb, the state uses these occasions as a means to consolidate and expand its power. Everywhere today, the upshot of the WTC and Pentagon plane crashes has been an extraordinary erosion of cherished American civil rights, through the creation of ever more powerful police bureaucracies, such as the new Homeland Security office, and the application of human and economic resources for an ill-defined and never-ending war. It is easy enough to see. People are put on ever more imaginary degrees of alert and the prospect of military takeover of civilian police functions is openly considered. Yet few expect the bureaucratic bloat to have much impact on the next real terror attack.

But does it end there? Is it simply a matter of the power mad elite taking advantage of the misguided actions of the dispossessed insane? As a compendium of the facts about 9/11 alone, *The Shadow Government* follows these questions to their inevitable conclusion: that the state participates in the events it exploits. Given the history of how useful acts of terror became in enhancing state power, it only makes sense that in time the state would orchestrate such acts. For readers who might find it a difficult proposition to accept, consider lessons in the spectacle of power abuse paraded repeatedly on TV: the Rodney King and Donovan Jackson videos--yes, They can do that to one or two ordinary citizens; the Zapruder film--yes, They can THAT to someone people thought they elected; 9/11--can They do that to such a large group of ordinary citizens? *The Shadow Government* presents the

historical backdrop and the current body of research and writing that makes this proposition credible. It is important reading in a world adrift, as Nobody serves out the term.

Notes:

1. Prior to 9/11 Mark Crispin Miller's *The Bush Dyslexicon* collected misstatements, crudities and ignorant arrogance made by Bush in various public and media forums. To his credit, Miller produced a new edition after 9/11, when the implications of having such an inadequate chief executive seemed far less humorous.

2. I heard news of the decision while standing on the corner of Bush and Mason streets in San Francisco, pondering the synchronicity. Two weeks later, while visiting author Bracken in DC, I had my first opportunity to attend a Supreme Court proceeding, respect for the institution perhaps at its lowest point in history.

3. A bibliography of books that outline some of the secret history involving the current president and his family should perhaps begin with *Fortunate Son* by J. H. Hatfield. Hatfield was a celebrity biographer found dead shortly after Bush family efforts to stop publication of his book, which included material about the president's drug and alcohol habits, failed.

Peter Brewton's *The Mafia, CIA and George Bush* (1992, Shapolsky) helped sound the clarion call on the senior Bush. It included information regarding Jim Bath, a good friend and real estate business partner to the current president, Bush Jr. Bath was a trustee for the two wealthiest families in Saudi Arabia, one of them a money conduit for Adnan Khashoggi during his partnership with Manucher Gorbanifar.

Khasshoggi and Gorbanifar managed the Iran-contra arms-for-hostages deal, and came under the research scrutiny of Danny Casolaro. As Dodi Fayed's uncle, Khasshoggi was also noted for his connection to the assassination of Princess Diana. (See: *The Octopus* by Kenn Thomas and Jim Keith, Feral House, 2003.)

4. For better or worse, definitive proof of Osama Bin Laden's involvement with the 9/11 disasters has never been offered. Neither have adequate reasons why the resources of the world police agencies failed to capture such a feeble man, afflicted with osteoporosis and kidney problems requiring dialysis. The identities of the plane hijackers remains disputed and officially most of them primarily came from Saudi Arabia, a US ally. After the plane crashes stopped all other air traffic in the country, a single plane made stops throughout the country to pick up members of Bin Laden's family and escorted them out of the country.

LECTURES

Maury Island

Following is the bare bones narrative of the lectures I give on the Maury Island case and the Octopus cabal. While this covers many of the two stories' major points, at each lecture I add material as more surfaces, many times taken from knowledgeable people in the Q&As after previous lectures. One observable fact about the Octopus and Maury Island case is the continued intense popular interest in each. Floodgates of long held-back information seem to open every time I give the lectures, even at UFO conferences where at least the Maury Island history should be common knowledge. For the sake of proper chronology, I have reversed the order of the two lectures as I gave them recently in Los Angeles.

For those who missed my lecture on the Octopus Thursday before last, let me introduce myself. My name is Kenn Thomas and I am a parapolitical researcher and writer. In the parlance of mainstream America, I am a conspiracy theorist. I publish a magazine, *Steamshovel Press*, that has the motto "All Conspiracy. No Theory." I also have in print about a dozen books on various conspiracy topics, including one with this title. I regard the Maury Island book as a sort of prequel to the events of another one of my books, entitled *The Octopus*. I covered that in the last lecture but don't think it's a prerequisite for understanding what I am talking about tonight. I will indeed be going into some interesting avenues of conspiracy history in reviewing the case of the Maury Island UFO, but hopefully I will provide you with enough information that you can understand it without having to connect it all up with the previous lecture.

28

If you have an interest in the Octopus lecture, I am available to do it again if you have a discussion group or some organization that takes on discussion about parapolitics. If so, just come up and see me after this lecture.

To help carry on this narrative, I will be throwing up on the screen panels from this 1968 comic book dealing with the Maury Island case called *UFO Encounters*. In the grand tradition of American investigative journalism, this is about as much editorial space as Maury Island received before my book on the subject came out. Even though the artists and writers got some of the main details wrong-also in the fine tradition of American journalism--and presented characters that look nothing at all like participants in the story, this is more than most journalists in this country have done in the past half century since the Maury Island event happened. I think it was Garry Trudeau of *Doonesbury* who coined the term "investigative cartooning" and here we have an example of it from the late 1960s. Again, it's just a means of moving the lecture along and I will be combining it with actual photos and documents.

There certainly is enough of that. One reviewer said of the Maury Island book that it is "information rich to the point of saturation." Details about the case-in case you're thinking I'm getting it all from a comic book-come from several

Freedom of Information Act requests filed by me and other researchers; first hand accounts and various published accounts, none of which, as I say, involve investigative journalists. They include books like Kenneth Arnold's *The Coming of the Saucers* and Edward Ruppelt's Project Blue Book report. The case is mentioned time and again in the UFO literature but this book (point) is the first one ever devoted exclusively to it. A lot of that has to do with a widespread dismissal of the case as a fraud and a lot of it really has to do with the fact that many of the historical facts-things that connect the story up to the 1960s and on to the present-things that make the story really interesting, have only become available recently. I don't pretend to iron out every contradiction in this huge pile of files. At the end I will present several theories about what happened, including my own, and let you decide. Actually, urge you to buy the book and then decide, since the book is one third footnotes and give you this in much greater deal than I can do here tonight.

So this story begins on June 21st, 1947, three days before what is widely regarded as the first modern UFO event, Kenneth Arnold's sightings over Mount Rainier. Out along the shore of the bay around Maury Island up in Puget Sound near Tacoma, Washington, a man named Harold Dahl was in a lumber salvage boat, the North Queen-timber, logs, sometimes break free from their normal shipping routes; each is branded and salvagers get paid for the logs they are able to return to the companies to which each log belongs- - and this is done by freelancer of a sort, who work for themselves and not for the lumber companies or for public authorities. I mention this because early on the people involved with this were referred to as harbor patrolmen. They do more or less patrol the harbor, but for logs and not to enforce law. Many took this early misidentification as an indication of a hoax. In any event, Dahl is out there with his son, his son's dog and two other people whose names we don't know. In the sky above him at about 2PM Dahl spotted six disc shape craft -

flying saucers, as distinguished from the chevrons Kenneth Arnold saw a few days later - one in the middle, wobbling, and five surrounding it. This was at an elevation of about 2000 feet.

This is where the comic book starts getting the story wrong. It has Dahl here saying that the saucers were 100 feet in diameter. He actually said twenty five feet, and this is in the earliest recounting by Dahl of the event. But they were doughnuts, right down to the hole in the middle. They also had five foot portholes on the side.

So let me try to give you a picture of this. Twenty foot saucers, kind of flattened in the middle - concave, not convex. Dahl said they were gold and silver and shined like a Buick dashboard (do Buick dashboards shine?), surrounded by portholes. Inside the bottom interior of the doughnut, each one had one dark porthole that spun around. All of this was done in complete silence and went on long enough for the boat to kind of back off and hit shore.

The comic here and in the next panel have it that all this took place in the bay. It did start there but the major action happened after the boat had returned to the shore. They were on the shore when Dahl pulled out his camera and took a few shots. And you could bet that if those images survived, you would be seeing them here instead of this comic book.

The middle saucer wobbled and dropped down about two hundred feet from the others. It dropped another 500 feet and stopped wobbling before one of the circling saucers broke formation, flew down, touched the other one and became still

itself. Dahl said it looked like that one was giving assistance to the other one that had been wobbling.

Then the really weird thing happened. The saucers started spewing out two different substances, black and white. The central saucer started releasing the white stuff, which Dahl described as a thin, white "newspaper like" metal that more or less floated down into the bay. But the second substance turned out to be a bit more dangerous. This was the black stuff. Dahl described it as similar to lava rock The chunks that fell into the bay were so hot they caused steam to rise. And, of course, pieces flew over to the shore and dropped on the crew, who mostly ran for cover.

Not the kid, though, as this panel shows. Charles Dahl was struck in the arm by some of the lava rock.

Another piece hit Charles' dog. We don't know what kind of dog it was or the name, but it was killed by the falling slag. This makes the dog the first casualty of the modern UFO era, a distinction that is usually given to Thomas Mantell, the Air Force captain who crashed his F-51 in January 1948 in pursuit of a UFO that interestingly looked like the Maury Island saucers. There are some other candidates for the distinction, however, and we will look at them as we go along here.

So there you have it. That's what happened near Maury Island on that day. It's just the beginning of the story, however, and almost not even the most interesting part. Dahl doesn't really say how long all of this took to occur. After the

saucers took off, he and his crew threw the dog's carcass into the water and collected samples of both the white and the black substances. They took off, all kind of saying to each other, "what the heck was that?" but also anxious to go somewhere and get medical treatment for Charles Dahl. Now, as I've said, we don't know the names of the other two people on the boat and we don't know what became of them. Charles Dahl would later have a rather bizarre set of circumstances come upon him, which in part led Dahl later to claim that all of this was a hoax, but we'll get to that. The thing of significance here is where Harold Dahl took his story, and that was to someone named Fred Crisman.

Now what's interesting about this panel from the comic book is how much it gets wrong. First we see that they've got it backwards. It's Dahl who actually reports to Crisman about what happened near Maury Island. So you have to switch that around. The panel should read "Dahl reports to Crisman, his superior officer." But, as I mentioned before, there is no superior officer in this situation because these are not harbor patrolmen. They are free-lance log

salvagers. At best, Crisman might be considered Dahl's boss. In fact, Dahl seems to have come to Crisman to tell him about how the boat had sustained the damage caused by the falling slag from the saucers.

OK. Now we're going to be done with this comic book for a while. Let's chalk up these problems with it as simple mistakes and not speculate too much about how disinformation in the media may reach down to the level of even comic books.

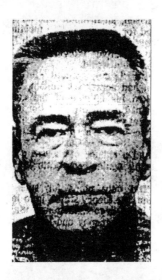

This is a mug shot of Fred Crisman, a man with a long and complicated life's story. It is his connection to Maury Island that moves from the realm of just another interesting UFO story into the realm of parapolitics. This is why the subtitle of the book is *The Crisman Conspiracy*, because it is Crisman who not only keeps the story alive over time but also seems to use it for a career that seems to have one foot in the covert intelligence world and another in the world of conmen, hustlers and bums. So we'll get more of the picture of Fred Crisman as the lecture proceeds.

But to underscore: the boat did not belong to Fred Crisman, so even calling him Harold Dahl's boss isn't correct.

Following is the ship registration for the North Queen. The name listed here for the North Queen's registration is "Dahl". So you have to wonder why Dahl felt compelled to explain the damage to his own boat to Crisman. Or is it even Harold Dahl's boat? The registration actually says Haldor Dahl on Union Avenue.

You might expect disinformation to be conducted on official records like this, either at the time or fudged later in order to obscure things, or you might just dismiss this as a typo, a mistake as in the comic book. That's what I did in the book. Since that time, however, one researcher, someone named John Covington, has pointed out that Haldor Dahl and Harold Dahl may be different people, that Haldor lived at 1801 North Union as it says here and that Harold actually lived on 3903 North Grove. I haven't checked his source for that information, though, so I'm sticking to the obvious possibility of a typo here.

The North Queen, by the way, was a 1942 fishing boat that was converted into a mine sweeper for World War II and then reconverted into a fishing vessel after the war. Some reports call it a decrepit old piece of junk, but actually it was not very old, a ship that saw military service and one that had just been reconditioned. Also, a year after the Maury Island

incident, in 1948, the registration passed to someone named Anderson in Tacoma.

And so we begin to submerge into this murky paper trail, which is something that would characterize Crisman's entire life, fudged and inaccurate documents, some of questionable provenance, some containing very intriguing pieces of information and disinformation. But his involvement with the Maury Island saucer story really begins two days after Dahl's. As Dahl had expected, according to the story, Crisman thought that he and the crew had been drunk when they saw the saucer incident. But since Dahl had samples of the slag as proof, and said that there was much more of the stuff along the shore, Crisman decided to go and take a look. He later said that he did indeed see an an enormous amount of white and black material there at Maury Island. But as he was looking it over, he had his own sighting. It was a doughnut shaped craft like the ones Dahl described, but different in that it had no squashed look. Convex, not concave. It did have an inner tube type structure, though, had the portals and it had the spinning little black thing on the inside bottom. This was a very brief encounter according to Crisman, but scary enough. Before he took off running, however, he supposedly collected more samples of both the black and the white substance.

So where did Fred Crisman come from? His earliest appearance in the historic record, two years before Maury Island - comes in the form of an extensive quote in *Harper's Magazine* in September 1946, in an article about the first postwar world convention of science fiction the preceding March in New York. Interestingly, the article, entitled "Little Superman, What Now?" was written by William S. Baring-Gould, whose grandfather, Sabine Baring-Gould the English clergyman who wrote "Onward Christian Soldiers" and also two books on ghosts and werewolves.

That led to an angry response from Crisman that originally appeared in the May 1947 issue of a science fiction

pulp magazine called *Amazing Stories*. This was one month before Maury Island. In it, Crisman complains that the article in *Harper's* about science-fiction fans, amounted to nothing more than a bunch of armchair philosophizing about science fiction concepts that he considered to be a very real phenomenon. This had nothing to do with flying saucers, however.

Flying saucers and the UFO craze in America were still a month in the future. The imagery of advanced aircraft had been around for a long time, of course. The Flash Gordon serials of the thirties, for instance, had various rocket-type ships and science fiction itself has a very long and interesting history in print, on radio and in various movies. And UFOs of all shapes and stripes have been around since the dawn of man. But the imagery of the flying saucers as a recurring popular culture theme began only in the late 1940s, just after the first modern wave of sightings, and with the help of pulp magazines like *FATE*, which still exists today. This is the first issue, published in 1948, by the same person who published Crisman's angry response to *Harper's*.

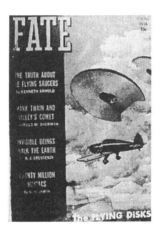

And that would be Ray Palmer. Science fiction fans would argue that Ray Palmer's place in their history is not one of great respect. Even one of his associate editors told a pulp

magazine historian that Palmer published "some of the sickest crap I had ever run into." Palmer was a man of diminutive stature who helped popularize and promote the idea of flying saucers in his many pulp magazines. *Amazing Stories*, the magazine that more or less introduced Fred Crisman to the world, was one of those. Actually in the 1990s Steven Spielberg once did a television version of *Amazing Stories*, using the title and the same kind of pulp magazine format. Palmer's publishing career continued on until his death the late 1970s. Among the last things he ever did was a magazine for the National Space Institute, a group of space industry insiders founded by the Paperclip Nazi scientist Werner Von Braun, and the significance of that will come a little later.

This is another shot of Palmer. Somehow only half of this was scanned. It's intended to show what a diminutive guy he was, especially next to a regular giant, the main contributor to Palmer's pulp magazine, a guy named Richard Shaver. Before 1948, Palmer was able to more than double the circulation of his various magazine by introducing the supposedly true stories of Richard Shaver - and unfortunately I don't have a photo of Shaver, although he's on the other half of this one - about a mysterious race of beings known as the *deros*. The *deros* were an underground alien race that looked very much like the little greys that seem to be so common

these days among people who claim to have been abducted. If there is some sort of connection there, it does kind of expose the myth that such creatures are the creation of the modern media.

Shaver and Palmer insisted that the *deros* were real, despite the original information about them was channeled to Shaver through the welding equipment where he worked in a steel mill in Barto, Pennsylvania. In addition to being alien creatures that in habited caverns deep under the earth , Shaver claim that all earth men are in part *deros* because they are being affected by detrimental energy streams in the post-atomic world. "Deros" is a contraction of the words "detrimental" and "robot" and really a lot of what the Shaver Mystery stories reflected was the weird way people were feeling after the end of the war. The interest in these stories was so great that it not only greatly increased the circulation of Ray Palmer's magazines but it lead many of his readers to write in with their own stories about encounters with the deros.

Fred Crisman was one such reader. After the long quote from him that appeared in *Harper's,* Crisman's second appearance on the scene came in the form of that letter to *Amazing Stories.* In it, Crisman claimed to have encountered the *deros* in Burma. He even described a wound to the arm the size of a pinhole, a description that sounded eerily like a laser and this was years before lasers existed.

Now forget all that. Ray Palmer did. Let's go back to the main event at Maury Island. Harold Dahl and company have had their encounter and Crisman went down the next day and supposedly had his. I suppose we can assume that Crisman put this in a letter to Palmer as he had his encounters with the *deros.*, although that's not really clear. What is clear is that Ray Palmer hired this man to investigate the Maury Island claims. I'm sure most people recognize that this is Kenneth Arnold, whose sighting on three days after Maury Island, started the first post-World War II wave of UFO

these saucers fit more the description the description of the Maury Island saucers than Kenneth Arnold's chevrons.

And, of course, there were more than just sightings. There were a number of recoveries of different things. Here is a sketch of one of them. This is a thirty inch saucer discovered by a housewife that month and turned over to the FBI. The newspaper describes it as gold plated on one side and silver on the other, the

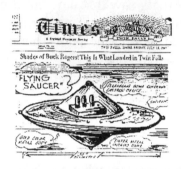

same colors basically as the Maury Island craft. Although it was later declared that this was built by four young pranksters using parts from an old phonograph, that only came after very strange actions by the authorities. Army intelligence officers were called in and the thing was locked in a back room and all were instructed not to say a word about it. It's hard to imagine that this was a response to something that looked obviously like it had been pieced together from an old record player. Oddly enough, the size and shape of the 30 inch saucer matched a second, lesser known sighting by Kenneth Arnold on July 29.

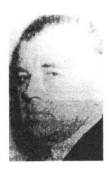

This is the man who to whom this two and a half foot disc was turned over. If he looks a little like Ed Asner to you, pat yourself on the back because Asner actually played this man in Oliver Stone's movie about JFK. This is Guy Banister. He was an SAC - that is, a special agent in charge - of the FBI in the Pacific northwest in the late 1940s, specifically Idaho and Montana, at time of the Maury Island case in Washington. Oliver Stone's interest in him begins about another decade and a half into his life. Banister. In the 1950s Banister testified before the Louisiana Joint Legislative committee that at the time that he was at the time working in counter-espionage.

During that same testimony to the Louisiana state body, Banister described the saucer as a Japanese Fugo balloon. The chief value of this statement is that it exposes the lie about the four boys rearranging the parts of a record player. Everyone is familiar with the Fugo balloon theory. It has been offered up as one of the many explanations for what happened at Roswell. In that case as in this one, it has been almost totally debunked since the Fugo balloons were launched from Japan in March of 1945, and the possibility of them staying aloft for such a long period is remote.

The Louisiana testimony included Banister's acknowledgement that he also was a coordinator for a right-wing militia group called the Minutemen.

But that's all getting ahead of the story. As I said, Palmer hired Kenneth Arnold to investigate the claims of

Crisman and Dahl for $200. Arnold went out what has become the infamous Linnard-Western Winthrop Hotel, Room 503. The first thing to make it infamous was the fact that the room had already been reserved for Arnold by persons unknown.

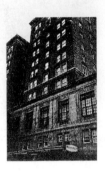

This is a shot of the Winthrop I took relatively recently. It still exists but it's be used for rent controlled housing. It is here, after acquiring the room from person or persons unknown, that Arnold first called Harold Dahl by looking him up in the phone book.

A very reluctant Dahl kept trying to talk Arnold out of his investigation but eventually agreed to come over and also agreed to take Arnold to the storage sight of the debris he had recovered from Maury Island. When he brought a chunk of it out, Arnold declared that it was just a piece of lava rock and started using it as an ashtray.

Fred Crisman showed up at the Winthrop the next day and went over the Maury Island story again with Arnold. He also told him of his flight experience and his missions over Burma during the war, although he mentioned nothing of the *deros*. After Crisman had his say, Arnold suggested that they all go out to Maury Island.

Then Arnold had another brilliant idea: bring in Emil Smith. Smith was an airline captain who had publicly derided Arnold about his Mt. Rainier experience but then had a UFO encounter of his own. Arnold had met him through a military

intelligence officer, Paul Weiland-who had been a judge at the Nuremburg trials--who had previously paid him to go on a fishing trip with him. The relationship of these two men, Weiland and Arnold, remains unclear, but we do know that at one point Weiland gave Arnold a .32 automatic that Arnold had on him at the Winthrop.

When Emil Smith arrived at the Winthrop and met Crisman and Dahl, they recounted Maury Island again and agreed to meet at the island the next day with more samples of the UFO slag. Crisman volunteered to drive Smith on a long trip to Seattle and back to recover his things.

Before Arnold and Smith went to sleep that night, they received a call from a reporter named Ted Morello. Instead of asking for information, Morello actually repeated back to the pair precise details of the conversations they had had with Crisman and Dahl. The room had been bugged.

All four men made it out to Maury Island the next day. Crisman and Dahl both brought more samples of the slag. They had to come back to the Winthrop, though, because the dry dock had been closed and there was no access.

Arnold filmed all this, by the way. In 1977 he mentioned that all of his film equipment had been stolen in a break-in, but the fate of all of his films is still unclear.

After all that, Arnold decided to call in the Air Force. Crisman was all excited about the idea but Dahl refused to talk to anyone from military intelligence. Nevertheless, through his connection with Paul Weiland, two Air Force investigators, Captain William Lee Davidson and First Lieutenant Frank Mercer Brown, came to the Winthrop Hotel.

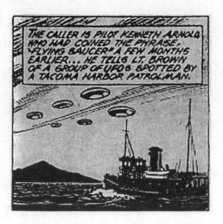

So here we are back to the comic book and everything it has wrong. It says here that Arnold coined the term "flying saucer" but that distinction actually probably belongs to a newspaper reporter named Bill Bequette. And, of course, it identifies the witnesses again as harbor patrol men.

Nevertheless, it is in this atmosphere of weird intrigue at the Winthrop, and blurred details, some film and some pieces of the Maury Island slag came into the hands of military investigators. Let me just leave the story at this point and take a bit of a break and we'll resume the story again from the point of the Davidson and Brown investigation.

This is Lieutenant Frank Brown. He was one of two men the Air Force sent out at Kenneth Arnold's behest to investigate the Maury Island claims of Crisman and Dahl. His partner was Captain William Davidson. The photo of Brown comes from a recovered ID, and in a minute here we'll get to where it was recovered from.. There doesn't seem to be any

photograph of William Davidson. Davidson. It's interesting that this is taken in Italy.

So Kenneth Arnold calls in these two Air Force investigators, Brown and Davidson, of the Fourth Air Force A-2 Intelligence unit to be precise. He knew them because they had previously investigated Arnold after the Mt. Rainier sighting. Arnold had cooperated with that investigation and had turned over the many letters he had received from people after his sighting had hit the papers. They expressed a particular interest in the letter he had received from Ray Palmer, so he thought they would be the logical people to contact about this.

Dahl, who again was extremely reluctant to talk about his Maury Island experiences at all, let alone to military intelligence, nevertheless repeated the story one more time. Crisman offered details about the white debris looking like aluminum that make is sound a lot like the material recovered in the Roswell crash.

Despite the fact Arnold apparently took the initiative to contact Davidson and Brown, in point of fact the two were on assignment to collect as much information as possible on the summer wave of UFOs. They had been dispatched by General Carl "Ptooey" Spaatz, a commander who had served in Italy during the war as a part of project Ultra, a decryption project in Italy similar to the Magic decryption project in Japan. I think it's interesting that these two secret decoding projects have names so similar to MKULTRA and MAJESTIC, two infamous secret projects of the more recent past and (present?) Spaatz provided Davidson and Brown with a B-25 to hop around and collect this information, particular on cases that involved recoveries. That explains their particular interest in the Palmer letter.

They were to report to the Air Technical Intelligence Command at Wright Field in Ohio. According to an FBI memo from August of 1947, Spaatz, Brown and Davidson in turn reported to General Nathan Twining at Wright Pat.

Now the significance of this command structure comes in the form of the Cutler-Twining memo, an MJ12 documents that still resides in the National Archives. Of all the MJ12 documents, I believe the C-T memo, in combination with another one found in a completely different official archives whose dates match up almost perfectly with the C-T, comprises the smoking gun proof of the existence of MJ12.

But that is a subject for another lecture. This one is already complicated enough. If you would like to see a discussion of this, I suggest you pick up the latest issue of *Steamshovel Press*, where it is discussed in detail.

Let's get back to Harold Dahl. Dahl kvetched at telling his story again to anyone for good reason. After he first began talking to people about it, Dahl had an experience that later became repeated often with many UFO witnesses and became quite well-known. He had a visit from a Man in Black. He dressed in black and he had a black Buick that he drove around in. When he met up with Dahl, he also demonstrated that he had a very detailed knowledge of Dahl's Maury Island experience. And he told Dahl that if he ever let the Maury Island story out, bad things would start happening to his family.

And sure enough, shortly thereafter Dahl lost a large number of logs he had salvaged from the bay, severely damaging his business. His wife fell deathly ill. And his son Charles, who had had his arm injured at Maury Island, disappeared. Charles was eventually found bussing tables somewhere with total amnesia about how he got there. The "where" is obscured by an FBI memos with conflicting reports about whether it was Lust, Montana or Lusk, Wyoming.

It's at this point that Dahl decided to stop talking about the experience, telling his wife that if anyone approached him, he would just say that it was a hoax.

All of this happened before the meetings at the Winthrop Hotel, so here again the comic book misleads us.

48

There were some other odd anomalies about the phones calls to the hotel. When Arnold first called Brown, for instance, Brown refused to accept the call on the military line and called Arnold back on a pay phone. Moments later, the UPI guy Ted Morello called again demonstrating that he knew all about the military investigators coming in. At some point, Dahl did indeed leave the scene and left the explaining to Fred Crisman.

But the biggest thing that Brown and Davidson took from their investigation was the recovered debris. Depending on who you read, they had either a trunk of the material, both white and black, or a *Kelloggs Corn Flakes* box full of it. Crisman gave it to them. Arnold noted that it as different from the one he had turned into an ash tray.

At 1AM the next day, Davidson and Brown died in a crash of their B-25.

The crash, of course, was widely reported. What wasn't reported much is that the counter-intelligence team sent out to do clean-up at the crash site, which supposedly was unsuccessful in finding any evidence of the Maury Island debris, recommended that all similar incidents in the future be handled by the foreign technologies desk.

In his book *The Day After Roswell*, Phillip Corso claimed that this was the same office that parceled out whatever technological benefits came from whatever it was that was recovered in Roswell.

So Arnold and Smith opted out after this - quite freaked out that the investigation had led to the deaths of two military personnel. Emil Smith retired to Florida, where he still lives as far as I know. Arnold went on to more fame with his own sighting. In fact, he became a national celebrity and gave lectures at UFO conferences across the country for many years. Although the Maury Island story appears in his book, *The Coming of the Saucers*, it does not comprise a big part of the story he told and retold on the lecture circuit.

The only public record of Harold Dahl is that he continued to live in Tacoma, once subletting a house to a typewriter rental office and once operating a gun shop with a federal export license and sold antique furniture. The log business never took off after the encounter with the Man In Black. Harold Dahl died in 1980. Even though Fred Crisman died five years earlier, the course of his life took far more dramatic turns.

Following is one of the MJ12 documents that the Woods' surfaced. I can't speak about its authenticity or its provenance but it is interesting for what it says at the bottom. After recapping the Davidson and Brown crash, it reports that "the material given to Davidson and Brown was believed to come from Maury Island and may be celestial fragments containing metal from a nuclear reactor from a UFO. The fragments were turned over to CIA agent Shaw and Crisman was ordered to the Alaskan ADC for assignment in Project IVI." Crisman did indeed return to Alaska after this. He was reactivated for military service during the Korean War.

Below is a document from the National Archives that supposedly demonstrates that Clay Shaw was in the US at the time of Von Braun's surrender. Is it exculpatory of his involvement with that? Was Shaw handling things from the US side? Shaw's historic record ha had a number of curious things done to it, including volumes

of *Who's Who* having been wiped clean of his connections to Permindex and the Banca Nazionale del Lavoro of Italy, two international agencies that the Torbitt document mentions prominently. Again, these references exist in earlier volumes of *Who's Who* and are gone after 1963. So take that for what's it worth in the official documentary record of Clay Shaw.

This is Clay Shaw. He was one of three people that New Orleans district attorney Jim Garrison attempted to indict as part of a conspiracy in the assassination of John F. Kennedy. One of the others, Edgar Eugene Bradley, was refused extradition from the state of California where he lived by then governor Ronald Reagan. Although Shaw was exonerated in Garrison's famous trial, a poll of jurors said they believed that Shaw had worked for the CIA or something like it. In the late 1970s, a former CIA operative named Marchetti verified that Shaw was on the CIA payroll.

Shaw is mentioned prominently in something called the Torbitt Document, a famous bit of underground information that was published for the first time in this book that I put together called *NASA, Nazis and JFK*. It claims that Shaw played a large part in managing the surrender of Werner Von Braun, one of the Nazi rocket scientist who helped build the American space program. The Torbitt Document fits this information into the background of the JFK assassination. In fact, the book includes a photo of JFK conferring with Von Braun just days before the assassination.

Garrison supposedly first became interested in Crisman because of this letter. The letter was sent to him anonymously? And it claims that Crisman was the first man Clay Shaw called after finding out that Garrison was pursuing

him. It also mentions involvement with the anti-Castro Cuban groups.

But Garrison knew Guy Bannister in the 1940s. Remember Banister? He was the FBI SAC who recovered the 30 inch disc near the time of the Maury Island case. Jim Garrison says in is biography that he knew Banister well, and often had lunch with him to talk about what was happening and to trade stories. Surely Banister mentioned the 30 inch saucer. Did either man have knowledge of Maury Island and did they discuss that? Certainly there was some buzz going around about it in the FBI and parts of it were appearing in the newspapers. And yet, Garrison seems to know nothing of Crisman in 1968. It's another instance, as with Ray Palmer, that Crisman's presence should have been telegraphed ahead and wasn't.

Again, if you're too young to remember this history, you'll have to harken all the way back to Oliver Stone's movie *JFK*. Crisman doesn't appear in it, but Kevin Costner does a good job of going over the more visible aspects of Jim Garrison's investigation.

Garrison pursued two lines of research with Fred Crisman. One was the fact that Crisman may have worked for Boeing in Seattle, Oregon ranch. And yet, when Garrison announced his interest in Crisman, he said that it was in connection with his undercover work for "that part of the

warfare industry engaged in the manufacture of what is termed in military language 'hardware - meaning those weapons sold to the US government that are uniquely large and expensive." In other words, Crisman was an industrial spy, and presumably, an assassin.

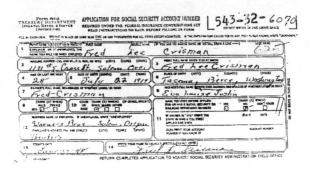

This is an interesting document. It's from the Social Security administration. It's Crisman's application for a social security number. It lists Warner Brothers as his employer. Much later in life, Crisman would claim that the old Roy Thinnes show *The Invaders* was actually patterned after his life, but this is an early indication that Crisman may have worked as an actor in some other capacity in the entertainment business.

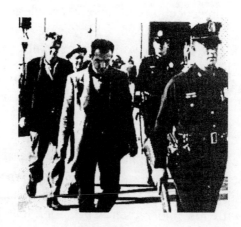

That photograph appeared the Torbitt document and it appears in *NASA, Nazis and JFK*. It is of three alleged hoboes or tramps that were arrested in the railyard behind

Here is a more close up look. Notice that despite the fact that these three may have been involved with the assassination of the president, the police guards, both of them, have their guns relaxed and pointing down casually. Jim Garrison took this on the Johnny Carson show.

These three have been identified as various people by various researchers. One famous accusation is that two of them are Watergate burglars Frank Sturgis and E. Howard Hunt. Another candidate is Charles Harrelson, the father of actor Woody Harrelson. There are even official arrest records for them, one of whom, Harold Doyle, has a name that sounds like Harold Dahl. And this one bears a resemblance to Fred Crisman.

Here are the tramps again, walking in a different direction along Elm Street in Dallas. Notice that one is obscuring himself from view. In another photo from this sequence that I show at the Octopus lecture, I have a blow up of this one that suggests he has a radio control device behind his ear.

One well respected researcher, someone named L. Fletcher Prouty who died not too long ago, argues that the man walking in the opposite direction of the tramps is Edward Lansdale. Lansdale is a well known figure in American history. He was a special assistant to ambassador Henry Cabot Lodge and a CIA/OSS operative in Vietnam in the 1950s. In fact, he has been the subject of two film biographies, 1963's *The Ugly American* where is played by Marlon Brando, based on a noel by William Lederer, and a very recent one with Michael Caine called *The Quiet American,* based on a novel by Graham Greene. The OSS connection is significant in that Fred Crisman often claimed to have a background with the OSS. Other researchres have suggested that a radio control device can also be found behind the ear of the Lansdale figure in this photograph.

One has to look at the famous Zapruder film to see how likely this scenario is. Most obvious there is the shot

from the grassy knoll. There for all to see. No magic bullet, evidence of your eyes where the head shot comes from here, the grassy knoll, which is right in front of the railyard where the three tramps were picked up.

The second thing to look at is the figure called by Kennedy researchers the "radio controller man". In the Z film and in other photographs of the scene he is very clearly holding on to a radio control device. He is also giving hand signals--to the Dal-Tex building across the street, to the Book Depository, and to the grassy knoll.

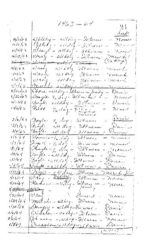

Here is a document that supposedly is exculpatory of Crisman. It demonstrates that no substitute teacher was called in for him at Rainier High School, supporting Crisman's claim that he was teaching that day. Interesting, though, that although it covers a period from October 1st , 1963 until August 7, 1964, it is written in a single handwriting.

In the aftermath of the life of Fred Crisman, we come to this individual, a rather well-known figure now among parapolitical researchers. This is Michael Riconosciuto, the son of one of Crisman's business partners in Tacoma, someone named named Marshall Riconosciuto. This is a photo that appeared in a Tacoma paper showing Michael as a boy of twelve, a *wunderkind* who at around this time built his own argon laser that got him a job working for a Nobel prize winner in laser physics, a scientist named Arthur Schalow. Remember that Crisman himself had given a prescient description of a laser in his battle with the *deros* in Burma, many years before the laser was invented.

Riconosciuto became much more widely known in the 1990s as the main informant to writer Danny Casolaro, and this involved his advanced technological skills. Casolaro was found dead in a West Virginia hotel room while investigating an international power cabal known as the Octopus. Riconosciuto's role grew out of modifications he made to a super-surveillance software used by this Octopus called PROMIS. He did this as party of something called the Cabazon/Wackenhut joint venture on a native reservation in Indio. At the time, a series of grisly murders accompanied what Riconosciuto was doing - which also includes the development of shoulder fired missiles and night vision goggles - and ultimately he was convicted for running a met amphetamine lab, something for which he seems to have received an extraordinarily long sentence.

This was the subject of my last lecture and also the subject of one of my books, called *The Octopus*, a new

edition of which will be released in November. And this one of the points and purposes of taking this look at Maury Island, to establish that there are individuals and situations that operate in this covert conspiracy world over generations. In an interview I conducted with Michael Riconosciuto exclusively about Maury Island, Riconosciuto swore that Fred Crisman wrote 1600 pages of notes and biography that have been tucked away in storage somewhere. He's not going to say where, however, unless the information somehow gets him out of jail. Most of what Riconosciuto says more or less serves this cause, getting out of jail.

So at this point let me introduce you to the various theories about Fred Crisman. I'll start with the one offered by Michael Riconosciuto, who after all was with Crisman as a kid and regarded him more or less as a father figure. He actually identifies the person that Fred Crisman worked for at Boeing. He says that Crisman was covering up secret disc devices developed by the military to fog enemy radar.

Let's then remember Guy Banister's idea, applicable to the Maury Island saucers, that these were Japanese Fugo balloon bombs. Since the last of the Fugo bombs were released two years prior to the events of Maury Island, this theory seems unlikely.

Another theory comes from a researcher named Ron Halbritter. Halbritter suggests that the Maury Island saucers, Kenneth Arnold's chevrons and whatever crashed at Roswell were all the same craft. The wobbling fixed at Maury Island got back in formation and that's what Kenneth Arnold saw. The repairs didn't maintain and the wobbly one came down at Roswell. Crisman's description of the white metal certainly matches what has been said about the material of the Roswell recovery. And the theory does satisfy a certain inclination to try to tie all of this material together. But like it or not, Halbritter has the best argument against the Riconosciuto theory

59

And then there are the two theories that Jim Garrison pursued.

It is very difficult to conceive that every document that I have presented here and all the research compiled in the Maury Island UFO book is the product of an elaborate hoax. It would be a hoax perpetuated by a large number of people with an extremely advanced knowledge not only of history but of the very specialized history of UFOlogy and the separate specialized history of the Kennedy assassinations researchers. Common sense dictates that this would be very difficult, unless of course you are a regular reader of *Steamshovel Press*. And take my word for it, I didn't and couldn't fake this material.

So that just about covers it. There are still many avenues to pursue. The supposed memoir that Crisman left behind according to Michael Riconsociuto. I'm in touch now with Thomas Beckham's daughter and Beckham is very much alive and would like to say more about his involvement with Crisman. The Reverend Bob LeRoy publishes his *Alarming Cry* newspaper. I am not going to give a blessing to any of the various theories, but I will conclude with one other note from the history books:

On the day of his death, John F. Kennedy gave one final speech. It involved the defense contract for the TFX tactical fighter. This was an extremely controversial contract that everyone expected to go to Boeing. Instead, JFK awarded it to General Dynamics. So you could certainly add Boeing to the list of people and groups that might have wanted Garrison dead.

More importantly, however, the TFX tactical fighter eventually became the F-11 and was a project that was eventually sold to Australia. And if you look at some of the parapolitical research into this, you find that many people seem to think that this is what opened a funding corridor to the Australians in their development of the Pine Gap listening post for the ECHELON satellites. Pine Gap, of course, is the

Australian Area 51. It was outside the scope of this talk, but we have an established biography of Lee Harvey Oswald as a spy attached to Area 51 through his connection to the U2 spy plane developed there.

So whatever you have to say about the Maury Island case, it sort of ends in this kind of science-fictiony atmosphere that we all seem to be enjoying or whatever it is we do with it - mostly just be frightened of it, I suppose. So the last thing you would want to do with all of this information, whether you believe in aliens or not, whether you believe in conspiracies or not, the last thing you want to do is dismiss it.

The Octopus

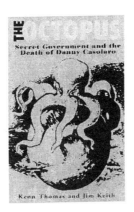

Good evening, my name is Kenn Thomas and I am the co-author of this book, *The Octopus*, which provides the basis of a lot of what I'm going to say tonight. It's called *The Octopus: Secret Government and the Death of Danny Casolaro* and it's a fairly comprehensive look at conspiracy politics in the twentieth and current centuries.

STEAMSHOVELPRESS #19, $7
ALL CONSPIRACY. NO THEORY.

NINE ELEVEN EPILOGUE by Kenn Thomas
DISCORDIAN HISTORY by Adam Gorightly
Airborn'd Loose At Lompoc Island
WHITHER UFOLOGY? by Greg Bishop
DIALOGUE IN HELL by Len Bracken
RUSH'S MIND GAMES

Plus: Jim Dahlke, Bob Sheldon, Al Martin,
Bohm Ramsey, Nam Lemarchianson, JFK and more!

And also I publish this magazine, *Steamshovel Press*, the motto of which is "All conspiracy. No theory." So I should say that many people dismiss what I have to say as conspiracy garbage. Theory. Speculation. Crazy, insane ranting and so forth. Needless to say, I don't like the term "conspiracy theorist" but it is the term that makes me most easily recognizable to the larger media. So I indulge that term in order to get some face time on TV, radio and in the newspapers and magazines. They all wrap what is known as this laughter curtain label around what I do basically because it doesn't fit neatly into the status quo, the government pronouncements and public relations press releases that define the reality tunnel they want to create, where everything is under control and there is no need to ask questions or offer protest.

But, in fact, for the past decade I have been going around supporting, encouraging, and cheerleading for writers and researchers who have something else to say, have pursued research tributaries ignored by the compliant media and have thought about it all in ways outside the box of that consensus reality, in real terms -- not in terms of the false left-right dialogue we see in the opinion magazines like *The Nation* and *The National Review* or on shows like *Crossfire*. The writers in *Steamshovel Press* defy that kind of easy classification, both by what they choose to write about it and the conclusions they reach. And this is called conspiracy theory

by the wider world and condemned by both the left and the right.

In reality, it is the study of parapolitics. *Steamshovel Press* is a magazine of parapolitics. It has the same relation to politics that the normal has with the paranormal. In fact, *Steamshovel* often examines various aspects of the paranormal including the existence and cover ups of UFOs, mind control technology, cryptozoological creatures, things like the Montauk material, also known as the Philadelphia Experiment; and the secret space program, including what goes on at Area 51 and what's behind the idea that the moon landings were hoaxed. That prefix "para" has Greek etymological roots and means "at to or to one side of", "beside" or "side by side" just as Bigfoot, the Mothman and the Loch Ness monster exist side by side with known animals in the paranormal world.

John F. Kennedy's election in 1960, for instance, was a political event. His assassination in 1963 was parapolitical, a kind of behind the scenes power and political manipulation that exists alongside the normal processes of voting and elections. Unless, of course, you buy the idea that Lee Harvey Oswald acted alone, but nobody really buys that anymore so it's hardly worth mentioning.

And just as a head's up, I should say that this lecture will deal with the Kennedy assassination as it fits into this idea of the Octopus and we will be looking at the Zapruder film in some graphic detail. More people are fascinated with this than anything else, of course, but to some it's a little too violent, as are some of the other things I'll be talking about. Just be forewarned if you don't have the stomach for it.

I feel a certain sense of responsibility to explain this and also to point out another use of that prefix "para" and that is "paranoid". Do be paranoid enough to avoid this graphic discussion of assassinations and murder if that kind of violence offends you, but also understand that if you stay and listen you might be labeled as paranoid by people, maybe

63

even your friends and family, unqualified to make the judgment, that you are paranoid.

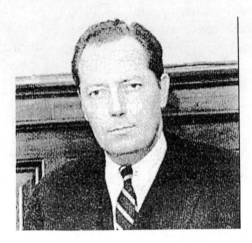

In history, we have several examples of this kind of quote "paranoid" unquote. Here's one. Jim Garrison. Garrison ran an investigation of the Kennedy assassination in 1968 that was dismissed as paranoid, and it was later made into a movie by Oliver Stone, who was also dismissed as paranoid. If you've seen the movie, you probably know that it's actually pretty good, and particularly if you get the accompanying book, which contains a great deal of research and documentation, you know it makes sense as far as it goes. Garrison was in reality not paranoid at all, but a great American hero, who surprisingly has a very early (1947) connection to the Octopus.

In fact, if you see the documentary based on the making of Oliver Stone's *JFK* you will see Jim Garrison on his death bed insisting that Kennedy was killed as a result of a conspiracy in the American military and intelligence world. It comes at a point in his life when whatever publicity or power he might have gained from his JFK investigation would certainly no longer serve him.

64

This is the matron saint of so-called conspiracy theorists, Mae Brussell, another paranoid. More appropriately let's call her the intellectual forbear of the study of parapolitics. From her home in Carmel Valley, California, Mae held court over the airwaves with her World Watchers radio show for seventeen years. Among the things she helped uncover and publicize were the Gemstone File, which connected behind-the-scenes history concerning Howard Hughes and Aristotle Onassis; the Watergate scandal; the extent to which the CIA and the space program were run by former Nazis from Operation Paperclip; and an extensive network of occultists in the Pentagon and throughout the military.

Mae was working on that topic when she came under assault, receiving death threats and having her home broken into, and causing her to go off the air. Shortly thereafter, she died of a fast-acting cancer at the age of 66 in October of 1983.

By that time, she had taught the only accredited course on conspiracy politics in the United States and had just received the George Seldes award from the American Society of Journalists.

I never met Mae but anyone who looks into conspiracy at all eventually comes across her work.

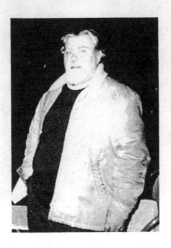

A lot of that work has been carried on by John Judge, an organizer, researcher and writer who now works out of Washington, DC. Perhaps some of you here have heard Judge speak. He is the founder of the Coalition On Political Assassinations, a group that grew out of that initial wave of renewed interest in the Kennedy assassination after Oliver Stone's movie. Judge led the effort to help free a great many government files on the assassination with the creation of the Assassination Materials Review Board. He by no means has exhausted that effort, even though the Review board has been closed for a number of years. Judge and his group continue to hold conferences and conduct research on JFK, also the murders of RFK and Martin Luther King, respectively in Dallas, LA and Memphis. The next COPA conference happens in Dallas in November, the fortieth anniversary observance of the JFK hit.

Here is a quick look at other parapolitical writers whose work have appeared in *Steamshovel*. Left to right: Bishop, currently at work on a book about recent conspiracy in the ufological community involving disinformation and an attempt to drive one man crazy with the tales of aliens at Area 51; Rob Sterling, who runs the number one site on the web for conspiracy information, called *Konformist,* spelled with a "K" (**konformist.com**); Jim Martin, who runs the best book service, flatlandbooks.com, and who also has authored the definitive book about the parapolitics of 1950s, called *Wilhelm Reich and the Cold War*; Acharya S, who has written a comprehensive book on conspiracy in religious culture called *The Christ Conspiracy*; and, of course, me.

All of this by way of demonstrating that *Steamshovel Press* publishes the gamut of "conspiracy theory" research. This is the most recent anthology of back issues, called *Popular Paranoia.*

It is actually a second volume, the first entitled *Popular Alienation*, which anthologized the earlier back issues and has since become very hard to find. Get 'em while you can. I don't know how much a copy of *Popular Alienation* would cost now, but you can't get copies of *The Octopus*, the book upon which this talk is based, for less than a hundred dollars now at **amazon**.

So that brings us to Danny Casolaro, the parapolitical researcher and writer whose work is the subject of what I have to say to you tonight. Casolaro is one of my specialties as a writer for several reasons. One is that it's probably the

most interesting of all the conspiracy stories out there, it's a body of work that gives the broadest view of the global conspiracy culture - and since I publish *Steamshovel,* I get the pick of the assignments.

Another reason I got involved with this is that what was left of Casolaro's work fell into my hands. What was left of his research was deposited at the university where I work as an archivist. This included his clippings file, his reference material and pages and pages of his handwritten notes. It did not include an accordion file which he carried with him all of the time, keeping his leads and most current. That disappeared when his body was found in the hotel room. All of this was to provide the basis of a book he was writing called *The Octopus.*

So it seemed like a good idea to me and to Jim Keith, another conspiracy writer whose life we will get back to later in the talk, that we take the ball and run with it. Since the accordion file was missing, we couldn't complete the book that Casolaro set out to write, but we could take what we had and combine it with what we knew and add some biography of Casolaro himself and posterity would have a handle on what Casolaro was trying to get at and we'd have a publishable manuscript. This was back in 1996. A few years after that, Jim Keith died under circumstances mysterious, making him a part of an ongoing story.

And giving me more of a personal interest in it, not only because of the unanswered questions about the death my writing partner, Keith, and then also the death thereafter of Ron Bonds, the man who published most of Keith's books and one of mine - and we will be getting to all this. So at that point, I figured it was already too late for me to be backing out of pursuing the story.

Even prior to that, Keith and I kept seeing Casolaro's research re-emerging in the news, with topics like super-surveillance software, Area 51, ECHELON tracking satellites, trans-global spy networks, extra-electoral political manipulations, and in a few cases what Casolaro researched could be traced directly to several high-level government resignations, even as recently as a few months ago.

But this is a particularly relevant topic tonight because of the anniversary of that horrible day, September 11 2001, when the planes crashed into the World Trade Towers and the Pentagon, killing over 3000 of American citizens, people in the planes, in the towers and the brave public servants who tried to rescue them.

OSAMA BIN LADEN, AGE 14

This is the man responsible for that crime at age 14. No reason to show him at that age, really, except it's a more interesting photo than the ones you usually encounter.

As you know, we have had two wars basically in response to the tragic events of 9/11 and Osama has yet to be found and neither has Saddam Hussein. This has been attributed to all sorts of things, mostly bad intelligence, but the truth seems to be that it has more to with good intelligence--in Osama's hands.

Last June Paul Redmond, the Assistant Secretary for Information Analysis for the Homeland Security department resigned. Described by some as a "legendary spy catcher" - he had a role in the capture of Aldrich Ames - Redmond resigned for "health reasons."

While the mainstream took that as polite cover for Redmond's frustration with underfunding of the department, the parapolitically aware connected it to a rumored secret investigation Redmond was conducting into Osama Bin Laden's use of PROMIS, an extraordinarily sophisticated software that keeps him one jump ahead of the people trying to track him. These sources conclude that Redmond had discovered shockingly long-standing common interests between the Bush and bin Laden families and was forced to resign.

PROMIS, in fact, also had been given to Saddam Hussein by the senior Bush in the early 1990s, and this was one of the things that Casolaro had dutifully reported.

PROMIS stands for Prosecutors Management Information Software and it has a history going back to the Vietnam War. A company late to be called Inslaw, represented by this symbol, originally developed it on public money with a law enforcement assistance grant and an early version of it was used by police. In Vietnam it was used to track and kill members of the Viet Cong in something called Operation Phoenix. Long before Casolaro stumbled upon it as part of his research, however, the public assistance money had run out and Inslaw was a private company. Thereafter it develop this thing into over a million lines of code, making it extremely flexible and applicable to a variety of purposes. It was, for instance, used to track Soviet submarines through Arctic ice, something that had long been impossible for cartographers to do.

The primary purpose of PROMIS, though, was to keep a detailed profile of various criminal elements and to track their movements through various prosecutors' offices. To this end, Inslaw was in the business of selling the software to various police agencies. In the course of doing that, it became embroiled in something called the Inslaw scandal, and this is where Casolaro's research began, and where a pattern of extra-electoral activity led him to his Octopus thesis.

Seems like we hear about an October Surprise nearly every election year. The last major one, of course, was that of Paul Wellstone, the senator from Minnesota who died in a still unexplained plane crash. That was a replay of the plane crash that killed Mel Carnahan, someone I knew and the governor of my state of Missouri. Carnahan was running for office again against John Ashcroft. Ashcroft was so loved in Missouri that even dead, Carnahan beat, thanks to his wife who took over Carnahan's campaign. When Wellstone crashed, the wife was in the plane with him. And Carnahan's crash was a replay of one many years earlier of Jerry Litton, who was running for a state senate that instead went to John Danforth for nine years. His death benefited that same

political power bloc that included John Ashcroft. Clarence Thomas, for instance, one of the US Supreme Court judges who later would appoint Dubya Bush as president, apprenticed in Danforth's senate office. I often refer to people like Carnahan and Wellstone as having been "Casolaroed." And I'll have more to say about these mysterious, coincidental death lists as the lecture progresses.

Before I leave the subject entirely right now, though, I'd like to point out that such other moderately progressive office holders as Tom Daschle and Patrick Leahy received anthrax tainted letters and John Ashcroft's attorney general's office has yet to find or prosecute anyone over that, just as they haven't found Osama, haven't found Saddam, haven't found WMDs in Iraq - so it's more than just mysterious deaths we're talking about here.

But in 1980, October Surprise meant one thing: a deal struck between members of Ronald Reagan's campaign team and this man, the Ayatollah Khomeini, to have Khomeini's followers hold on to the 52 American hostages in Iran until after Jimmy Carter lost the presidential election.

The word that Casolaro got was that behind the scenes, this October Surprise cost some entity $40 million in a pay off to the Ayatollah.

This has never been admitted, of course, even by the supposedly oppositional Democrats, but is a clear event in history that set up a pattern of collaboration between the US and its supposed enemies. This led to the Iran-Contra scandal, where arms sales to Iran went to fund the Contra War in Nicaragua. The same pattern characterizes al-Qaeda, which the US funded under its guise as the *mujahadeen* in the struggles against the Soviets in the 1980s; and with 9/11 perpetrated by terrorists with strong connections with a US ally, Saudi Arabia.

The word that Casolaro got was that behind the scenes, this October Surprise cost some entity $40 million in a pay off to the Ayatollah.

The person who made the pay off to the Ayatollah was someone named Earl Brian, an associate of Ronald Reagan's equivalent to John Ashcroft, attorney general Edwin Meese. As his reward for doing this, Earl Brian was given the PROMIS software to do with as he pleased. Brian sold it - to the CIA, MI5, MI6, Interpol, the Mossad, the Royal Canadian Mounted Police - and a made huge profits. Unfortunately, the software still belonged to Inslaw and selling it was a criminal act itself. Two congressional committees reached this same conclusion, PROMIS was stolen and sold illegally to make millions for Earl Brian.

Then, of course, after Reagan, we had the elder Bush, who was a kind of shadowy figure in the Reagan administration in the first place. According to Bush he had never worked for the CIA prior to the time it had previously made him its director. Above and beyond the absurdity of that claim, of course, we have documentation that Bush was receiving debriefings as far back as the Kennedy assassination. He was also on hand in 1980 at a meeting in Paris for secret negotiations with the Iranians, according to Gunther Russbacher, the pilot who flew him there, and which resulted in the arrangements with Earl Brian. By the end of the Reagan years and the beginning of the first Bush

74

administration, the activities of this Octopus that Casolaro envisioned that Bush was a part of envisioned had grown into a full-scale, covert and illegal war in Nicaragua, funded by money from arms sales to Iran. This was all done without the approval of Congress - off the books money like Earl Brian had made off of the illegal sale of PROMIS.

Despite Bush's appointment of a special prosecutor, few were ever successfully prosecuted for the Iran-contra crimes. In case you think this is all ancient history, let me remind you of recent headlines that add to the list of high-level resignations of people who seem to come too close to this Octopus entity of Casolaro's. This would be John Poindexter, a man whose names appears in Casolaro's notes. Poindexter was one of the few convicted in the Iran-contra scandal, of five felony counts in 1990.

An appeals court overturned those convictions in 1992 and more recently Poindexter was appointed head of a new information technology unit of DARPA, the Defense Advanced Research Projects Agency, which developed the internet, called Total Information Awareness, symbolized on its website and in Poindexter's office with an eye over a pyramid - a tip of the hat to the idea that he works for secret masters. MSNBC's description of the office's purpose was to "develop computer software that could virtually track every detail of an individual's life" - sounding very much like a version of PROMIS.

Poindexter was forced to resign from the current administration when it was discovered that DARPA was developing a futures trading market based on the prediction of terrorist events. Of course, a short-selling spree on the real market made a fortune for someone just after the destruction of the World Trade Towers, so someone was already pretty good at predicting terrorist events.

Danny Casolaro wound up dead in the course of pursuing research like this - off the books funding for black ops, in Vietnam and in something called the Nugan Hand bank scandal in Australia, which is where his hunt for the Octopus began. His body was found in a West Virginia hotel room in August of 1992 with an unconvincing suicide note, just like Vince Foster's, who later had his foreign bank accounts tapped by PROMIS. The slashes in Casolaro's wrists were too deep to be considered self-inflicted. An accordion file of his most important research, which he kept with him at all times, was not with him in death and has never been recovered. The night before he died he met with one final contact who had made his Octopus thesis complete, and on that night he called family and friends and warned them to be suspicious if an accident would befall him. Everything suggests that Casolaro was "suicided" for having gotten close

to the truth about something, hence the verb "to be Casolaroed", applicable now to a lot of situations.

THE

CRIMES

OF

PATRIOTS

A True Tale of Dope, Dirty Money, and the CIA

"Important and timely...impassioned and convincing"

JONATHAN KWITNY

So where did Casolaro get his information? He started with a book called *Crimes of the Patriots* by Jonathan Kwitny which not only documented the Nugan Hand bank scandal but also included early reference to Pine Gap, the satellite relay station in Alice Springs, Australia known as the Australian Area 51. Casolaro began his work with another mysterious suicide, that of Frank Nugan, found shot to death in his car in Lithgow, Australia in 1980. Nugan's pockets had lists of many wealthy and prominent Australia political, sports and entertainment figures followed by huge money amounts, and a business card of former CIA head William Colby. Nugan's death came shortly around the time his partner, Michael Hand, announced that their Nugan Hand bank-a transnational operation with office all over he world--could no longer pay its depositors, that even its secured bonds were phony, and all of this led to the Nugan Hand bank scandal.

Not too get bogged down in the details of too many scandals, suffice it to say that Michael Hand had partnered up

with Frank Nugan coming off a tour of duty as a US intelligence operative in Southeast Asia. Many of the offices of Nugan Hand bank turned out to be money laundering fronts for various narco-dollar projects, including secret funding for the Pine Gap facility.

Working backward in time from that, Casolaro probably first encountered the PROMIS software while looking at operations similar to the Nugan Hand bank fronts in Southeast Asia. He encountered the name of this man, John Singlaub, a man involved with the use of an early version of PROMIS against the Viet Cong in an assassination program called Operation Phoenix.

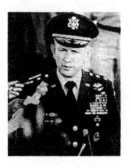

Singlaub was also involved with Air America, which ran weapons to the Vietnamese in exchange for a cash crop of heroin. Ross Perot discovered this in the course of his investigation of the plight of the MIAs in Vietnam. It was also part of a lawsuit brought by Daniel Sheehan of the Christic Institute. The heroin traffic in the Golden Triangle of Southeast Asia was an important part of what the war in Vietnam was all about. I mention these two to give you a sense of the full political spectrum that understands. Both Perot and Sheehan have been dismissed as conspiracy theorists, of course.

Bo Gritz, the decorated former Green Beret who also led a POW recovery mission into southeast asia, in a video he put out called *A Nation Betrayed*, documented the testimony

of a major Golden Triangle drug lord named Khun Sa that this man, Richard Armitage was a key connection in a ring of heroin trafficking mobsters in that aprt of the world when George Bush was the head of the CIA. Armitage, of course, is currently deputy secretary of state in the current administration and one of the great fallouts of the war in Afghanistan he helped to orchestrate is an increase in heroin production in that troubled part of the world by 900% according to some estimates. Bo Gritz, of course, dismissed as a conspiracy theorist.

Knowing of Casolaro's interest in this kind of material, a reporter from *Village Voice* put Danny Casolaro on to a story that seemingly involved the kind of guns and drugs exchange that characterized what happened in Vietnam. This was the case of a series of murders happening on the tribal lands of a native tribe called the Cabazons outside of Indio, California. This is one victim in that list of mysterious deaths, a Cabazon who was later found hog-tied, his body baking in the desert sun. He was one of a number of tribal leaders trying to revolt against the white administrators over a joint venture deal involving this group.

Wackenhut, a private security force said to have more files on ordinary citizens than the FBI. On Cabazon tribal land, sovereign and so out of the legal reach of adjacent governing bodies and remote so relatively few irate citizens to oppose, except those tribal members who were murdered, Wackenhut built a weapons plant. Interestingly, this began in 1980 with designing a security system for the palace of Saudi Crown Prince Fahd, but also included the development of biological weapons and hardware like night vision goggles and MANPADs, the shoulder firing missile launchers US soldiers encountered in the Afghanistan war. But since it's chief interest was in keeping files on people for surveillance purposes, I bet you can guess what Wackenhut felt was the security technology most worthy of development.

That's right, the PROMIS software. Wackenhut had an illegal copy of PROMIS and was trying to figure out way of improving it and using its millions of lines of code to spread the power and control of its clients.

Chief among the people working on PROMIS was this guy, Micahel Riconosciuto, shown here at age 14 just prior to going to work as an assistant to a Nobel prize winner for laser physics.

Riconosciuto was a child prodigy, a technological wunderkind, who had gone to work for Wackenhut as a computer expert. He would become Danny Casolaro's chief

informant and the basis of his Octopus book. Casolaro called him "Danger Man" because of the world of shadowy intrigue he occupied.

Shortly before he met Casolaro, Riconosciuto in legal affidavits declared that he worked at the behest of Earl Brian to modify the PROMIS software. It was Riconosciuto who outfitted the software with its infamous backdoor capacity. That is, when coded with Riconosciuto's modifications, PROMIS not only tracked and extrapolated the activities of criminals, it reported this data back to the people who sold it in the first place. By this means, the Octopus could keep track of what the RCMP was doing, what Interpol was up to, what the Mossad was doing, etc. It serves them all right for buying PROMIS illegally in the first place.

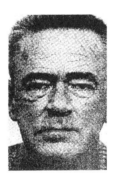

We can track Riconosciuto's pedigree back to this man, Fred Crisman, who was a close business associate of Riconosciuto's father and someone he regarded as an uncle, even as a father figure. Crisman was a veteran of World War II and like many such veterans was reactivated for service in the Korean War. In between, however, he primarily became known for his connection to a UFO sighting in 1947 near Tacoma, Washington, something called the Maury Island UFO event. After the Octopus book came out, I followed this research path through various sources, including a Freedom of Information Act request for all of the documents involving this case, which happened three days before Kenneth Arnold's

famous flying saucer sighting over Mt. Rainier, making Maury Island really the first UFO event of the modern era.

I documented all of this in a book called *Maury Island UFO* which I regard as a kind of prequel now to *The Octopus*.

But as I say, Jim Garrison subpoenaed Fred Crisman as part of his investigation of JFK's death. That investigation yielded this famous photograph of three tamps being arrested in the railyard behind the grassy knoll in Dealey Plaza on November 22, 1963. This person right here was identified as Fred Crisman in something called the Torbitt Document. This was a report written by someone identified as William Torbitt which names many others as being part of the parapolitical backdrop of the assassination. For many years a multi-generational photocopy of the Torbitt Document circulated within the JFK assassination research community and many people see it as a key to the assassination. It was never published in book form until I came along, annotated and documented it and brought it out as *NASA, Nazis and JFK*.

Of course, no presentation on conspiracy politics in complete without a showing of the Zapruder film. My purpose in showing it here tonight, as always, is to establish again in the minds of everyone who has seen it a zillion times and to those of you who are watching it for the first time, the evidence of your eyes, that a shot is indeed coming from the

grassy knoll area, back there by the railyard where possibly Fred Crisman and two others were picked up.

I'd like to point out the umbrella man here, someone that Fletcher Prouty said shot JFK with a flechette dart, paralyzing him thusly, and radio controller man, who apparently has some kind of communication device and is coordinating the assassins at the Dal Tex building, the Book Depository and on the knoll.

Here are the tramps again, this man walking in the other direction-someone Prouty also identified by name-also apparently has a radio control device behind his ear. All of this by way of showing what a high tech operation this was, involving many people.

Lee Harvey Oswald, of course, had a long career in high tech operations, most notably the U2 program. He served

in the Marines out of the U2 base in Atsugi, Japan; provided information to the Soviets to help them shoot down Gary Powers' U2; and worked at a photographic firm in Texas that processed U2 imagery, before getting a job at the book depository.

The U2, of course, was developed at a very high tech facility in Nevada called Area 51. I have footage of a flying saucer I saw at Area 51 in 1992 that I could show after the lecture.

Getting back to Fred Crisman: again, these three men are being escorted from the area where that shot came from.

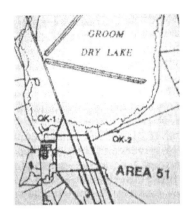

Some researchers have argued that that one of these tramps is a famous spy and author of bad spy fiction, E. Howard Hunt. Here is an actual photo of Hunt.

He does look like the tramp,

but he also looks like Jack Lemmon. E. Howard Hunt was a Watergate burglar but also, according to Casolaro, an Octopus operative in the Bay of Pigs operation. Casolaro developed a relationship with Hunt during the course of his Octopus investigation.

The point of all this is to show the interconnections and the durability of certain personalities and situations when we look into the history that was important to Casolaro. Clearly he could see what we all can see, the conspiracy in the JFK case and could see clear conspiracy in the October Surprise case, the acknowledged conspiracy of the Iran-contra scandal and he could see it all connected to the PROMIS/Inslaw software.

Osama bin Laden poster

So, again, Fred Crisman's "son", Michael Riconosciuto, was Casolaro's main informant about PROMIS, the one who had modified the software in the first place. Now, everyone if aware that the CIA built up Osama Bin Laden's *mujahadeen* from the late 1980s onward in their struggle against the Soviet Union in Afghanistan. Micahel Riconosciuto claims to have met Bin Laden at that time, attempting to sell him shoulder-firing MANPADS - Man

Portable Air Defense Systems - missile launchers that American troops encountered in this recent Afghanistan War, the kind that according to some shot down the infamous Flight 800 and the kind that have currently been the concern of airport security officials.

Word now is that Osama Bin Laden, if he isn't dead, evades capture using Riconosciuto's modified PROMIS software. He reportedly paid the Russians two million dollars for an upgrade version of it, called Enhance PROMIS. The Russians, in turn, received the software from the famous FBI turncoat Robert Hanssen.

Just as a quick review: Bin Laden left shortly before a missile strike on two of his training camps after the US embassy bombings in Africa; also in the Sudan at the time of the bombing of the USS Cole; in December 2001, Bin Laden escaped capture at a cave complex in eastern Afghanistan, a place called Tora Bora, despite advance intercepts that supposedly gave away his precise location. And, of course, he has not been captured since, despite his having kidney disease and osteoporosis.

Two researchers, Tom Flocco and Michael Ruppert, made the case for the use of PROMIS in insider trading deals that preceded the nine eleven tragedies. Interestingly, Warren Buffet actually benefited from similar insider trading deals just after the JFK assassination, a fact documented in the book *Mind Control, Owald and JFK*. In pursuing their story, Ruppert and Flocco got the first ever confession from an official CIA spokesperson that the CIA uses PROMIS quote "beyond American borders to scrutinize world financial markets for national security purposes." And, of course, we should not forget John Poindexter's idea of creating a financial marker based on prediction of terrorist events. And we should not forget, as I mentioned, the resignation of Paul Redmond and the connection that may have had with PROMIS being in the hands of another elusive enemy, Saddam Hussein.

Another recent application of PROMIS has been in the ECHELON satellite system, one of the components of the Star Wars initiative, the funding of which was revived after 9/11. ECHELON is a network of giant "domes" ("radomes"), satellite dishes,

satellites and networked super computers that intercept and analyze virtually all phone and internet communication - and, of course, can take pictures of your car's license plates from high orbit using "fusion framing", a permutation of the PROMIS software that extrapolates visual information from the distant pixels.

Casolaro's interest in ECHELON was drawn by a series of deaths from 1982 to 1988 among SDI scientists working for an SDI contractor called Marconi. Twenty skilled experts in super computers and computer-controlled aircraft either couldn't control a car enough to avoid unusual deadly accidents or were so depressed by their highly paid professional success that they committed suicide.

As many of you know, a similar death list has been occurring more recently among the microbiologists of the world. One was murdered in Virginia; one was found comatose near the lab where he worked in Miami; another in Australia found dead in an airlock entrance to a walk-in refrigerator. Another one, Don Wiley, an expert in deadly viruses, jumped or was pushed over a bridge in Memphis. The most famous recent one, of course, was microbiologist David

Kelly, the scientific adviser for Britain's Ministry of Defence. One little known fact about that is that Kelly helped MI6 debrief Victor Pasechnik, a Soviet defector microbiologist who also appears on the list

Following is a book by the late Jim Keith, my writing partner for *The Octopus*.

Keith examined the issue of microbiological warfare in part as it manifested itself in the famous cattle mutilation deaths of the late 1970s. Keith determined that those deaths resulted from the use of clostridium bacteria, a biowarfare agent that a Congressional committee once determined was stockpiled in canisters by the CIA. And, again, under attorney general John Ashcroft, we have had the mysterious and still unsolved anthrax attacks. Many now agree that those anthrax spores came from US military sources connected to CIA research.

Oddly enough, Keith died after receiving a knee injury at the Burning Man festival, a death that was attributed by the authorities to a pulmonary embolism. Shortly thereafter, six cases of knee surgery leading to unexpected fatalities were reported around the country, one state even halting all knee surgery at one point. Medical authorities later determined that the deaths were due to clostridium poisoning traced to a tissue

89

bank in Atlanta, Georgia. Last year, another mutual friend and publisher of many of Keith's books and two of mine, a man named Ron Bonds, died after exposure to clostridium bacteria at a Mexican restaurant in Atlanta.

Keith was a remarkable writer and a bit of a celebrity in the conspiracy underground. I have some footage here also if we have the time and anyone has the interest in finding out about Keith.

So there you have it. Mysterious death lists, resignation lists that look like limited hang outs to protect higher-ups, a world of super-surveillance software and other high-tech weaponry, solid historical connections to known conspiracies of the past - and the life and death of a writer who had pieced together a big chunk of it and gave us a greater view. And here we sit, two years to the day after the incredible destruction of the World Trade towers, not knowing the extent to which our own government made it happen, through incompetence. We have pointless false dialogues in the media among mindless pundits of the so-called left and right. We don't seem to have any real political choices in the coming presidential election. We live in a world of conspiracy.

PROMIS and Computer Paranoia
Lumpen, **March 14, 2001**

The research of Danny Casolaro, the writer who died in Martinsberg, West Virginia while investigating an intelligence cabal called the Octopus, continues to contextualize current events in ways that the mainstream media fail at daily.

At the start of the Clinton administration, Casolaro's work illuminated Vince Foster's death, when speculation began on how the banking systems got PROMIS, the software system so crucial to Casolaro's research. PROMIS had been stolen from the Inslaw company by Ed Meese cronies in the US Justice department under Ronald Reagan, and its infamous "back door" - allowing the Octo-cronies to spy on the clients that had bought PROMIS illegally. According to one theory, Foster's Swiss bank accounts were made vulnerable in this way and may have led to his suicide or murder.

Casolaro's name came up in the periphery again after the Heaven's Gate cult incident when it became apparent that the last significant news from the area where the cult lived, Rancho Santa Fe near San Diego, involved the murders of Ian Spiro and his family. Spiro was a British intelligence spook who had been helping Casolaro's main informant, the creator of the PROMIS back door, Michael Riconosciuto.

Finally, even the death of Princess Diana has a tentacle reaching back to the Octopus in the form of Adnan Khashoggi, Dodi Fayed's uncle. Khashoggi's signature appeared on a document that had excited Casolaro on the day that he died. That very night he was to meet with someone named "Ibrahim" who would have shed more light on Khashoggi's role in the Iran-contra scandal. Khashoggi is a notorious arms merchant responsible for developing supra-legal contracts that sustain Middle-East defense and oil

industry corruption. Those politics certainly play a role in whatever happened to Diana and Dodi Fayed in the Pont de D'Alma tunnel.

Of most interest to the desktop conspiracy student, however, is the ongoing development of PROMIS-like back doors that have been popping up to spy on average personal computer users. Rumor had it that when the original versions of Windows 95 appeared, they contained a back door that surreptitiously read the user's hard drive and reported it back to Bill Gates.

The rumor came with the story that pressing some key combination during the opening "clouds" screen of Windows 95 brought to the screen a photograph of a prized Palomino owned by Gates. The first draft of Casolaro's book on the Octopus was entitled Behold, a Pale Horse.

The back door feature ostensibly was removed from later versions of Windows 95 and today it has a registration that does the same thing, only with the consent of the spied upon.

Presently there is no indication of how it works with the pre-installed software often bought by many non-computer-savvy people.

Encryption security and the Clipper chip--a "front door" strategy for keeping tabs on the Internet--became issues with the general public. Philip Zimmerman used a public domain algorithm to create the Pretty Good Privacy encryption software and publicized it freely, bringing that protection to the masses. However, even the cyberheads have trouble dealing with PROMIS-like phenomena that may not even exist. Back door access has enough obvious political espionage applications to ensure that the problem will never go away, and even some business managers still today claim the right to spy on worker e-mail. So, odd little PROMIS-like "back doors" keep sneaking on to the cyberscape.

In January 2000, a "glitch" in the protocol for removing phone listings from the Yahoo site gave private

address listings by punching in phone numbers. Glitches found in the Netscape browser in the mid 1990s, one that allowed Netscape to extract the history of a user's session and another that subverted encryption/decryption operations, won $1,000 from a bug-bounty hunter group for two young hackers in Australia and San Francisco. Perhaps it is not surprising that two years later - presumably long after it fixed these other bugs - Netscape awarded another thousand dollars plus a T-shirt to a Danish software company called Cabocomm when it discovered another glitch. This one allowed Web site operators to read anything stored on the hard-drive of a computer logged on to their site.

The biggest concern over these matters is the protection of credit card information on the Web/Net. Others throw up their hands and declare that they have nothing subversive on their hard drives, so there is no reason to be concerned about this espionage--despite the affront it poses to supposedly cherished democratic principles. Still others simply do not believe that the technological capacity exists to do these things, a supposition that has been mirrored in the discussion about PROMIS itself.

Daniel Brandt, producer of *CIABase*, and a renowned data engine on intelligence literature and personalities called *NameBase*, argued that "a 'back door' to get around password protection is easy for any programmer . . . [but] you still need physical access to the computer, either through a direct-connect terminal or remote terminal through the phone lines, in order to utilize back door. [It is difficult] to believe that foreigners allow technicians from another country to install new computer systems in the heart of their intelligence establishments, and don't even think to secure physical access to the system before they start entering their precious data . . . claims that PROMIS . . . can suck in every other database on earth, such as those used by utility companies, and correlate everything automatically . . . needlessly discredit [whistle blowers] by their own high-tech gullibility."

Bill Hamilton, the owner of Inslaw - the company that originally developed PROMIS - maintained that it could run on "an UNIX machine, Hewlett Packard UNIX, RISC 6000, AT&T AS400 under its own operating system and on mainframes unde MVS," that it was comprised of 88 program modules, and that the source code-replete with the Inslaw name throughout the code commentary - was kept by any government that had it.

When asked how a foreign country could modify the source code without discovering the back door, Hamilton was cryptic: "I don't know what's meant by the back door. What we've been told is that not only the software was sold, but computers with extra chips . . . What the chips do, we've been told, the extra chips, is to broadcast the data inside PROMIS to satellites owned by the NSA... but we don't know enough about it as they've never shared anything with us." This possibility perhaps addresses Daniel Brandt's objections that physical access is required for a back door to work.

Writer J. Orlin Grabbe elaborated on the idea in a column:

"Since intelligence computers are, for security reasons usually not connected to external networks, the original back door was a broadcast signal. The PROMIS software was often sold in connection with computer hardware (such as a Prime computer) using a specialized chip. The chip would broadcast the contents of the existing database to monitoring vans of collection satellites using digital spread spectrum techniques whenever the software was run. Spread spectrum techniques offer a way to mask, or disguise, a signal by making it appear as 'noise' with respect to another signal. For example, one may communicate covertly on the same spectrum as a local TV broadcast signal.

From the point of view of a TV receiver, the covert communication appears as noise, and is filtered out. From the point of view of the covert channel, the TV signal appears as

noise. In the case of the PROMIS broadcast channel, the signal was disguised as ordinary computer noise . . ."

Unfortunately, thereafter Grabbe's discussion, which includes correspondence with PROMIS architect Michael Riconosciuto, becomes more technical than is useful to a non-technical understanding of how PROMIS works.

It is the same with remarks about further criticism from Daniel Brandt, penned by Riconosciuto, that have circulated among conspiracy researchers. For example, Riconosciuto states that, "as far as the requirement of special hardware to transmit data and the example that Mr. Brandt uses that software can only alone supply various combinations of ones and zeros to the CPU, only shows Mr. Brandt's lack of knowledge of what WALSH functions are . . . Brandt's comments start out that computers radiate electromagnetic energy unless they are shielded. This is an insult.

"Anybody who has been around knows what Van Eck hacking is? [Editor's Note: Named after the Dutch scientist Wim Van Eck, who published a *Computers and Security* journal article (December 1985) on "Van Eck" or "Tempest" phreaking, which he had developed since January 1983. Since computer monitors and other equipment emits faint radiation, Van Eck was able to eavesdrop on these transmissions, scan the information, and display it on a modified television set. He used readily available equipment, including a directional antenna, an antenna amplifier, a variable oscillator and a frequency divider. The technique became popular for industrial espionage and has been reportedly used by various US government agencies. Plans for Van Eck units, and manuals, are commercially available.]

"An active phased array antenna is superfluous at the short distances he describes. A high performance surveillance receiver such as those made for Vatkins Johnson Corporation, Stoddarts/Singer or Fairchild will do the job quite nicely with a standard Biconical antenna . . . Brandt will find that if an

arbitrarily small section of a Sine function is known, the function is known everywhere. This feature of sine wave is referenced to sinusoidal waves transmit information at a net rate of zero!

"Mr. Brandt's statement that software can only provide combinations of ones and zeros to the CPU totally misses the point that Walsh functions are inherently suited to binary operations. This is one reason why such tight, compact code can be written around operations with Walsh functions. It is is why it is so difficult find these routines and differentiate them from routines normally used at the register transfer logic level.

"This is at level of programming that is one jump lower than machine language." Which is, of course, several steps above the average person's ability to follow. It seems almost inarguable that the PROMIS software has properties and applications to military and industrial skullduggery that surpass the threats it seems to pose to hackers, conspiracy students, and the other riffraff who populate the cybersphere.

In addition to being a bell-ringer for the dangers PROMIS posed to the average person, Casolaro died in part trying to uncover its other, perhaps more sinister capacities.

Michael Riconosciuto has been as vociferous as possible about it for someone in his position-in prison on trumped-up drug charges.

This part of the story is still unfolding.

OCTOPUS REDUX

She Dated Danny Casolaro

The following interview correspondence with a woman who dated Danny Casolaro has never before appeared in print

Hi Kenn,

I'll try to answer your questions as best I can; however, I do not want my name "out there"--on the internet, in articles, etc. I am happy to provide you with background information, however, in the hopes that it is useful to you. Also, I'm aware that internet correspondence is not very private, but, since I won't be telling you anything new, I guess it is okay (I feel safe about it, anyway, except for perhaps a few names I'll leave out). It's nothing that I haven't already told to Justice Department investigators and producers who were going to make the movie about Danny, so I guess it's okay to tell you, too!

Taking your questions in order:

How did you know Danny? When did you first meet?

I met Danny at a bar called *The Sign of the Whale* in Fairfax VA while waiting for some friends to meet me there. I'm not sure the date, exactly, but it was around and about the spring/summer a year before he died. I knew him about a year, maybe year and a half before he died.

He struck up a conversation and, as I later learned was typical, he began talking about his investigative project. He had files with him. He was likeable and harmless...fun. I'm

not sure, but I think he tagged along with me and my friends that night, and we stayed in touch from then on, got together, mostly with my friends, but, sometimes he would come by my house and hang out. We both worked from our homes and were more or less "free agents"--when other people were working in offices. He always wanted someone to tag along with him on his "adventures." Anyway, he talked ALL THE TIME about the Octopus. We used to meet for coffee/lunch, etc...and often I would meet him at The Sign of the Whale in the afternoon, because it was right next door to the gym I worked out, so I would sometimes see him there afterwards.

How much of his research did he share with you?

Just about all of it. He was always talking about it...although I seldom retained it, because it was usually disjointed and jumbled--I didn't get a "big picture" so a lot of it went over me. Without the big picture, it seemed "crazy" because it seemed like everything I ever talked about--me, who was unrelated to the Octopus--was somehow related. For instance, I had met Judge Bason through a friend of mine (unrelated to Danny), and I happened to mention I'd had lunch with him to Danny--Danny was very excited and said, "YOU know Judge Bason? That's the judge related to Inslaw..." Soon, it seemed as though EVERYTHING was related, so I unfortunately dismissed a lot of it.

At one time, he asked me if I could make copies of volumes of documents and turn them around quickly...he brought some over once and I did, but it was only the one time. I also had a copy of an earlier version of the book, when it was called *Behold a Pale Horse*, which he asked me to store for him.

Did he talk about the PROMIS software at all? Michael Riconosciuto? Robert Booth Nichols? The Cabazons? Wackenhut? Inslaw?

Yes, all of them. He wanted me to attend a meeting with Nichols, but I couldn't go with him. I think Ben, or maybe Wendy his ex-girlfriend went...I spoke with Bill Hamilton a couple of times but never met him. He was impressed with Nichols...he said I would have liked him, he looked like Clark Gable, and he wanted me to meet him next time. For a while, he (Bill) mailed me documents related to the case, such as the Congressional Committee report and the Bua Report, etc., to keep me abreast.

Did he explain to you any of the dangers he faced?

Yes. But he would always laugh it off and say "I'm just a dumb reporter. Who would want to harm me?" Sometimes it made me worry, but, since he didn't seem to take it seriously, I didn't also. My ex-boyfriend, however (we were still in touch with one another--friends), was an ex-SF major, and he was not so sure. He used to warn me to stay away, not get involved, but mostly on "general principles," and not over anything specific I related, so I didn't pay much attention to him, either.

When was the last time you talked to him? What kind of spirit was he in?

I spoke to him maybe...a week?...before he died. I had been away, so hadn't actually seen him...just talked to him once after I got back. He seemed normal--excited about his investigation--he was about to "break it wide open"...I wasn't so sure, because he had been saying that for a month or two, it seemed. He did seem very certain, though. Excited.

Did you attend his funeral? Did you/do you know his family?

Yes. (So did Joe Cuellar, by the way, though he didn't acknowledge me there). I didn't know his family before. That was the last time I saw Joe.

How did you know Joe Cuellar?

It was at the *Sign of The Whale* at around 2 in the afternoon. I met Danny there after my work out. Joe was at the bar. I was talking to a guy who was a "regular" there about my book project and that I needed knowledge about female slavery (I know, sounds strange!!) in Morocco...he said, you need to talk to this guy (Joe). He's been to Morocco...so Joe and I talked. He said he wanted to help me...invited me to lunch, etc. Well, I didn't want to give him my #, so asked for his. He said he didn't have one because he had just gotten in--that day--from Desert Storm operations. I asked him for his work number then...again, didn't have one...had left his job...anyway, it was sort of strange...evasive. But, we ended up arranging to meet for lunch later that week. I knew he was really more interested in me than in my silly book, but well, he was reasonably attractive, and I was coming out of a relationship. Okay, more info than you want to know, I know! But the whole thing about Joe was that he was not...typical...He was "supposedly" interested in me, but never really came across like someone who was...sort of pursued me, but not really. Looking back, it would seem that I was his contact to Danny, but at the time, I just wondered what he was about. It was half-hearted at best. But, I did end up spending a good deal of time with him...he would invite me out, we would meet at his place in Old Town (Alexandria) and go out...when we came back to his place, we'd talk...he'd act a little jealous of my ex-boyfriend (I had told him I didn't want involvement because I was still attached to the ex)...I'd start to leave as it would get late, and he would ask me to stay...just talk...almost pleading...he had a very soft, detached manner about him...so, I'd stay and we'd talk.

Danny had noticed his business card on the bar, from Business Risks International (I think)...it seemed to mean something to him. They talked, but I didn't hear what, as I was talking to someone else most of their conversation. Danny was excited. He was telling me all about it on the way out, and I thought it sounded strange...what's an ex military intelligence guy doing blabbing his lips in a bar to a stranger? Danny said, well, he seems to want to "do the right thing." Which worried me a little. But, he added, "or else he's a red herring sent here to get me off the track." I felt better that Danny wasn't being totally naive. It all just seemed to coincidental I said, and Danny agreed.

What kind of person was he?

Sad. A little bitter sometimes. Quiet. Had contempt for his mother. By coincidence, he had attended West Point during the same tenure as my ex-boyfriend (I think they were 2 yrs apart), I looked him up in the yearbook.

He drank heavily, though not drunk. He asked me to design some business cards for his photography exhibit--in exchange he took some photos of me for my "About the Author" for my book (which I never got by the way--he said he had left the lens cap on!)...He had an attack of malaria once when I was with him...He would get strange phone calls...once he asked me to wait before we left for dinner as he was expecting a call from a buddy/partner in South America...finally, the phone rang...he didn't answer it, it rang twice and hung up. I said, "maybe that was your friend, why didn't you answer it?" He replied, "well, if it was, he'll call back...let's go to dinner." "What about your friend?" (I'm thinking, we've waited this long and it was so important! Now it seemed unimportant!)...oh, well, we left.

He was military intelligence he said, and he showed me pictures of him as an exotic bird dealer in Africa? I think. I asked him if he worked for Army Intelligence or CIA? He replied it was sometimes hard to tell. He wore civilian clothes to work. He had some exotic birds in his apartment. He was also very interested in voodoo...had a lot of voodoo "stuff" he had collected. He had also been in the Amazon among some Indian tribes. He also mentioned Canada, but I don't recall specifically...

He said he was best buddies with Peter Viednicks (don't know how to spell) and that Peter's wife worked with his ex-wife in Sen. Byrd's office. He had been golfing with Sen. Byrd he said and done some work with or for him. He was still on good terms with his ex. One of the wives' name was Barbara, I think, but not sure which.

One time we were supposed to get together on a Saturday, and he called to cancel, saying that he had to meet with some business associates, couldn't be helped. I said forget it, but then he suggested my friend and I come to where they were meeting, as there was a pool, and my friend and I could swim. We went, and it was very strange! The two other guys were not at all happy to see my friend and me, it was clear. They were mad at Joe (at least the older guy was). The three of them sat at an umbrella table, and my friend and I swam in the pool...the paid absolutely no attention to us. My friend and I talked about how strange it was, kind of laughed about it. Once or twice we would walk over to say something, and the older guy seemed angry/annoyed...they would all clam up...finally we left.

What was his relationship with Danny like?

Friendly. Danny asked me to go on a couple of meetings with Joe, as he said people talk better in triangles. Joe had asked

me not to tell Danny that he and I had had lunch. I wasn't sure why. Actually, I was eager to go, because I wanted to see for myself, listen to people who were involved in this so-called Octopus, and judge for myself how serious or real this thing was. Anyway, we met in Old Town, the three of us, and they talked for hours that first time. Ranging from the Golden Triangle to Nigeria, to BCCI...to many things that I didn't recognize or understand. Mostly they talked about Viednicks, and Danny apparently had been trying to talk to him, but Viednicks wouldn't talk to Danny. Joe said, no problem, he would introduce him. He assured Danny that Peter would talk to him. They were buddies. There was apparently some misunderstanding that would be straightened out (I think about Danny's understanding of something), once Danny met with him and understood what Peter had to say.

Frankly, I didn't pay that much attention after a while.

Ben Mason called me and told me that Danny was dead, murdered and warned me to "stay away from Joe Cuellar." He said he had people he never heard of contacting him warning him about Joe. As far as I knew, none of Danny's other friends had ever met Joe, so for a while, I was a little scared that I even knew what he looked like! I also got a call from a friend of mine...someone unrelated to Danny...and someone I hadn't heard from in several months, who worked at the Pentagon. Just coincidence...calling to see "what's new?" I told him that a friend of mine had just been murdered. His reaction was not typical...very matter of factly suggested I not go to the funeral because you never knew who would be attending. He wouldn't say more.

I called Joe a day or two later and he claimed not to have heard about Danny. When I told him, he said, "I told him not to go to that warehouse in DC!"

Joe called me before the funeral and asked me if I was sad. I asked him what he had meant about a warehouse, and his tone completely changed. He told me not to ask a lot of questions...He said, as if through clenched teeth, very slowly, firmly, "this is a business, do you understand? It doesn't matter if they like you. Do you understand?" I said, "but I don't know anything--" and he got aggravated, "It doesn't matter what you know. It's what they THINK you know...Stop asking questions. Do you understand? Stop asking questions. You have two little girls to think about." There was harshness, a sharp anger, "You don't want to end up like Danny or like that other reporter in Guatemala, who died a horrific death..." "What reporter?" "Stop asking questions!...Now go make yourself a nice cup of cocoa, go to bed, and stop asking questions." A friendly warning? Or a threat? I don't know. I took it as a threat.

He called me after the funeral. Apologized for avoiding me at the funeral. He said softly, "You were crying." He said he was sorry. That was the last time I ever heard from him, except that he left a message on my machine saying he was out of the country but would call me when he got back...something about a party that was being organized for Danny's friends. I never heard from him again, though.

I am certain that during this time period, my phone was tapped, though I never knew why.

No one ever interviewed me (police, etc). Quite a while after Danny's death, though, a Justice Dept. agent and a JD lawyer asked to interview me. They said they were interviewing people who knew Danny and just wanted to know about Danny, my relationship with him, his frame of mind, etc. They came to my office, and they barely asked me about Danny. They talked almost exclusively about Joe Cuellar, wanting to know all about him. They wanted to know about

my ex...had he done any checking into Joe? Could he? Would he? ...I thought that strange. I said, "You're the FBI...isn't that what YOU do?" "Well, all the red tape...it's just sometimes easier if other people have other means..." The lawyer was hostile, the agent friendly. He said they were taking this very seriously. They said they would get back to me, as I had said I was curious about it. A few weeks later, I called the "nice" one...he had completely changed. He was nasty, implied that I was a "scorned lover" trying to cast aspersions on Joe out of some sort of revenge thing or something.

How has your opinion changed about Danny? How has it changed about conspiracy writers in general?

I sobered up. Took what I used to dismiss as much more serious. People had tried to tell me, but it seemed too outside the normal realm. I'm still skeptical of much of it, but am open to it.

What did you think about the press coverage of Danny's death?

That's an interesting question. I think I wasn't too impressed. It was mixed. It was superficial, I think. I don't think they dug very deep before they made their conclusions. One reporter contacted me long after it, George Williamson, but I don't know what became of him.

What important information do you think was left out of *The Octopus*?

I wish I knew.

ORGONE

The psychologist Wilhelm Reich has become a perennial parapolitical topic. Reich died an early death after being hounded by authorities for his scientific work, which challenged some scientific paradigms as well as the pharmaceutical industry, and the pathological character structure of parapoliticos. Jim Martin wrote the best book on the subject, Wilhelm Reich and the Cold War. *In addition to helping with research on that book, I filed one of the latest Freedom of Information Act requests for his file. I have on occasion also brought the subject up in* Steamshovel Press *and in a number of other magazines. If nothing else, it tweaks the so-called skeptical community which often attacks Reich without reviewing his scientific work.*

Fortean Times, October 1997

Hunting Orgone

Ian Simmons fell victim to the very phenomenon he discussed in "I've Found What I'm Looking For" [*FT99:47*]. He looked for Wilhelm Reich deceiving himself over the orgone and he found it. Otherwise, he would have reported that his own explanation for the atmospheric excitations Reich observed - what Simmons regards as actually white blood vessels moving through the retina - was directly addressed and disproven by Reich in the late 1930s, as reported in correspondence with WF Ron printed in *Beyond Psychology, Letters and Journals, 1934-1939* (Farrar, Straus, 1994), ppl91fol.

Reich notes: "There is no doubt that the radiation can be seen under the microscope. I distinguished it from light reflexes by removing the reflex mirror as well as the iris

106

diaphragm... I observed this at a magnification of 2,000x to 3,000x with dark field illumination."

Reich made the point again in a letter to Summerhill's AS Neill, describing an exchange with Albert Einstein, who looked through one of Reich's orgonoscopes and declared: "But I see the flickering all the time. Could it not be in my eyes?" Reich then explained at length "the question of the objectivity of the rays, which are in the eyes and outside of the eyes. The objective proof for the objectivity of the rays is the fact that you cannot magnify impressions in the eye, but you can magnify the objective rays."

Einstein could not contradict Reich. In fact, he held on to the orgonoscope and it later took quite a bit of coaxing from Reich's assistants to get Einstein to return it. All of this is documented in Reich's *The Einstein Affair*, which is available from the Reich Museum in Rangeley, Maine.

How unFortean that Ian Simmons overlooked this history and presumed that Reich had ignored the obvious in a rush to prove his theory! A more apt analogy would be to the clerics who refused to see the moons of Jupiter in Galileo's telescope. The phenomenon is as Fortean as they come, and in the larger world one gets branded a fanatic just for reporting facts about Reich and noting that scientific teams to this day study and use his research.

Fortean Times, 2/98

Reich Fanatic?

Admirers of Wilhelm Reich have been characterized as kooks, fanatics and cultists. Reichian groups have a certain fame for factionalizing into separate schools. The situation is not entirely different from any body of ideas that that outlives its progenitor - few Freudians, Jungians or even Christians or Buddhists, speak with one voice over generations. Are the Reichians particularly quixotic in this regard?

During the *Fortean Times* convention in 1996, I traveled to an infra red imaging lab in a small town north of London at the invitation of a BBC producer. Lo and behold, we verified the orgone box's temperature differential using new infra-red software. Later, a Reich enthusiast flew from the US to the office on my BBC friend and asked to be paid for our research on the topic. That seemed a bit fanatical.

This person was actually a fanatic in reverse, however. He had for some time been supplying bad information against Reich to the so-called "skeptics" press. *The Skeptical Inquirer* ran two of his stories falsely connecting Oklahoma City bomb suspects to Reichian cloudbusting equipment. Skeptic mathematician Martin Gardner, who had unfairly attacked Reich in the 1950s, reported in his autobiography that this same person had taught him *mangani,* the ape language of the *Tarzan* novels. Over time, it became clear that much of the distorted press Reich has received could be traced to the same source, who also had also repeatedly threatened others with an interest in orgonomy. The *Steamshovel* website contains an essay about this entitled "Toxic Disinformation", complete with full documentation.

The majority of those interested in Reich should not rightly be called fanatics, just open-minded, curious people, like me and my BBC companion. In this case, the fanaticism was on the other side.

Fortean Times, 7/98

Burroughs, RIP

I liked your write-up of William Burroughs. "Immortality? We can get you to the first checkpoint." He was secretly buried in St. Louis to avoid having the gravesite turned into something similar to Jim Morrison's grave in Paris.

I have visited Burroughs' grave several times (I met and knew him a bit). The grass is still fresh atop his plot, which I attribute to residual orgone. The cemetery is also down the block from a coffeeshop called "Pharoah's Donuts." Burroughs loved Egyptian lore, especially the business about the seven souls leaving the body one at a time, the Ra, the Ba and so forth.

I'm sure each of his souls stopped at the donut shop for a dunker on the way to *The Western Lands*. (*Steamshovel* debris: *The Western Lands* was the name of one of Burroughs' last novels.)

Kenn Thomas

Nexus, February-March, 2000

Joe Fuel Cell and Orgone Energy

I appreciated Alex Schiffer's article on "The Joe Fuel Cell: Orgone Energy Accumulation" (*Nexus* 7/00) because of my own experience with the orgone energy discovered by Wilhelm Reich.

On a trip to London, I went with a BBC producer named Jon East to an infrared imaging lab with an orgone box. Reich and colleagues demonstrated many times that the temperature inside an orgone box is always one or two degrees higher than the ambient temperature of the room. It obviously has great potential as an energy source. In fact, Reich himself created a motor that ran on orgone.

Using the most advanced software available for infrared imaging, East and I established again the reality if the temperature difference. Reich, of course, was carted off to the hoosegow and ushered into an early death, in part because his discoveries were such a threat to the oil monopoly. I'm encouraged, though, when people like "Joe" and Alex

109

Schiffer encounter the same phenomenon and understand its implications.

Kenn Thomas

Saucer Smear, May 15, 2000

KENN THOMAS of *Steamshovel Press* writes, seriously:

"I'd like to point out that I think Jim Martin has smoking gun proof of the existence of MJ-12. It's in his new book, *Wilhelm Reich and the Cold War*, which he makes available through his 'Flatland' book service. Jim found a document in the archives of British diplomat Lew Douglas. The dates match up such with the Cutler-Twining memo (which is still in the National Archives; I've held it) that it is difficult to look at it as just a coincidence. The Cutler-Twining, of course, mentions an MJ-12 "Special Studies" group. It seems clear to me that the special study was of Reich and all the UFO info he was supplying to the Air Force. I'm not able do justice to the whole story, but it's in that new book by Martin and I recommend it to your readers."

Saucer Smear, April 25, 2001

KENN THOMAS of *Steamshovel Press* writes:

"I don't understand what you disagree with about Stan Friedman's letter in your latest issue. I thought it was interesting that he brought up the names of Philby, Burgess and McLean. Jim Martin gives the history of that Cold War spy cabal a new twist in his book 'Wilhelm Reich and the Cold War'. He has a small but dwindling number of copies still available through **www.flatlandbooks.com**; but more importantly, he has corroborating proof of the existence of MJ-12.

"In short, Jim has found a document with dates that synchronize with the National Archives' Cutler/Twining memo, from the archives of Lew Douglas, who belonged to Elsenhower's 'kitchen cabinet'. I think it takes tremendous intellectual acrobatics to not understand that the 'Special Studies' sub-group of MJ-12 noted in the Cutler/Twining memo refers to Wilhelm Reich and his encounters with UFOs at the time...

"How about directing your readers to Jim's very well-reasoned discussion of all this in his extraordinarily well-researched book? Thanks."

WILHELM REICH "IMPLICATED" IN ST. LOUIS MEDIA MURDER

On February 18, 2003 in St. Louis, a popular on-air personality at St. Louis' KMOX radio named Nan Wyatt, was killed by a bullet wound inflicted by her husband, Thomas Erbland, Jr. In the March 2nd edition of the *St. Louis Post-Dispatch*, reporter Heather Ratcliffe offered an unusual conclusion to a report on Erbland's mental state in the days prior to the shooting. Ratcliffe repeats an allegation by Ronda Burgmann, a former babysitter for Wyatt and Erbland, that Wilhelm Reich's 1945 book, *Listen Little Man,* contributed to the murder.

The report includes mention that Thomas Erbland recently had joined the First Unitarian Church in St. Louis and had been building an extensive collection of "spiritual guides and self-help books". Also according to the report, he had planned his wife's murder the previous week, several days before he read *Listen Little Man*. The quoted passage from the book includes Reich's admonition to take responsibility for depression, and the reporter notes that it does not "literally" encourage murder or suicide.

The reporter, Heather Ratcliffe, can be reached at **hratcliffe@post-dispatch.com**, 314-863-2821 and the

Letters to the Editor section at the *Post* can be reached at **letters@post-dispatch.com**, but letters must include name, address and daytime phone number, and the editors reserve the power to edit "for length and clarity."

Excerpt from "Ex-nanny Says Erbland Was Unraveling" by Heather Ratcliffe, *St. Louis Post-Dispatch*, 3/02/03:

Messages from a book

The next day, Erbland and Burgmann [Erbland and Wyatt's friend and ex-nanny] exchanged e-mails. Erbland told her about a book he had spent the past two days devouring. It is called *Listen, Little Man*, written in 1945 by the late Wilhelm Reich.

"He said the book described him so succinctly," Burgmann said. "It confirmed his ideas he had about himself. It explained his failures."

Reich had written it as a conversation with a "common man" about taking responsibility for his life against the backdrop of German society in World War II.

In the 127-page book, Reich says men destroy themselves and create their own misery. He repeatedly uses words like "murder" and "kill," although the text does not seem to advocate literal violence.

"You are afflicted with the emotional plague. You are sick, very sick, Little Man. It is not your fault. But it is your responsibility to rid yourself of this sickness," the book reads.

The evening of Feb. 18, Erbland dropped Drake [his son] at the home of Wyatt's mother in St. Louis County and then called police on a cell phone. He admitted he killed his wife

and spoke of committing suicide before officers talked him into surrendering. He is held without bond on charges of first-degree murder and armed criminal action.

Erbland also told authorities he had planned the murder for a week and shot Wyatt with a .357 Magnum revolver he had bought 16 years before in an abandoned plan to kill himself.

He said he sent Drake to a friend's house at the time of the killing, but the boy came home early and waited downstairs, hearing the shots upstairs but not seeing his mother die.

Stunned at what happened, Burgmann scoured bookstores until she found a copy of *Listen, Little Man.* She said she was horrified to read the harsh words and imagine how they might have sounded to the anguished Erbland.

"It was like he was getting suggestions from this book," she said. "I believe that it was the last straw that pushed him over the edge."

--end of excerpt--

In a letter to the *Post-Dispatch*, I noted that Wilhelm Reich is a well known figure in American history. His books were burned and he was thrown in jail, where he died in 1957. His work remains controversial but few question that this was a notorious and shameful episode in this country's recent past. It is unfortunate that this *Post-Dispatch* report contributes to the atmosphere that keeps most of Reich's work out of print. Similar reports, like the supposed subliminal messages John Hinckley (Ronald Reagan's attempted assassin) and Mark David Chapman (John Lennon's assassin) received from the book *Catcher In The Rye*, either got no attention from the *Post* or were dismissed as crazy conspiracy theories. It is difficult to understand why the Post finds such an idea

appropriate when applied to the reputation of this maverick psychologist.

Wilhelm Reich:
Eisenhower's Secret Ally
Against the Aliens
Phenomena, July 2004

In one version of events, President Dwight Eisenhower was flown to Wright Patterson Air Force Base on February 20, 1954 to see the debris and dead bodies from the Roswell crash. Some versions weave a far more elaborate tale, that Ike met with Nordic looking creatures and began intergalactic peace talks with them, the grays and several other alien races. He struggled to deal with those alien presences in the remaining years of his presidency by secret negotiations and by building up the military way out of proportion to peace-time needs. He retired in frustration with it all in 1961, giving a gravely foreboding warning that the military industrial complex he helped create would get out of control.

Or so the story goes among UFO mythologizers and folklorists.

Although it remains a well-known legend in the UFO lore, like all such legends little actual proof exists. Unlike many other legends, however, what corroborative historical trail does exist provides some provocative concrete details. Strangely enough, archival documentation and secondary historical sources come together in remarkable ways regarding Eisenhower's UFO involvements. Stranger still, those crossroads occur primarily in the biography and career of one of Sigmund Freud's most renowned protégés, Wilhelm Reich. Reich spent the last of his years in America chasing UFOs, ostensibly with Eisenhower's blessing, and leaving behind an unusual paper trail.

114

Reich's story begins in Vienna in the 1920s. Recognized as a maverick in Freud's inner circle whose ideas included a Marxist strain, Freud eventually Reich dismissed him. As a member of the Communist Party, Reich's ideas were deemed too psychoanalytic, and he was dismissed from that as well. With the ascendancy of the Nazis in Germany, Reich fled first to Norway and then to America, moving away from both psychoanalysis and Marxism in to equally controversial ideas on biophysics. Reich discovered what he termed "orgone", a biological energy found in living organisms and in the atmosphere. In the Eisenhower America of the 1950s, Reich used this energy to combat UFOs. The historical record suggests, too, that he met with Eisenhower at around the time Eisenhower supposedly met with the aliens.

Dwight Eisenhower's contact with aliens happened in February 1954, according to the legend. The president's cover story—that he was on vacation in Palm Springs—was belied by the fact that he had just returned from a vacation in Georgia. Even newspapers of the day reported the alarming news of a total disappearance by Ike on the night of February 20 during the Palm Springs stay. The official explanation offered after the fact was that the president lost a tooth cap in some chicken he was eating and had to make a late-night visit to a local dentist. Evidence of this does not appear in the existing, extensive medical record on Dwight Eisenhower from his time as president. The widow of the dentist had only vague memories of the event, which by any measure should have made a detailed and lasting impression.

Was Ike actually flown to Wright Patterson Air Force Base that night to view the recovered saucer from the crash at Roswell and the alien bodies, as the persistent rumors go? Enter Wilhelm Reich. In the course of his UFO adventure, Reich traveled through Roswell, New Mexico the following year. He was on his way to Tucson, Arizona with orgone equipment, to both study its capacity to alleviate desert conditions, and to do battle with UFOs. He recorded these

experiences in his last book, *Contact With Space*, now an extremely hard-to-find underground classic. Although his immediate destination was Ruidoso Downs, New Mexico for an overnight stay on his way to Tucson, there seems little doubt that Reich had aliens on his mind as he passed through Roswell.

He writes, "Although it was very hot as we neared Roswell, New Mexico, no OR flow [OR was Reich's abbreviation for orgone] was visible on the road, which should have been shimmering with 'heatwaves'. Instead, DOR [Reich's abbreviation for "deadly orgone radiation", which he believed came from the exhaust of UFOs] was well-marked to the west against purplish, black, barren mountains, in the sky as a blinding grayness, and over the horizon as a grayish layer. The caking of formerly good soil was progressively characteristic and eventually caked soil prevailed over the vegetation, which now consisted only of scattered low brushes, while grass disappeared."

Reich's concern about the environmental impact of UFOs stemmed from experiences he had at his lab in Rangeley, Maine, called Orgonon. It was there, in 1951, that he first discovered DOR, the noxious reaction of the natural energy he called orgone with nuclear material. He put a milligram of radium into one of his orgone boxes, an invention he created to accumulate and harness the orgone. It resulted in highly polluted air around the facility, with a great deleterious effect on fauna and animals. The DOR clouds formed and a strange black substance fell on the area. Strange, red pulsating lights, UFO, appeared in the sky over Rangeley. In response to all of this, Reich came up with a second invention, the cloudbuster gun, which intensified and redirected the healthy orgone, causing the pulsating lights to twinkle out and diminishing the DOR effect on the environment.

The Roswell episode in *Contact With Space* concludes, "After the desert valley it was a relief to spend a

116

night in Ruidoso, New Mexico, in the Sierra Blanca Mountains (near 7000 feet). Here a strong, reactive secondary vegetation had sprung up, again more marked on the western slope..."

Skeptics of the Roswell story often claim that interest in the event dropped off immediately after its initial media flash, only to be revived in the late 1980s by unreliable UFO researchers seeking to profiteer from a myth of their own creation. Reich's visit to Roswell, with its clear references to aliens, contradicts that assumption. So does remarkably strong archival documentation from several disparate sources that show an interlocking connection between Reich and Dwight Eisenhower.

First in this line of documentation is the Cutler-Twining memo. This National Archives in Washington, DC still contains this onion-skinned carbon of a memo calling for the postponement of a special studies section of the group MJ-12. Ufologists recognize MJ-12 as the group ostensibly started by Harry Truman in response to the Roswell crash, established to secretly deal with the alien presence. Skeptics claim that the documents reflecting this possibility, the infamous MJ12 documents, have all been faked. Nevertheless, the National Archives retains this one letter, unwilling or unable to establish that it is not authentic. It's date: July 14, 1954, five months from Eisenhower's supposed meeting with the aliens. Since no proof is absolute, even the government's retention of the document (authenticated by paper-lot and typewriter style dating) for a half-century, skeptics suggest that the Cutler-Twining memo was smuggled into the archives.

The author of the C-T memo, Robert Cutler, served in the CIA under Eisenhower in its division of psychological operations. Cutler had virtually written Ike's famous "Atoms for Peace" speech, which took as its title a phrase used by Reich long before to describe his orgone work. The recipient of the C-T memo, Nathan Twining, is well-known among

students of ufology as the general to whom Air Force investigators regularly reported UFO sightings and retrievals. One such retrieval, involving flying saucers in the Maury Island area in the Pacific northwest, also involved the kind of black substance that Reich had described at his lab in Maine.

But the second curious document in this research line was recovered only recently by a researcher named Jim Martin, as part of his comprehensive look at Wilhelm Reich's life in the 1950s called *Wilhelm Reich and the Cold War*. Entitled the Moise-Douglas memo, Martin discovered it in the archives of Lew Douglas, a member of Eisenhower's "kitchen cabinet" who was assigned to a presidential committee on weather control. In Contact With Space, Reich claimed that he had corresponded with Douglas and Martin discovered this memo as proof. It's from Douglas describing the latest of several failed attempts by Reich's assistant, William Moise, to make contact with this high ranking official in the Eisenhower administration. Although the memo itself is not dated, a handwritten note at its bottom indicates a great change of heart by Douglas, who ultimately did telegraph Moise on July 27, 1954.

This timeline is the best indication in the historic record that MJ-12 exists and, by inference that Eisenhower met with aliens. Douglas' about face with regard to Reich, coming at any point in July 1954, indicates that he had been briefed at the MJ-12 meeting described in the Cutler-Twining memo. The object of the "Special Studies Project", then, would be Reich's counterattack on UFOs, and at it Douglas was directed to take a greater interest. In the end, Douglas wound up bankrolling in part some of Reich's environmental work in Tucson.

Finally, there's Reich's own meeting with Eisenhower. One witness claimed that during a hunting and fishing trip to Rangeley, Maine, where Reich's Orgonon lab was located, Eisenhower met face to face with the inventor of the anti-UFO technology. The Eisenhower Library even

records a visit to Rangeley during that UFO laden period of the mid-1950s, from June to July, 1955. In the end, however, the memory of the witness to the meeting became as vague as that of the dentist's widow from Ike's alien visit of the year before.

The historic trail vaporizes after that, to re-emerge obliquely only once. According to the biography of his second wife, the screen comedian Jackie Gleason caught a glimpse of alien bodies in 1973 at the behest of then president Richard Nixon. Nixon, of course, had been Eisenhower's vice president. He took his friend Gleason to a secret facility in Palm Springs, where Ike had disappeared for one night for his visitation with aliens all those years ago.

Does any of this amount to proof that such creatures exist and that Eisenhower met with them? Such questions always contain relative judgments, and in the end no absolute proof can be offered for anything. However, more historic evidence exists for this bizarre proposition, for instance, than for Lyndon Johnson's claim of an attack on US ships in the Gulf of Tonkin or George Bush's claims for the existence of WMDs in Iraq. Those two bits of mythologizing started major wars.

Reich was eventually prosecuted for his orgone devices. They had been unfairly characterized as quack cancer cure machines and a technical violation of an FDA injunction led to Reich's imprisonment. Federal authorities destroyed much of his scientific equipment and even had his books burned. Many believe that the prosecution resulted from big-money medical and pharmaceutical interests threatened by Reich's work. He died in prison in 1957.

Some of the language In Eisenhower's retirement speech, the one that coined the phrase "military-industrial complex", conjures up an image of Wilhelm Reich, Ike's possible secret ally in the war against extraterrestrials. "Today," Eisenhower notes, "the solitary inventor, tinkering in his shop, has been overshadowed by task forces of

scientists in laboratories and testing fields...a government contract becomes virtually a substitute for intellectual curiosity. The prospect of domination of the nation's scholars by Federal employment, project allocations, and the power of money is ever present ..."

Although the record suggests that Reich had the interest and support from the Eisenhower administration in his desert battles against UFOs, he never required it. Although he believed in nuts and bolts space ships piloted by extra-terrestrials, he regarded contact with them as characterological events, not simply sightings of craft. But he needed no stamp of approval from government authority to make this claim.

"There is no proof," wrote Reich in *Contact With Space*, "There are no authorities whatever. No president, Academy, Court of Law, Congress or Senate on this earth has the knowledge or power to decide what will be the knowledge of tomorrow. There is no use in trying to prove something that is unknown to somebody who is ignorant of the unknown, or fearful of its threatening power. Only the good old rules of learning will eventually bring about understanding of what has invaded our earthly existence."

CORRESPONDENCE

This section includes a variety of correspondence on several topics.

ParaScope Dispatch Three
December 1999-January 2000

RE: Operation Mongoose

Parascope Dispatch Two came out before I could comment on *Parascope Dispatch One*, so I'm sending this belatedly. Fine little zinelet you have there, and I wish it the best success. Hard copy zines still have many advantages over the internet, like reaching new readers from people who browse the newsstands. Despite the proliferation of conspiracy info on the web, it's all targeted to those of us who have a specialized interest. It is obviously important that conspiracy researchers reach larger audiences, so I hope *Parascope Dispatch* can help serve that function.

The article about Operation Mongoose (*Dispatch One*, The Paper Trail, "Dirty Tricks Vs. Cuba") particularly grabbed my attention. It reported on Brigadier General William Craig's bizarre projects to discredit, harass and possibly assassinate Fidel Castro.

According to new DoD files released by the Assassination Records Review Board, Craig came up with projects above and beyond those initiated by Edward Lansdale. As I pointed out in my new book *Maury Island UFO*, according to researcher Gus Russo, who wrote a book entitled *Live By The Sword*, Lansdale's projects may have originated in a conversation between Lansdale, JFK and James Bond author Ian Fleming.

To this, I would like to add another often overlooked history lesson about these attempts against Castro. The Cuban

dictator made a clear effort to track them up the American intelligence hierarchy to see if indeed they were a matter of official U.S. policy. On the day that one potential Castro assassin, Rolando Cuebela (codenamed AMLASH), was to have a meeting at CIA headquarters, Castro made a public statement at the Brazilian embassy, where AMLASH had previously met with a U.S. contact. In regard to the attempts, Castro said "We are prepared to fight them and answer in kind. United States leaders should think that if they are aiding terrorist plans to eliminate Cuban leaders, they themselves will not be safe" and that the "CIA and other dreamers believe their hopes of an insurrection or a successful guerrilla war. They can go on dreaming forever." CIA apologists have long tried to offer this threat as suggestive of Castro's involvement in JFK's assassination, in defiance of the logic that he would have hardly announced such intentions publicly. Historians suggest that Castro actually was announcing his awareness of the plots and putting official D.C. on alert. Cubela may have been a double-agent, on assignment for Havana to find out where the responsibility for the plots ended. Since back-channel diplomatic rapprochement was happening between Kennedy and Castro at the time of the assassination, it seems likely that Castro felt that such responsibility did not reach all the way to the top. Maybe it ended in a Pentagon intelligence eel that included Lansdale and Craig.

The *Steamshovel Press* web site includes a photograph of Lansdale having dinner with Ollie North and Iran-contra/Octopus figure John Singlaub. Fletcher Prouty has long argued that Lansdale was actually on hand at the Kennedy assassination site, coordinating events, and appears in one of the photographs of the infamous railyard tramps.

Best,
Kenn Thomas

Thanks very much for your feedback on *ParaScope*'s new print project. We're still building up steam, but this issue is our most ambitious yet, and we have some interesting special issues lined up for the near future. I agree that it's crucial for the underground media to reach out to readers both in print and on the Internet. Those of us who are "wired" can easily forget how many intelligent, active people there are who have absolutely no interest in the Internet, but who nevertheless read quite a bit. It would be foolish for the "conspiracy" media to isolate its efforts solely on the Internet.

I offer my heartfelt condolences on the recent loss of your friend and co-author, Jim Keith. His passing was a sudden shock - at first I thought it had to be an unsubstantiated rumor, I just couldn't believe it. But your confirmation of the news brought home the sobering reality that the underground research community had lost one of its heroes. Jim's work was an early inspiration for *ParaScope*. He will be sorely missed.

In regards to your comments about "The Cuba Project," I referred your letter to Jon Elliston, editor of "The Paper Trail" and Dossier, whose knowledge of such matters far exceeds my own.

-Charles Overbeck

Jon Elliston responds:

I'm glad our coverage of anti-Castro covert operations, a topic near and dear to us, was read by similarly interested individuals. There is an avalanche of newly released documentation on this matter, and it has become possible to clear up (or at least illuminate) some of the shadowy corners of Kennedy-era Cuba operations.

I want to offer my two cents on some of the incidents and operations you mentioned. Some are tangential and some are of real importance to the JFK-Cuba story.

123

In order, they are:

JFK, FLEMING AND LANSDALE:

In his book *Die by the Sword*, Gus Russo recounts the well documented story of a dinner party at which then-Senator John Kennedy asked Bond author Fleming what could be done about the pesky revolutionary Fidel Castro. I have not heard that Lansdale was present at the dinner, and I doubt he was – so there was probably no conversation among Lansdale, Fleming and JFK. However, President Kennedy and his brother Robert are reported to have referred to Lansdale as "our James Bond" when they assigned him to run Operation Mongoose.

CUBAN COUNTER-INTELLIGENCE:

Castro's security forces and spies are renowned - Cuba always seems to know what its enemies are up to. You mention Castro's efforts to track operations against him "to see if they were a matter a/official US policy." I doubt that was his motive. There is plenty of evidence that Castro managed to discover, through espionage and direct experience, what he was up against when the Eisenhower and Kennedy administrations unleashed a secret war against revolutionary Cuba. But there was little question who was sponsoring and directing the anti-Castro campaign. Certainly there were some Cuban exile groups that attacked the island without U.S. government support, but in the overwhelming majority of cases, the sabotage, propaganda and paramilitary actions were directed straight out of Washington. Castro knew this from the get-go, and he publicly identified his attackers in numerous speeches. (A choice example: shortly before the Bay of Pigs invasion, Castro announced that he knew the CIA was up to something, and suggested they be called the "Central Agency of Yankee Cretins.") His spy

operations were important for defensive purposes, but he need not have searched for the origins of hostile policies that he well knew were originating in the White House.

ROLANDO CUBELA:

I have never heard that Cubela "was to have a meeting at CIA headquarters." CIA officers did meet with him in such far-flung countries as Brazil and France, but to bring a potential Castro assassin, a "defector in place" who was still serving in the Cuban government, into the CIA's Langley headquarters would have been a display of ineptitude and bad judgment that even the CIA was probably not capable of. Cubela may indeed have been Castro's agent the whole time he was supposedly working with the CIA, but the fact remains that he was ultimately arrested by Cuban authorities for his plotting and wound up with a 25-year prison sentence.

If Cubela was "on assignment for Havana," again I doubt that the purpose was to "find out where the responsibility for the plots ended." That the Kennedy brothers were leading the secret war against Cuba, a fact demonstrated again and again the recently released government files, was no secret to Castro.

THE BACK-CHANNEL TALKS:

Emissaries of Castro and Kennedy were indeed engaging in tentative talks shortly before JFK was gunned down. (See an upcoming installment of "The Paper Trail" for new revelations on this matter.) Were the talks a sign of a sea change in Kennedy's Cuba policy? Was he really interested in making nice with none other than Fidel Castro? The preponderance of the evidence suggests not. Even as some White House aides argued that the talks might be an avenue for pulling Castro out of the Soviet orbit, the U.S. covert

action program against Cuba was expanded - an the orders, and with the knowledge, of John and Robert Kennedy.

Gus Russo's book, which you mentioned, does a nice job of summarizing the unceasing attack against Cuba in JFK's last year.

-Jon Elliston

Saucer Smear, September 1, 2001

KENN THOMAS of *Steamshovel Press* writes as follows:

"Did you cut up your copy of *Steamshovel* to get that graphic of the screaming Acharya S. on the cover of the latest *Saucer Smea*'? Shame on you! Do I need to send you another copy?

"I notice that physicist Jack Sarfatti (**www.stardrive.org**) and Remy Chevalier (**endsecrecy.com**) have been arguing on the internet over the same thing that caused Richard Hall to quit MUFON: Letting Stephen Greer and Daniel Sheehan speak. Sarfatti even calls them 'Ban Space Weapons Marching Morons, mere Cannon Fodder to their Puppet Masters (who) plan to disrupt U.S. Military (and might be under foreign influence). - Where is General MacArthur when we need him?'

"Both Hall and Sarfatti seem to be woefully or willfully ignorant of the parapolitics surrounding the Star Wars initiative. They killed a couple of dozen guys like Sarfatti – scientists, contracted to Marconi – who worked on the original SDI – because they knew too much. Sheehan, of course, brought a bold lawsuit against the Iran-Contra secret government baddies.

"I can think of no better public forum to discuss the issue than at MUFON-type conferences."

Saucer Smear, April 1, 2002

KENN THOMAS of *Steamshovel Press* writes:

"The Prophets Conference dropped. Robert Anton Wilson as a speaker for using the 'dirty' words long ago liberated by the likes of Lenny Bruce and George Carlin. I was reminded of when Acharya S., great chronicler of the conspiracy known as Christianity, was kept off the dais at one well-known UFO conference in Nevada because her topic might have offended one of the other speakers. Then I thought of what Jerry Lucci wrote in the last issue of *Saucer Smear*, about the same people ranting on and on about the same things. Small wonder, considering the kind of decision making that apparently goes into these conferences. Too bad, since they should be places where free speech and new ideas reign. I called for Ram Dass to remove himself from the Prophets Conference in protest."

Saucer Smear, August 10, 2003

KENN THOMAS of *Steamshovel Press* writes:

"...Surely you don't believe that they can't find Weapons of Mass Destruction (WMDs) in Iraq because of incompetence! I am a bit surprised that they haven't planted any yet, but then again, why should they bother? The war is over.

"As for Roswell, read the article by Jim Martin in the new issue of *Steamshovel Press*, and. tell me that we haven't at least said something new about it. I think Jim found the smoking gun for the existence of MJ-12, and it has very little to do with Stanton Friedman. (By the way, he's not alone in having a financial interest in UFOs; witness every other cover of *Skeptical Inquirer* with a gray alien on it.) And the idea that interest in Roswell trailed off after the late 1940s, until

127

Friedman and crew revived it, is belied by the fact that Wilhelm Reich went there looking for aliens in 1955. So the history of the thing doesn't stop with the Mogul balloon. You know I did a book on the Maury Island UFO case, right? Did I send you one of those?"

JAMES MOSELEY of *Saucer Smear* writes: We'd love to see the Maury Island, book. We differ with Thomas & Martin on many points about Roswell, but if you really enjoy conspiracy, you'll love *Steamshovel Press!* - Ed.

Defense Industrial Security Command
from e-mail

October 28, 2003

Dear Kenn,

I sent a similar post to you a couple years ago, but from what I see on the web I'm unsure that you got it. I'm virtually positive that the former DISC is now Defense Security Service. DSS has an office at the 3990 East Broad Street address referred to in the Torbitt Document, as well as in Huntsville (also in Torbitt); it performs the same functions for industrial security. What's funny is that the website claims that DSS was founded as the "Defense Investigative Service" in 1972 - could that have been after Torbitt/Copeland outed DISC in 1970? I'm going to do a FOIA on the subject and see where it leads...

Bill Simpich

www.dss.mil/ (DSS website)
www.dynetics.com/news/y98News/
award.htm

(re: the DSS office at 3990 East Broad Street)

www.defenselink.mil/privacy/notices/dss/V8-02.html

(re: the DSS office in Huntsville)

October 28, 2003

Bill,

Thanks for this. A stand up comic named Bob Harris concluded that DIS is a descendant of DISC. I'm not sure how he reached the conclusion, however. Certainly the timing suggests it. DSS looks like a descendant of DIS. There are so many "Defense" agencies these days, the big one being the DIA.

Let me know how your FOIPA turns out.

kt

October 29, 2003

Kenn - I think the argument could be made that DIS was renamed DSS in November 1997 (in the DSS FAQ) to cover the tracks of DIS after you re-introduced DISC to a mass audience in 1996.

DSS uses a DISCO form (Defense Industrial Security Clearance Office) for a variety of requests - this jibes with Bob Harris' footwork.

I've done extensive searches for DISC, and have never found any reference to it that didn't stem from the Torbitt document. But Columbus, Huntsville, and Muscle Shoals are long-time centers of defense business, and the

"industrial security" business is of mammoth proportions in those towns as well as others.

The FAQ also mentions that DSS has 2600 employees - many of these employees work on an intimate level with the most powerful aerospace and missile outfits in the country. Talk about a revolving door of influence and intrigue.

DISC may have also been within the allegedly "unified office of the "Industrial Security Program", founded in 1965 by Gen. James Cogswell. (see attached DSS article) The ISP was folded into DIS in 1981 (in the Loyola article, apparently trying to recruit impressionable Catholic youth)

Another reason this subject is so fascinating is b/c of our friend LHO - if he's helping out Tom Dodd's internal security subcommittee by doing controlled buys of a gun and a revolver, his role in the assassination makes more sense. If you haven't read Barr McCllellan's new book on LBJ, I can say that it's a fascinating read on the Mac Wallace evidence which I've always felt is compelling. What is McCllellan's story - as the estranged dad of the White House press secretary, I want to know more about him. I do know that he's been on the Mac Wallace case for five years.

I'll let you know about the FOIA request - that will probably take quite a while to get a response.

Bill Simpich

INTERVIEWS

Shoveling It
A Busy Week for Kenn Thomas, gatekeeper of conspiracy theories
Chicago Tribune, January 23, 1994

WASHINGTON—Now, if I understood correctly some things I heard and read here last week: Bobby Ray Inman, who some thought was "Deep Throat" in Watergate, says he's a victim of a McCarthy-like conspiracy by a senator and a columnist, the latter an old friend of Richard Nixon and William Casey, the latter a former boss of the CIA; which did try to knock off Fidel Castro and might nave been involved in killing President Kennedy but most definitely fooled around with Oliver North and the Nicaraguan contras, one of whom used a small Arkansas air field for drug smuggling and money laundering perhaps with the knowledge of the governor then, Bill Clinton, some of whose former bodyguards sure can't keep a secret.

A bit confused about the above—as well as with any possible links among Inman, the Whitewater Development Co. estate partnership and Tonya Harding—I just had to put in a call to Kenn Thomas.

Thomas is an archivist at a midwestern university, where processes manuscripts, including diaries and letters, of groups and people as part of a collection that emphasizes the social, labor, black and women's history. These days he toils on the papers of a husband and wife team of civil rights activists, De Verne and Ernest Calloway.

But in his off-hours, he publishes and edits a 5-year-old quarterly, *Steamshovel Press*, devoted to serious

discussion of conspiracy theories, both substantive and wacko. His publication is part of what he calls the "parapolitical underground," of which Inman forevermore will be a subject "Given that he apparently takes conspiracies against him so seriously tells me he's more of a conspiracy theorist than many in the research community. Even we don't take things that seriously," Thomas said.

Steamshovel's aim is to present what Thomas, who has a master's degree in 20th Century English literature, terms alternative information, namely "discussion of rumors and new information, some unsubstantiated, stuff you will not find in the daily papers." It distributed to retailers nationally.

The 62-page current issue includes an interview with poet Allen Ginsberg, which offers his thoughts on J. Edgar Hoover ("I haven't seen anybody discussing the consequences of Hoover being a closet queen"); the suggestion by longtime liberal activist David Dellinger that Abbie Hoffman might have been murdered, rather than the suicide previously assumed; lots of stuff on flying saucers; and an essay on "The Usefulness of Conspiracy Theories."

Thomas gets lots of unsolicited manuscripts and tries to do a lot of traveling to such events as a symposium on the Kennedy assassination, in Dallas last year. He's also been to UFO conferences in Las Vegas and took a field trip to an emerging hot spot for conspiracy theorists, a place called Area 51, a U.S. military base in Rachel, Nev.

They're intrigued by the place since they believe it is where the government may be studying-flying saucers that have crashed to Earth, and that it may be home for a secret space shuttle servicing a base on the moon.

Lest one think that Thomas is a 24-hour repository for any and all claims, he has "rejected things as too goofy," including one prospective contributor's assertion that Jack Ruby lives. Still, his tendency is to be tolerant, even when he doesn't quite understand a claimed theory, which helps explain the publication's title.

132

"We shovel it out," he says about conspiracies.

Thomas had been concerned that there'd be much less grist with the end of 12 years of rule by Ronald Reagan and George Bush.

"For 12 years, we had people who were the embodiment of keeping secrets. I thought Clinton would be more open, but he has ties to some of the same people," says Thomas, who is writing a book on "Inslaw," the quintessential Washington conspiracy, which alleges that the Justice Department stole a sophisticated software-program depriving its creators of uncounted millions of dollars. A federal investigation on that continues.

So it seems as if an even grander era may beckon for the sub-culture to which he caters.

"There's a stronger thrust to conspiracies. People want to know more, get more information than they normally get," he says.

He spoke at the end of a big week: Inman, the Iran-contra final report and the naming of an independent counsel for Whitewater.

And, lest we forget, "even figure skating is immersed in conspiracy."

Yes, even Tonya may yet make it into the pages of *Steamshovel Press.*

Who Killed the Calendar?
New York Times, September 11, 1994

"It's a tad tasteless, but it has meaning," says Kenn Thomas, editor and publisher of the 1994 *Assassination Calendar.* True on the tasteless from, but what meaning, exactly?

"The idea," he says, "was to make people aware of assassinations and the role they play in current events." And

to raise questions like, "Was Abbie assassinated?" Hoffman, that is.

The calendar comes from Thomas's *Steamshovel Press*, a magazine devoted to making people aware of conspiracies and secret truths of all sorts, including those involving UFOs, the AIDS virus as an escaped weapon of biological warfare, the Shroud of Turin, the eerie similarity of Jesus and Dracula and the role of immortal bloodsuckers through history.

"Do the vampires still exist, and somehow rule us today?" writes 'William Meyers in issue 10. "I can't answer with total certainty, but there is much
evidence that they do."

Perhaps most disturbing of all is Thomas's revelation that there will not be a 1995 assassination calendar - although there's hope for 1996. Has Thomas been attacked by vampires or kidnapped by aliens? No. As is so often the case in real life, the cause is far more banal Thomas was unable to meet his production deadline.

"Not All the Same Nuts"
New York Times, June 4, 1995

Some folks on the political margins are feeling more maligned than usual these days. "When people talk about conspiracy theorists since Oklahoma City, they're talking about these militia types," says Kenn Thomas, editor and publisher of *Steamshovel Press*, a small St. Louis magazine. But there are many kinds of political paranoia.

"We may all be nuts," Thomas says, "but we're not all the same nuts." Thomas thinks of himself as part of the "marginals press," which includes a variety of small magazines and publishers with names like *Paranoia* and Feral House.

He says he is "uniquely tolerant of the gun-toting right," and will publish "the rant" of one of the two Michigan Militia leaders who suggested that the Japanese could be responsible for the Oklahoma bombing. But he himself is non-violent.

He is not alone in the belief that there are kinder, gentler "researchers" or "forensic historians," as some conspiracy theorists call themselves. They may believe that the Kennedy assassination was a *coup d'etat*, or that spaceships routinely visit the planet, but they prefer desktop publishing to automatic weapons.

Jim Martin puts out a small magazine called *Flatland* and that includes volumes on history and UFOs. "I sell a lot of silly stuff," Martin says. He, too, argues that most believers in conspiracies have no military aspirations.

Asked how he would describe himself and the other kinder, gentler "nuts" that Thomas jokes about, he replies, with a laugh, "We're the loyal opposition."

Uncover Story:
Kenn Thomas' *Steamshovel Press* has the information conspiring minds want to know

Riverfront Times, October 18-24, 1995

If there is a New World Order, it may very well be as chaotic a place as Kenn Thomas' home office. In this small second-floor room, there is barely enough space for two chairs among the clutter.

A large portrait of LSD guru Tim Leary stares down from on high. Stacks of paper are piled on every available surface. One wall is lined with esoterica ranging from obscure UFO books to tracts on political assassinations. There is a cardboard box on the floor filled with a jumble of audio

cassette tapes. On this particular afternoon, his young son, a rambunctious preschooler, is rhythmically pounding on his father's typewriter while engaging in mostly incomprehensible conversation with himself. To the uninitiated, the competing adult discourse, which is being carried out in the same cramped quarters, might seem to be only slightly more intelligible.

Here at the headquarters of *Steamshovel Press*, the arcane, if not absurd, is commonplace. Thomas, a university archivist by profession, is the art-time publisher of the quarterly conspiracy magazine that has no definable edge to its worldview. On its pages, pieces of reality constantly shift in a human kaleidoscope of political intrigue.

The real-life characters that make up the designs are, of course, stranger than fiction. Where else, for example, could readers peruse articles with captivating tides such as "The Encryption/Decryption Dickwads of Cipherspace" or "Only a Pawn: Bob Dylan, Lee Harvey Oswald and MK-Ultra"?

When Thomas started *Steamshovel* back in 1988, the initial press run was a whopping 30 copies. The bulk of those were sent to publishers. "Basically for the sake of getting books to review," recalls Thomas. The publication is now distributed throughout me United States and in several foreign countries. It has a relatively large circulation, Thomas says.

Popular Alienation, - a compilation of *Steamshovel* articles, is being published this month by IllumiNet Press. Thomas has also co-authored a soon-to-be-released book on the mysterious death of freelance writer Danny Casolaro. Next month he plans to travel to Libya to take part in a conclave, where he is scheduled to speak on the American militia movement. Closer to home, the alternative publisher will lecture at the Big Picture conference this weekend at the Radisson Hotel near Lambert Field. That meeting is being billed as offering "alternative perspectives on our dramatically changing world." Other speakers at the

conference will include authorities on UFOs, ancient civilizations, alternative health therapies and me Kennedy assassination.

Once considered perhaps only a tad loopy, the purveyors of such unconventional ideas are no longer viewed benignly by the establishment.

Since the April bombing of the federal building in Oklahoma City, *Steamshovel Press* and similar periodicals have garnered considerable criticism from the mainstream media. In particular, an article by Michael Kelly that appeared in the June 19 edition of *The New Yorker* magazine has discredited conspiracy, theorists on both the left and the right of the political spectrum. Kelly lumps every body from the Christic Institute to the John Birch Society together and labels them all part of what he calls "fusion paranoia." For Thomas, the left-right political paradigm is a canard. "This whole division between the left and right is just a bunch of propaganda being shoved down our throats from the people at the top," says Thomas. "The real division is top and the bottom.

"That's what the whole *New Yorker* piece is about — to fuse them together and then dismiss them both — the weirdos of the left and right," says Thomas. "I personally don't see there is anything that you can do about the mainstream media. They're never going to change. They are always going to think that everything that isn't them is kooky." Thomas contends that control of the communications industry is becoming more concentrated among fewer corporations, inevitably resulting in the systematic exclusion of dissenting viewpoints.

"I consider at least portions of the militia community (to be) a community of dissent," says Thomas. "I may not agree with everything they stand for, but I agree with dissent." In his opinion, liberal elitism is another factor behind the lambasting of conspiracy theories. "There is a particular snob element to

leftist thinking that just goes against my grain, because I know that there are liberal people teaching history teaching bullshit," says Thomas, an archivist at a midwestern university. There are post-office workers out there who have collected files that reflect a lot more truth. What a guy does for a living has hardly any bearing on the quality of me information that he has added to the historic record. I'm not saying that all of this (conspiracy theory) is correct, but I am saying that it is just as correct as anything you see in the newspaper."

This seems quite plausible, even reasonable. But it is still difficult to picture Thomas in the halls of Tripoli. What is the proper protocol for a middle-aged academic from the Midwest if hailed by dictator Muammar Qaddafi?

The conference is called the "Second Green Dialogue for an Alternative World Order." It is sponsored by the Jamahirya Society for Philosophy and Culture, which describes itself as a nongovernmental group. The Revolutionary Committees of Libya, however, also involved in promoting the conference, Thomas says. The title of his speech is "The American Militia Movement, the Marginals Press and the Alternative World Order."

They are picking up the tab for the whole trip, but nothing I say is tailored to meet propagandistic goals of the Libyans," he says. "In fact, I was a bit concerned that my discussion of free speech might piss them off. The talk is basically about the need for extra-national communication between communities of dissent in the world."

Thomas has already received special approval from the U.S. State Department to attend the conference, he says. His traveling companion in North Africa will be Jim Keith, who collaborated with him on his latest book. "I got the Libyans to sign him on so I can have a human shield when the gunfire breaks out," quips Thomas.

Keith, who Thomas describes as a "bit of a loose cannon," is the author of *Black Helicopters Over America:*

138

Strike Force for the New World Order. Whether the book goes over as well in Libya as it has on a famous Texas radio evangelist's broadcasts remains to be seen. Says Thomas, "He's selling books by the thousands to the World Living Ministry or whatever it's called). Jim's really working that crowd though he's not really one of them."
— CD. Stelzer

"Far, Far Out"
St. Louis Post-Dispatch, January 2, 1997

Publisher's lecture promises to tie UFOs, covert ops, and the Kennedy assassination into one ugly package

by Jeff Daniel

"Check this out," Kenn Thomas requests after a brief greeting at his office. In his hands is a wonderfully tacky American flag print tie—not the stylish, silk Tommy Hilfiger model, mind you, but a prized political relic from the late early '70s.

"And 100 percent polyester," he adds with pride, breaking into a laugh when it's suggested that his new neckwear is, by its chemical make-up, a deterrent to flag-burning agitators. "Think I just might wear it at my presentation this weekend," he concludes with a sly grin.

Thomas's lecture/slide presentation at the SOHO Cyberjunction Saturday will give visitors a hint of why his conning of stars and stripes literally drips with irony. It's OK to love your country, Thomas might say, "but trusting its government is another matter altogether.

As publisher of *Steamshovel Press*, a magazine dedicated to conspiracies, cover-ups and all things unexplainable. The skeptical but extremely affable Thomas has developed a national reputation as a conduit for

disbelievers of the left, right and middle. Compared to Thomas, Oliver Stone is a veritable company yes-man.

The Kennedy assassination, UFO sightings, covert government operations: Thomas has researched and written reams on all of these subjects, and his latest lecture ties them all together in one single case—the mysterious death of investigative journalist Danny Casolaro/

"I've been examining the UFO angle of the Casolaro case for a book that will be published this summer," Thomas explains.

"I'm hoping that this presentation will open up what I do to the public," he continues. "Give people an idea what the marginalist press is all about and allow them to hear about incidents that otherwise wouldn't be covered." Incidents such as Thomas' trip to Area 51—the desert site long associated with rumors of extra-terrestrial happenings.

Also on tap is a tribute to the recently-departed Timothy Leary, a long-time friend of Thomas and a thorn in the side of the status quo in his own right. If they are lucky, audience members will be treated to a great, albeit tragic, anecdote about a chance meeting between Timothy Leary and Art Linkletter shortly before Leary's death.

But interesting anecdotes abound when you put out a magazine that offers up subjects ranging from "JFK's LSD Madonna" to "Black Holes and the Trilateral Commission."

"I started *Steamshovel* after the conspiracy press started to falter," Thomas says, alluding to the demise of the genre's standard bearer, Critique. "And what started out a small poetry and reviews journal has really taken off, I guess."

Cups, The Café Culture Magazine, 1999

World wide financial transactions, double dealing, spy networks, the Kennedys, UFOs, the CM, drug running, mind control. It all comes together in the Octopus: an international

network of quasi-government spies and their friends in the underworld. An investigative reporter named Danny Casolaro was on the tail of this beast which he linked to the theft of surveillance computer software called PROMIS from the private company, Inslaw, when he mysteriously died. Kenn Thomas and Jim Keith's book *The Octopus* (Feral House) is about Casolaro's death and research. Cups interviewed Thomas.

Cups: So how did this Octopus project come about?

KT: Danny was an investigative reporter looking into this tiling called the Octopus when he turned up dead in West Virginia in 1992. And then I discovered that the research he had collected was on him when he died. A lot of his papers, the most crucial stuff, just disappeared. But everything that he left behind in his apartment and so forth was actually turned over to ABC's *Nightline* program and then picked over by the Intelligence community.

Cups: What happened with ABC and these papers?

KT: They were turned over to a friend of Casolaro's brother, a guy named Andy Scott who heads an office at the University of Missouri in Columbia. They put them in file cabinets there and opened them up to anyone who wanted to look at them. I thought, Wow! How often do you get that opportunity, when somebody dies doing his research? This is a measure of how close you are to getting to the truth of something. But here all the papers had been turned over for public inspection, and at the time very few people were doing anything with it. It was a perfect opportunity to pursue Casolaro's research to find out about the Octopus for myself and to look at the process of a conspiracy research reporter who took it as far as it can go.

Cups: Why do you think the scandal around Casolaro hasn't received much press?

KT: The kind of conspiracy that Casolaro was into involved players who were still on the scene, people with power, killers – people don't want to go near it. And everybody in the mainstream press has the convenient excuse, "Oh that guy was a nut, he killed himself," which is the official story. But CIA operative E. Howard Hunt, who is associated with the assassination of JFK, Watergate and alleged mind control activities, is still out there, and he is allegedly one of the members of the Octopus. The Octopus is still a thing.

Cups: Who are all the people at Casolaro's funeral?

KT: That's another thing we don't know. A black man in a military uniform put a medal on Casolaro's casket. Casolaro never served in the military so the suggestion is that maybe he was doing some of this investigative work for the government. I discussed the funeral with one of Casolaro's cousins. He said there's a videotape. I tried to get him to track it down; apparently an aunt has it. If we could get that tape, with the technology we have today, we could zero in on name tags. They were asserting that Casolaro committed suicide. It looks to me, from what I've read, that he did not, there's no way he could have.

He had three fingernails missing. You don't torture yourself before you commit suicide. It's pretty clear that you have a scandal here that those guys did not investigate in any depth.

THE OCTOPUS AND THE COLD WAR

Cups: How can the Octopus continue now that the Cold War is over? What's the justification?

KT: The Octopus is not strictly American patriots vs. Soviet communists. In fact, it kind of exploited the whole superficial structure of the Cold War for the sake of the profits, for the power of the people who were involved. The Octopus is basically a transnational group of intelligence operatives whose allegiances are not to the US, the CIA or the Soviet KGB. They exploited these structure for money and power. Just because the Cold War has thawed out, I don't think those motivations would go away.

Cups: What are they going to use instead?

KT: One of the bugaboos is terrorists. The secret political landscape in this country is turning more and more into the kind of thing they've had in Europe for many years, a thing called the strategy of tension, where you never know when a Basque separatist is going to blow up a building. Now you don't know when a Texan separatist is going to do that.

Cups: Is the Octopus protected by national security?

KT: Co-author Jim Keith draws the beginning of the Octopus to the Albanian operation to destabilize Albania that was betrayed by Kim Philby, a famous British Spy. The main core of the Octopus arose in response to Philby's betrayal. That was in the late 40s. This core group of people had a hand in everything from the overthrowing of Arbenz' government in Guatemala to the Bay of Pigs to the assassination of JFK to the theft of the PROMIS software and the October Surprise (in which the Reagan campaign allegedly bought off the Iranians not to release American hostages until after the 1980 election was held.)

THE BLACK BUDGET

143

Cups: What is protecting these people? What is the secret government's relationship with the regular government? How much do the elected officials know and why do they keep it a secret?

KT: By nature it is transnational and it uses money that is beyond the reach of governments. There are black budgets in our government. There is an enormous amount of money that is spent on spying. We don't even know what the amounts are. It goes beyond any public accounting.

Cups: Are there are any efforts to trim the black budget?

KT: No! They're tremendously successful in what they're doing. We're only beginning to know about it, and that's only because a couple of guys were able to rescue what was left of the research notes of a guy they pretty much stomped on and killed. You try to explain it to the ordinary citizen, the transnational presence that exploits world situations for its own power, and the people don't know what the hell you're talking about.

Cups: Couldn't a political campaign be waged to release this budget, or reduce it?

KT: It doesn't matter if you're Republican or Democratic. What really matters are these behind the scenes connections to the same group of Good Ol' Boys, none of whom are going to allow any serious challenge to the black budget, drug running and everything else.

HUNT AND MIND CONTROL

Cups: Who are some of the key members of the Octopus who are living and active and what are their activities?

KT: One interesting person is E. Howard Hunt who was involved in the Bay of Pigs. He was also involved in the Albanian operation. He's a player that goes back really to the formation of the Octopus. He's still around. Casolaro developed a relationship with him.

Cups: How much money do you think Hunt has made? It seems to me from reading your book that the Octopus is basically a means by which people can make a whole lot of money illegally through using the National Security cover.

KT: In some cases it's not money, it's power. A lot of these people have so much money that it doesn't mean that much anymore. Overthrowing governments, consolidating your own power and creating spheres of influence is still important to them.

In Hunt's case, shortly after Casolaro developed this relationship with him, he had some kind of accident. Friends came over to his house and noticed he had a scar on his head and was acting kind of funny. There's a guy in Atlanta, Kerry Thornley, who was in the Marines with Oswald. At the time of the Kennedy Assassination, he had these meetings with Hunt in which he felt he was being corralled into a mind control operation involving an electronic implant. There is in fact a book called *Were We Controlled?* by Lincoln Lawrence, in which he argues that Oswald and Jack Ruby were mind controlled into their behavior and in each of these cases E. Howard Hunt is somewhere in the background.

Cups: I was curious about these implants and how they work.

KT: It's all based on technology developed by a guy named Jose Delgado. He was in a photograph on the front page of the *New York Times* in 1965 showing a bull that had one of his implants in its brain, charging at him. He pushed a button

145

and stopped the bull cold. Delgado, for the last thirty years, has been pursued the controlling the brain through electronic stimulation. It's very Fascist, Nazi behavior control, behavior modification, a Skinnerian nightmare...

Cups: So how would you install an implant in someone without them knowing?

KT; According to Lincoln Lawrence, in Oswald's case, he went in for an adenoid operation when he was living in Minsk and he stayed in for a much longer time than it usually takes for a simple operation like that and that's where he got the implant. Now in his case, I think Lawrence was arguing that he had volunteered for that, it was part of what he was doing as a spy. Doing it without knowing it's being done to you, I don't know about. Kerry Thornley apparently believes that's what happened to him. The evidence is sparse. It's an urban legend kind of thing, so it may not be true at all. But mind control technology isn't publicized, that's why we don't know. That doesn't mean it doesn't exist. The absence of evidence is not the evidence of absence.

Cups: What else do you know about mind control methods in the Octopus and the CIA?

KT: Well, right now I'm working on a new edition of that book by Lincoln Lawrence and I've been doing a lot of research along these lines. Mind control is not LSD or that kind of stuff. It's electronic implants, which is, of course, what Timothy McVeigh said in some of his statements has happened to him. He got an implant in his butt. In one statement he said it was a mind control implant, not just a tracking thing, and in fact he did work for a while at a company that manufactures these injectable transponders for tracking lost pets and animals.

146

Cups: Who would put a mind control device in Timothy McVeigh's butt, and why? Does this relate to Octopus?

KT: I've heard some speculation about the Oklahoma City Bombing and how it might be connected to the Octopus by way of Michael Riconosciuto. (An inventor linked to the Inslaw theft and other secret government activities, who is currently serving time in prison for drug possession.) I heard the same thing about the World Trade Towers, that those bombs were not what they were made out to be but were part of this fuel-air explosive that Riconosciuto developed on the Cabazon tribal lands.

A BROKEN PROMIS

Cups: What do the Hamiltons (the husband and wife team that own Inslaw who are suing the government for the theft of their PROMIS software) think of the Octopus?

KT: They believe that Casolaro was murdered. Implicit in this belief is the belief in the Octopus. The Hamiltons are regarded as victims and to a certain extent they are. First they developed the PROMIS software on public money and then the funds through the LEAA dried up and they took the software and further developed it with their own money, on their own time. They made these deals with the Justice Department. PROMIS is Prosecutor's Management Information System. And the Justice Department was going to pay them for their work and install the system in prosecutor's offices throughout the country. Instead, they didn't make the payments. They violated the contract and they took the software.

According to the story, they gave it to Earl Bryan who sold it to the Royal Canadian Mounted Police, the Mossad, Interpol and other police agencies illegally because it belonged to the Hamiltons. But on the other hand, Hamilton

and his brother, who served on the police board in St. Louis, have long-standing connections to the NSA and the software itself was developed as part of an assassination program in Vietnam. So these are not "innocent" people in a broad sense.

Cups: What's happening in their lawsuit?

KT: The first person to pass judgment on this agreed that the Justice Department did indeed steal the software and abused Inslaw. That judge who made that decision, George Mason, was later kicked off the bench, one of only four federal judges that year who was dumped. Obviously it was connected to that. But after that, Sam Nunn's committee, the Congressional Committee on Investigations, and Jack Brook's committee both agreed with George Mason's ruling. So that's three different judgments each saying that Inslaw got screwed by the Justice department.

And then a special judge was assigned to the case, Nicholas Bua, and he made the opposite judgment, but only made that decision after offering a huge bribe to the Hamiltons' attorney from the government Apparently through a special resolution of Congress the Hamiltons are getting another trial, which was supposed to be last November but has been postponed until February. I called in February It's still not on the docket. So that's where it stands. And hopefully I'll be there at that trial to take notes and continue reporting on the story

Cups: Do you fear for your own life, publishing this book? You're covering the same turf as Casolaro.

KT: Right. But I'm more visible. I publish a magazine. I've got a web site. I did these interviews. Casolaro talked to a lot of people who were involved in the case but he was trying to keep it under wraps until he sold the book contract. Also I

don't directly antagonize. I could be a target as much as anybody else, but you can't live in fear.

Midweek (UK), November 25/29, 1993

The latest addition to the shelves of my National Library of Oddness is a fascinating little feller called *Steamshovel Press*, available for just five bucks. It's a magazine for fans of conspiracy theory - which includes all of us, right? - and runs some truly splendid articles concerning "Secret research on antigravity and space flight organized by the German Secret Societies during World War Two", "The FBI and cattle mutilations", and "Bob Dylan and mind control". Naturally, there's also plenty of stuff about the CIA's involvement in the illegal drugs trade; unfortunately, that story has finally made it onto the pages of the straight papers, so the cabal-connoisseurs are going to have to find something new to boggle our minds with. I don't doubt they'll succeed.

"Our Cybertown:
These St. Louisans are riding the crest of a trend in virtual community building,"
St. Louis Post-Dispatch, January 2, 1997
by Joe Williams

The Rabble Rouser

"It's a sickness really," says Kenn Thomas, referring to the amount of time he spends online. As one of the foremost conspiracy researchers in America, Thomas spends countless hours culling the Web and Usenet discussion groups for news and speculation on government misdeeds and unexplained phenomena.

Thomas is publisher of *Steamshovel Press,* a periodic compendium of conspiracy lore that stretches from sober speculations on the Kennedy assassination to tripped out manifestoes on altered consciousness. He is also the author of three books; his latest, *The Octopus,* examines the possible link between the Iran-Contra scandal, the continuing UFO cover-up and the alleged suicide of a freelance investigator named Danny Casolaro.

The *Steamshovel Press* home page provides excerpts from the print periodical as well as links to the most reputable conspiracy sites online. But Thomas is not overly optimistic about the battle he is waging.

"Clearly there are many people out there who are not ready to participate in the kind of public discourse the Internet provides. The specialized groups become generalized because they must have a low common denominator, and therefore they are of less value to the specialist. I'm afraid the Usenet discussion groups have too much acrimony for me. New forums must evolve that screen out insults and meaningless posts. This has happened with the JFK, UFO and mind control groups. Sometimes you can see a pattern of formless, unfocussed animosity transforming into intelligent exchange."

Thomas, who earns his daily bread as a university archivist, says the Internet is analogous to both a library and a madhouse-particularly when the subject is as broad as conspiracy. [KT's note*: The writer sent a questionnaire asking if I thought the Internet was like a library or a madhouse. I answered "Yes."*] "There are many, many ways of looking at anything and a tremendous amount of information that can be brought to bear from a variety of sources and perspectives. I'd say there's still too little critical analysis from a conspiracy point of view, especially compared to the vast amount of bandwidth taken up by the government, industry, and other 'establishment' points of view."

St. Louis Post-Dispatch, June 6, 1997

"...Kenn Thomas takes Art Bell's show more seriously than most. Although he's not a huge fan, Thomas occasionally tunes in to see if Bell's topic of the night sparks some interest. As publisher of *Steamshovel Press*, a journal devoted to writings on conspiracies and cover-ups, Thomas is familiar with many of Bell's guests.

"But a problem with the program is its exclusivity," says Thomas, who works as an archivist at a university. "There's still an undercurrent of beliefs that doesn't even make it in to that show."

Jim Keith:
The Life and Death
of a Conspiracy Writer
After Dark, March 2000

Interview by Lex Lonehood

Jim Keith would have been fascinated by his own death. A prolific conspiracy writer, known for such books as *Black Helicopters over America and Mind Control World Control,* he delved deeply into some our world's darkest secrets. He co-authored *The Octopus,* a book documenting the mysterious 1991 death of Danny Casolaro, an investigator on the verge of exposing a shadowy international conspiracy. But now, at age 49, Keith himself has died under what could be called odd or suspicious circumstances, very much like some of Art Bell's guests.

His turn of ill fate began at the Burning Man, an offbeat outdoor arts festival held in Black Rock, Nevada, northeast of his hometown of Reno. Keith fell off a three-foot stage and was subsequently taken to Washoe Medical

Hospital to be treated for a fractured knee. It was there that he was pronounced dead after a blood clot traveled from his leg to his lung, during surgery on September 7th 1999. "There's no conspiracy here," Steve Finnell, Washoe County deputy coroner told the *Reno Gazette.* "This could happen to anyone. We see it all the time. This is considered an accidental death," he said.

"Maybe Jim died of just a blood clot, although anecdotal information I've accumulated suggests this is very rare," wrote fellow parapolitical writer Kenn Thomas in his column for the online *Nitro News.* Thomas, who took over the column for Keith, has been calling for an official investigation into Keith's death. Some suspect that it was Jim Keith's last column for *Nitro News* that may have led to his demise. In it, Keith wrote that Princess Diana was pregnant at the time of her death (which Keith called murder) and that he had the name of Dodi Fayed's physician who had made the diagnosis. The connection between the story and Keith's death was amplified when *Nitro News* suddenly went offline for a number days just after Keith's passing in September, though the site is now back online.

"The last time we communicated was on September 3rd. We were discussing the weird 'coincidence' of deleted files on our computers over the last few days. Jim said that three or four other researchers...had experienced anomalous hard-drive erasures in the past week...By the next Tuesday he was dead," wrote colleague Greg Bishop, publisher of *The Excluded Middle*, a journal of the paranormal, in an internet remembrance.

Researcher/friend George Pickard added to the suspicions surrounding Keith's surgery, saying in a *Creature News* story: "In one of our last discussions he told me that he didn't want to be put under, that he couldn't handle the anesthesia. He told me they had arranged to use a local, an epidural. The *Creature News* article added that "Keith's nephew, Chris Davis, concurred that his uncle insisted on not

being administered anesthesia. It remains unexplained why Keith was given anesthesia."

"Maybe this is common in Reno that people go in for simple knee problems and DIE, and if that's true it's a scandal that should be exposed," said Kenn Thomas in a recent phone conversation I had with him. The new issue of Thomas' conspiracy oriented *Steamshovel Press*, will feature a tribute to Keith who had been a regular contributor to the magazine. "Keith and I were friends for many years. We'd done zines, - the way the underground communicated with itself- before the Internet." Back in the 80s Keith produced his first zine which was called *Dharma Combat*. In an odd bit of effluvia, Thomas told me that Keith gave permission for someone to use his zine's name for their band. That someone it later turned out was one of the (now deceased) members of the Heavens Gate cult.

"Keith and I are well-known in the little underground of conspiracy information and parapolitical study... Jim Garrison, Mae Brussel. Danny Casolaro was part of it. When Jimi (Hendrix) and Janis (Joplin) died, Jim Morrison was going around saying that 'you're drinking with #3'. And I've been doing that lately! But you can't take it all that seriously," Thomas, who co-authored *The Octopus* with Keith, laughed. "We had many conversations--if all the stuff is true-how come they haven't come after you and me? I can't have that conversation with Jim anymore, can I? But, I'm certainly not going to crawl underneath the woodwork. Jim never did. You can't be afraid."

Keith brought a creative and humorous atmosphere to the material he studied Thomas said. As a performer/lecturer Keith "would take conspiracy theory and put it out there for people to look at and discuss. But he also took it seriously and was a good researcher," Thomas added. Keith often gave presentations at Planet 9, a small club in Reno. "He was an interesting speaker, definitely passionate and highly intellectual... His energy kind of took over. He always "made

his mark," Georgia Ross, an Art Bell chat club leader, told the *Reno Gazette.*

Keith, who is survived by two teenage daughters, had a long-standing interest in the paranormal. "I was a big UFO buff as a kid in the 60s. I bought hook, line and sinker the stories of guys like George Adamski who said they had taken trips to other planets in UFOs. I recall keeping my eyes open for neighbors who might be aliens," Keith said as a guest on a radio show. In 1972, Keith didn't have to look far, for in the middle of one night when he opened his eyes, a grey-type alien was staring him in the face. Later he became skeptical of many of the reports of alien encounters, questioning in his writings whether the aliens might be the product of government mind control experiments. Keith concluded that Scientology, after having spent 13 years in that organization, was also "a very clever mind control operation, so clever in fact, that I think (L. Ron) Hubbard might have fallen for his own creation."

Two of Keith's most influential books were *Black Helicopters Over America, Volumes 1 & 2* that alarmingly documented a cluster of perpetrations possibly carried out by the American government on its own citizens. In Volume 2, *The Endgame Strategy*, Keith connects the dots to a sinister agenda that he attributes to an expanding National Police Force and/or a New World Order. Citing numerous reports of unmarked black insectoid choppers flying low over US residences, Keith variously ties them in to biochemical warfare testing, animal mutilations, and so-called 'alien' abductions.

"On August 7, 1994, the small town of Oakville, Washington...experienced the first instance of a toxic assault from above. Tiny, gelatinous blobs...rained from the sky, blanketing 20 square miles. There were six falls of gelatinous material over the next three weeks. Numerous people became ill within

a few days... and some animals sickened and died... A hospital lab technician analyzed the gel that had fallen... and found, surprisingly, that it contained human white blood cells."

--*Black Helicopters II* from the chapter "Toxic Shocktroops"

Keith goes on to report that the gelatinous samples were further tested and found to be teeming with bacteria found in spoiled food, diseased plants, sewage and hospital environments. Based on his correspondence with various Oakville witnesses Keith summed up the situation: "Strange falls of gelatinous material that sickens everyone who touches it taking place in conjunction with military maneuvers, repeated flights of black aircraft, visits from a mysterious military man...The evidence suggests that the government knows far more about the rain of noxious gel on Oakville than they are telling."

"The answer to a substantial percentage of the cattle mutilations, many of them connected to black chopper sightings, is what the most likely evidence points to: secret testing of biological warfare viruses," Keith wrote in an article for *FATE Magazine*. He noted that many of the mutilated cattle have been found tagged with fluorescent paint (to identify them in the dark) and that a large number had been found injected with strains of *Clostridium* bacteria.

In the 1980s the black helicopters' surveillance of UFO witnesses and abductees was stepped up Keith wrote in Black Helicopters II. It was scare tactics by air instead of the bizarre at-your-front-door visits that Keith wrote about in his earlier *Casebook on the Men in Black*.

"The black choppers were also often seen in connection with mysterious unmarked vans, with abductees sometimes saying that they had been transported to unknown locations in vans or helicopters and examined or implanted with possible electronic implants by human doctors... Victims

of encounters... are usually strapped to an examination table or gynecological chair in a cubical room, are given a drink or injected by a hypodermic, and are sometimes implanted with a tiny device or have one removed. Other abductions take place with virtually all of the usual otherworldly trappings, with the single difference that the examinations or implants are conducted at houses, military installations or laboratories.

--Black Helicopters II from the chapter "The Abductors"

The idea that humans could be the victims of mind control experiments is a subject Keith has explored in a number of his books, including his latest *Mass Control: Engineering Human Consciousness*, written just prior to his death. "More than anything I've been trying to orientate people so that they're a bit distrustful of control. So that they become aware of ... all of the methods by which their choice and their freedom is infringed," Keith said in a 1998 radio interview. He also said that the government could be "counterfeiting the paranormal".

Keith documented the insidious program MK-Ultra in his *Casebook on Alternative 3* saying it "included such varied behavior control approaches as psychoactive drugs (LSD beginning in 1952), hypnosis, bio-electrics, radio brain bombardment, brain surgery, electronic destruction of memory, occult and parapsychological research, radiation, microwaves, and ultrasonics. 'Expendables' i.e. persons whose lives could be terminated without concern of investigation were used in these tests."

Only slightly less ominous, the strange Men in Black (MIB) phenomenon with its incidents that straddle the boundaries of science, occult and fantasy was another topic tailor made for Keith's particular research skills. His entertaining dossier Casebook on the Men in Black probes the mystery that he traces back to demons of the Middle Ages. However, modern MIB reports often involve visitations from

odd, sometimes Asian appearing men, who warn witnesses or researchers not to discuss UFO information.

The secret about Keith's life has emerged since his death. "Jim told me that he was one of the Commander X authors," Kenn Thomas revealed. The Commander X series published by Timothy Green Beckley is purportedly written by a "former military intelligence operatives" and have become notorious for their reckless claims about aliens working with a secret government and various fringe topics. Perhaps this was a chance for Keith to let loose with some of the wild speculations he encountered over the years or for him to play at being a Bill Cooper-type writer, whose inflammatory style he was said to be intrigued by.

But beyond the lark of Commander X, Keith will be remembered for his uncompromisingly researched books, many of which are available through IllumiNet Press, who also plan to publish posthumously Keith's manuscripts tentatively titled *Biowar and Occult Secrets of the New World Order.*

"Jim Keith will not be replaced. He was a unique person in the last century. Anybody who touches on this material owes Jim a great debt," Kenn Thomas said with a touch of sadness.

His sudden death could be considered an occupational hazard for those toiling in the minefields of parapolitical theory. After all it was the writer himself who formulated Keith's Law, which stated: "All conspiracy writers must die of mysterious circumstances."

157

The Truth Hurts

Real Life Conspiracy Muckrakers Insist Their Job Is A Lot Tougher Than It Seems on TV
X-Files Magazine, Winter 2000

The Winter 2000 issue of The X Files Official Magazine *contained an article incorporating interviews with me and writers Alex Constantine and John Quinn. They did not contain a lot of substance. In fact, I came off as quite whiny, primarily due to the fact that* X Files *producers were then planning a new program,* The Lone Gunmen, *about some supposed conspiracy zinesters that they wanted to hype. I tried to give a more accurate depiction of what it takes to do zines like. After the magazine came out, I opined on the web that it proffered such untruths as "Kenn Thomas, editor of conspiracy-theory magazine* Steamshovel Press, *envies the Lone Gunmen" and "Thomas can only wish he had it so good." I also urged readers not to buy the* X-Files *magazine, which only wanted to commodify parapolitics and turn it into kiddie entertainment. I concluded, "Buy* Steamshovel, Flatland *and* Excluded Middle *instead." The perception that the idea of conspiracy was being turned into a saleable theme for TV entertainments only continued to grow after this interview. Interestingly, conspiracy researchers fought back by accusing the show of a real conspiracy. When an episode of* The Lone Gunmen *featured a hijacked plane set on a course to crash into the World Trade Towers, broadcast in the March preceding the events of 9/11, conspiracy writers held it up as evidence of foreknowledge of Rupert Murdoch, whose corporation produced the show.*

Kenn Thomas, editor of conspiracy-theory magazine *Steamshovel Press*, envies the Lone Gunmen. Time, circulation—nothing seems to prevent Byers, Frohike and

Langly from uncovering the government's deepest, darkest secrets in their paranoia-heavy newsletter *The Lone Gunmen.*

The computer-hacking trio makes conspiracy-themed publishing seem downright glamorous, especially with all their fancy, high-tech equipment. Even more amazingly, they always find time to help Mulder crack an X-file whenever he calls.

Thomas can only wish he had it so good.

Ideally, *Steamshovel Press* should be published quarterly. But realistically, Thomas is lucky if he produces a couple of issues each year. He even pokes fun at his tardy publishing schedule in each *Steamshovel Press* issue with a small feature called "What's with the infrequency, Kenneth?" It's certainly not from lack of trying. If Thomas had the time and economic resources, he would do nothing but work on the magazine. Each issue, however, yields just enough profit to produce the next. And that's with its contributors working for free and Thomas' income subsidized by a full-time day job as an archivist.

"The way I try to organize it is I do my day job, come home at night, sit down at the computer and go through the editorial end and try to create the magazine," Thomas says. "I've got two kids that I see on Wednesdays and every other weekend. I've got a girlfriend I see every night. On a good week, I'd say maybe I spend 15 hours on the magazine."

Thomas created *Steamshovel Press* on a lark in 1988. Originally, it was only meant to be a small newsletter. He planned to circulate it among 30 or so people, making it look nice enough to convince publishers to send him free review copies of their latest conspiracy literature. He thought it was a perfect scheme: he could inform other people of the conspiracy culture—a culture that has fascinated him since high school—while at the same time drastically cutting down his book spending.

But it quickly became something more. When *Steamshovel Press* debuted, the conspiracy culture was

reeling. Its patron saint Mae Brussell—who many view as the woman who brought conspiracy writing to the fore with her investigations into JFK's assassination—had recently died, creating a factional split among her followers, and one of Thomas' favorite conspiracy 'zines shifted its focus to the occult. After just two issues, Thomas decided to fill the void by turning *Steamshovel Press* into something more than an excuse to get free books.

"The conspiracy culture thing seemed to be falling apart," Thomas says. "At that point, I thought this was an opportunity, since I was doing this newsletter anyway. So for the third issue of *Steamshovel Press*, I printed a call for papers. I tried to attract all the conspiracy writing stuff. That's how it began. At that point somebody donated a print run. We used the photocopy equipment of a major corporation in town to print a standard size magazine with the sheets stapled in the corner. I did all the work to find the distributors and get it out on the newsstands, sad as it looked."

The result from Thomas' call for papers was staggering. He was flooded with articles from conspiracy writers looking to get their work published.

The Conspiracist
Immerse Magazine

The following interview appeared in Immerse, *a techno/ ambient/ atmospherica/ industrial/ noise /jazz/ electronics/ forteana/ graphics/ film/ print zine produced in the UK. The issue (003) also included an interview with* Saucer Smear's *James "It was a Fugo balloon; no it was a Mogul balloon" Moseley and gives some attention to Philip "'twasn't nothin'" Klass. Visit* Immerse *at* **haywire.co.uk/immerse.**

Steamshovel Press is the bible of conspiracy theory. Kenn Thomas is the editor of this quarterly collection of snapshots from the dark side of reality. From the JFK assassination and Watergate to Area 51 and the Octopus cabal, *Steamshovel* is the acknowledged authority.

A NEED TO KNOW

Kenn began his quest for the truth, or at least a plausible version of it, at the ripe old age of five. Although he certainly wasn't conscious of the fact, something happened which would shape his perceptions for years to come. "When I was five years old they shot JFK! It guaranteed that one of my strongest early memories always would be of conspiracy. In a conscious way, though, as a reader and student of Conspiracy, the best I can track it is back to comedian Lenny Bruce. My early abiding interest in Bruce's comedy led me to Paul Krassner's *The Realist* (Krassner ghosted Bruce's autobiography), and from that I learned about the work of Mae Brussell, the intellectual foremother of conspiracy research in the US." Such synchronicity still lends a guiding hand. "Recently, while looking at my copy of Bruce's 1957 samizdat booklet, *Stamp Help Out!*, I noticed reference to Wilhelm Reich, which I thought was rather far out. In 1957 Reich was embroiled in his final battle with the Con, and it killed him. Bruce eventually came to understand that his own life was ruined by a police conspiracy." Kenn's abiding interests in both hidden history and the works of the 'beat' generation of Ginsberg, Kerouac and Burroughs led to the first early attempts at formulating a fanzine of sorts. "*Steamshovel* began as a small newsletter circulated primarily to convince book publishers to send review copies of books. It had a secondary purpose of presenting an interview with Ram Dass I conducted that I was unable to get published elsewhere. This story is recounted in the introduction to the *Steamshovel* back issue anthology, *Popular Alienation.*

"Like most writers, I resent the predicament of having to do work without guarantee that it will be published and paid for, so *Steamshovel* became my outlet for writing that I didn't already have pre-sold. At the time, I worked as the rock music critic for a daily newspaper and was getting a lot of things published in local and regional newspapers and magazines. I began to notice, however, that the more I wrote about things that interested me, the less I had to say in the mainstream forum."

GENESIS OF AN INQUIRING MIND

The early issues of *Steamshovel* included an interview with Imamu Amiri Baraka and it was Baraka's connection with the New York branch of the Fair Play For Cuba Committee, of which Lee Harvey Oswald was the sole member of the New Orleans chapter, which propelled *Steamshovel* in a more conspiracy driven direction. "By the time of the third issue of *Steamshovel*, Mae Brussell had died and Bob Banner, who published a quality conzine called *Critique*, abandoned his effort. Conspiracy culture seemed waning. This happened in the late 1980s: factional fighting beset Mae Brussell's admirers; Oliver Stone's *JFK* movie and that damned *X-Files* show were well into the future; even the impact of the Internet had not yet been felt fully.

"In a panic, I published a call for papers on conspiracy topics for publication in the following issue. At the time also, I developed a friendship with someone who had access to printing equipment. With all the conspiracy-related articles and the free printing, *Steamshovel* number four became the first magazine-sized issue. Money from selling that issue paid for the subsequent issues and I started doing the legwork to get distribution.

"The current issue of *Steamshovel* has an interview with the late great Tim Leary and reproduces a Catholic Charities report on Neal Cassady. So that 'beatnik' thing

remains an important part of the magazine. There's even a newsclipping reproduction I took from a New Orleans paper in the 1960s: Do Newspaper Boys Grow Up To Be Beatniks? 'Beatnik' is a vague concept to begin with--it defines everybody from Woody Guthrie to John Lilly-- (it's actually a red smear, as in 'Sputnik') and difficult to measure. The only thing the New Orleans paper could say was that you could hardly call Bob Hope one. This new *Steamshovel* also has a nine-page article on David Ferrie, Lee Harvey Oswald's albino pilot buddy, who lived a 'beatnik' lifestyle."

THE CONSPIRATORS HIERARCHY

Along the way Kenn has been aided by many in the loose knit research community, most of whom have been published in *Steamshovel*'s pages. Many have become close colleagues, one such gentleman being the prolific author Jim Keith, an Immerse icon and penman of classics like *Secret & Suppressed, Casebook On Alternative 3, Black Helicopters Over America* and *OKBOMB.* "I met Jim Keith in the flesh first in Atlanta, Georgia at the Phenomicon conference. I knew of him previously from his zine *Dharma Combat*, which published many interesting writers from the marginals arena, including G. J. Krupey, Wayne Henderson and X. Sharks DeSpot, all of whom later wrote for *Steamshovel.* After the Heaven's Gate deaths, I pointed out to Keith that one of the dead, someone named Darwin Lee Phillips, previously played with a rock band called *Dharma Combat.* Keith remembered that he gave permission for the band to use the name. It's possible that Phillips found out about the Heaven's Gate group through its ad in *Steamshovel* #9. That makes *Steamshovel* as guilty as the Hale-Bopp comet for that Heaven's Gate disaster!"

Another well known comrade in arms has been Jim Martin of the mail order service, Flatland Books. "I think I attracted Jim Martin's attention with an article on Reich in

Steamshovel #2. Martin had a tremendous insight for seeing something of value in *Steamshovel* as it looked back then. If I had thought of his Flatland book service at the time, I would have felt (there was) less of a threat to the kind of marginals/conspiracy material I thought was disappearing and may not have developed *Steamshovel* into a zine. He gave tremendous guidance on what to do and how to do it, from his experience as a printer and bookseller, and Flatland remains one of the best places to find this stuff."

ECONOMICS AND THE CON

Even with such assistance from the researchers themselves, *Steamshovel* is still plagued by the economics of magazine publication, something *Immerse* is only too aware of. "Both subscriptions and news stand sales rise with each issue and I have a hard time holding on to back issue stock, even with the *PopAlien* anthology. Unfortunately, *Steamshovel*'s chief distributor, Fine Print, just declared bankruptcy. The thousands of dollars it owes *Steamshovel* appear somewhere at the bottom of a list of 2200 creditors and *Steamshovel* will never see the money. That is currently slowing down production of the next issue considerably. Zine distributors are notoriously unreliable business partners. Even when they do what they're supposed to do, they have unfair returns policies and sales practices that I'm told are rooted in the Mafia. I always am forced to find a book project or hit the lecture trail just to raise money to produce the new issue. Zine economics are so bizarre that even success does not guarantee future success."

THE OCTOPUS

Steamshovel's editor has been involved in several book projects. The previously mentioned *Popular Alienation* collected together the contents of most of the back issues,

albeit devoid of ad copy (so if you want to see the advertisement for the Heavens Gate suicide cult you'll have to chase down a copy of #9). Recent titles include *NASA, Nazis & JFK: The Torbitt Document* and *The Octopus: Secret Government And The Death Of Danny Casolaro*. The book on Casolaro's research, co-authored with Jim Keith, has ensured some recent publicity as has the phenomenal success of 'conspiracy as soap opera' television programmes like *The X Files* and *Dark Skies*. "The media profile has increased a lot recently due to the publication of *The Octopus*. I'm doing a lot of print and radio promotion for that. It covers the case of Danny Casolaro, who died under mysterious circumstances while he was investigating the Justice Department theft of the PROMIS computer software, the Inslaw case.

"Casolaro was waiting for the book contract to come forward, with all that he knew, if he had kept a larger media profile, he may not have suffered his fate. *Crossfire*, a popular cable news program here, wanted to have me on in the wake of Heaven's Gate, but I was busy visiting David Hatcher Childress's clubhouse outside of Chicago, looking actually to meet up with *Nexus* publisher Duncan Roads who never showed. Jonathan Vankin, author of *60 Greatest Conspiracies*, did make that program, however, but they changed his title from the derisive 'conspiracy theorist' to 'internet researcher', the new bugaboo.

"The major media always warps things into unrecognizable dimensions. The CBS program *60 Minutes* wasted an hour and a half of Vankin's time with an interview for a feature that only briefly flashed his website. In recent weeks I have talked to producers from two British documentary teams, one person from the Discovery channel, and someone else from an HBO special on the making of Mel Gibson's 'Conspiracy Theory' movie. I doubt if any of that will amount to substantial publicity for *Steamshovel*."

TORBITT

The new edition of the Torbitt document which Kenn has worked on has also recently been published, under the title *NASA, Nazis & JFK*. For the uninitiated, the Torbitt document was a manuscript written by a Texan lawyer under the pseudonym of William Torbitt and which claimed to illuminate the inside workings of the military-industrial cabal who may have murdered JFK. We asked for Kenn's comments on this seminal document. "The second printing of *NASA, Nazis & JFK,* which is the title for the edition of the Torbitt that I annotated and introduced for Adventures Unlimited Press includes an afterword by Len Bracken making the case that it might be Soviet disinformation. My annotations were designed to emphasize what the Torbitt has to say about the Paperclip Nazi role in the assassination, which is certainly not the main point of the document.

"Martin Cannon and *Lobster* editor Robin Ramsay have both complained that there doesn't seem to be any independent verification for the existence of Defense Industrial Security Command (DISC), the police agency that the Torbitt holds out as culpable in the assassination. I have argued that veteran researcher Penn Jones wrote about DISC (although his source may have been Torbitt); that a lawsuit was filed in California over a call made by Oswald to a DISC agent in Raleigh, North Carolina; that the address of the agency's headquarters should be listed in the city directory of Columbus, Ohio from 1963; and that (famed JFK researcher, John) Judge connected the group to Kerr-McGee and the Karen Silkwood murder. Look it up in the current DC phone book and you'll find something called the Director of Industrial Security-Capital Region, which basically retains the DISC acronym. So it's real.

I think the best thing about the Torbitt is the view it presents of transnational corporations and how intelligence services work for them and not the country they ostensibly

represent." Kenn is working on two new projects as well as attempting to get the next issue of *Steamshovel* together. "I am currently annotating and writing substantive introductory notes to *Were We Controlled?* by Lincoln Lawrence, a classic on mind control technology to be published this summer by David Hatcher Childress' Adventures Unlimited Press. The other is a book on the Maury Island incident, the first UFO sighting of the modern lore. This book will be based on correspondence by one of those involved, Fred Crisman, who also is suspected of being one of the tramps in the railroad yard at Dealy Plaza on assassination day.

"At one time, Crisman had Marshall Riconosciuto as a business partner, whose son is Michael Riconosciuto, the chief informant in the Casolaro case. So that promises to be a fascinating look at conspiracies spanning the generations. IllumiNet will publish that within the next six months, in time for the 50th anniversary of the incident."

E-CONSPIRACY

Steamshovel has followed the trend in establishing a site on the World Wide Web but Kenn is a little dubious about the often heard suggestion that electronic publishing will replace the printing press. "I have noticed a pattern common with many websites: an initial enthusiasm where changes and updates are made often and then a tremendous drop off. Like putting up a billboard and walking away. *Steamshovel* has a link to a site that shows the word 'Shit!' lit up in the windows of a college building from a photo taken on the night of the Kennedy assassination. That site has been up there unchanged for three years. The *Steamshovel* site includes a column called *The Latest Word* containing material that never appears in the magazine. I change it often, but not as often as I would like. It's difficult to make that work pay, so the energy goes into work that keeps the magazine alive. *Steamshovel* will never become all- electronic. If I get to the

167

point where I can change *The Latest Word* column every week, I expect to issue a challenge to other conspiracy websites to do the same.

FLAME WARS

Since the popularization of the Internet, conspiracy and even more so specifically UFO related sites have become very common-place. Along with this has come the inevitable gossip and rumor regarding and between researchers, something which plagues the UFO community to a great extent (as often reported by Jim Moseley in his irreverent newsletter *Saucer Smear* - see interview in this issue of Immerse).

"The acrimony that exists between many researchers bugs me. It seems to me fundamental to give everyone the right to be wrong, to suspend judgment until you can come to some complete understanding of various points of view, and simply to accept that multiple points of view on a topic is as final as some things get. I don't like anonymous flame wars on the net - although I understand the need to vent - and so I just do a lot of lurking until I find a productive conversation into which I can inject some research or analysis.

"One problem is that the intelligence community does have its assets, infiltrators and *provocateurs*, so honest disagreements become charged with the suspicion that one or the other side is spreading disinformation. In many cases, the charges are true. I had one such person follow me to London and demand an audience with a BBC producer I had traveled with to an infra-red imaging lab to test a Reichian orgone box. The same person has supplied disinformation about Reich to the so-called 'skeptics' press, including CSICOP (Committee For The Scientific Investigation Of Claims Of The Paranormal), *Skeptical Inquirer* and Martin Gardner, for many years. There's an essay about this on the *Steamshovel* webpage called 'Toxic Disinformation.'"

168

PHIL KLASS &
HIS LITTLE NOBODIES

Kenn's disparaging views of the skeptical community extends to the crown king of Ufological debunking, publisher of the *Skeptics UFO Newsletter* and many books on the subject, Phil Klass. Klass was interviewed by *Immerse*, along with Jim Moseley, at the 1997 *Fortean Times* UnConvention and that interview appears elsewhere in this magazine. Comparing and contrasting Kenn's and Phil's viewpoints is an interesting exercise.

"The last time I saw Phil Klass quoted in the *New York Times*, he sniffed that those who have UFO experiences are 'little nobodies' craving attention. It's obviously a prejudiced and unscientific point of view, especially concerning a phenomenon that has affected all kinds of people over all of human history, no matter what one thinks of any particular case or set of cases. I do think it's interesting that as the *Fortean Times* becomes more mainstream, it begins to have more people like Phil Klass show up at its conferences. Without putting too fine a point on it, since I do still have immense respect for the Forteans, when I sat on a panel with Peter Brookesmith at the last UnCon (in 1996 Kenn lectured on the Casolaro/Maury Island axis, Wilhelm Reich's persecution by the US Government and took part in a panel discussion on the topic of UFOs and Governments) he argued that Belgium could not be part of the international UFO cover-up because, well, because they're Belgian! He was being clever, of course, but it's the kind of quip, like Klass and his 'little nobodies' remark, that shows the rush toward a dismissal of the topic rather than engagement with it."

EXTRADIMENSIONAL UFOLOGY

"A much more reasoned point of view about UFOs than that of Phil Klass recently was expressed to me by *Steamshovel* contributor Roy Lisker, who is a scientist and a mathematician and has reached no closed-minded conclusions about the phenomenon:"

"...suppose that it was possible that a sentient consciousness in our world could exist entirely on the surface of a two-dimensional plane. This mind would be unable to conceive of a third dimension, except as an unpicturable mathematical construction. If it were possible for one of us to communicate with this being, we might say something like: "Don't you realize that all you have to do is go 'up'?" Say we then took a stone and dropped it through his plane. He would interpret this event, a simple causal phenomenon in our world, as an uncaused, arbitrary event in the physics of his world. However, the true causes of the disturbances created by the stone passing through his world would be intrinsically unknowable to him as the limitations on his consciousness do not give him access to the third dimension in which we live.

"Likewise, it 'ought to be obvious' to us, that all we have to do in order to enter a fourth (spatial) dimension is to go up* (the direction of "up-asterisk"!). Up* might then be a dimension which is unknowable to our consciousness-in-the-world by virtue of the limitation or our sensory organs to a three dimensional continuum. If there was a fourth spatial dimension then, just as in the example with the dropping of the rock, an event from that dimension could 'pass through' our world without our being able to reconcile it with our physics. Its causes would be 'intrinsically unknowable'.

"Still, four or more dimensions pose no problems for a mathematician. In terms of their purely mathematical content, one can easily plot lines, describe shapes and axiomatize any space with any number of dimensions. In fact, many of today's mathematicians are only comfortable in Hilbert's

Space, the vector of space of infinitely many dimensions. Four dimensional space, therefore, is not 'unthinkable' as a mathematical object; but a fourth dimension of physical space, if there is one, is unknowable to us, since no-one with a mind like ours can conceive any way of moving in the direction up*."

ALIEN SEX MAJIC

Along with the idea of extradimensional/ultraterrestrial entities, another plausible theory is the 'alien craft as black project and alien abduction as mind control'. Chief proponents of this theory are Martin Cannon, author of *The Controllers*, and Alex Constantine, author of *Psychic Dictatorship In The USA*. "Reich said it best: 'everyone has part of the truth'. Cannon and Constantine have both presented convincing cases that many alien abduction scenarios serve as government psyops (psychological warfare operations), as has Jacques Vallee. John Judge makes a good case that Nazis developed flying saucers. Certainly not all unusual aerial phenomena fall into this category, though, and not every abduction case tracks back to a psyop,

"Cannon and I had a tiff when I tried to get him to do a sidebar to an interview I planned in *Steamshovel* with Cathy O'Brien, who claims to have been made into a sex slave by an MKULTRA program. Cannon believes that O'Brien and her partner, Mark Phillips, are frauds who use details about a real mind-control program called Operation Monarch to embellish a dog-and-pony show. I wanted Cannon to do something on the real Monarch; he didn't want me to give O'Brien/Phillips any space at all. So it concerns me when any researcher thinks he has the one 'real' answer. It tends to strangle dialogue."

171

THE WILD SIDE

And what of Kenn's feelings on the convoluted tales of US government/grey alien treaties and hybridization schemes of 'Wild' Bill Cooper and others of like mind?

"Everyone has part of the truth. Cooper's take on the Kennedy assassination, for instance, that the driver shot JFK with a .45, has elements of truth. The driver does put on the brakes; you can see them come on the Zapruder film. There are photos of an agent picking up a .45 slug from the opposite side of Elm Street after the motorcade has passed. In fact, disinfo schemes always contain elements of truth, which is not to say that Cooper is a disinformationalist. He certainly didn't create the circus atmosphere that surrounds much of the UFO community.

"It's really the nature of the Beast: an aerial and psychological phenomenon that affects millions; governments hiding the data they have collected on it to preserve their credibility (which they lose as well if, as they say, they do not collect data on it); a history that has built up a lore; entrepreneurs trying to exploit the commercial possibilities of all this excitement. Every researcher/writer/lecturer is a natural product of that spectacle."

DISINFOTAINMENT

Such reasoned and thought provoking views on the UFO topic are indeed rare in these days of supposed alien autopsy videos, grey and abduction 'mania', and disinfotainment like the *X Files*.

"Television is the very essence of the Conspiracy, a mind-control device that transmits stimulation for the eyes and ears but leaves the brain wanting. So *X-Files*, *Dark Skies*, even programs like *Fortean TV*, can never become more than part of the culture of denial. All this stuff about Area 51, alien abductions, government conspiracies, Fortean phenoms--it's

172

all just fodder for a silly TV show. Students of the conspiracy culture, publishers of magazines like *Steamshovel*, become the 'Lone Gunman' geeks on *X-Files*. Meanwhile, *X-Files* writer Chris Carter lectures for the CSICOP, which happened recently."

OK BOMB

The ongoing trial of Oklahoma bombing suspect Tim McVeigh is another media circus waiting to happen but thus far seems not to have received the epic international proportions of the OJ Simpson trial. With talk of a decidedly conspiratorial defense strategy by McVeigh's attorneys, it may soon become a media led case of 'conspiracy on trial'.

"Lois Fortier just testified and even the mainstream news reports noted that her story sounded very rehearsed. She's the wife of McVeigh chum Steve Fortier. Both of them at first insisted that McVeigh could not have had anything to do with the bombing but when the FBI threatened them with the death sentence, they changed their story and made up the current one. *Steamshovel* reported on this in issue #14.

"Hoppy Heidelberg, the person whose common sense questions caused him to be dismissed from the original OKBomb grand jury, has stated openly that police authorities will not call in certain witnesses because they may be informers or *provocateurs* attached to government undercover operations. Apparently McVeigh isn't even telling his lawyers about who he worked with. He's either taking it all like a good soldier or they never got that mind control implant out of his butt (as detailed in *Immerse 001*). Anyone following the case in the papers would do well to read Jim Keith's *OKBomb!* book from IllumiNet. It asks all the pertinent questions."

TWA 800

The other current mass media 'conspiracy' story has been the TWA Flight 800 splashdown. We asked Kenn what the current climate's like - Stinger, US Navy friendly fire, mechanical failure or, as some of the more extremists have alleged, UFO?

"The theories now also must account for these continued sightings of missile-like objects in nearby airspace by pilots and airline passengers, as well as the eyewitnesses to the missile event when the plane came down. Pronouncement by the National Transportation Safety Board that mechanical failure took down TWA800 will satisfy nobody, especially anyone familiar with Sherman Skolnick's exposure of that agency's cover-up of the 1973 Chicago Midway crash that killed E. Howard Hunt's wife Dorothy and other Watergaters. Skolnick discussed this with *Steamshovel* in issue #11. The NTSB is now floating its TWA800 'mechanical failure' conclusion in the press to see how the airlines respond."

HISTORY IS A LIE

The mainstream press titillate the masses with coverage of 'wacky' conspiracy theories, which are more often than not more plausible than the official version. The history books unfortunately have much the same, the victors write the history and the first victim is the truth. Conspiracy theory is shunned as 'nutters talking about aliens and faked moon landings'.

"The process of tenure and promotion often involves conspiracy, if I understand university department politics correctly. So academics have a vested interest in steering away from the study of the process. After tenure, you find people like John Mack (tenured at Harvard) and Courtney Brown (tenured poli sci professor at Emory University who claims to also work as a remote viewer) who come forward

with things. Also, educational bureaucracies must insist that they know the 'truth' about things, even though they mostly just regurgitate government and corporate media reports, which by any measure is a tiny, distorted part of the spectrum of available information. Many postal workers in this country keep better historical files than many history professors, who often work from pre-fabbed textbooks."

ARTICLES

Sunday *Telegraph* (London)
January 23, 1994, Sunday
MANDRAKE P. 26

Clinton Cabal

Meanwhile, Washington is having even more fun with conspiracy theories about President Clinton. The theorists are asking themselves whether the President is a member of a secret, self perpetuating cabal - a master of the universe put in place on the beyond-the-grave instructions of the Victorian empire builder Cecil Rhodes. Mr. Kenn Thomas, editor of *Steamshovel Press*, a US journal devoted to conspiracies, has conveniently provided a round-up of the "New-Age" speculation surrounding the Clintons. The theories range from secret Arkansas airstrips for Colombian drugs barons to the allegedly mysterious deaths of Clinton campaign-trail bodyguards in the Waco cult-siege. Strangest of all is the "Oxford connection" triggered by the fact that there are three times as many alumni of England's oldest university in the Clinton administration than there are in John Major's Cabinet. Among Mr. Clinton's team, 16 of whom were his fellow Rhodes Scholars, are seven from Balliol, three from Univ, two each from Hertford, Pembroke and Magdalen, and one each from Worcester, Exeter, New College, Lincoln and St John's - 21 in total. The Rhodes scholars include Mr. R. James Woolsey, the director of the CIA, and Mr. Joseph Nye, chairman of the National Intelligence Council. "There - told you so - it's a plot," chorused the conspiracy cognoscenti. They have now seized on the late Professor Carroll Quigley,

the Georgetown University academic who taught the undergraduate Bill, as the spook-in-chief. Mr. Clinton invoked Quigley's memory as his greatest inspiration in his acceptance speech as presidential candidate in 1992. Professor Quigley believed the world was run by a secret high-priesthood of financiers - Rothschilds, Rockefellers and Morgans. In his 1966 book *Tragedy and Hope* the professor described the operations of the behind-the-scene players in international affairs, which he viewed as a "benevolent conspiracy". Quigley's thesis turned on the "Rhodes-Milner Group", an informal discussion group of adventurers inspired by Cecil Rhodes, the great 19th-century imperialist, whose will founded and funded the Rhodes scholarships that propelled the young Bill Clinton towards University College, Oxford, in 1968. With three years left in President Clinton's term, Mr. Thomas's organ and like-minded conspiracy researchers have found enough material to keep them busy well into a second term - if Bill's secret Oxonian masters allow him another.

"Clinton Era Conspiracies!
Was Gennifer Flowers on the Grassy Knoll? Probably Not, but Here Are Some Other Bizarre Theories for a New Poltical Age"
Washington Post, January 16, 1994
By Kenn Thomas

The Clinton White House Counsel's office used the article below as the first example in its report, "Communication Stream of Conspiracy Commerce", a basis for Hilary Clinton's infamous "vast right wing conspiracy" quote. Primarily intended to draw attention to the quite real press manipulations of Richard Mellon Scaife, the report concluded that discussions of conspiracy were "the mode of communication employed by the right wing to convey their

fringe stories into legitimate subjects of coverage by the mainstream media." Of course, none of that was true of this article.

"As a teenager I heard John Kennedy's summons to citizenship. And then, as a student at Georgetown, I heard that call clarified by a professor named Carroll Quigley, who said to us that America was the greatest nation in history because our people have always believed two things: that tomorrow can be better than today, and that every one of us has a personal, moral responsibility to make it so."

-from Bill Clinton's acceptance speech to the Democratic National Convention, 1992

To most of those who watched the Arkansas governor accept his party's nomination for the presidency, these words had no special resonance beyond their inspirational tone. But for the nationwide networks of researchers who probe the tangled webs of intrigue, the words marked the dawn of a new age of conspiracy theory, one that may do for the '90s what the JFK assassination and the Trilateral Commission did for eras past.

Carroll Quigley, the Georgetown University professor whose memory was invoked by Clinton, had already been flagged by conspiracy theorists as one of their own, a theoretician of the one-world secret cabal. A respected academician, Quigley authored a 1966 book, *Tragedy and Hope: A History of the World in Our Time*, that has long been regarded by right-wingers (even cited in televangelist Pat Robertson's books) as a codex to the hidden ambitions of those generally well-regarded pillars of the foreign policy establishment, the Trilateral Commission and the Council on Foreign Relations. By invoking Quigley, Clinton had virtually telegraphed to the conspiratorial cognoscenti a signal to start massaging its database.

178

Response to that signal was impressive. With three years left in Clinton's term, conspiracy researchers have found enough raw material to keep themselves busy well into his second term-that is, if his secret masters deem he will have another.

No question, the conspiracy research community-a loose collegium of competing schools of conjecture, unbound by the normal constraints of academic or journalistic verification or disproof-needed the feast set before it by the Clinton administration. The 30th anniversary of JFK's death had passed while the staid *Wall Street Journal* was characterizing JFK researchers as primitively malicious, no less a hip source than *Doonesbury* creator Garry Trudeau lambasted them in the funny pages. Ex-CIA chief George Bush had been ousted from the Oval Office; such Reagan offenses as the October Surprise seemed like ancient history. Something new was clearly indicated. Make what you want of it all, but here's a look at some of the main strands in Clinton-age conspiracy thinking:

The Quigley Connection

Before Carroll Quigley died in 1977 he had come to be viewed as almost a reverse barometer by highly paranoid elements of the conspiracy community such as the ultra-right John Birch Society-when Quigley said something was good, that was taken as a signal that it was bad. Both Quigley and the Birchers agreed the world was run by a secret cabal of Rockefellers, Rothschilds, Morgans and like-minded financiers. In *Tragedy and Hope,* Quigley described the operations of the behind-the-scene players in international affairs.

The book's thesis, however, was not critical of these arrangements. Rather, Quigley viewed it as a "benevolent conspiracy," in the words of Jonathan Vankin, author of *Conspiracies, Cover Ups and Crimes* (published by Paragon

House, which is owned by the Rev. Sun Myung Moon's Unification Church). The Birchers were enraged by what they viewed as the confession of an insider, a player himself in the globe's power structure. They began listing Quigley's book regularly in the footnotes of their books as proof of the monied interests behind their bugaboos, groups like the Trilateralists. That Clinton referred to the late professor on a regular basis throughout the campaign and virtually enshrined him at the Democratic National Convention caused some to laud Quigley's work as the rhetorical foundation of the new administration's political philosophy. In the conspiracy realm, it caused others to review Quigley's research.

Writer Jim Martin, whose *Flatland* book service remains one of the few places where copies of *Tragedy and Hope* still can be purchased, points out that Quigley's main research involved the Rhodes-Milner Group. This informal discussion group of financiers, founded by 19th century British industrialist Cecil Rhodes, had real connections to both the. Morgans and the Rothschilds. Martin also points out that Cecil Rhodes was one of the world's wealthiest men, that he had a country named after him (Rhodesia), that his will founded and funded the Rhodes scholarships and that Bill Clinton is a Rhodes scholar. "The function of the Rhodes scholarships," explains Martin, "was to identify future leaders, instill them with common values at Oxford and send them back to their native colonies where they could spread these acquired traits."

Researcher Len Bracken explores the disparity between Clinton's evocation of Quigley as an idealist and Quigley's own hard-nosed views in a coming issue of *Steamshovel Press*. In a study of speeches by Quigley made 10 years after Clinton left Georgetown, Bracken finds this assessment of the American state in one of Quigley's last speeches: 'Today everything is a bureaucratic structure, and brainwashed people: who are not personalities are trained to fit into this bureaucratic structure and say it is a great life-

although I would assume that many on their death beds must feel otherwise. The process of copping out will take a long time...." This is a far cry from the Carroll Quigley who exhorted Bill Clinton to make each tomorrow better than today.

The Mena Mess

Less intellectual entanglements between Clinton and the conspiracy netherworld have occupied the attention of researchers at least since April 1992. In that month, a decidedly non-intellectual source, Geraldo Rivera's old *Now It Can Be Told* infotainment/tabloid, ran two stories-based in part on earlier stories by Alexander Cockburn in the *Nation* drug smuggling, money laundering and the possible movement of Nicaraguan contras in and out of an airstrip in the small Arkansas town of Mena. The case has since been expanded upon in the Village Voice; Paul Krassner has brought it to the attention of the readers of his satirical newsletter, *the Realist*, and it took up an entire chapter of John Bainerman's book, *The Crimes of a President*, which offers itself as an expose' of Bush administration abuses.

The alleged coverup in Mena promised to be the weak link in a chain that entangled Clinton not only with Bush but also with Oliver North's secret network of operatives and under-the-counter involvement in the contra war. The Mena story begins with a major drug trafficker named Barry Seal who apparently began smuggling drugs through the airstrip in 1982. The operation continued pat Seal's 1984 drug conviction in Miami. As Seal was working deals with the Drug Enforcement Administration (DEA) and North's network, trading undercover work against the Sandinistas for leniency, according to Bainerman, a second wave of mysterious businesses descended upon the Intermountain Regional Airport at Mena. These businesses described themselves variously as aircraft and parts delivery services

but stories of drug traffic continued and in 1989, new allegations were made by a former criminal investigator for the U.S. military. Gene Wheaton, that the airfield was also used for commando training. The Arkansas state police investigated and reported to the U.S. attorney, but the expected indictments were never returned, leading to the suspicion that the Reagan administration could add one more small cover-up to its tally.

Clinton does not enter the story until April 1992, when a pair of students at the University of Arkansas, Mark Swaney and Tom Brown, appealed directly to their then-governor to investigate. The appeal, and another call for financial assistance for a state grand jury investigation from Arkansas' deputy prosecuting attorney, met a stonewall. When Arkansas Rep. Bill Alexander met with Clinton, according to Bainerman, he was told that a scant $25,000 in state money had been set aside to investigate Mena, but even that was never delivered. The prosecuting attorney in Mena's Polk County at the time said he never received the offer from the governor's office.

The IRS began an investigation of Seal's operation in Mena after Seal was murdered in Baton Rouge by Colombian drug traffickers. But according to Bill Duncan, a former IRS investigator, the investigators were warned off, causing Duncan to quit and testify before a House committee about all he had learned of money laundering, covert operations and drug smuggling in Mena.

The claim that Clinton was remiss in not investigating Mena was first made publicly by Larry Nichols in a defamation suit against the governor. Clinton had hired Nichols as marketing director for the Arkansas Development Finance Authority but fired him when his alleged contacts with the contras became apparent, citing the charge that Nichols had made unauthorized phone calls to Central America as reason for the firing. In Nichols's subsequent

lawsuit contesting that charge, he also first publicized the claims of Gennifer Flowers.

Another court case, that of Terry Reed, described by Bainerman as a CIA contract operative, also added to the Mena story. In 1988 Reed was charged with postal fraud for receiving insurance money on a false claim. Reed claimed that his airplane had been stolen as part of a project called "Private Donation," wherein "donations" to the contra cause were filed as lost or stolen with insurance companies and then reimbursed. According to Reed, he had no awareness of "Project Donation" at the time of his plane's disappearance and so reported it as a legitimate loss. The plane reappeared after Reed learned of the donation project and warned his contacts in the North network that he would have no part of it.

The person who first reported the discovery of what turned out to be Reed's plane to the National Crime Information Center was Raymond L. (Buddy) Young, then working for Bill Clinton as security chief and since chosen by Clinton to head the Dallas regional office of the Federal Emergency Management Agency. Federal Judge Frank Theis later said that Young and an associate "acted with reckless disregard for the truth" in their version of how they came to realize the plane was not stolen, and charges against Reed were dropped.

Waco Weirdness

At a candlelight vigil held in Dealey Plaza by Citizens for the Truth About the Kennedy Assassination on its 30th anniversary, a suggestion that President Clinton might join in the event was met with a lukewarm smattering of applause. Had not the Clinton administration emasculated the Assassination Materials Review Act of 1992 by delaying its nominations to the review board? Clinton did not show and later made a statement that he believed that Lee Harvey Oswald acted alone.

183

For those who attended the Assassination Symposium on Kennedy (ASK) for which the vigil was organized, it was not the only sign that Clinton's claims to affinity with JFK were bogus. Jack White, who has done an enormous amount of work analyzing a large inventory of Oswald photographs, flashed a slide before his ASK presentation. It showed a tank backing away from the destruction at the Branch Davidian compound with flame ostensibly spewing from its cannon. "The coverups continue!" exclaimed White.

The scene came from a videotape entitled *Waco: The Big Lie* circulated by the America Justice Federation, which is headed by Linda Thompson, who filed a petition during the Waco siege to represent David Koresh and his followers. The tape is said to contain a detailed view of the bungled BATF raid taken by Ken Engleman, contributor to a new book, "Secret and Suppressed," from an unedited satellite feed of a video transmission by a foreign correspondent covering the raid. Other viewers say the alleged flames coming from the tank are just debris from the conflagration falling in front of the tank as it backs out after destroying a wall of the compound. What has not been challenged, however, is Thompson's assertion that three of the murdered agents had been among Clinton's many bodyguards during the presidential campaign.

Thompson also claims the tape shows that the alleged former bodyguards were actually killed by a fourth BATF agent, either deliberately or with reckless application of the "spray and pray" method of gunfire used after the three had entered a roof-top window. No one has yet attempted to weave these strands into a coherent conspiracy theory.

The Body Count

Dave Emory does a syndicated radio program originating in California's Santa Clara Valley called *One Step Beyond* in which he reads into the public record various kinds

of research material he has collected from newspapers, magazines and books, puts the material into a context by linking similar and connected stories and offers tapes to listeners for review. Through this method, Emory has reached an interesting conclusion about the mortality rate in the Clinton campaign and administration: It exceeds what would ordinarily be expected from a study of the laws of statistical probability.

In addition to the suicide of White House assistant counsel Vince Foster, Emory notes that two important Clinton campaign aides died during the campaign. Also, the woman who had been doing sign-language interpretation of Clinton's speeches for the hearing-impaired and was scheduled to do the same at the inauguration died unexpectedly before Clinton took the oath, at age 36. Presumably, the statistical wave now includes the bodyguard deaths at Waco. Emory offers a reminder that natural deaths and accidents can be easily faked with the resources available to the intelligence community. Although he makes no direct charges in this regard, he does place the statistical anomaly in a category familiar to his listeners: food for thought and grounds for further research.

Inman The Spaceman

Extraterrestrial theories are frequently thrown in to the conspiracy milieu as comic relief, although conspiracists note that flying saucer rumors are often injected into situations where real leaks of government secrets occur in order to deprive those situations of any credibility. But the disinformation theory has yet to be applied to Clinton's new nominee for secretary of defense, retired admiral Bobby Ray Inman, since the only known improprieties of his past involve tax discrepancies apparently shared by many Clinton nominees (save for the suggestion in Jim Hougan's 1984 book, *Secret Agenda*, that Inman might have been Deep

Throat of Watergate fame). Inman figures prominently in at least one UFO researcher's tale, however.

Alien Contact is a follow-up to author Timothy Good's *Above Top Secret*, a book well-received among UFOlogists for its documentation of international government interest in UFOs. In it, he describes the efforts of a retired NASA engineer named Robert Oeschler to contact Inman and discuss military knowledge of extraterrestrial craft because of Inman's extensive background with technology-related government projects. Oeschler approached Inman after a speech and handed him a note requesting that the admiral help get him in closer contact with MJ12, alleged in UFO lore to be a secret government liaison group with space aliens, Inman, according to Oeschler, said okay.

More than a year later, Oeschler, who occupies some of his retirement with being assistant state director for the Mutual UFO Network in Maryland, says he phoned Inman to discuss MJ12 and perhaps gain some access to government data on extraterrestrial craft. Inman, says Oeschler, demurred that he had retired from intelligence work and was seven years out of date on any such information.

Oeschler continued, "Do you anticipate that any of the recovered [extraterrestrial] vehicles would ever become available for technological research-outside military circles?" according to Good, who says he was present during the phone conversation. "Ten years ago the answer would have been no," Inman is said to have replied. "Whether as time has evolved they are beginning to become more open about it, there's a possibility." Good also says that while Inman now denies any knowledge of UFOs, he admitted in a signed letter to Good that this was the topic of his phone conversation with Oeschler.

186

The Foster Death

The suicide of Vincent Foster last July left a conspiratorial quagmire. The circumstances of the death, a wound inflicted by an antique gun, were quickly overshadowed by questions of motive. Was, some asked, Foster driven to such an extreme by an aspect of his involvement with the Rose law firm in Little Rock in which Hillary Clinton was a partner?

Was there a connection with the Whitewater Development Corporation real estate partnership whose files were, it was subsequently revealed, removed from Poster's office shortly after his death? The extent of any financial impropriety remains to be seen, but the conspiracy mill already has attached the scandal to international murder plots and long-standing connections between Clinton, George Bush and the Atlanta branch of the Italian state bank, Banca Nazionale del Lavaro (BNL).

Researcher Sherman Skolnick, who has been prominent in conspiratorial circles since Watergate, insists Foster died trying to prevent a CIA-aided assassination of Saddam Hussein in July. Such a plot, but not a supposed Foster connection, was later reported upon in the London *Sunday Times.* Foster did not attempt to do this out of love for Saddam or even to make tomorrow better than today, according to Skolnick's scenario. He did it to prevent Saddam's half-brother from releasing bank records revealing Clinton and Bush involvement with BNL.

An official of the Atlanta branch of BNL, Christopher Drogoul, was recently sentenced for laundering money used in Saddam's buildup before the Gulf War. But the bank was also fingered as a presence in the JFK assassination in a 23-year-old document that makes a series of extraordinary claims-so extraordinary that it is controversial even in conspiracy circles. Known as the Torbitt Document, it claimed in 1970 that BNL had financed training of the hit

team used against Kennedy. A connection had been made between the labyrinth of the JFK assassination and the burgeoning Clinton conspiracies.

In the end, Skolnick is not clear on what kept Foster from making the fateful appointment that was to block the plot, or how the plot failed anyway. He also asserts, however, that former FBI director William Sessions was removed for something related to the Clinton-Bush-BNL connection and that Foster was actually a victim or an assassination team from Germany.

If indeed Clinton is as immersed in these plots, counterplots and various intrigues as some of the researchers suggest, the need for the kind of moral certitude he ascribed to Carroll Quigley seems obvious. The president will also be hard pressed to find time for reforming health care, never mind NATO.

"You Too Can Be A Researcher:
Tips On Using the Freedom of Information Act and the National Archives"
by Kenn Thomas

Flatland, February 1996

A newspaper recently quoted me as saying that "people who are teaching history are teaching bullshit. There are post office workers out there that have collected files .reflecting a lot more truth. What someone does for a living hardly has any bearing on the quality of the Information that he or she has added to the historic record." In addition to making that description a little less scatological (the quote came from an informal conversation), I would otherwise qualify it now by adding that "some" history teachers teach buildups-from unfocussed survey courses on one extreme to overly focussed, narrow academic course work on the other- but that the overall response to the topics and research concerns that drive *Steamshovel Press* generally have been snubbed by academia.

Certainly some history teachers are impassioned and eloquent transmitters of some historic truth, but how many have pooh-poohed the passions of students that have had new angles on political assassinations, an interest In UFOs or things like the possible laboratory origins of AIDS? More often than not work in these areas falls to non-credentialed, non-academic researchers pursuing their own intellectual passions; average people who have taken it upon themselves to be the independent caretakers of the alternative archives.

Two tools that have at times assisted this independent effort include the Freedom of Information and Privacy Act (FOIPA) and the National Archives. Both involve research processes accessible to anyone, and both have yielded much information concerning US history that has been neglected or

actively suppressed by the government and institutional education. Two good examples of the effective use of the Freedom Information Act can be found in *The COINTELPRO Papers* by Ward Churchill and Jim Vander Wall (South End Press, 1990), which documents FBI surveillance of domestic political dissident groups; and *The UFO Cover Up* by Lawrence Fawcett and Barry J. Greenwood (Prentice Hall, 1984; previously titled Clear Intent), which documents government interest in the UFO experiences of its citizenry. Both give a good look at the kinds of primary source material (as distinguished from second-hand accounts like books, newspaper reports and stories passed person-to-person) that Freedom of Information Act searches have wrested from the government's secret vaults.

To be sure, the very nature of clandestine and surveillance government precludes the possibility that everything, or even the most interesting material, will ever surface. FOIPA researchers invariably encounter the redacted document-a report or memo with marker scratches over the important stuff. Even with the FOIPA mandates, the real skinny often will be withheld in this manner, or in its entirety for the sake of national security. That excuse has always begged the question of how a people can be secure if they do not know their own history, but it is the standard by which government agencies block access to the most important secrets. Agencies, of course, do not have to release documents they claim do not exist, thereby excluding them even from being tagged as protected by national security concerns.

The government is a large monolith, however, and FOIPA can cut out chunks of its treasures when wielded correctly, as the Ward/Wall and Fawcett/Greenwood books demonstrate.

When I began a Freedom of Information Act search on Wilhelm Reich in 1991, I discovered that multiple requests for the same material can bring about fresh leads. Jerome Greenfield had used a FOIPA request as the basis of his

excellent history of Reich's trial, *Wilhelm Reich Vs. The USA* (W.W. Norton, 1974), and yet *Steamshovel Press* has used material from my search results in new articles. Much has yet to be done about Reich's handwritten prison memoranda, also released as part of my request. Long after my initial request had been fulfilled, in fact, the Immigration and Naturalization Service released to me another file detailing an FBI report of an agent trying to get Reich to fink on old European friends suspected of subversive activity (the report appears in *Steamshovel Press* #12). Although I later learned that Greenfield had traveled to the INS office in the early 1980s and looked at the report for an article in the *Journal of Orgonomy*. The version that appeared in *Steamshovel* included the name of one of the people that the FBI would have had Reich snitch on had he known him, a Mr. Feuchtwanger (pronounced FOISHT-vahn-ker). The name is redacted in the rest of the report. So mistakes happen and new information emerges.

Mine had been a second-party request. That is, I had asked for Reich's file and not my own, which led me to encounter a roadblock that others may do well to anticipate before starting on a FOIPA research. Second party requests require either the permission of the person being researched or an obituary of that person.

Stonewalling is reflexive with the FBI and the CIA; my request was delayed for months until I forwarded an obituary of Reich from *Time*. That simple precaution and the language for a good request letter can get a researcher started on a FOIPA search right away, although libraries all contain reference works that instruct researchers in detail on how it's done. Two that come recommended: *How To Use the Freedom of Information Act*, published in 1986 by Washington Researchers Publishing; and the comprehensive *Guidebook To The Freedom of Information and Privacy Acts* compiled by Justin D. Franklin and Robert F. Bouchard and

published in 1987 by dark Boardman Company, Ltd. In the cyber environment, FOIPA kits can be found at

hyperreal.com/drugs/politics/misc/FOIA.kit

hawaiishopplng.com/sammonet/foya.html and

execpc.com/magnesum/freedom.html

A newsgroup entitled **alt.freedom.of.information.act** also exists.

Short of studying FOIPA's nine exemptions (privacy, confidentiality, national security, etc.) and other nuances in these reference works, researchers can begin their researches with a letter similar to the following, my letter to the FBI concerning Wilhelm Reich:

Dear Madame/Sir:

Under the provisions of the Freedom of Information Act, I request access to all records pertaining to the Bureau's investigations into the career of Dr. Wilhelm Reich from 1947 to 1959. Dr. Reich was born March 24, 1897 in Dobrzcynica, Austria and died on November 3, 1957 at the Lewisburg Federal Penitentiary in Lewisburg, Pennsylvania.

On February 10, 1954, the U. S. attorney for the District of Maine, Peter Mills, filed a Complaint for Injunction against Dr. Reich after an investigation of his medical practice by the Food and Drug Administration begun in 1947. Dr. Reich was convicted of violating the injunction on May 7, 1956. I believe that Dr. Reich's activities during this period also led to the opening of an FBI file on him. I seek access to this file.

I am willing to pay for copying expenses that do not exceed $35.

If any part of this request is refused, please explain the specific exemption justifying the refusal and direct me to the legal appeals procedures.

Thank you very much for your attention. I look forward to hearing from you soon.

I am indebted to Jim Fisher, author of *The Catholic Counterculture in America, 1933-1962*, Chapel Hill: University of North Carolina Press, 1989) for the fairly comprehensive language in this letter. Its important features include a detailed but brief biography of the subject; a detailed description of the period in his or her life when he/she might have been under surveillance and why; and a request to explain any refusal to provide records and directions for appeal. It also offers a reasonable amount of money for copying expense. Various government agencies charge for a variety of services, not only copying but also many times even the cost of looking into indexes and databases. In some instances, this fee can be waived by special request for records determined-by the Feds, not the applicant-in the "public interest"; in other cases, it is possible to forego copy charges by viewing records for free at the agency office (then of course, there are travel expenses.) Although researchers mostly look through records that have already been paid for by their tax money, they should be prepared to pay some amount for getting copies.

Remember, the above letter covers third party requests and therefore requires that an obituary or the permission of the person whose records are being sought, so a note to that effect should also be included. This kind of search is most fruitful for people looking into historic figures like Reich (or Tesla, or Vannevar Bush, Einstein, John Lennon... A large section of the historic record has yet to be plundered), and again new and multiple searches often yield information that has not yet surfaced.

If a researcher determines to look for his own records, of course, permission has already been granted by the person under investigation. In order to check any record the CIA or the FBI has collected on you, rewrite the preceding letter appropriately with details from your own life and the period under which you suspect a file was opened. Address requests to the Freedom of Information Act officer.

The FBI is located at the U.S. Justice Department, 10th and Pennsylvania, Washington, DC 20S35; address requests to the CIA to the Information and Privacy Coordinator, Central Intelligence Agency, Washington, DC 20S3S. Other good sources to tap for records are the Federal Bureau of Prisons, 320 First Street NW, Washington, DC 20534; the Immigration and Naturalization Service, 42S I Street NW, Room 5304, Washington, DC 20536; the Food and Drug Administration FOI Office, HR-35, Room 12A-16, 5600 Fishers Lane, Rockville, MD 20857; Attorney General Janet Reno can be reached at the Justice Department on Constitution Avenue and 10th Street, NW in DC; and for records particular to UFO related activity contact Air Force Technical Intelligence, 4115 Hebble Creek Road, Suite 14, Wright-Patterson AFB OH 45433-5618.

The Reich FOIPA request is currently stalled with ATIC, which now denies the existence of UFO reports that Reich submitted and printed in his last book, *Contact With Space*. ATIC's last "no records" response is under appeal. So two caveats govern FOIPA requests: develop a certain resignation that the basic US principle of freedom is at odds with the national security state and therefore many things will never be released; but develop also patience that eventually some records may eventually be turned over to you if you work at it long enough - by mistake, bureaucratic inertia or the occasional defiance of an alienated file clerk. Perhaps it is too obvious to make explicit: Government denial that such records do not exist does not mean that they do not exist. Slap this work in a file somewhere and get on with life, checking

on it occasionally and doing follow-up correspondence every three-to-six months, or one can get anal about it and check every ten days, the response period dictated by law.

Research at the National Archives always requires specificity and often requires proximity. As a national administrative bureaucracy, the National Archives (technically called the National Archives and Records Administration) gives a full explanation:

gopher.nara.gov:70/l/about.

Through the National Archives of the *Steamshovel Press* uncovered and was the first to publish the only photograph of JFK with Mary Pinchot Meyer, the woman with whom he apparently shared the psychedelic experience. According to one theory, suggested by Tim Leary, Meyer gave Kennedy pot and acid as part of a mission by a feminist cabal to turn on political and military leaders. (JFK's response to smoking a joint reportedly was, "This is not like cocaine. I'll have to get you some cocaine.") *Steamshovel Press*, author G. J. Krupey suggested that JFK may have been a pawn of the MKULTRA mind control project of the intelligence community, a scenario supported by events surrounding the recovery of Meyer's diary after her murder.

In his 1970 book *Conversations With Kennedy,* Ben Bradlee described a scene in which Kennedy traveled to Milford, PA, officially to dedicate a building to the cause of conservation, but in reality to meet Mary Meyer's mother. Bradlee described the outdoor, on-the-porch, meeting as one of "history's frozen shots" and mentioned that photographers were all over the place. In his book, Bradlee also narrowed the date to; September 1963, and with that provided enough information-subject, place and a date-to find the photograph in the National Archives. After Its publication in both *Steamshovel Press* and *Popular Alienation*, the new *Steamshovel* anthology recently released by IllumiNet,

Bradlee himself included the photograph in his latest book, A Good Life (Simon & Schuster), this time calling the scene "one of history's stiffest sets of smiles." Several other photos in the series still have been published only by *Steamshovel.*

That level of detail is pre-requisite to doing work in the National Archives building in Washington. A general search for, say, the papers of MJ12 signatory and hypertext prophet Vannevar Bush yielded nothing, for instance. Subject control like that can mostly be found at the JFK assassination collection (see sidebar discussion with John Judge). The recent publication of Reich's correspondence at the time of his immigration to the US, however, in a book called *Beyond Psychology*, provided enough information to uncover the passenger manifest of the ship he came over on-along with other passengers and details that will be important to future research. A similar document with Einstein's name currently decorates a lobby display in front of the National Archives.

Another recent roadblock thrown in front of researchers at the National Archives is the movement of much of the collection to another facility in Archives II. Taking the shuttle there from the main archives can add a day to a research; so knowing which facility contains a particular record is useful, and the JFK collection is at College Park. The move derailed a possibly verifying the existence of MJ12, something known as the Cutler/Twining memo, a document that had a specific record number and box location.

Although its existence, if not its authenticity, is certain, the provenance of the Cutler/Twining memo remains fishy. In his 1992 book. *Crash At Corona*, (Paragon House) Stanton Friedman reported that his comrades William Moore and Jaime Shandera were directed to the memo by a postcard with a New Zealand post-mark but an Ethiopian return address. It ostensibly came from the office of Elsenhower assistant Robert Cutler, was addressed to Lt. Gen. Nathan Twining and concerned the rescheduling of an MJ12 meeting in 1954. It appears between a pair of folders dealing with

completely unrelated Air Force topics. Friedman argues that it was smuggled into the archives by the post-card writer or a co-hort possibly working for the National Archives or the Air Force "as the means of access to such material is carefully controlled by the security-conscious National Archives staff." That consciousness is actually directed more at preventing the theft of materials from the archives than attempts to smuggle things in, and the opportunity to actually hold and look at the memo and make an independent judgment is available to any researcher now. At the time of *Steamshovel's* attempt to examine the Cutler/Twining memo, the National Archives insisted that it had been transferred to Archives II; Archives II agreed, but claimed that the record group had not yet been unpacked and made available for research.

(Stanton Friedman has done some quite remarkable research over the years, including uncovering papers establishing the secret life of 1950s UFO debunker Donald Menzel-another alleged MJ12 signatory and possible MJ12 back channel to JFK. The quality of his research is such, in fact, that I have encountered UFO researchers who think Friedman may have struck a deal with the intelligence community-a compliment, in my view-in order to get his hands on some of the material he has surfaced over the years. Under this scenario, Friedman's ill-advised support of Jerry Anderson, an ostensible witness to a second saucer crash in New Mexico, was deliberate disinfo to discredit the Roswell story. Strangely, Friedman has joined the chorus of critics who now say the same thing about the recent "alien autopsy" footage, even though he has successfully defended the original MJ12 documents against identical criticism, that markings on the artifacts do not live up to a mythical standard of uniformity in classification and dating formats.)

Readers of this anecdotal trek through only two avenues of research will have no doubt determined by now that this type of research can lead to major discoveries, but more often than not leads primarily to the accumulation of

small bits of information over time. That is what makes it particularly important that researchers assault the country's archival resources en masse, and not leave it to the hired guns of academe.

JOHN JUDGE ON THE NEW JFK FILES AND DOING RESEARCH AT THE NATIONAL ARCHIVES

Flatland #13, February 1996
Interviewed by Kenn Thomas

Q: What are some of the new things that have come out of the Assassinations Material Review Act?

A: Probably the most exhaustive look at the new records has turned itself now into a new book, John Newman's *Oswald and the CIA*. Although it hasn't got, as he says, a smoking gun, it has smoking files. Some very interesting stuff about how early on the CIA opened up files on Oswald. A lot of surveillance pertaining to him that they had not admitted in the past. It's evident in Newman because of his intelligence background and familiarity with looking at files, not only what you and I would see in a file from reading it, but also the initials on it, the routing, who saw it, what division it was in. From that he decided to reconstruct a lot of the structure of the CIA at the time, especially the segments that would have been dealing with Oswald in Mexico.

That's been interesting. A lot of us have heard about 2R Rifle and AMLASH-he found nearly fifty similar operations that he was able to identify. In some cases, who they were connected with. He also clearly shows that there was some sort of deception going on that involved the agency and the embassy in Mexico City at the time that Oswald was down there. There was an Oswald impersonator. There was

evidence earlier that Oswald's name was being used in connection with intelligence operations, and also that Oswald was clearly being tracked during the time he was with the Fair Play for Cuba Committee.

There's a whole Fair Play for Cuba Committee section of the documents there, including, interestingly enough, that show that David Atlee Phillips was working with James McCord of Watergate fame early on. We brought that document out. In Open Secrets [the newsletter of the Coalition on Political Assassinations] we try to present one of these kinds of documents a month. Each issue has at least one document that's sort of new or interesting.

Also, the "Solo" files were released. "Solo" was a nickname for an FBI informant that was actually two people, two brothers, one of them was the accountant and one of them was the newsletter editor, of the CP USA, the Communist Party. Two brothers named Childs. They were reporting on a lot of stuff that had to do with the reaction of the Communist Party, the reaction of Castro, the reaction of the Soviet Union, to the assassination of JFK. These documents, which have finally been released and declassified after these many years show us a number of things. One of the things that they are saying about them from inside the system is that these were the documents that the Warren Commission relied on for its conclusion that there was no role by the Soviet Union or Castro in the assassination. Early statements by Castro in response, asking when they were going to go after the other gunman; evidence that Castro actually tested the assassination, had Cuban gunmen try it out. He discovered that there were at least three people shooting. Also, there are early suspicions of Oswald from this strange visit to Mexico City where an Oswald goes into the Cuban embassy looking for a visa. Castro's first reaction is that he doesn't understand why he has to come to Mexico City to get that. That's a lot of expense to go through when he could just get it from inside the United States, so why not? What's the purpose of this ruse

of coming down to the embassy? And then on being denied an immediate visa, Oswald storms out and says, "I'm going to kill Kennedy for this! "-as if there was some sort of sequitur between getting a visa and killing Kennedy. These things are reported by the Childs from conversations they're having with Castro.

Q: Does Newman have all this?

A: I don't know if Newman picks up on this. He may have right at the end, but it was getting close to the deadline when this happened. This is the most recent large release of files. There were also files on Sam Giancana, a Mafia figure that the FBI was looking at, the release of which was contested for a while by the FBI on the grounds that these were organized crime files and didn't necessarily relate to the assassination.

Q: Are you getting copies of the new JFK files and storing them somewhere?

A: We have limited copies but a full copy of everything being released into this collection, a second copy is also released to the AARC, the Assassination Archive and Resource Center here in DC. Jim Lesar is the president of it. So they have a second copy of the files over there and a number of the researchers use their version. Others went out to Archives II. As you know, being an archivist, this was the most visited exhibit or file collection in the National Archives in recent history. The only thing comparable in terms of numbers and people wanting to look at anything was the genealogy section. But in terms of any one exhibit, this outstripped Watergate and everything else.

Q: It's a permanently separate exhibit.

A: Yes. And yet they've moved it out to this College Park location and reduced the number of hours that the archives are open to the public. So it's really made it inaccessible. A lot of tourists come downtown and right in the middle of downtown, here on Pennsylvania Avenue, not far from the White House is the National Archives, sitting there. But you can't see any of this JFK stuff in the regular archival building there, you have to go out to College Park to see it.

Q: They do have a shuttle there.

A: Yes, but that's still more time and it's a separate day's trip.

Q: My take on the National Archives is that there's a built-in Catch 22: you don't know what you're looking for unless you can look at it but you can't look at it unless you know what you're looking for.

A: Well, they do have a finder's guide, a printed one. And they also have electronic finding aids and they've switched over on their data system to handle the ID cards information. Every document that is released under the JFK act requires a card to be made up relating to the document. This tags the document and identifies it within the system, its source, it's date, key names. Then they look also for names that they feel are related to the Kennedy assassination and they'll make a list of the topics and the names of organizations. Those things are digitized. Not the document, but those finding tags, are digitized into a system there. Their software was recently shifted, so what used to be a twenty-five to thirty minute search is now a matter of seconds. So they can find things very quickly and eventually they want to have terminals for that system right there in the reading room so that the people coming in can just go to the computer themselves. They don't have that yet. You have to turn in a card.

Q: The current system is really funky, actually. You have to go to somebody...

A: ...and have them look for it and wait about an hour. They will come back quicker. . .

Q: And there is no subject access.

A: It's all name or organization access, it's not by subject topic.

Q: At the National Archives in DC not even that. If I want to look at what it has on Vannevar Bush, for instance, which I tried to do. You can't just say "what do you have on Vannevar Bush?" You would have to know that they had something and what it was. . .

A: You would have to know. You can know that about the JFK collection in the sense beyond that specific finding aid, they do have general categories. In other words, these are documents released from a certain committee, which studied certain things, so you can get a sense at least of what some of the chunks of the collection have to do with, and go from there.

Q: What distinguishes a conference like the one out on by the Coalition on Political Assassinations from the others?

A: They are a little different from the conferences that have been put on like the ASK Conference (the Assassination Symposium on Kennedy, held annually) in Dallas, where people are just invited to speak. We do our conferences in a semi-professional manner, like a scientific conference. We put out a call for papers and we ask people to send a 500 word abstract of a paper they want to present. Then there' some peer review, committee review. ASK tended to be a showcase

for current or known authors. ASK was basically a podium-down situation only. It also had a lot of frivolous presentation. It didn't have any standard to what could be presented.

Q: A little bit celebrity driven, with Norman Mailer and all.

A: Certainly it was that. People who would draw a crowd, because it was basically a commercial venture. It was never putting any resources back in to the hands of the research community. The Coalition is made up of and run by the research community and represents the interests of the research community and its long-time members. We try to put on a conference that would not only have an interest to that limited research community but to the general public. W focus on new analysis, some of it based on old material and medical evidence, or new things we've found out about the official versions of it but also presentation on what's in the files. There have been a number of searchers looking through different aspects of the files and what connections there are to be made.

The Anthrax Terrorists
Fortean Times 110, May 1998

Conspiracy correspondents and mainstream news people alike noted serendipity in the Las Vegas arrests of Larry Wayne Harris and William Leavitt for possession of the deadly anthrax virus last February. Information about Harris started coming out of Columbus, Ohio, where earlier in the week US Secretary of State Madeleine Albright was booed at a televised public relations event, planned to help convince the public of the dangers of Saddam Hussein's chemical weapons and the wisdom of the coming military action against Iraq. Had the same disinformation team that created

the event also staged Harris' arrest to stir up hysteria over chemical weapons?

As details emerged, this became the least interesting of the research avenues surrounding the anthrax arrest. Harris and Leavitt were set up while pursuing the purchase of lab equipment based on the experimental anti-cancer technology developed by Dr Royal Raymond Rife in the 1920s and 1930s. Leavitt - a 47-year-old former Mormon bishop from Logandale, Nevada - reportedly offered $20 million for the equipment to Ronald Rockwell, legal heir to the Rife technology. Instead of taking the money, Rockwell tipped off the FBI about the possibility that the two men were carrying military-grade anthrax around in their beige Mercedes-Benz. The FBI arrested the men at a medical office complex in the Las Vegas suburb of Henderson after a day of ground and air surveillance. Their car was sealed in plastic and transported to a safe area at Nellis Air Force Base near Las Vegas and later to an Army base in Utah where testing determined it contained only a harmless vaccine.

The more prosaic explanation for the Columbus connection was simply that Harris lived in nearby Lancaster, Ohio. He attended Ohio State University from 1972 to 1976 and eventually received a bachelor's degree in "comprehensive science" from another college in the state. In May 1995, Harris was working at the laboratory of Columbus businessman James Gossard when police arrested him for illegally purchasing freeze-dried bubonic plague bacteria - see FT82:10. In addition to violating his probation on that charge, Harris' new arrest (for possession of anthrax) violated laws that were written because of that earlier arrest.

Suspicions in the case naturally turned to Rockwell, identified in the news as a cancer researcher with claims of a new technology designed to electronically neutralise dangerous bacterial toxins such as anthrax. Reports were quick to note that Rockwell had two prior convictions for extortion, but few were explicit about his background

204

regarding the Rife technology, based on using resonant energy to destroy cancer cells.

Rockwell was a former chief engineer for the defunct Royal Rife Engineering Company in San Diego. He apparently acquired rights to Dr Royal Rife's work in a deathbed agreement made with John Crane, co-author with Barry Lynes of *The Cancer Cure That Worked*, a 1987 book that revived interest in Rife's work. The agreement with Crane made Rockwell the inheritor of what many call yet another quack cure for cancer. Dr Royal Rife used an electronic instrument to discover the "mortal oscillatory rate", or MOR, of cancer cells. According to one 1934 study at the University of Southern California, he had great success at treating cancer patients without surgical invasion.

Enthusiasts of alternative health therapies argue that economic forces in the business of treating cancer kept the Rife device from ever gaining the wide use it properly deserved. Critics contend that the low energy levels of radio waves cannot make it possible for them to have such destructive capability. Nevertheless, in addition to cancer treatment, Rife claimed to have identified the MORs for over 55 bacterial diseases.

Could a Rife device be "tuned" to anthrax? By all accounts, William Leavitt anthrax? By all accounts, William Leavitt is a pious man who seems overwhelmed by the situation that his association with Larry Wayne Harris has put him in. Shortly after the arrest, he began a fast he planned to continue until all charges were dropped and his name was cleared. But somehow he came to offer Ronald Rockwell $20 million for the Rife technology. Why did Rockwell turn down the offer for a technology that, at best, is extremely difficult to reproduce and that most believe does not work?

Since Dr Royal Rife's day, advances in traditional medical science have led to improvements in the Rife beam ray unit. An Albuquerque chiropractor named James Bare notes that "latter day investigators have discovered [that]

resonant energy can be re-radiated as magnetic waves or radio waves." He points out that this is the basis of the commonly used magnetic resonance imaging (MRI) technique for non-invasive brain and body scans. When applied to the Rife technology, Bare claims that it provides the means to treat people by the room-full. He reports that groups around the world meet several times a week to pursue the benefits of such radio-magnetic resonance. The bizarre case of Larry Wayne Harris and William Leavitt ends on speculation about the possible military application of Rife technology against the fear of germ warfare attack by Iraq armies beam-inoculated by a Rife device to fend off anthrax.

The Anthrax Terrorists Redux
Fortean Times, December 2001

Back in 1998, *Fortean Times* carried my report of Larry Wayne Harris, a laboratory worker arrested outside of Las Vegas for possession of the anthrax bacteria - *FT110:46*. Harris had previously been arrested for purchasing freeze-dried bubonic plague bacteria. That arrest had led to the creation of additional laws in Nevada about possession of biowarfare material. Harris's second bust was for violation of those new laws.

The particulars of Harris's story gain great relevance in the wake of current events in the US, of course. Following the terrorist attacks on the World Trade Center and the Pentagon on 11 September, a great anthrax scare has come upon the American public. British-born photojournalist Bob Stevens, working for American Media (the publisher of *The National Enquirer* and other gossipy tabloids in Boca Raton, Florida), died after inhaling anthrax spores sent to his office. Then two additional American Media workers were discovered to have been exposed to the bacillus via the same mailed package...then five others...and next, hundreds of

American Media office and mailroom employees were tested. An assistant to NBC newscaster Tom Brokaw also became exposed to anthrax in a similar way, as did the office of US Senate majority leader, Tom Daschle.

Although antibiotics have prevented anyone else from coming down with the disease, America still has a full-blown anthrax panic on its hands.

What made Harris's case unusual was its connection to the technology of Raymond Rife, a renowned maverick among alternative energy aficionados. Harris' partner, a Mormon bishop named William Leavitt, tried to buy Rife equipment - a radio-wave device touted as a cancer cure - from Rife's legal heir, Ronald Rockwell, for $2 million. The deal turned out to be a swindle.

Rockwell informed the FBI that Harris and Leavitt were in possession of military-grade anthrax. Apparently, the idea had been to create a 'Rife resonator' that tuned to the 'frequency' of anthrax and banished it as, they claimed, it did cancer, by locating the disease's MOR("mortal oscillatory rate"). Apparently Harris and Leavitt intended either to create an anthrax panic and sell the cure, or to provide the US military with a means of treating the disease by the troop-load, with a beam from the Rife device. Authorities eventually dropped charges against the two when they discovered that their 'anthrax spores' were only vials of anthrax vaccine.

Now that a real anthrax panic has gripped America, however, an odd and pertinent footnote appears in the Larry Wayne Harris story. While in training to become a terrorist before his time (that is, while picking up a science degree at Ohio State University and working as a lab technician with ambitions set for greater things), Harris met a woman related to the former president of Irag, Abd as Salaam Arif, whose family had been wiped out by Saddam Hussein. She told Harris of a plan by Saddam to discharge anthrax-laden

material into important operational facilities at various cities in the US, like the water supply and post offices.

According to the story, Iraqi women smuggled the spores into the country in their body cavities. Indeed, after Harris finally found federal authorities that would listen to him, they arrested several Iraqi women in possession of anthrax spores, near Iowa State University in February 1997. According to early reports by Florida law enforcement officials, the anthrax strain that killed American Media's Bob Stevens came from the 'Ames strain'. It had been isolated in the 1940s at Iowa State University in Ames, Iowa, and is now used as the comparison standard to determine if tissue samples contain anthrax. Given the current concerns, Harris' veracity should be re-examined; instead of dismissing his tale as improbable there should be an investigation into whether or not those Iraqi women were smuggling anthrax in or out.

Harris's story-telling certainly intersects eerily with current events. For instance, he claims to have been poisoned with an injection of cobra-venom in order to keep him quiet about the Iraqi anthrax. The poison caused blood clots in his lungs. One person who listened to him, Jim Keith, died of a mysterious blood clot in the lungs. In addition to being alarmingly prescient about the biowarfare in today's news, Harris had one more detail about the Iraqi plot he stumbled upon: anthrax was to be used in conjunction with the explosive destruction of buildings in the US.

FATE, November 1999

Late Breaking News: Octopus Conspiracy Claims Another at Burning Man

Conspiracy author Jim Keith, featured in the October *FATE*, fell from a stage at the Burning Man event and broke his knee. He died during surgery on September 7 at 8:10 p.m.

at the Washoe Medical Hospital in Reno, his home town, when a blood clot entered his lung.

Keith, who evidently died under somewhat mysterious circumstances, is co-author of The Octopus, about a writer who died mysteriously while investigating an international conspiracy. Rumors suggest that Keith was killed after revealing the name of the physician who claimed that Princess Diana was pregnant at the time of her death. "I have long noted the connections between the Octopus story and the death of Diana," says Keith's co-author, Kenn Thomas. The web news service where Keith named the source has become inaccessible since his death.

"Keith himself would certainly have been suspicious of the circumstances of his own death," says Thomas.

MEDIA

"Media Monotone"
by Kenn Thomas

The view of the last space shuttle launch on the television where I was staying in Manhattan looked different than it had in previous launches. Ordinarily the videocams shoot from a side angle of the shuttle, but this time they were pointed toward the rear, jet plumes facing the viewer. The angle made the ascent seem slower, of course. In fact, it looked like the Star of David slowly lifting up to heaven.

Maybe I had too much Israel on my mind. This launch was the first with an Israeli astronaut, and with a 300 member Israeli team monitoring. It also had an extra degree security, ostensibly because of the terrorist threat, but conveniently also providing an extra layer of protection for whatever secret payload this one had.

(*Steamshovel* debris: As it turned out, this was the ill-fated Columbia mission, which disintegrated above the earth on February 1, 2003, killing its crew. Eerily enough, the media focused on a town called Palestine, TX, where search for debris from the disintegrated vehicle began.)

I also was thinking about the purpose of this visit to New York, though, a panel entitled "Monotone Media and Voices on the Margins" for j-school alums of Medill and Syracuse. I was the representative conspiracy "theorist", of course, flanked by a Marxist; someone from a media watchdog group; an editor of a pre-Christian European culture journal (a kind of a Satanist); and a financial news writer. (A complete list of the participants went out in an issue of TAGS, the *Steamshovel* e-wire.} The setting and the topic -- how various points of view get screened out of the

210

mainstream media -- I felt would inevitably lead to an acrimonious room full of people fighting over the extent of Jewish control on the media. I had seen it happen many times at various conferences.

To the great credit of the person who organized the panel, someone who had no prior experience with this sort of thing, that question was saved for last, allowing time for many more questions about the media to be discussed by the panel. But it did ignite an argument, put up by an ardent audience member, and was well defended by the media watchdog guy. It devolved around the editorial control of the rightist magazine *National Review*, no doubt to choked-back yawns from all but the two who were arguing.

Previously, media watchdog man (I am avoiding panelist names to get more to the point) brought up Matt Hale, founder of the racist World Church of the Creator, now charged with seeking to arrange the killing of a federal judge. Actually, he called him "David" Hale, and this became a slip exposing the subliminal control over him by the Jews, according to one critic. I attempted to correct, "isn't it Tom Hale?", showing the extent to which I'm controlled by the Welsh ("Thomas" being a Welsh name.) "Matt!" someone chimed in from the audience, to which I replied, "whatever-- the Illinois Nazi," a line from Dan Aykroyd that puts a little perspective on the likes of Hale while Bush cronies, major fascists with actual power, are now poised to wreak hell and kill hundreds of thousands in Iraq.

The *New York Press*, which I am sure qualifies to many as liberal and Jewish influenced, characterized me as the "famed" member of the panel, but the Vanguard News Network, a neo-Nazi web presence, said I was the panelist "hitting far harder" than the others. The latter comment stemmed from my insistence that a network of Israeli spies using the cover of being "art students" surely had foreknowledge of 9/11, and that the mainstream media had

suppressed the story. (See *The Shadow Government* by Len Bracken.)

That was one of many fishy stories left unattended by the mainstream, for a variety of reasons not the least of which is that it embarrasses Israel.

Unfortunately, another such tale, the short selling spree on Wall Street that followed 9/11, did not get asked or answered on the panel. This, despite the presence of the financial news writer, who primarily argued that he just writes "good stories" and hopes people likes them enough that he'll get published. He had written a history of American Express that did not even have a footnote observing the fact that Warren Buffet first bought into American Express after a similar short selling spree following the JFK assassination. (See *Mind Control, Oswald & JFK*).

That's a good story. Why no mention? Did he not know parapolitical history, which would have amply demonstrated how the media filters out uncomfortable facts. Or did he not think it fit to broach such a subject so close to such a powerful player still on the scene? For mainstream journalists, it's all about access, something they might lose if they tell the bad stories about the wrong people--a process that is easily understandable and a path that certainly the "Jewish influence" follows.

Both the Marxist and the media watchdog panelists said they opposed including racist and Nazi perspectives into the broader media discourse, a position I thought was at odds with the purpose of the panel. I later learned that one activist group actually has the ultimate oxymoronic motto: "No free speech for fascists!"

When the mass media blocks out separatists and racists of any stripe, it has censored a perspective that would otherwise contribute to the public's understanding of the world.

212

Why is it that the same mass media also blocks progressive points of view, reactionary ones, Marxist, anarchist, radical feminist, Earth Firsters, etc.?

One doesn't have to think Jews are behind it all to wonder about the obvious: does the false dialogue of the liberal-conservative mainstream factions--and the endless parade of toadies and pseudo-celebrities like Bill O'Reilly and Paula Zahn--best serve the profit interest of the one global corporate party? How can such a thing be so at odds with the true diversity of perspectives on earth?

"Monotone Media and Voices on the Margins" will be broadcast at **freethoughtradio.com** and at **killradio.com**'s *Radio Mysterioso* site at times yet to be determined, but hopefully also the program will be archived for later listening. CD recordings of the discussion might become available to the public at a reasonable price.

Zevonfest
by Kenn Thomas

"Here's the song of sheer and tortion
Here's the bloodbath magazine..."
--*Transverse City*, Warren Zevon

Ever since word reached *Steamshovel Press* of Warren Zevon's impending demise - the singer/songwriter has inoperable lung cancer -- the office has been conducting Zevonfest 2002. Zevon's songs play virtually 24-7 at the *Steamshovel* office, and I have brought him along via CD on my recent travels. His music first came from the wimpy, Dylan-wannabe, oh-so sensitive Southern Cal songwriter milieu of the late 70s. Jackson Browne, Glenn Frey, Linda Ronstadt and all such groovy people who made punk rock inevitable, appear on Zevon's earliest records. It's difficult to connect him, through that, to conspiracy themes and to find a

reason for a *Steamshovel* editorial praising his genius. He is precisely that, however, a genius of cynicism and dark humor that demonstrates to my satisfaction anyway why rock'n'roll is the soundtrack to the global conspiracy culture.

His 1989 cyberpunk album, *Transverse City*, strikes up familiar themes of the desolated cityscape, an exhausted science and the alienation found in its best known song, "Splendid Isolation." It also provides a snapshot of the political picture of the late 80s that would warp into the ugly reality that dominates everything today, a tune entitled "Turbulence":

We've been fighting with the mujahadeen
Down In Afghanistan
Comrade Gorbachev
Can I go back to Vladivostock, man?

But the one classic Warren Zevon tune, one that David Letterman begged to play on a kind of farewell appearance on his *Late Show*, certainly ranks in the top ten list of war /anti-war songs summarizing the sad truth, "Roland the Headless Thompson Gunner", about the Congolese/Bantu conflict of the mid 1960s. Often taken simply as a bizarre ghost story, "Roland" tells the tale of a mercenary whose head gets blown away by a CIA operative and who stalks eternity wreaking vengeance, even after slaying his own killer. The final verse drives its point home with a catalog of hotspots of the eternal war, as relevant now as when the song came out back in 1979, and slaps at the violence of the pseudo-left:

In Ireland and Lebanon
Palestine and Berkeley
Patty Hearst Heard the Burst
Of Roland's Thompson Gun And bought it!!!

I brought Zevonfest 2002 to a bar situation recently, cranking up "Roland" and waving a mug around like it was a German drinking song, even toasting to it and, with no small measure of cynicism, the coming war with Iraq. "Time, time, time for another peaceful war..." Everybody loved the song. A couple of the guys started talking about what an effective weapon the Tommy gun makes.

The song "Genius" appears both on Zevon's latest album, *My Ride's Here*, and on the new Best Of compilation, also entitled *Genius*. Mata Hari and lady's man Albert Einstein are among the geniuses catalogued in the song, and when the concept of conspiracy poetically emerges, it favors the outlaw:

He thinks that he'll be alright
But he doesn't know for sure.
Like every other unindicted co-conspirator

 ...

The poet who lived next door
When you were young and poor
Grew up to be a backstabbing
Entrepreneur
 ...

Everybody needs a place to stand
And a method for their schemes and scams
If I could only get my record clean I'd be a genius

As he continues work on his last record, Zevon's great wish to not miss the new James Bond movie has been granted, although its title, *Die Another Day*, drips with the irony of many of his own song titles. On one of the Zevon web pages, a young fan grasped inarticulately at his

frustration in a letter to Zevon: "Man, I'm sorry your shit's fucked." I concur. Godammit. Warren Zevon. *Genius.*

While he yet lives, and long beyond, Zevonfest plays at *Steamshovel.*

"Penn, Teller and Bullshit"

Penn Jillette is a lard butt. Teller, of course, is a mime. 'Nuff said about that. In the comedy pair's new Showtime program, *Bullshit!,* Penn and Teller join the humorless and condescending "skeptic" crowd by "debunking" everything they think is false. If turnabout is fair play, then any viewer can feel justified in calling these two names. They freely hurtle such epithets as "bitch" at their victims, whom they often approach without revealing how vicious their attacks will be when aired. Most of the shows end with a simple-minded homily from lard butt about how what all these geeks need is love, after thirty minutes of delivering hate and humiliation to them.

One episode attacked last year's UFO conference in Santa Clara. The first thing the camera focused on in the UFO report was disinfo's book, *You Are Being Lied To*, a collection of very powerful essays on parapolitics. P&T admitted that David Icke's notion of the world as run by shape-shifting reptilians was "the first thing anyone here said that made sense", and they did not repeat the oft-held criticism of Icke being an anti-Semite. Nevertheless, Icke did commit the crime of being more interesting than Penn & Teller, and so was ridiculed. So too was Roger Leir, the podiatrist who admits to not knowing where some of the weird things come from that he pulls from people's bodies. The "authority" podiatrist consulted by P&T knew exactly, of course, without ever examining Leir's patients. The public record of Leir's practice was offered to viewers; and examination of the other guy's apparently never happened.

The reliance on banal, ignorant "experts" is, of course, what distinguishes P&T's work from any truly iconoclastic or thought-provoking presentation of paranormal and parapolitical material. To counterpoint the "bitch" psychotherapist, for instance, they used a rather geeky looking one who quoted conventional explanations about alien abduction and implants as if they were verses from the Bible. At their web site, P&T note "we are people living in the USA trying hard to make sense out of the world. We use the expertise available to us and we try to tell the truth as we see it."

(The mime even suggested at the web site that none of P&T's superior audience ever goes home and tries to do the magic tricks. Now THAT's bullshit.)

They aren't alone in this crusade, of course. "We know nothing, but we have experts we consult." Their experts, of course, better than those that speculate freely and with an open mind. The people out there who want to think for themselves and do for themselves are idiots, according to Penn & Teller. They are just out to make a buck. P&T found one disgruntled conference attendee disappointed because she came to the event for "science" and all she got was anecdotes and experiences, sold in books and on tapes. She was going to spend the next day at the theme park across the street. P&T aren't selling anything, of course, just exposing the bullshit. Viewers should remember that when they pay their bill for premium cable.

Too bad Penn & Teller don't get it. Too bad they can't figure a way to laugh with instead of at the UFO crowd, the conspiracy crowd or whatever off-mainstream crowd they plan to slam next.

Comic Book Conspiracy
by Kenn Thomas

I originally thought Nick Nolte accomplished a great feat of public image engineering for himself in the summer comic book hero movie, *The Hulk*, while at the same time delivering again the Hollywood stereotype of the conspiracy theorist. Nolte's last impression on the public was in an extremely messed up looking police mug shot. The police had arrested him for drunk driving and apparently he was drunk on the club drug GHB. Although he had not been beaten by the cops, he certainly looked like it. After *The Hulk* and as this image receded into the past, people would associate that ignominious visage with his *Hulk* role as a crazy scientist with an equally messed up face.

In the movie, Nolte--who once starred as the great Beat personality Neal Cassady in a 1980 film called *Heartbeat*--plays an obsessed madman. Ranting at the soon-to-be transformed big green King Kong, he tirades against the military terror state. That's a common enough phenomenon in the post-9/11, post-Patriot Act, post-Afghanistan and Iraq Wars, and a thing worthy of common sense discussion. Nolte, however, made it sound like the crazed rantings of the totally insane.

Hollywood presents this picture all of the time, most notably in Mel Gibson's *Conspiracy Theory* movie. Anyone who has any of the facts about conspiratorial politics and manipulation and tries to talk about it with others is a nut.

Or, as *Lobster*'s Robin Ramsay once put it: "...one of the bedrocks of the ideology of liberal democracies like ours is that conspiracy theories are always wrong, and those who believe them are mental incompetents at best. This unquestioned belief manifests itself in phrases like, 'As usual the cock-up theory of politics turned out to be true.' Belief in the cock-up theory of history and politics is at the heart of

218

what passes for political and intellectual sophistication in liberal democracies like ours. Public genuflection before the cock-up theory of history shows that one is serious - sound; aware of the inevitable incompetence of human beings. The subtext here is: only the ignorant simpletons believe the world can be explained by conspiracies."

Simpletons, yes--and the mentally unstable. I have pointed out many times that watching Mel Gibson or Nick Nolte, or even the dorky threesome in the old *Lone Gunmen* series, in these kinds of roles must be what it's like for African Americans to see Steppin' Fetchit on the screen. (Interestingly, one black actor, Will Smith, has a cultivated public relations perception as being part "conspiracy theorist", but also wraps the laughter curtain around the topic.) Only this time the stereotype is a cartoon of everyday people, who should and most often do have an opinion, a speculation or some little known facts about public events and their parapolitical underpinnings.

The cock-up theory in *The Hulk*, of course, is that mad scientist Nolte has no rational gripe against the world, just a "cocked up" genetic experiment. Then *Parade* magazine ran this Q&A over the last weekend:

Q: Has Nick Nolte cleaned up his act since the paparazzi got that shocking photo of him being hauled out of his car by cops?

A: Yes. Nolte, 63, is out of rehab and in the new film, The Hulk, in which he plays the hero's dad. The actor admits being under the influence of a drug when photographed last September but also claims he was still inhabiting his slovenly Hulk character a week after the film wrapped. Preposterous? Perhaps, but it's common for actors--especially those as intense as Nolte.

It does sound like a lame excuse for a GHB binge, but I can no more dismiss it than I can what his character is actually saying in that movie. Perhaps Nolte got carried away by the verisimilitude of the role.

The Hulk has another conspiracy attached to it, however. It concerns creator rights and falls under the category of "conspiracy as usual" - i.e. the daily corporate theft and exploitation of the creative work of others. Jack Kirby is the comic book artist who created the *Hulk*. He also created the *X Men* and *Spiderman* and any number of other comic book characters that turned Marvel Comics into a corporate entertainment bureaucracy. Kirby labored under work-for-hire, page rate conditions as an artist and did not get even a microscopic fraction of the billions of dollars his creations made in decades of merchandising, especially now with these blockbuster movies.

Kirby died in 1994 and his estate seems to have little interest in correcting this enormous wrong. Even Stan Lee, who had an at-best nebulous connection to Jack Kirby's work in the 1960s, has sued Marvel for a bigger share of the *Spiderman* movie profits, complaining on *60 Minutes* about the same work-for-hire contracts that left Kirby shut out, although Marvel pays Lee a salary that makes him a millionaire.

On that same *60 Minutes* broadcast Lee claimed falsely that he thought up *Spiderman* while watching a fly climbing a wall. "I've told that story so many times," said the admittedly charismatic Lee, "that it might even be true." It isn't, of course, and *60 Minutes* leaving it unchallenged is another "conspiracy as usual" by that bastion of in-depth investigative reporting.

Kirby's artwork also factored in on a spy and conspiracy story surrounding the 1980 hostage crisis in Iran. That story is told in the current issue of *Steamshovel Press*. Readers will be happy to learn that the issue is in the mail. In addition to the Kirby conspiracy, the issue includes a new

interview with John Judge; Jim Martin on Wilhelm Reich's connection to the MJ12 UFO group; satire from Len Bracken; Acharya S untangling more lies of Christianity; more from me about Jim Keith and the Octopus; Chica Bruce on the Philadelphia Experiment; and much more. Jack Kirby's art graces the cover.

There's some crazy stuff in that issue. Readers should be forewarned that they may walk away from it ranting deliriously about the world it exposes.

"Michael Kelly and the Conspiracy Fusion"
by Kenn Thomas

Michael Kelly made a final distinction on his vitae: he became the first US journalist killed in the Iraq war. Prior to that, his career spanned the gamut of opinion magazines, starting with the *New Republic* (holding the same job once held by Michael Straight, a now confessed spy who had a hand in the persecution of Wilhelm Reich), including the *New Yorker* and *National Journal*, a regular column for the *Washington Post*, and winding up with *Atlantic Monthly*, where he served as editor in chief before becoming "embedded" with the third infantry in Iraq. He died there on April 4.

"Embedding" with the military was only the latest, most egregious example of the press whoring to the Pentagon, and Kelly's contribution was hardly distinguished in that sense. Previously, Rob Sterling's *Konformist* listed Kelly as a co-recipient of its Beast of the Month award to note "his hack work ensuring the swindling of the presidency"--for Kelly's anti-Clinton writing--and noted with that to his credit Kelly died in a war he helped promote. No one yet has placed Kelly on the mysterious Clinton-related deaths list, but some mystery still surrounds the circumstances of his passing. Reports suggested it resulted from a Humvee accident that happened in an attempt to avoid enemy fire, but in other

reports military officials concluded it had not been combat related.

One quote appearing in the news stories about it reflected the irony of Kelly's under-abundant paranoia about the chaos and injustice of war: "There is some element of danger, but you are surrounded by an Army, literally, who is going to try very hard to keep you out of danger." It is precisely that effort that led to many friendly-fire deaths in this conflict.

Kelly and I spoke once about the Clinton death list. He interviewed me, in fact, for an article that appeared in the June 19, 1995 issue of *The New Yorker* entitled "The Road To Paranoia". It focused on Robert Fletcher of the Militia of Montana. Rather than the wild-eyed caricature of such people very common in the media at the time, Fletcher was a grandfatherly type, well versed in conspiracy literature and articulate, who believed that ideologies of the left and right "must converge to fight their common enemy--the governing elite."

Kelly coined the phrase "fusion paranoia" to describe Fletcher's idea, specifically as it related to the alternative media, for which, I provided him a list. According to Kelly, such "fusion" paranoids "meet in *Paranoia*, the magazine. They also meet in such publications as *Flatland, Spotlight, The New Federalist, NEWSPEAK, Kattazzzine, Steamshovel Press, Nexus, Crash Collusion, Behind the Barriers, Conspiracy Update, The Probe, The Eye, Incite Information, EXTRAPHILE, Flashpoint, Trajectories*; in publishing houses such as IllumiNet Press, III Publishing, Victoria House, SPI Books, Aries Rising Press, Feral House; in the bookstores-by-mail of America West, Flatland Books, and the Ruling Class/Conspiracy Research Resource Center; in computer databases such as *CIABASE* and *NameBase*; on the Internet in the news-groups **alt.CIA** and **alt.conspiracy**." If it was good for nothing else, at least Kelly's writing provided a snapshot of a heady period, eight years ago, when reading in this area

was abundant. Jim Keith and I took this idea of "fusion paranoia", which was later utterly eschewed by *Konformist* Rob), and made it the basis of a radio discussion that *Steamshovel* now makes available on CD ($7, post paid, from POB 210553, St. Louis, MO 63121 --checks payable, as always, to "Kenn Thomas" not "Steamshovel Press").

In the eerie coincidence department, another journalist casualty of the Iraq war, NBC's David Bloom, died of a pulmonary embolism that may have resulted from a knee thrombosis due to the cramped conditions of his "Bloom mobile" reporter's vehicle. Officially, Jim Keith died that way as well, of a knee injury that led to an embolism.

Kelly's conclusions at the time were relatively generous, especially in light of the caustic conservative he later became. Of the fusion paranoids, he remarked: "They question everything, and believe nothing but what is proven to their own satisfaction, until they have refigured the world. In this way, truth lies. Unfortunately, so does madness." People like Fletcher, Kelly determined, "are undone by an excess of expectation and a dearth of imagination, by the failure of their country to live up to itself, and by their own failure to explain how this can have happened."

Strange how those words might apply to Kelly himself now.

Below is the relevant excerpt from Kelly's New Yorker *article on fusion paranoia.*

"Fusion Paranoia"
by Michael Kelly
***New Yorker*, June 19, 1995**

"They call us radicals," Robert Fletcher said. "How come they don't call Bill Clinton a freaking radical for passing an executive order to steal twenty-one billion dollars from the American people, telling their Senate and Congress to go to

hell, and sending it to his Mexican banking friends?... We don't want to hear about left and right, conservative and liberal, all these bullshit labels. Let's get back to the idea of good guys and bad guys, righteous government--the honest, fair, proper, American government that all of us have been fooled into believing was being maintained."

Fletcher's conviction that the right and the left must converge to fight their common enemy-the governing elite-is the guiding philosophy of the rapidly growing alternative media that traffic in conspiracism. Here, the conspiracists put aside their ideological differences and meet in paranoia.

Literally, they meet in *Paranoia*, the magazine. They also meet in such publications as *Flatland, Spotlight, The New Federalist, NEWSPEAK Kattazzine, Steamshovel Press, Nexus, Crash Collusion, Behind the Barricades. Conspiracy Update, The Probe, The Eye, Incite Information, EXTRAPHILE, Flashpoint, Trajectories*; in publishing houses such as IllumiNet Press, III Publishing, Victoria House, S.P.I. Books, Aries Rising Press, Feral House; in the bookstores-by-mail of America West, Flatland Books, and the Ruling Class/Conspiracy Research Resource Center; in computer databases such as *CIABASE* and *NameBase*; on the Internet in the news-groups alt.CIA and alt-conspiracy.

Some of these entities are old and established, and represent an identifiable ideological point of view, some of them are on the extreme edge of paranoia, while others are more or less sober in content and tone. But most of them are only a few years old-upstarts of the information highway-and the most interesting of them are radical and explicitly fusion-oriented, rejecting the right-left dichotomy. Three on the cutting edge-and a strange place that is are *Steamshovel Press*, *Paranoia*, and *Flatland*. These magazines are essentially of the left, but they publish and advertise much of what the right has to offer, too, as long as it is conspiracist, radical, and anti-government. They present the world according to Noam Chomsky and Jerry Rubin and Timothy

Leary and Oliver Stone and William Burroughs and Ramsey Clark and Allen Ginsberg. They also present the world according to the John Birch Society and Lyndon LaRouche and Nesta Webster and the Holocaust revisionist Eustace Mullins and retired Lieutenant Colonel James (Bo) Gritz, the far-right conspiracist-populist-survivalist of Almost Heaven, Idaho.

In this world of pure fusion paranoia, the Jonestown massacre is linked to the murder of Martin Luther King, Jr., Woodstock never happened (it was faked by the media); J. Edgar Hoover set up Teddy Kennedy at Chappaquiddick; government agents are brainwashing Americans through drugs and mesmeric techniques; Dan Rather's "Kenneth, what's the frequency?" mugging is traced back to the *CBS News* anchor's "extremely curious behavior in Dallas, Texas, on November 22, 1963"; Newt Gingrich is a secret Rockefeller Republican; AIDS is a government plot to kill off blacks and homosexuals; and the environmental movement masks a plot by the Rothschilds to gain control over all the land on the planet.

There is no left and no right here, only unanimity of belief in the boundless, cabalistic evil of the government and its allies. In a characteristic *Paranoia* article, the writer Mark Weston argues a New World Order theory quite similar to that of the rightist militia movement-a "shadow government" operating behind the scenes, George Bush and Bill Clinton as puppet Presidents, the Gulf War as a vast scam to enrich the Bush family-except that Westion is coming at the subject from the vantage point of hippie nostalgia…"

Casolaro Continued
Fortean Times, 2003

Just before he mysteriously turned up dead in 1991, in Martinsburg, West Virginia, writer Danny Casolaro gave the

name 'The Octopus' to a cabal of international power brokers and to the book he planned to write about it. Jim Keith and I entitled the book we wrote about Casolaro and his research *The Octopus*; the concept has had a surprising durability, and the original edition now commands a hefty price tag at online book services.

For Casolaro, the Octopus presented a complex web of intrigue involving a super-surveillance software called PROMIS; the inter-connection of various police services, intelligence agencies and organized criminal groups; and a large number of parapolitical operators, weapons brokers and dealmakers. All of this continues to have an impact on the post-9/11 world, with PROMIS figuring in many contempoary stories. The turncoat spy Robert Hanssen, for instance, sold PROMIS to Osama bin Laden and thus helped the world's top terrorist to elude capture. The geographic profiling system used recently to track the DC sniper came from the Royal Canadian Mounted Police, who were the first to purchase PROMIS on the black market.

More interestingly, Casolaro's Octopus wrapped its tentacles around Jim Keith, another writer who attempted to expose it. He fell off a stage at the Burning Man festival (a hippy happening in Reno, Nevada) in 1999, suffered a knee injury and was taken to hospital. It later declared that Keith had died of a blood clot on the operating table after treatment. Fans of conspiracy literature mourn Keith, who wrote well-known books such as *Black Helicopters Over America, OKBomb!* and *Biowarfare in America*, and had a long pre-Internet history of circulating conspiracy stories through small press zines such as *Dharma Combat* and *Notes from the Hangar.*

Conspiracy speculation about Keith's 'accident' was rife, of course. Had it something to do with the column he announced he was writing which would name the physician who could establish that Princess Diana was pregnant when she died? No official investigation ensued, and skeptics

attributed the rumors to imaginative fancy, as they did for most of Keith's published output. It nevertheless remained true that Dodi Fayed's uncle, Adnan Khashoggi - an Iran-contra arms dealer in whom Casolaro had an intense interest - appeared in the background of the Diana crash story.

Then the state of Minnesota cancelled all knee surgery for a brief period after three patients died: Cryolite, a tissue bank outside of Atlanta, Georgia, was found to have supplied cadaver tissues tainted by a form of clostridium bacteria. Keith's passing had long been old news and no one checked to see what procedure had been done on his knee. He had died of a blood clot, after all.

Feral House published the *Octopus* book I co-authored with Jim Keith, but most of his other books were published by IllumiNet, a small but well-respected press near Atlanta. One night last April, IllumiNet's owner, Ron Bonds, returned from a Mexican restaurant and died, poisoned by clostridium bacteria. A lawsuit against the restaurant is pending, but nothing has been said about its proximity to the Cryolite tissue bank.

This is the kind of coincidence chain for which conspiracy theorists are famous. Add that in his biowarfare book Keith wrote about Larry Harris, who was busted by the FBI for anthrax possession in 1998. According to Keith, Harris claimed that an attempt had been made on his life with a needle containing a cobra venom which could induce blood clots in the lung. Keith had previously written at length in Fate magazine about the CIA's warehousing of a large supply of - what else? - clostridium bacteria.

The best final footnote to the strange tale of Casolaro's Octopus would have been that Keith had sounded the clarion call about biowarfare in his 1999 book, Biowarfare in America. Unfortunately, there would be another. In June 2002, the body of Jim Keith's former wife was found on an interstate highway in Reno, Nevada; though the cause of death has not been determined, the police suspect murder.

The circumstances looked very much like the kind of murders Casolaro had himself investigated at the Cabazon Indian reservation, where the PROMIS software was first developed.

The Octopus, 2004
by Kenn Thomas

Here's a quick refresher paragraph on the Octopus:

> Danny Casolaro was "suicided" in 1992 on the trail of the mother of all conspiracies, a transnational cabal manipulating world political events since World War II called The Octopus. Key to his research was a super-surveillance software called PROMIS, which was given to a crony of Ronald Reagan's as a pay off for the deliverance of $40 million to the Ayatollah Khomeini for the "October Surprise" -- holding on to the 52 American hostages in Iran until after Jimmy Carter lost the 1980 election. The crony profiteered from PROMIS (really owned by a company called Inslaw) by selling it to police agencies throughout the world for the purpose of tracking criminals and extrapolating their next moves.
>
> Feral House plans a new edition of the book *The Octopus: Secret Government and the Death of Danny Casolaro*. Casolaro's own notes - those that didn't disappear the night he died - provided the basis of the book, which I co-wrote with another celebrated conspiracy writer, Jim Keith. That first edition came out in 1996 and is now a bit of a collector's item, costing about $100 on **amazon** if you can find a copy.
>
> Like all great conspiracy writers, Casolaro was dismissed as a paranoid crank. The book's existence as a kind of cult classic testifies to how cutting-edge parapolitical insight is pushed into an underground of the few who care to know. It's re-emergence now, however, has an eerie, although

not unsurprising, parallel with events and people easily recognizable to the wider world. The Octopus, the real one, has returned just in time for the book.

Example one: shortly after the Afghanistan war stories began circulating that Osama Bin Laden was using the PROMIS extrapolation function to avoid capture. According to these stories, it was given to him via a circuitous route from the Russians who got it from the famed turncoat spy Robert Hanssen.

Example two: the June resignation of Paul Redmond, Assistant Secretary of Information Analysis for the US Homeland Security department. Described by some as a "legendary spy catcher" - he had a role in the capture of CIA traitor Aldrich Ames - Redmond officially resigned for "health reasons." Most took that as polite cover for Redmond's frustration with under-funding of the department, but others connected into to a rumored secret investigation Redmond was conducting of long-standing common interests between the Bush and bin Laden families and was forced to resign. Among the connections: PROMIS, also had been given to Saddam Hussein by the senior Bush in the early 1990s, and he too now uses it to avoid capture. Danny Casolaro had reported that Iraq was among the countries that originally purchased the software illegally.

Example three: Casolaro had also written about John Poindexter, one of the few people convicted in the Iran-contra scandal, a trading-with-the-enemy affair that grew out of the October Surprise. An appeals court overturned his five 1990 felony convictions, however, and more recently Poindexter was appointed head of a new information technology unit of the Defense Advanced Research Projects Agency, the Pentagon agency that developed the internet. This new DARPA unit was called Total Information Awareness. Symbolized on its website and on a wall decoration in Poindexter's office by an eye over a pyramid - a tip of the hat that he worked for secret masters -- it's purpose was to further

develop PROMIS-like software that could track every detail of every American citizen's life.

In July, Poindexter was forced to resign from the administration when it was discovered that DARPA's TOI also was developing a futures trading market based on the prediction of terrorist events. Of course, a short-selling spree on the real market made a fortune for someone just after the destruction of the World Trade Towers, so someone was already pretty good at predicting terrorist events.

Examples four and five: the central conspiracy that concerns even the major media now is the role of the Saudis in the 9/11 disasters. Casolaro had written about the al-Yamama aerospace contract umbrella that keeps US and British money flowing into Saudi Arabia. He focused on the career of arms merchant Adnan Khashoggi, who helped develop the contracts, and his partner, Manucher Ghorbanifar. Back in March, because of meetings Khashoggi set up with Bush defense adviser Richard Perle to privately profiteer from the still pending war in Iraq, Perle was also forced to resign. This month it has been reported that Pentagon underlings for the Undersecretary of Defense Douglas Feith, have been meeting with Manucher Ghorbanifar, unauthorized by Dubya, of course.

The pattern of resignations is erupting around the edges of the Octopus entity that Casolaro began to delineate back in the late 80s/early 90s. The low-level, limited hang-out resignations more or less shield the central creature from true exposure. The compliant press helps with that, of course, not having enough historical memory to see the pattern. The only memory it has of Danny Casolaro is that he had whacky conspiracy "theories".

The new book looks at all of this and much else concerning The Octopus, Casolaro's original research as well as how it illuminates what now goes on in the post 9/11 warfare world.

Conspiracy and Credibility in Minneapolis
By Kenn Thomas

At the opening reception for the Midwest Popular Culture Association conference recently in Minneapolis, the discussion turned to David Kelly, the UK's Ministry of Defense adviser found dead of a slit wrist last July. I gave my opinion that Kelly - a high profile whistle blower over the false data about Iraq's weapons of mass destruction used to justify the war - was murdered. A woman from the Netherlands assured me that she followed the European press more closely about this and that Kelly indeed had committed suicide, the view of Kelly's death most charitable to the Blair administration.

When dealing with the parapolitical, individual opinions rarely coincide and even agreement on the facts is rare. I maintained that neither of us had an absolute certainty about Kelly. We were flanked on my side by speculation and a large pattern of facts (the microbiologist death list), and on hers by official conclusions and what runs in the press. We did agree on one thing: not much functional difference exists between murder and driving someone to suicide.

But the nuance of difference in our views colored the rest of the conference proceedings. Presenters for the most part simply explored themes and social reflections found in various aspects of popular culture, but occasionally it turned to the parapolitical. Obviously, this was true of the panel I chaired on conspiracy culture. One member of the audience, a *Steamshovel* fan of long standing, effectively challenged Jerry Lembcke, a panelist who wrote the book *CNN's Tailwind Tale: Inside Vietnam's Last Great Myth*, a well done examination of media distortion. While the book has a lot to recommend it, its author often makes his points by receding

231

into the vagaries of "institutional analysis", the facts-avoiding tactic advocated by Noam Chomsky.

To describe parapolitical research, Lembcke uses terms like "conspiracism", a word that Fletcher Prouty pointed out long ago contains the subtle smear of "racism" within it. Lembcke also labeled Prouty "right wing", as he did people like Michael Ruppert and Jeff Rense. To my great pleasure, the *Steamshovel* reader had my co-panelist trace this line of reasoning to the absurd point where he actually declared Peter Dale Scott "right wing" as well.

John Stauber, the director of the Center for Media and Democracy in Madison, Wisconsin, gave the keynote address on how the Bush administration uses public relations propaganda to promote the Iraq war. His book, entitled *Weapons of Mass Deception* (co-authored with Sheldon Rampton), rightly blasts such Dubya newspeak successes as convincing the American public that Iraq was behind the 9/11 attacks, although the book doesn't use the term "brainwashing".

I had lunch with Stauber just before he took the dais and we talked conspiracy. He explained that he knows Jim Fetzer, author of the highly regarded book, *Assassination Science.* Stauber seemed genuinely interested in news that the new LBJ-did-it book was written by the father of the current White House press secretary. He even seemed open to such notions as Paul Wellstone possibly being assassinated, although he more or less rolled his eyes at that as well as some of Fetzer's more startling conclusions. Parapolitics never rose to the level of a mention in his keynote speech, however.

Stauber instead told the assembled that public relations is a business practice that tries to put a credible face on scams and screw jobs. He recalled an example from work on his previous book, *Toxic Sludge Is Good For You,* when a PR firm tried to convince him that the poisonous pollutants of solid waste are actually "recyclable bio-matter". I wondered,

though, to what extent Stauber could not really talk about parapolitics because of its label: "conspiracy theory". He only discussed the parapolitics of the public relations world that was digestable to his moderately progressive audience. These people would probably never get acquainted with the work of Jim Fetzer or the significance of the new LBJ-did-it book. As "conspiracy theory" books, both no doubt lacked credibility here.

The search for credibility haunts the opinion industry, left and right. Jerry Lembcke defined respected conspiracy writers as "right wing" - not just people whom he felt had it wrong - because it helped establish his credibility as a critic coming from the left. Stauber had little to say about parapolitics as a broadstroke concept, even though his work studies it in detail. If someone called him a conspiracy theorist, it would tarnish his politics.

The artificial infamy of that term, "conspiracy", is one public relations success that is often overlooked.

PRESIDENTIAL PARAPOLITICS

Fortean Times, December 2004

Presidential elections provide one obvious reason for the durability of conspiracy theories in the US; after all, few of them in the living memory of most Americans have been decided by anything *but* conspiracy.

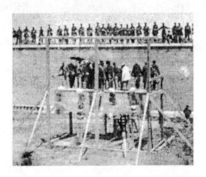

Historically, great heroes of the office, like Abraham Lincoln, have actually gained in stature as victims of conspiracy, so it's ironic that under the modern presidency the topic almost became taboo. In 1865, the US government convicted eight people for their parts in the conspiracy that killed the Great Emancipator; by 1963, it refused even to acknowledge one additional gunman in the death of John F Kennedy. The shift signified more than the US government having become less resolved to prevent a corruption of its electoral process. For American voters, it meant a creeping cynicism about the office that, by the year 2000, had them settling for a resolution of the presidential contest in court rather than at the ballot box.

With the second George Bush in the White House, the seeds of presidential conspiracy reached full fruition. The dawn of Dubya heralded the first American presidency gained by judicial appointment rather than free election, and by a candidate who campaigned in opposition to what he called "activist" judges who reshape American laws for the sake of special interests. This contradiction alone provided enough of a heads-up to convince liberals and conservatives alike of a serious aberration in the traditional American route to power. And that was just the start. By the end of his first term, Bush had brought the country to war by means widely acknowledged as at least quasi-conspiratorial, from public miscues about Iraq's connection to Al Qaeda to the outright falsehoods concerning weapons of mass destruction. Public debate in America became more than one of mere dissent over policy – it turned into a popular culture in which charges of conspiratorial corruption surrounded just about every public issue, with some of the citizenry becoming convinced that the Bush administration itself was responsible for the biggest horror in American history: 9/11.

The stakes may be higher than ever before, the parapolitical agendas more brazen, but looking back over the last half-century of American political history reveals a vein of conspiracy running through every presidential term, and usually outlasting it. From the vantage point of the current election, perhaps we can learn something by tracing these less-than-savory threads back through presidential history.

GEORGE BUSH THE FIRST

George W Bush, of course, is the son of former President George Bush, the former head of the CIA and, in turn, also the secret agency puppet master behind Ronald Reagan for two terms as vice president, perhaps even reining in the runaway popularity of his boss via the tried and true

CIA technique of assassination. Strangely, one of his sons, the brother of the current president, was scheduled to have lunch with the brother of the would-be Reagan assassin on the very day of the assassination attempt. Conspiracy history also has it that the first President Bush built up the military power of Saddam Hussein only to knock it down via parapolitical manipulation. Under Bush I, the diplomat April Glaspie gave Saddam a green light to invade Kuwait, precipitating the first Gulf War.

Sources:

"Bush son had dinner plans with Hinckley brother before shooting," *AP,* March 31, 1981.

Cole, Carleton, "US Ambassador to Iraq April Glaspie," *Christian Science Monitor*, May 27, 1999

REAGAN AND IRAN-CONTRA

The Gulf War came on the heels of the Iran-Contra scandal investigation, a carry-over from other conspiracies under the late US president Ronald Reagan. Reagan's team had sold arms to the enemy Iranians in exchange for the release of hostages and diverted the profits to an illegal war in Nicaragua. That scandal ended under the

administration of George Bush I with few serious prosecutions. One such, John Poindexter (whose convictions were later overturned in court), served in the second George Bush's administration, in a spy office called Total Information Awareness. He was forced to resign after a public scandal erupted over a system he'd developed to profiteer on stock market speculation about terrorist activity. Poindexter was just one of several Iran-Contra players to serve under George Bush II.

Sources:

"John Poindexter: Place Your Bets," *Newsweek*, August 7, 2003

www.fas.org/news/iran/1992/921224-260039.htm

CLINTON AND MENA

The president sandwiched between the two Bushes, Bill Clinton, could also be regarded as an Iran-contra alumnus according to conspiracy critics. Long before his celebrated sex scandals, Clinton was known for his role in covering up a guns-and-drugs transit route between Nicaragua and the little town of Mena, Arkansas. The operation was one of many run by the most notorious Iran-Contra convict of them all, Oliver

North. Prevention of any serious investigation of the Mena airstrip by the then Arkansas governor established for Clinton his credentials to hold national office, or so the story goes. When the first George Bush decided to recede into the shadows after four years of glaring publicity, he could only hand over the reins to a full-blown player in the Iran-Contra cover up.

Source:

Arbanas, Michael, "Truth on Mena, shrouded in shady allegations; drug smuggling rumors won't die," *Arkansas Gazette,* December 22, 1980

REAGAN AND INSLAW

Iran-contra actually had only continued a pattern of sleeping-with-the-enemy arrangements begun under the new era of conservatism ushered in by Reagan. This stemmed from the infamous "October Surprise", a secret arrangement with the Ayatollah Khomeini to have Iran hold on to 52 American hostages until after the 1980 presidential vote. The hostages were released on the very day Reagan was sworn in.

The pay off to the Ayatollah added up to $40 million, according to some conspiracy researchers. The man who delivered the money was given the super-surveillance software called PROMIS to sell to police agencies worldwide. This ended in the Inslaw scandal, a Rosetta stone of modern presidential conspiracy uncovered by writer Danny Casolaro just before his mysterious death.

Source:

Kenn Thomas and Jim Keith, *The Octopus: Secret Government and the Death of Danny Casolaro,* Feral House, 1996.

JIMMY CARTER AND AL QAEDA

Jimmy Carter retains his image as a nice but ineffectual man, even to the conspiracy minded. Although he back-pedaled on investigating the UFO issue after telling of his own sighting, the tinge of conspiracy was otherwise strangely absent from his administration. Some complained about his membership of the Council on Foreign Relations,

but Carter came to office as the alternative to the possibility of a freely elected Gerald Ford. Ford's secret deal to pardon Richard Nixon's well-known conspiratorial crimes made that possibility remote, and Carter's election may represent the largest measure of fair-play found in 20th century American presidential elections.

As president, however, Carter made his contribution to the present-day global conspiracy culture of state-versus-terrorist competition (as opposed to the old conspiracy culture of Cold War superpower competition.) Another CFR stalwart under Carter, national security adviser Zbigniew Brzezinski, asserts that in July 1979 Carter signed the first directive to order secret aid to opponents of the Soviet puppet regime in Afghanistan, a half year prior to the USSR's actual military invasion of that country. That group became the *mujahaddin,* some of whom later evolved into al-Qaeda.

Source:

"The CIA's Intervention in Afghanistan: Interview with Zbigniew Brzezinski, President Jimmy Carter's National Security Adviser," *Le Nouvel Observateur*, Paris, January 15-21, 1998.

GERALD FORD, LYNDON JOHNSON AND JFK

Gerald Ford not only had pardoned Nixon, he had served on the Warren Commission investigation of the JFK assassination. According to some accounts, he back-channeled information to the FBI and helped direct the commission's investigation to the foregone conclusion of a single assassin. Even today, aged 90, Ford appears tireless in his attempts to prevent any other conclusion from becoming part of public discourse on the topic.

When the History Channel recently aired an installment of its *Men Who Killed Kennedy* series containing an examination of Lyndon Johnson's possible role in the conspiracy, Ford and two Johnson administration veterans asserted enough pressure to have it removed from broadcast. The TV show was based on a recent book by the father of the current White House press secretary, Barr McLelland, a fact that undoubtedly embarrasses the White House.

RICHARD NIXON

Richard Nixon, of course, resigned from office rather than face the wrath of law in response to his many conspiracies, most notably the 1972 break-in to the national headquarters of the Democratic Party at the Watergate hotel in Washington, DC. Historians seem to agree that the Watergate cover-up followed an amateurish crime and was totally unnecessary to Nixon's pursuit of power. Most Americans planned to vote for Nixon under the fatalistic view expressed in a common bumper sticker of the time: "Don't change Dicks in the middle of the screw! Vote for Nixon, '72!" Less cynical right-wingers lost their candidate, George Wallace, to an assassination attempt later traced to elements within Nixon's campaign team. Some have argued that Nixon

was set up for a fall at Watergate, pointing to the fact that the door at the hotel had been duct-taped open, essentially inviting the police in to discover the burglar operatives.

Nixon came to power in 1968 after the landside defeat of Hubert Humphrey, an affable, ineffectual Jimmy Carter prototype, although before his spell as LBJ's VP, he was known as a major figure in the Liberal wing of the Democratic Party. Riots broke out at the Democratic National Convention in Chicago that year because the Democrats had an even worse Vietnam plank on its policy platform than did the Republicans. The "Yippies", led by Abbie Hoffman and Jerry Rubin, had agitated for protest and political theater and Chicago mayor Daly had satisfied paranoiac fears by sending the police in with billy clubs to attack peaceful protesters— neither the first nor the last such "police riot" to occur in the 1960s. Humphrey was the Democratic candidate by default, after the assassination of peace candidate Robert F Kennedy during the primary election season. Five years previously, of course, the great conspiracy at the heart of all modern presidential elections took place – the JFK assassination.

Sources:

Colodny, Len and Gettlin, Robert, *Silent Coup: The Removal of a President,* St. Martin's Press, New York, 1991.

Krassner, Paul, "A Tale of Two Conspiracies," *Exquisite Corpse*, March 2000.

JOHN KERRY, THE NEW JFK

Presumably much of this history still resides somewhere in the famously limited attention span of the American voter and, perhaps, in the 2004 election, visual cues may trigger these memories. Another Boston Brahmin Catholic with the initials JFK and hair piled high now seeks national office. John Kerry's position on the hated Iraq war – a war widely regarded as the product of lies and conspiratorial manipulation exploiting the 9/11 disasters – is much like that of the Democrats on Vietnam in 1968: a call for increased troop strength in the region. The original JFK also had the image of a hard-liner, though, and now popular lore has him as a secret dove sacrificed to a plan of withdrawal from South East Asia. Kerry has even made compromises similar to Kennedy's with America's southern conservatives to create an electable ticket. Kennedy chose the Texan Lyndon Johnson as vice-president; Kerry chose North Carolina

senator John Edwards. To some, the question now facing the US electorate is not so much of whom it wishes to elect but of which conspiracy scenario it plans to re-enact. In the movies, at least, the answer to this question seems to be the mind control scenario.

THE OLD JFK AND
THE MANCHURIAN CANDIDATE

In the movies, the answer to that seems to be the mind control scenario. Transnational corporatism has taken the place of the original's international communism in the new film remake of *The Manchurian Candidate*, based on a novel by Richard Condon. Condon had concocted Condon's law: "When you don't know the whole truth, the worst you can imagine is bound to be close." The baddies in the 1962 John Frankenheimer movie made of his book were in fact Manchurian; in Denzel Washington's version they became the executives of "Manchurian Global", a corporate entity with less of a face even than vice-president Dick Cheney's real-life counter-part corporations, Haliburton and Carlisle. The mind control technology in the movie had been updated as well. The 1962 version had the brainwashed assassin responding to deep hypnosis; the new one uses microchip implants.

244

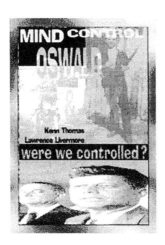

The idea of mind control implants dates back at least to Lee Harvey Oswald, however. In fact, the earliest rumors of such things arose shortly after JFK's assassination with regard to his killer. Oswald supposedly received an implant while living in the Soviet Union, under the guise of receiving an adenoid operation. The technology, known as RHIC/EDOM (Radio Hypnotic Intracerebral Control of the brain and Electronic Dissolution of Memory), did something to guide LHO's actions on November 22 according to a famous book, *Were We Controlled*, by Lincoln Lawrence. More recently, I put together a new edition of that book along with an extensive look at mind control technology going back to the 1930s, entitled *Mind Control, Oswald and JFK*. The *New York Times* once ran front page photos of a scientist named Jose DelGado stopping a charging bull using similar technology. It's good at stopping action, and Oswald always claimed he did nothing that day.

Sirhan Sirhan is the would-be assassin likely to have been hypnotized into his role, which also did not include shooting Robert Kennedy. But with regard to JFK, Frank Sinatra (who had Denzel Washington's role in the original) considered the topic of the original movie too sensitive to have it in continued release. For a decade it became very

difficult to find. Perhaps as a testament to the post-*X-Files* state of popular entertainment based on conspiracy ideas, this year American public television ran the original on the very night of the new version was released, on the weekend following the Democratic National Convention.

The pernicious difference between the two movies, however, involves the ending. The international Communist conspiracy is defeated at the end of the 1965 version. In 2004, lip-service has been paid to the defeat of Manchurian Global, but ultimately the Conspiracy rules. Denzel Washington defeats his programming and instead shoots two of the bad guys, but his arrival on the scene has been captured by security surveillance video. High tech operatives replace the video image of Washington's character with that of some transnational terrorist, a baddie for sure but nevertheless not the true killer. The mind-control technique that forced the assassin's hand remains a safe secret in the hands of the authorities. This has become a familiar reprise in movies feigning to expose conspiracy. They instead replace cowboys in white hats for men in black suits. Mel Gibson's 1997 *Conspiracy Theory* movie provides the best example, where the hero finally sheds his crazy conspiracy notions and is brought in from the cold by secret government agents.

The subtle suggestion remains that the surveillance video manipulation in *Manchurian Candidate* suggests something similar with regard to the video released shortly after the 9/11 commission findings showing the hijackers going through airport security. Is that really what's on that tape? That's quite subtle, though, and the movie was produced long before the 9/11 commission. Subtle, too, is the use of a version of John Fogerty's song, "Fortunate Son", a title shared by J. H. Hatfield's 2000 biography of a cocaine-adled Dubya Bush. Hatfield wound up mysteriously dead as well. Surely all of this reverberates with the movie audience, as must the name similarity between Washington's character Bennet Marco and Washington DC sniper Lee Boyd Malvo.

It's not the first eerie coincidence of names with regard to *Manchurian Candidate.* The original had Janet Leigh and Laurence Harvey and was missing only n Oswald.

CAPTAIN AMERICA's BICENTENNIAL CONSPIRACY

If conspiracy has corrupted hero Sgt. Malvo in *Manchurian Candidate,* not so Captain America. The good captain was fighting Nazis back in World War II, a creation of Jack Kirby (along with partner Joe Simon), a legendary figure in the American comic book industry who died in 1994 but who has now surprisingly re-emerged as the chronicler of conspiracy from the time of the US Bicentennial. One of Kirby's former employers recently released *Madbomb* as a graphic novel, reprinting a run of the comic book from 1976, the bicentennial year. (Weirdly, the original run of the comic at that time ended with issue #200.) Conspiracy was not a regular theme in Kirby's work, not one actually found too often in the popular culture at all prior to the *X-Files* -- recall the decade-long suppression of the original *Manchurian Candidate* -- and so it is doubly surprising to rediscover it in

this collection. Like *Manchurian Candidate*, *Madbomb* involves a mind-control weapon.

This one, however, more accurately reflected the emerging "paranoid" complaints of the "wavies", a large number of American citizens who felt they had been harassed and victimized by directed microwave weapons designed to destroy their minds. After the tumultuous politics of the previous decade, many people in America thought they were going crazy and began attributing it to a developing new and secret technology. Kirby imagines this as a weapon of mass destruction, alludes to conspiracy on every page and includes Men In Black and underground bunkers in the "western badlands" in a way that prefigures remarkably the 1980s stories about Area 51 He even includes the master conspiracy bugaboo Henry Kissinger as a character in the tale! Kirby himself worked under work-for-hire contracts that deprived him of the mega-billions in profits his creations, such as the X-Men, Spider-Man and the Hulk, now make for Marvel as

licensing properties and block buster movies, so he was not unfamiliar with conspiracy.

Bearing all this in mind, one clichéd dictum sums up the presidency of George W. Bush: *past is prelude*. While most conspiracy theories eventually end tangled in increasingly complicated trails of evidence, the various suspicions and speculations about Dubya begin there. Critics had only just begun to sharpen their pencils over the apparent conspiratorial scam of the 2000 election when the terrible events of 9/11 occurred. What happened in the wake of that boggled even the labyrinthine minds of seasoned conspiracy watchers. George II was not just transformed from slow-witted "fortunate son" to inept president; for many, he became the malevolent force at the center of every twist and turn in the ensuing conspiratorial tornado.

DUBYA AND DIANA

Michael Moore's infamous movie *Fahrenheit 911* made its claim on the conspiracy cognoscenti by offering information about a man named James Bath. Moore presents documentation that Dubya and Bath served in the military together. Conspiracy fans have long known Bath as a money conduit between the Saudis and baby Bush, a connection most notably spelled out in a book by Peter Brewton entitled *The Mafia, CIA and George Bush*. Bath was, in fact, closely associated with Adnan Khashoggi, an arms merchant linked to Iran Contra (written about by the aforementioned Danny Casolaro) and also Dodi Fayed's uncle, suspected by some conspiracy watchers as having a hand in the deaths of Dodi and Princess Diana. Khashoggi brokered the al Yamama contract umbrella, a series of contracts covering the deals between the Saudis and the British aerospace industry; this, in turn, might help explain why Tony Blair has been in lockstep with Dubya over Iraq.

Sources:

Brewton, Peter, *The Mafia, CIA and George Bush,* SPI, New York, 1992

Thomas, Kenn and Keith, Jim, *The Octopus: Secret Government and the Death of Danny Casolaro*, Feral House, Second Edition, 2004.

DUBYA AND THE BIN LADEN FAMILY FLIGHTS

Much has rightly been made of the planes that took Bin Laden family members out of the United States when all other air traffic was stopped after 9/11. Michael Moore, for instance, has been criticized (by Christopher Hitchens, for example) for not mentioning that the person who claims

responsibility for approving those flights was Richard Clarke. Clarke later became a great critic of the Bush administration, particularly with regard to its failure to do anything about terrorist threats prior to 9/11. The Clarke/Bin laden plane connection actually *is* made, but only in a background newspaper article seen on screen in Moore's movie. Hitchens' criticism made about as much sense as Moore's off-screen defense of Clarke: what difference does it make which functionary of the administration approved such a bizarre and suspicious thing?

Source:

Hitchens, Christopher, "Unfairenheit 9/11: The Lies of Michael Moore," *Slate,* June 21, 2004.

DUBYA AND THE PLANE CRASHES

Fahrenheit 911 also mentions the death of Mel Carnahan, the governor of the Midwestern state of Missouri, in an unusual plane crash during the 2000 elections. Carnahan

had been running against John Ashcroft, who failed to win even after Carnahan's death. Bush subsequently made Ashcroft US attorney general. Michael Moore's movie does not mention the even more unusual plane wreck that killed Minnesota Senator Paul Wellstone during the next congressional election year, resulting in a pivotal loss to Bush's opponents. Another eerie coincidence lurks further in the past: in 1976, a plane crash killed another Midwestern politician, Missouri's Jerry Litton, abruptly ending his favored bid for a seat in the Senate. It went instead to long-time Bush ally John Danforth, who remained there for nine years. Danforth served as a mentor to Justice Clarence Thomas, a key member of the Supreme Court that appointed George Bush president. Danforth is now Bush's nominee as US ambassador to the United Nations.

Sources:

"Ashcroft Unseated by Late Governor Carnahan," pbs.org/newshour/election2000/races/mo-senate.html

Niman, Michael, "Was Paul Wellstone Murdered?" *Alternet*, October 28, 2002

"Politicians Killed in Plane Crashes: August 3, 1976 – Missouri Rep. Jerry Litton (D)," **CNN.com**, Friday, October 25 2002

DUBYA AND THE ANTHRAX LETTERS

Although now most frequently criticized for uneven prosecutions under the Draconian new legislation known as the Patriot Act, John Ashcroft's earliest failures in the Bush administration promise to remain, at least until the end of its first term, the post 9/11 anthrax letters. In the December following the 9/11 attacks, moderately progressive office

holders such as Democratic senators Tom Daschle and Patrick Leahy, received letters tainted with deadly anthrax bacteria in a famous series of incidents that triggered wide-spread panic. Ashcroft's office has yet to find or prosecute anyone over these incidents. Just as with George Bush's inability to capture Osama Bin Laden, the situation raises dark suspicions about Dubya's crimes of omission and commission.

Source:

Kincaid, Cliff, "Anthrax Killers Still On The Loose," *American Daily*, October 10, 2003

DUBYA AND THE 9/11 SHOOT DOWN/STAND DOWN

The latter category includes the accusations of French author Thierry Meyssan that a plane did not hit the Pentagon at all on 9/11 (*L'Effroyable Imposture* (*The Frightening Fraud* and *Pentagate*), rather, that damage to the building was done by an unmanned drone aircraft or a Cruise missile. The popularity of this theory provides some measure of the extent to which George Bush has become *the* conspiracy president, and the belief that he has been able to pull off the boldest, most horrific crimes and yet retain an authority and power he has very little claim to. Even those who reject Meyssan's idea

nevertheless accept the notion of Bush's culpability for 9/11. Most current among moderate 9/11 conspiracy theorists is the proposition that the Bush administration let 9/11 happen as part of a political strategy to take advantage of terrorist incidents.

They find support for this in the public record going back to Bush's well-known malingering in a Florida elementary school after receiving first official word of the attacks. Vice president Dick Cheney claims that shortly thereafter Bush gave the order to shoot down commercial aircraft being used as part of the attack – an order given in time to stop the Pentagon-bound Flight 77. Military pilots say they never received such an order. Could these actually have been stand down rather than shoot down orders? Unlike many of the conspiracy charges leveled at George Bush's predecessors, that have passed unresolved into parapolitical lore, to the conspiracy minded this one impacts crucially on the current national election.

Source:

Bracken, Len, "Shoot Down Or Stand Down, A 9/11 Mystery," *Steamshovel Press* #21, Summer 2004

The 2004 US election has been described as a choice between the lesser of two Bonesmen, because both major candidates belonged at one time, some say the same time, to the secret fraternal group Skull & Bones during their time at Yale University. In the US, Republicans and Democrats are often seen as two factions of the same corporate party, but there is really no parity between the enormity of the conspiracy charges currently directed at Dubya and any public criticism of his opponent. John Kerry's biggest conspiracy so far seems to have been that he filmed his own heroic acts in Vietnam for later use in his political career. But the suspicions aroused by George W. Bush's administration

have pretty well ruptured any remaining American notions that conspiracy only bubbles up into public view on rare and isolated occasions. The facts behind 9/11 and its attendant wars remain hidden behind the parapolitical clouds, which are not likely to disappear no matter the outcome of the election.

JOHN JUDGE

9/11:

CONSPIRACY QUESTIONS AND COMMISSION OMISSIONS

INTERVIEWED BY KENN THOMAS

John Judge has been a scholar of parapolitical activity for decades, having been raised in the shadow of the Pentagon and educated by the very model of conspiracy researchers, his friend and mentor Mae Brussell. Over that time, his role as a social critic has taken on many forms, not the least of which included the successful effort to liberate long withheld government files on the JFK assassination. That effort culminated in the Assassination Materials Disclosure Act of 1992. Judge's group, the *Committee for an Open Archives*,

255

was instrumental in lobbying for the passage of that act, and his assemblage of fellow researchers brought new depth to public understanding of JFK's murder. The group evolved into the *Coalition On Political Assassinations*, which now regularly conducts conferences in the cities where major assassinations of the 1960s took place--Dallas, Los Angeles and Memphis—bringing together the most credible forensics and legal specialists with the most knowledgeable scholars and many surviving witnesses to the tragedies. Judge now struggles to make a similar effort to root out the parapolitical dimension of the 9/11 tragedies with his group, *911 Citizens Watch*. When *Steamshovel Press* caught up with him recently in Washington, DC, Judge was working on dissembling the pronouncements of the 9/11 Commission and identifying its multiple deficiencies. He agreed to spend an evening with *Steamshovel* editor Kenn Thomas reviewing various aspects of his current understanding about various aspects of 9/11.

Q: What's your take on exactly who is responsible for the events of 9/11. Who flew the planes into the buildings?

A: I don't think we yet know who is responsible for 9/11 on either the mechanical or the broader level. We certainly don't know who was on the planes and who the specific pilots were other than the assertions of the 9/11 commission to that effect, and the FBI report naming the 19 suspects. The FBI claimed that the list of names and pictures that came out so quickly after the attack was based on getting that information from the manifest of the airplanes and then somehow I guess having enough file information to have photos of all these people already themselves. But one has to wonder that if they had that kind of information on each of these individuals that they wouldn't have been tracking them before that. In any case, they pretty quickly put out both photos and at least they never released any extensive photos of any of these people coming through the security checks. We got pictures early on of

256

Muhammed Atta and one of the other plotters up in Logan airport coming through a security check. Finally, on the day that the report was released, we got security photos of two of the people getting on to Flight 77 at Dulles Airport but presumably either no other security pictures were taken, which doesn't make much sense since you'd presume they'd be taking pictures of everybody coming through, or they haven't released them. If they're trying to conceal these identities, that would make sense. It's not the case as some have speculated that none of them were on the planes or that no Arabs got on the planes. I have talked to ground crew at least on the American Airlines Flight 77 who later recognized some of the pictures of some of the people getting on to that plane at least.

Q: Of course, there are people who have come forward claiming that the names actually belong to them.

A: The problem is that we don't really know if that these are these people's real identity, even if the pictures match. The problem was that the airlines release manifests fairly quickly. They're required by law to release every name.

Q: They don't release the passenger manifest until everybody is aboard the flight and it takes off.

A: That's the internal release to Homeland Security. But a public release, after a crash of a plane that identifies who was on the plane, has to be released and made public at some point. They usually wait a period of several days or maybe a week while they individually notify the families but at some point they also have to post it publicly. If they leave names off of that manifest they actually can be sued by the families involved.

Q: And this release happened, right?

A: And this happened. I went immediately to the manifests on the American and United Airlines sites and pulled them down within two weeks of 9/11 to my memory. And in each case none of the nineteen names of the suspects were on the manifest. Also in each case when I counted the names that were there, and none of them were Arab names, they were short the total given for passengers and crew that died on the plane. In other words, if you would say 72 died on the plane, then 68 were listed and there were names missing when you counted the actual names. The number missing is consistent with the official story on three of the flights. The passenger manifests on three of the flights are short just the exact number of alleged hijackers in the official story. On Flight 77 the official story is five but there are six names missing in that manifest. That is also consistent with a statement named by Renee May, an airline attendant for American who called her mother. It's in the 9/11 Commission report but no weight is given to it apparently because it's contradictory to the commission's version. She told her mother that she had to call headquarters, she gave her a number to call for the airline, and said "tell them we're on the Dulles/LAX route, flight 77 and we are being hijacked." Then she said, "And there are six of them, mom." The official story is that there are five but the sixth is consistent both with the number missing from the manifest and from the number of names missing from a later, Pentagon-released list of bodies identified by a DNA search of all the remains. It was considered one of the most exhaustive and thorough DNA searches and they got 98% of the material from the bodies. That list also exactly matches the manifest list in terms of number of names and is six names short. None of the names on the DNA list match the conspirators or the alleged hijackers either.

Q: Given that, why is the official word that it there were only five hijackers on that flight?

A: Well, who knows? Are they concealing an additional hijacker's identity? Was Hani Hanjour not the pilot of the plane, being so incompetent? Was there, in fact, a sixth person who was more competent and able to do the maneuvers in the plane? Most pilots told me you'd have to be a very experienced pilot to do this dogfight maneuver around the Pentagon to come in so low, so fast. I don't know. The implication is that you've got yet one person on that plane that to this day has never been identified in any official or non-official version. The manifests to this day are also still short all of these names. There's been no subsequent release of any more names. Since the airlines can be sued for not releasing names, my assumption is that pressure would have had to have been put on them not to release them. That pressure apparently came from the government. I don't know where else it would come from because the corporate interest is not to get sued. So it came from outside, I would assume that would be the government, the FBI, or somebody in the investigation. If those names actually match the list of suspects that we were given, then shouldn't that mean that they would have been glad to list them? The pressure had been put on because whatever those manifest names are, they do not match those 19 hijackers, at least to some degree.

Now the second layer of the question is that we have seven people that have come forward, some in Egypt, some in Saudi Arabia, most in Saudi and they have said, "that's me! That's my picture, my identification, my name." In some cases they said that their identifications had been stolen in the past. They said, "I was not on the plane. I was not in the United States." Some had never been in the United States. Others were pilots, some of whom were trained in the United States. Five of the seven names of these people who came forward said "that's somebody using my ID, I wasn't on the plane" relate to a single company in Saudi Arabia, Saudi Airlines. It may not be

so surprising that people involved in a criminal enterprise or a covert operation would use false identity; they could be using false identity either to hide their identity or in a covert operation. The reason you would do it in that case is more primarily to give a false sponsorship to the event. In other words, use someone else's identity so that the wrong people would be blamed. But the report of the 9/11 Commission and the FBI's statements don't give any credit to these people. I've talked to some individuals who at second hand know people who know them and have spoken to them. The BBC interviewed them. Their pictures were shown in some cases.

Q: What does the commission report say about them? That they're simply not credible?

A: Nothing! The report doesn't mention them to one degree or another. It doesn't discount them. It just in just omits that they even exist or that the contradiction is there. Then the report proceeds to follow those 19 names, which we can't match to the manifest, which we only can rely on the FBI for, to trace them back in history, to a cell in Hamburg, to working in Afghanistan and being trained, to swearing fealty to bin Laden, et cetera. But if you have a stolen identity, you don't know six months prior then whether you're talking about the actual person or you're talking about the person who stole their identity and got on the plane with that identity, or if you're talking about yet another person who at that point was using the stolen identity. So it's impossible to track backwards just using that name and tell yourself anything about how this plot unfolded. By ignoring that and pretending that it's consistently the same person named in the Hamburg cell and everything else, the whole thing could be an intelligence legend from the beginning, dipping these people into the *mujahadeen*, into the cells, penetrating the cells and using their identities in order to link the event back to the sponsorship they wanted to show for it.

The other thing that's suspicious and doesn't let us fully identify the plot is the link to Bin Laden. At first we were told that the entire story would be revealed and that those links would be revealed in a white paper. Colin Powell, secretary of state then, said that it would be released to the public in a short time. Then he said, "I misspoke myself." Then there were reports in the US and British press that the US brought the evidence to the British and there was a statement, I think by Blair but certainly by some of the British authorities, I believe it was Blair, where he said, "well, it's not enough to go to court but it's enough to go to war." Then the Brits and the US invaded Afghanistan. Of course, the invasion of Afghanistan had been on the books for months, if not longer, prior to the actual invasion, because the Taliban had stood in the way of Unocal, a southern oil company in the United States that wanted to develop a pipeline down through northern Afghanistan to the gulf, to the water, from the Caspian sea basin.

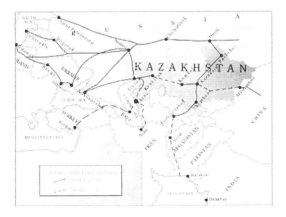

Q: Didn't Unocal drop the plans to do that?

A: Yes, Unocal backed off and actually a secondary plan, because the Taliban wouldn't let it come through southern

Afghanistan. A secondary plan to by-pass them by going across northern Afghanistan through Pakistan to the sea was then developed by Enron. Then, of course, Enron's plan was dropped when the company folded. Now there is going to be, I think, one that goes through Turkey out of the Caspian Sea.

Q: This is Unocal?

A: No, but Unocal is involved with another one that is being planned to go through Afghanistan. So they're back in the picture now, along with Russian and French interests as well. So there's been a lot of shifting around about who is going to get their hands on the profits from this oil. But the Taliban balked at the price, basically. Not being willing to offer more, Unocal sent their foreign relations representative to Congress in '99 and testified that this Taliban group was basically standing in the way of progress and our access to oil and had to be removed. The British and US troops were fully staged for the invasion well before 9/11. In June and July, Colin Powell visited the surrounding countries, Pakistan, Uzbekistan, Tajikistan, and told the leadership there, according to foreign press at least, that the United States was going to militarily intervene in Afghanistan in mid-October, and take out the Taliban. Then 9/11 happens and becomes the pretext and the context under which we're going to attack Afghanistan because it's sheltering Bin Laden. In fact, the Taliban was one of a number of foreign groups and countries that gave the United States preliminary warnings that an attack was imminent in the United States.

Q: Is that so?

A: Yes. That's one of the sources. And when 9/11 happened, the Taliban offered three times to turn Bin Laden over to an independent, international tribunal, like a Nuremberg trial, for a crime against humanity, to turn him over as a possible

suspect for interrogation to such a tribunal. The United States' response was, "we don't negotiate with terrorists." They invaded Afghanistan, they failed to capture Bin Laden, or they did capture and kill him but we just don't know it, who knows? At least they *say* they failed to capture him and history moves that notch forward and on to the war in Iraq, which was also on the books before 9/11. The whole link then to Bin Laden rests on the official claims of the state department, which never to this day has produced the evidence to the American public. And the evidence produced by the 9/11 Commission relies on the testimony of three individuals, Khalid Sheik Mohammed, who is considered the mastermind of the plot; his nephew, Ramsey Yusef, and Binalshib, and all three of these guys are captured at different points.

So these three people have been in a status of having been arrested and concealed, sort of like going to Guantanamo but they're in undisclosed locations. This has lasted over years now, in the case of some of them, Khalid Sheik Mohammad and others. They have never been charged with anything, although publicly they are said to be the masterminds of the plotters behind 9/11. They have never been brought into a military tribunal or an open court in the United States. They are held incommunicado to the rest of us. When the 9/11 Commission attempted to interview them, they were rebuffed for national security purpose. Then the 9/11 Commission asked if they could talk to their handlers and interrogators and they were rebuffed in that as well. So the 9/11 commission had to rely solely on redacted reports that they were given of their testimony taken by their interrogators and to rely on that solely. We, of course, don't know, number one, whether these people are yet alive or dead. We don't know if they gave the testimony under torture. We don't know if they gave testimony at all. These are the only three sources that link the

19 suspects to Bin Laden. So the whole case rests on three prison snitches that no one can interview.

Q: Who are supposedly the masterminds of the whole 9/11 plot but whose names are nowhere as recognizable as Osama Bin Laden's. How is it that 9/11 Commission didn't have the authority to talk to them?

A: They were asking the executive branch in the White House. The White House obstructed their investigation from the start. First they didn't want a panel. Then when they got the panel they didn't want them to see anything. Like Tim Roemer, who had sat on the House intelligence and Senate intelligence joint committee that made a report. That report was confiscated and vetted for a very long time by the White House and at least one of the early commissioners, Max Cleland, who quit the Commission saying that it was a whitewash, and got appointed by the Bush administration to a job at the Export/Import bank. He early on, or actually it was near the time he was leaving, but when that report finally did come out, he said the White House had intentionally delayed the report to not have it come out prior to the election. The report was damning, but Tim Roemer, who had sat in on the hearings, was one of the commissioners, he was not allowed to see the transcripts of his own committee hearings that he sat in on! They were closed hearings, but he was in them. When he asked the White House to see the transcripts of them, and, you know, get the evidence, they were denying it even to him, much less to the rest of them. So they were fighting at all different levels, whether they could get certain people to testify. When they finally concede to allow Condoleeza Rice to testify, the agreement was that no other member of the Bush administration's executive staff could be asked to testify after she did. That was one of the conditions. Other conditions were that Bush and Cheney testify not under oath, not in public. One person was chosen to take the notes,

Philip Zelicow, the executive director, and the notes had to be vetted before they were given back, again, to the same people who were sitting in the room listening. In some cases certain people were chosen to see certain parts of the record, and only they could see it and they could only see it in a locked room and they couldn't take it with them and they couldn't copy it. In some cases I think they were allowed to make notes but then the notes had to be vetted. It was this insane level of security around all these things.

It was only over time that certain documents like the presidential daily briefing that's given by the CIA to the president, for August 6th of 2001, prior to the attack, came out. The title of it was concealed in their public statements. The title said that Bin Laden would attack not just the United States but *inside* the United States and that the attack was imminent and that it might involve hijackings. The response to that report, which was requested apparently by Bush, that somebody give him a report on the imminence of the attack after he's hearing from Richard Clarke and they hear from Sandy Berger that things are imminent, that this is a big danger from the time they come into office. That was the point at which Bush took the long vacation. He went golfing and he was out of the White House for a long time, after getting this report that bin Laden was close to doing something. They had to fight tooth and nail to see that and then only other persons were allowed to see certain parts of the full report of all days' briefings, but not all commissioners were allowed to see all the days' briefings. It as just one layer of obstruction after another.

So to this day we don't know the actual identities of all the people that got on the planes, or affected the plot, whatever the plot was. We don't know what they did on the plane, we don't know which ones were pilots or not pilots. When we go in to the background of the 19 named people here in the

United States, at least, where people like Daniel Hopsicker and other researchers have tracked them inside the United States and talked to the people that knew them. You find people who don't appear to be very devout Muslims. They're college educated; they're doing drugs, drinking…

Q: Running around with hookers…

A: Yes, sleeping around—they don't follow a pattern of people who are fanatics, who are killing themselves for a religious reason. You also find instances where it was obvious that the FBI and the CIA were stumbling over them, but in some cases when they tried to do anything about it, they were blocked. So without knowing their real identities, we may just have a criminal enterprise that stole some ID, concealing itself, or we may have an intelligence operation that, as George Tenet said the first week after 9/11, is a sophisticated, state-level covert operation. That's still the way I'm analyzing it. If so, then it's consistent with that kind of an operation, to create a legend, a false story, a false sponsorship. Even with the people you are using, if you are using them as negative assets, you can have what's called a false flag operation, where you have them thinking that you are working on behalf of a particular cause or country or interest when in fact they are being manipulated by the intelligence groups.

Q: What does it take to track it from that angle? What other kinds of research can you do?

A: What you do then is you start to take the suspects apart in detail, which is really the way the Kennedy assassination was solved, I think. A lot of people focus on the gunmen, but the gunmen were cut outs and could lead you anywhere even if you could find out their real identities or how many there were. I think they are hirelings that are meant not to lead you back to the actual sponsorship. So what bore fruit in the

Kennedy assassination in my view was to research the patsy, the named suspect, the alleged killer. So when you do Oswald, a whole plethora of stuff opens up about his intelligence ties and the legend that's created about him: a false Oswald in Mexico City two weeks before the assassination; going to the Russian embassy and the Cuban embassy, and trying to get in to Cuba, basically to make a link to Castro two weeks before he's going to be set up as the patsy in the killing operation.

Q: So the named suspects in 9/11 are patsies then?

A: I would say that would be the parallel, that you see them as patsies, even if they are operational patsies. Even if they are actually carrying out the crime, unlike Oswald.

Q: But they are identified as Saudis…

A: Fifteen of them were from Saudi Arabia.

Q: But, in fact, a war in Afghanistan in order to create the pipelines you mentioned works against US dependency on Saudi oil.

A: Yes. The US is also moving militarily out of Saudi as a base of operations in the middle east, in to the surrounding the stands.

Q: So are you suggesting that they are trying to pin this on the Saudis?

A: Well, that might be one read, that the identities given lead to Saudi Arabia. Remember, when the joint inquiry report came out, the intelligence committees, Porter Goss and Bob Graham's report, had 28 pages completely redacted. The statement they made was that the eight pages referred to

countries—plural—that were involved in the 9/11 plot. Graham continually hinted and winked at the idea that Saudi Arabia was one of them, saying "I can't say so or I'll go to jail" or something. But he clearly was indicating that Saudi Arabia was one of these countries. I tried to pin him down on whether Pakistan was one of these countries, because we have a link to Pakistan intelligence...

Q: The ISI.

A: Right, the ISI, their military intelligence. The head of the ISI at the time of 9/11, General Mahmoud Ahmed, reportedly, according the *Times of India* and also *Wall Street Journal* confirming it, transferred $100,000 to Muhammed Atta in Sarasota, Florida in August of 2002, right before the attack. The carrier for this money was allegedly Saaed Sheihk, who has his own set of ties to being involved in a lot of terrorist operations, but also being involved with British intelligence and some hints that he was involved with US intelligence as well. So we don't really know whose side this guy is playing on. Then he is brought up under charges of killing the *Wall Street Journal* reporter Daniel Pearl, although Daniel Pearl's wife was told by the Pakistani state authorities, not the ISI, but the actual state authorities under Musharraf and the police forces, that Khalid Sheikh Muhammad killed her husband, not Saaed Sheikh. But Sheikh is the one who has been convicted of doing so.

Q: The story that Pearle was pursuing when he died was tracking this pay off, right?

A: Well, that's at least what the wife hints at. She says that he was looking into this, because the *Wall Street Journal* is the only US source that covered the transfer of the funds. He's a *Wall Street Journal* reporter over there and he was getting close to the circles around Khalid Sheikh Muhammad. So he

was getting into the middle of the plot. Then he's murdered. The indication from his wife is that he was working on material that might have linked US intelligence to some of the plotting.

Q: Some of the ISI plotting.

A: Yes. The other link in that is that this general that actually affected the transfer—and this was, in fact, reported early on...

Q: ...and he had to resign over it.

A: Yes, but this was also the first sort of smoking gun that the FBI said that they were following in the case. They made public statements about it and said that they were tracking this money that was sent to Muhammed Atta. It's also interesting, I think, that Muhammed Atta in Sarasota was renting his room from someone who had ties to the contra-gate operation. This is an important story because then General Ahmed then came to the United States on September 4, the guy who supposedly the source of this transfer to Atta, and the head of Pakistani military intelligence. This also is important because that was the CIA funds that were sent to the *mujahadeen* resistance, as part of the large covert operation to draw the Soviet Union into the struggle in Afghanistan and then help collapse the Soviet Union by putting them into a quagmire, an idea that came from Zbigniew Brzezinski and Jimmy Carter but was basically inherited and carried out by Reagan and Bush administrations through William Casey as the largest covert operation in history, in terms of the cost—over three billion dollars from the US and another three billion from the Saudis. The funding was Saudi royal family and Saudi intelligence, through BCCI, the Bank for Credit and Commerce International, which itself was a nest of US covert operations abroad and drug money, and being funded through

the opium money in Afghanistan, which was 85-90 percent of world opium. So it was funding things like the Kosovo liberation Army through the CIA later, but at this time it was funding the *mujhadeen*. Then the CIA was sending a similar amount of money and its conduit was the Pakistani ISI, and through that conduit the *mujhadeen* would be trained in Pakistan and sent up there.

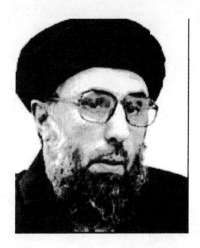

Gulbuddin Hekmatyar

One of the major benefactors of that conduit of money was Mr. Gulbuddin Hekmatyar. What's important about him is that he's not only taking and distributing the CIA funds, but he's also the sort of mentor to Osama bin Laden. Bin Laden, of course, is adding his own funds because he comes from a very rich Saudi family, Saudi construction that did a great deal of CIA contracting and military contracting that in fact built the caves in Afghanistan used by the *mujahadeen* to hide in. Later we're told that Bin Laden was in these caves running the operations of al Qaeda against the United States. So here comes the current head of Pakistani ISI to the United States, on September 4, after having in August given money to

Muhammed Atta, and he meets with George Tenet at the ICA, his counterpart. He meets with Colin Powell and Richard Armitage after 9/11, at the state department, and on the day of 9/11 he's having breakfast with Porter Goss and Bob Graham, the two people who later write the joint intelligence report on 9/111 and on the intelligence "failure" of 9/11, which is how this is all posed. So he's in with all those people, and then he comes back to Pakistan and his role is exposed and he is basically forced to resign. His head rolls because he's too close to Bin Laden and because he transferred this money to Atta.

Q: A lot of the ISI were sympathetic toward bin Laden and, in fact, have tried to assassinate Pakistani president Pervez Musharaff twice now, and there's still a big fear that they might stage a coup.

A: Yes, there's an apparent split between some ISI elements and the state government. It operates kind of the same way our intelligence does: don't operate directly with the government and sometimes in opposition to it. There's a large Muslim community in Pakistan and elements of this international Islamist terrorists are still being trained there, and these tribal areas that are contentious. So, yeah, there have been attempts to kill Musharaff but this particular guy was Musharaff's pick. He had been responsible as a military man for bringing Musharaff into power and staging the coup that put Musharaff in. So part of his reward was being put into this position. We're not clear about what role Pakistan plays then or still plays to this day in terms of this funding, or if there's ongoing funding or training of terrorists.

The point is that you've got people from Pakistani ISI, which had relations right up until then, obviously, with American CIA, funneling money into the alleged perpetrators of this plot. It doesn't have to mean that the whole thing was a

271

creation of American intelligence. Nor does it have to mean that the whole thing was a blowback against intelligence, where they created a Bin Laden who then turned and bit the hand that fed him. I think an alternate explanation might be that this doesn't involve the whole of the US government intelligence but involves elements within military intelligence, or DIA, operating abroad and the CIA with assets, who may be used as positive assets to attack the Soviet Union, and then turned as negative assets attacking the United States, or believe they are attacking the United States, and are manipulated or penetrated in that role, either to stop them or to limit what they're doing, or to use them. The CIA does not only penetrate groups that would carry out the positive thing that they want done, but they'll also penetrate enemy groups. So did the FBI. The 1993 bombing of the Twin Towers, it's now known from the trial testimony, that entire operation was penetrated right to the heart by an FBI informant who told the FBI and warned them that they were planning to bomb. The FBI even fed information through this informant to them of where the most efficacious place to plant the bomb would be, to make the damage happen. Then they assured this informant that at the last minute they would substitute a harmless powder so that the bomb would never go off. Realizing that it was imminent, he asked, "don't you want to come in and raid or stop it?" and they said, "no, don't worry about it." Then the plot went through and the bomb did go off in the building. But the FBI was right in the middle of it even at that time. So you have these conflicting loyalties where you're penetrating to find out what they're doing, but then there are other elements that don't want to either expose the informant or whatever and it ends up with them going ahead and facilitating the crime. Or maybe you want a provocateur situation, where like in COINTELPRO, they would send FBI penetrators in to a group that wasn't otherwise violent and say, "oh, I have all these, skills, I know how to get in these

272

buildings, I know how to build a bomb, I can help you blow it up" and actually facilitate and encourage a crime...

Q: Entrapment.

A: Yes, to entrap people who previously wouldn't have even thought of doing such a crime. So you don't know until you get down to that level, and that's certainly not the level of the testimony or the evidence that the 9/11 commission sought. But those elements are still, to me, all in the air. The other major paradigm problem with the way we're looking at 9/11 is that it's been defined from the beginning as a failure of intelligence, a failure of cooperation between FBI and CIA. A failure of the intelligence agencies to have enough human intelligence sources, all these different "failures". Of course, the response to the intelligence failure has not been to hold anybody accountable for that failure or to hold anybody accountable for the bad oversight on that failure, but in fact to reward all those people who were involved in the failure and to further fund and buttress these intelligence agencies and give them an expanded level of powers.

Q: The so-called "failure of intelligence" delivered them an event that justified the already pre-set foreign policy goal, the war. In that sense, 9/11 was a success.

A: Yes. So whether it was something that they used, an event that they didn't know was coming for that purpose, or they let an event happen at a certain level, or they pulled the plug, or...

Q: ...or these competitions between these police bureaucracies and the people they conscribe into them, like the hijackers, just fell out of control. This is something less than blaming it on the Bush administration.

A: Yes. I think everybody sort of wants to go the top and say that Bush is in charge and therefore Bush knew and Bush did everything.

Q: You have people now saying they launched a Cruise missile into the Pentagon when in fact, the situation as you just reviewed it, shows that there is a real conspiracy mystery there. A sixth missing hijacker may have been the real pilot, which could account for some of the anomalies that these researchers have picked out, like the impossibility for Hani Hanjour, the known incompetent pilot hijacker, to have performed the wide angle turn that crashed Flight 77 into the Pentagon.

A: That's probably true of Hani Hanjour—but we don't know that he was the pilot. On the other hand, I don't believe that you can explain such a maneuver and the last minute corrections that had to have been made even as it approached the first floor, by remote control. I do believe that you can guide a plane in a particular direction, either with geo-physical satellite information or even with just a radio beacon. You could guide a plane to a building and crash it in but even that is belied, I think, by the fact that on the second tower, when it's hit, there's a last minute correction by the plane, which is going very fast. If you're flying this plane, to see those towers, they're just going to whip past you.

John Judge

To get back to New York, first of all, in a plane where you don't know where you are, you are out in the middle of Ohio or Pennsylvania, how do you find New York? Much less that particular building at that speed. Then to actually drive the plane into it so that one plane smacks right into it and the other plane hits a lower floor, which I believe is why it falls first. The second tower is hit later but it falls first because the plane goes in at a lower level, so there's more weight pressing down on the collapse. But that plane has to curve in, if you've watched the video, at the very last second. It's like the pilot jerks it over into the corner of the building and it doesn't make as direct a hit. Then at the Pentagon, the plane is 5000 feet in the air and it does a descending loop around the Pentagon, 270 degrees around--almost the entire 360. Then flies in at over 500 noughts, tremendously high speed, fifteen, twenty feet above the ground, knocking lampposts off, and slams into...

Q: ...which is very hard to do...

A: Yes, it's very hard to hold the plane down because the reason a plane slows down to land and speeds up to take off is because you have lift! Even if you aren't using the flaps,

just the wings are going to lift the plane. So to bring a plane down that fast, low, is destabilizing it and also you've got tremendous pressure to lift the plane back up over the building at that speed. So it's got to be somebody that knows how to hold the plane down with the flaps. I said initially that the pilot would have had to be standing up to have had enough press down on the pedals to keep the wing flaps down so that it wouldn't actually crash. There's also at the last minute that it almost tips over. The wing on one wide goes down and it hits some of the emergency vehicles that are there. It almost flips over or crashes and then it slams into this area just between—it basically goes in mostly on the first floor but a little bit up to the second floor level.

Another thing that people don't know about that area in there is that in the wedges of the Pentagon, the ring walls don't continue. So that at each wedge side of the five points, within that little triangle that comes out, between them there are these rings--A, B, C, D and E--of the Pentagon, with two walls each. When you get into the wedge area, at the corner, those ring walls disappear on the first floor, which is an open floor. In other words, what's going in there is not going through six walls in order to get to the inner walls.

Q: What simple thing can you say that definitively pooh-poohs the idea that it was a Cruise missile or drone or that it wasn't a plane that hit Pentagon?

A: What would pooh-pooh a Cruise missile to me is that a Cruise missile has all sorts of remote control and generally flies on a straight line to its target. So it's even more incredible that a Cruise missile would do a 270 degree descending loop to go into the building! Why would you go all the way around it with a Cruise missile?

Q: What single thing can you point to, though, to the people who say that the Pentagon was not hit by a plane?

A: A simple thing to say is to come to Washington, DC and interview any twenty people and you will run into somebody who either saw the plane or knows somebody who saw the plane. I have talked to dozens of direct witnesses on the ground, in surrounding buildings, up close to the building, some of whom ducked, who saw the plane come in. They saw its distinctive silver color, which is American Airlines. Some of them saw the American Airlines logo on the plane. They saw the size of the plane. You have literally hundreds and hundreds of witnesses to that event.

Q: Don't you know a flight attendant who was supposed to be on the plane?

A: I know a flight attendant who worked for American Airlines and her regular route was Dulles-LAX and on Flight 77, on that route. The entire crew that she normally worked with died in the plane that day. In fact, when I heard the route announced, I thought she was dead. As it turned out, she was not assigned to the plane that day and she was home taking care of her father who was sick, and she wasn't in the air that day. She subsequently did go down with her mother at the invitation of some of the people at the Pentagon and the rescue crews. They asked the airline attendants, who often already have security clearance, to come down and serve drinks to the rescuers and the people who were doing the clean up. This was about a week and a half after the crash. She went down and did an all night stint with these people, giving them drinks. Then they came in the morning and asked her and some of the attendants if they wanted to see the crash site. Some of the attendants said, "No, I don't want to see it." But my friend is a researcher and she's a trained professional…

Q: Could *Steamshovel* use her name?

A: I'd rather not use her name just for the fact that there are
so many people vilifying her that I'd rather just spare her the
difference. It's not concealment, it's not that she doesn't exist,
but I just would rather not get her more trouble than it's
worth. There are so many people trying to discredit her that I
don't want her bothered by this. But she exists, her friends
died on the plane. She went in to the crash site. She saw
pieces of the plane, remaining debris. She saw a window that
told her that it was a 757 by the shape and size of the window.
It's different than on smaller planes. She's been an airline
attendant for that airline and has known those planes for
years.

Q: They did recover a lot of the plane, didn't they?

A: They did recover a great deal of the plane parts. These
people that say there was no debris, they're relying on one or
two press reports or what they can't see in a photo. But there
was a great deal of debris and there was also DNA and she
saw charred bones. She also saw upholstery that was charred
but she could recognize the patterns as belonging to that
plane. That's a plane that she worked on two or three times a
week. So it's not unfamiliar to her. She could recognize it.
Then she was also shown photographs, as were the families
and other crew, and this is standard in a plane crash, of body
parts that were photographed on the scene by the forensic
experts. In those photographs, she was able to identify a
severed forearm that was charred, but around the wrist was a
bracelet that she shared with Renee May, the attendant on the
plane. That was her best friend on the plane. They wore the
same bracelet, so she could tell that that was Renee's arm.
Rather grisly, but...I mean, Renee didn't ride in there on a
Cruise missile. They did extensive DNA and identified all the

278

passengers on the plane except for the terrorists, whose identities I think differ from what we've been told, and that's why that was withheld, not that nobody was on the plane.

Q: As you were saying before, this is a genuine mystery, who that sixth person is on the list, but this is nothing that's even brought up by these no-Pentagon-plane researchers. What purpose is served by Thierry Meyssan, the French author of the no-plane theory book *9/11: Pentagate*, and all these people promoting this, by putting that kind of cartoon version of what happened, when in fact you have an actual mystery that you would assume everybody would be on?

A: On the most benign level, it could just be someone who wants to make a name for himself and wants to take some kind of a theory that he's involved with and get himself out there and promote himself and, who knows, maybe even believes it. But a guy in France who has never been to the crash site, who is working from a couple of photographs from a web site and a bunch of speculation that a hole isn't big enough in his mind to accommodate the plane—I mean, it's just not credible. Then a more sinister interpretation would be that, as in the case of the Kennedy assassination and other things, alternate, false information, or disinformation, is put out relating to the story in order to help discredit it. In classic disinformation, what you do is you give the truth to the person who has the least credibility and you give the lie to the person who has the most credibility. Then at the same time you also have claims like, "Oh, the mob did it" or "or oh, the anti-Castro Cubans did it" or "oh, the oil men did it" and you have seventeen different suspects and nobody can figure out what's the hand that wiggles all these fingers.

Q: But we don't seem to have competing culprits here. Every "no-plane" researcher says it's Bush and his buddies that did it.

A: Or they say it's Osama Bin Laden and his buddies. So we don't have that particular piece, but if you wanted to discredit the research community, and easy way to do it—and it's already been done in *Popular Mechanics* magazine recently—is you put up these straw men that are easily knocked down by any scientist and you say that these are all nut case conspiracy theory people. That's why I think you have to have people that have expertise, that do real research. I'm not a pilot, I'm not a forensic building engineer, I'm not a trained scientist. I do common sense, nuts and bolts research. I'm not even a formal academician. I'm somebody that's looking for the truth. But I don't claim to be more than I am and if I want to find out how the buildings fell down, I would go to, as I did, the sites of the engineering people and see what they're putting out and whether that seems plausible given the other facts. If you see conflicting facts, you can bring them up, but you don't bring them up among yourselves. You bring them up to the people that are involved. If somebody says something about the building and it seems suspicious, you go to that person and try to determine what it was that they said or what they meant to say. Instead, I find people that build whole arguments based on what one or two witnesses that say something different. A little bit of research and basically they prove a thing by a lack of evidence. But a lack of evidence proves to me your lack of research.

Not that the government isn't blocking evidence. A simple way to prove that a plane went into the Pentagon or not would be for the government to release the evidence that they collected as part of the investigation, which included video

cameras on nearby buildings. The Marriott Hotel took pictures of it.

Q: One video was released from the Citgo station across the street, right?

A: It's actually not a video. It's a series of five photographs that they put into Photoshop or something and tried to make them move along as a sequence. It wasn't shot as a video, but it was a sequence of photographs. That actually shows something consistent with the plane going in to the building, although everybody says it doesn't. You can fit the plane in the space but also a great deal of the scenario is not visible because this is downhill and you are looking up over a ridge. So the whole plane is not visible as it goes into the building, but the tail of the plane is visible. In fact, one of the sites, to prove some other point, did a high-contrast photo to show something else, but when they did that you could see the tail and see the A-slash-A logo of American Airlines on the tail in that photo. I think you need people that really know how to do the analysis.

from the Citgo station

The big explosion outside of the building comes from the fact that the fuel is underneath the wings. When the plane hits, the wings begin to collapse and hit the front of the building. This fuel underneath is exploding outside the building. That's what that huge fire balls is. Also, when the nose of the plane hits the building, the momentum backwards, the shock of the building, is pushing against the 500 mile-an-hour force forward and the wings break forward. A plane is not a solid piece of metal. Somebody said there was like 1.5 million pieces to each plane. If you've ever watched wings on a plane as you're landing, all these flaps come up and it's not just a solid chunk of stuff. You're basically taking an aluminum can and throwing it into a building at 500 miles an hour. Of course it's going to disintegrate. The wings break forward and the hole size is consistent with the fuselage, which is what does go through. At that speed, it goes through further than it would normally. You can take a piece of straw in a hurricane and drive it into a tree if it's going fast enough. So you've got that tremendous momentum bringing it in further than it would normally go, in to an area of the building that had not yet been reinforced. That whole side of the building was being reinforced. The only practical effect of taking the plane all the way around the building and hitting that side is that it was the side of the building that had almost nobody in it, where the office were under construction for the better part of three years. If Atta was in fact a plotter, there were descriptions of Atta carrying a model of the Pentagon around. All you have to do is drive by to see that it had been a construction area.

That is consistent with another thing that I think is a mystery in the hitting of the towers. The towers were first hit at 8:45 and then at 9:05. They began the evacuation, although some people were told to stay tin the building, but they did begin the evacuation and they saved most of the people in the floors below where the planes hit. About 1500 people got out and

282

were taken to other places. Of course, many people died and when it collapsed it killed people around the area as well, we don't know how many, including some of he rescue crews that were coming in. By arriving at 8:45 rather than 9:00, if they had come an hour later, if they had taken the next flight out and hit well into the hour between 9 and 10, they would have had tens of thousands of deaths, even with the evacuations. But at 8:45, most people are not at work. Then also if you look in detail at the plotting, the planes that did hit there, took off anywhere from a half hour to forty five minutes later than they were supposed to have taken off. So actually the plotters would have gone into the buildings even earlier had the planes taken off on time, which meant fewer people would have been there.

Q: Minimizing the number of deaths.

A: And it's consistent with minimizing the number of deaths at the Pentagon, which does not seem to me to be consistent with a terrorist plot. You just want spectacle but you're trying to be kind these people you want to kill? It might be consistent with somebody creating a plot that, although it's going to have some collateral damage, they try to minimize that but they want the psychological effect. Who are those people? Well, that's a question. But if we are to believe they are murderous, Islamist terrorists, who hate the United States and everyone in it, then they would presumably want to kill as many people as possible. All those early morning planes are sparsely populated on those days of the week. There would have been more planes up in the air if they had taken a later flight. I don't think it was necessary for them to take the first flight out in terms of planning. It just strikes me that those things point to something else.

There's no sense in a pilot who is bent on smashing a plane into the Pentagon coming within visual sight of the Pentagon

and not just driving right into it. You would do more damage if you landed in the central court yard and plowed through the building form the inside then what was done. And it was a very difficult maneuver to do in a plane that size. One of the trainers in Florida, Rudy Decker, said if they had tried the Pentagon maneuver on his simulator, it would have shut down because they're putting tremendous stresses on the plane. The plane itself would have shaken the stick and had override capabilities built in to the plane to keep that from happening. Whoever the pilot was, he would have had to know how to turn those off. It's not impossible to turn them off, and pilots often do fly manually.

Q: But with a would-be suicide pilot, you are getting into a counter-intuitive idea of somebody who is about ready to commit suicide trying to limit the number of other deaths...

A: Right, that's not consistent either, is it?

Q: Are you getting back then to remote control?

A: Well, no. I'm suggesting that you have a plot of some kind, whatever those people think they are doing, maybe they think they are just following orders. But those orders, wherever they come from, are meant to minimize the deaths. I've looked at remote control, you have to put millions of dollars to get one of those planes up to remote control capability and then the particulars of the corrections and thing argue against it. The do have planes...they this Global Hawk system where they can take off and fly to another point and land, but that's usually a straight line. It's not doing aerial maneuvers and dogfights and loop-de-loops. To do that, how can you see what you're doing by remote well enough not to crash the plane? If you are flying remote, one would presume that there's a pattern that you've already laid out and that

you're not going to be making these last minute stick jerks to get around to the building because you're going to have it on a GPS or something where you know where it is you're going. The Pentagon one especially argues against the possibility of a remote control or a missile, that you have a human pilot.

How do you get that pilot to kill himself? That's a different question. I've studied a lot of so-called mass suicides in human history and in every case I found that they were mass murders, including Jonestown, even going back to Masada, Solar Temple, Heaven's Gate—all of these actually, if you check the forensics, were murders, not suicides. Even a lover's pact often ends in one killing themselves and the other one bolting. The attack on the Khobar Towers by al Qaeda supposedly, the one guy drives in and the last guy jumps out of the truck at the last second! There's a will to preserve life that usually goes beyond other things. Not entirely. You can have a disciplined Buddhist monk immolate himself. But the idea that a bunch of rock-n-rollers and some crazy Bible freak at Waco chose fire, the most painful death possible, as a suicide move under a siege—I mean, it just doesn't make sense. It's also an old conqueror's lie. There are instances where they came in and slaughtered people and said, "oh, they were so afraid of us they all killed themselves." The old Nazis would say that the Jews had *lebensmude*. They were sick of living and they killed themselves in the camps! It's a common cover story, but when you go the details, not a single person at Jonestown committed suicide, according to the Guyanese grand jury. This is just me talking. It's when you look at the forensic and the pathological evidence.

So how do you get 19 guys in a suicide pact going over moths and months and none of them are defecting and they all get on these planes where there's no escape? Can you have a *kamikaze* pilot? Yes. But if you remember the *kamikaze* pilot

285

scenarios, they were individual pilots in individual planes. They weren't even taking anybody else with them. In addition to that, they didn't just go out like lemmings and all kill themselves. It was a tactic, when everything else failed and the only thing you could do to make damage was to kill yourself and then you would dive down. And some still didn't, of course, and shamed themselves for the rest of the lives or whatever. No matter how deep the fanaticism, there's other cells in the brain and the body that are going to vote and try to get you to change your mind. That leaves us with a possible scenario that the commission itself doesn't rule out that only one person knew in each flight that it was a suicide mission. Then how do you get that person to go along and kill all of these people with them? I don't know. But the official story of the 19 guys with a suicide wish and an ATM card, who don't even appear to be Muslims, doesn't fit any better. That's a conspiracy theory in my view that has yet to be proved. I don't think they we have the final word on it but I think that the official version of it has too many holes and that it really needs a much more thorough examination and background, which the commission doesn't give us.

It gives us this "intelligence failure" instead of break down in standard operation procedure, which is what this was on each

level. On the investigative levels of the FBI, on the warnings that came in to CIA and other intelligence that wasn't followed up on in some cases, but in other cases were followed up on. When I went into the detail I found that as early as 1996 the bare bones of this plot were known to the CIA at least. Even in the months prior to 9/11, there were CD packages created for the airline people that they showed to their employees about suicide hijackers taking over planes and using them to attack buildings. In 1996, Ramsey Yusef's computer was confiscated in the Philippines and it had the Bojinka plan on it, the "Big Noise" plan, and that was to hijack planes from outside the United States, but nonetheless those planes would come into the United States and they would be used to attack the Twin Towers, the Pentagon, the CIA, the White House—the Capital. So the targets were known. It's not rocket science to figure out the Twin Towers would be a target. They were a target already in '93. The others are just common sense. You would go after the government buildings.

So not only did they have that warning but in some cases they took it seriously. The Pentagon did an exercise in October of 2000, about a year prior to 9/11. With the Arlington County fire teams and rescue teams and first responders, simulating a plane going into a building and how they would respond to that. NORAD had a plan that it had laid out but not implemented called "Amalgam Virgo 2". It was mentioned by Richard Benvenista, one of the commissioners, in the testimony, when they were getting testimony from NORAD. This was a plan about hijacked planes being used as planes against government buildings and how NORAD would intercept them and whatever they would do. This scenario wasn't approved prior to 9/11, they didn't actually test it out, but they wrote it up. In addition to that, in 1999 I was with the head of security in the Pentagon, a guy that had been there for thirty years, and he told me that they were on Delta alert, the

highest form of alert—Alpha, Beta, Charlie, Delta. This was '99 and I asked, "why are you on your highest form of alert?" He said, "We have bomb threats from Muslims every day." We were standing outside of the building and he turned and he pointed to the roof of the Pentagon and said, "We have camera and radar up there so that they don't try to run a plane into the building." This was in '99, OK? When he said it, I thought he was out of his mind. I didn't know what he was talking about. Of course, they knew about these plots and they were preparing for them. I confronted Richard Shelby, one of the minority people on the joint intelligence inquiry. Bob Graham and Shelby were taking questions at the press conference that followed the release of their joint inquiry report. First, I quoted Condoleeza Rice saying that this attack was so outside the box that no one could possibly imagine that it would have happened. As I was saying that, Shelby started grinning. Then I said, "Did your investigation find that in fact planes had been used as weapons or could be used as weapons or had been used as weapons by these particular groups?" Because I knew that in Chechnya, a plane plot involved Osama Bin Laden reportedly. Another al Qaeda plot in Paris was foiled to bring a plane into the Eiffel Tower. The one in Moscow actually hit an apartment building, I think. So he acknowledged it, he said, "Yes, we found numerous instances where planes had been used as weapons or might be used as weapons." Then I followed up right away and said, "And did you also find instances of preparations being made for that possibility?" His demeanor literally changed. He stepped back, he mumbled something that sounded like "I can't get into that", and he walked away from the podium without answering the question. He turned his back to me, and walked away to consult with somebody over on the sidelines while Graham stepped up and took the next question. When Shelby came back, he pointed to me before they went on to the next questions, and said, "and in answer to your question, on advice of counsel, my answer is no."

Now I wasn't quick enough to say, "Why not? If you knew about it, why didn't you prepare for it?" But I think in fact they did.

We also know that at the Genoa Summit in that summer that they ringed Bush and the other people with surface-to-air missiles. They prohibited any commercial or non-commercial traffic over the area where the summit was taking place. They moved Bush from location to location, including out on a ship in order to keep anyone from knowing day-to-day which building he was in, to prevent planes being used as weapons or attacking the building.

Interestingly enough, on the day of 9/11 it was reported in the *Washington Post* later that when the twin towers were hit, the second tower was hit, they went to Alpha, their lowest form of alert. That is merely a communication, "heads up, something might be happening". After their building was hit, there's a report also in the *Post* that the commandant of the Marine Corps asked his assistant, after they saw on TV the Towers being hit, to go down the hall and talk to the security people in the building and find out if there was a rated security alert. The assistant came back to him after a bit and said, "No, sir, there's been no change in the security alert." Then the plane hit. It was also reported in the *Post* that after the plane hit the Pentagon, they went to Charlie alert! So on a day when they're getting nothing but calls, they're at Delta. On a day when a plane flies into their building, they're on Charlie. And when this recent plane came into the restricted airspace and got into P56B, the most restricted 16 mile circle around the monument, and flew over Dick Cheney's house and got within three miles or two minutes of the Capital, the Pentagon did not evacuate or call *any* kind of an alert!

On 9/11, they began to evacuate the Pentagon, the capital and the White House prior to the arrival Flight 77. *Prior to.* So

they knew it was coming. Still, there was no standard operating response on all of those planes. They would have picked them up from the beginning of no transponder, no radio communication, not following orders, going off course, for even a few minutes. The air traffic controller will try and re-establish control for two or three more minutes. If he doesn't get it, he immediately flags his supervisor and the military liaison at the control center. The military liaison puts the report into the national military command center at the Pentagon and they in turn relay it to NORAD to prepare to scramble, because it's an air emergency. You don't know if it's a hijacking or not. It doesn't matter what it is. All you know is that a plane is not doing what it needs to do, and especially a large plane full of people, where hundreds of lives on the plane. and who knows how many more wherever it hits, are at stake. You are going to start responding as immediately as possible to that air emergency.

In his testimony to the commission, General Ralph Eberhardt, the NORAD commander in charge that day, said that had they been given sufficient notice. They could have intercepted all four of the planes. That's in fact the case, because the first

plane starts having trouble at 8:14 and doesn't hit until 8:45. So that's a good half hour. These planes can be scrambled in six to ten minutes. They go to a staging point and they can come in on the bogey at 15 to 18 hundred miles an hour. Once the air traffic lane is cleared, they can shoot right into the bogey on full burner. The pilots out of Otis, when they were finally sent up after the first tower had been hit, went on full burner to their staging point because they thought something was the matter. But FAA gave them no designator, no bogey. They said they weren't getting any "bogey dope"—that's how they put it. They sat out at Whiskey 105, off of Long Island, their point, and looped until after the second tower was hit, and then they were told to go in to the New York air space.

Also, according to someone we talked to whose son was stationed at Otis and had talked to those pilots on their return, the pilots told him that they were aware from chatter they were getting that the government was getting real time information on the flights. As early as 8:24 a phone bridge began to open between the FAA, NORAD, the Pentagon, the Secret Service, all these government agencies exchanging real time information about the flights that were off course or were being hijacked and that information was also being relayed to the pilots. So the pilots as well as everybody else know real-time that a plane's coming to DC and where it is— and that the Otis pilots, aware of that, turned to intercept Flight 77 and were called back and told to stay in New York air space.

Q: A stand down order.

A: That's essentially the effect. Also, the Langley pilots 130 miles south of DC that were scrambled, were scrambled too late and thought when they were scrambled that they were going to New York. They went out on the Atlantic to their staging point and started heading north and were asked on the

way up to verify that the Pentagon had been hit. They saw a plume of smoke and said, "yes, it's been hit." That was the defense. And they don't have to go 130 miles south of DC because we have Andrews Air Force base within ten miles. We have Anacostia Naval air station right across the river from the Pentagon, with the Air National Guard unit there that's responsible for guarding the DC skies with F16 and F18s. There were Andrews planes over North Carolina on maneuvers that could have been tasked. The regulations say that in an air emergency any base commander can task a place anywhere. He doesn't have wait just for NORAD. NORAD can task any plane, not just the scramble planes. We also know that at Pomona Air National Guard 177th Air Wing in Atlantic City, which had been a NORAD scramble base in the past although at the time of the Bosnia war they took them off that duty and used them abroad, had two F15 fighters out on the runway, at the end of the runway, ready to take off on bombing run patterns into New York. That's an exercise that they did each month. They're out there with their engines running and they were so close to the scenario that Flight 175, which went into the second tower, actually came south and going back north passed over Pomona air field, in the New Jersey air space. They were for the first time in their career called back, off the runway, when they could have been activated and gotten up. These aren't all shoot-downs, but at least you go up, you identify the problem, you wag your wings, you can divert, you can throw flares, you can sandwich—there's numbers of ways to divert a plane and try to identify what's that matter. That's why you go up, to identify the problem. You have different protocols if it's a hijacking than if it's something else, but none of those protocols prevent you from getting up there in the first place.

That's what completely falls apart on 9/11. There's even in the commission report a story that at some point the FAA regional office in Boston, overseeing the Logan situation and

picking up these planes, knew that there was a problem shortly after 8:14. They put in a call, I think it's still even before 8:30 but if not it's very close to 8:30, they put in a call too on their own, to Otis and to Pomona. They said, "We've got a problem, you need to get something up, you need to scramble some jets and get something up." They called both of those bases. But no planes ever went up from Pomona and the Otis planes didn't go up until well after that situation happened. They weren't responding to these direct calls from the airlines and they weren't going from the places they normally would have been ordered to go, nor were any additional planes scrambled.

I sat and watched television that morning, when channel 8, the local news channel, announced that one of the planes that had been hijacked was coming in to DC twenty minutes before it hit. I know when it hit, because it shook my window. I'm right across from the Pentagon, within a mile. It shook my window from the impact. But they announced it was coming! Well, that isn't the channel 8 investigative team! *Announcer voice:* "Channel 8 news team has discovered…" (laughter) That's them reporting something that the government told them. So the government knew it was coming. The official story in the commission report is that they lost track of the plane somewhere over West Virginia and they didn't pick it back up until it was like five minutes away. That's nonsense. They can track these planes even when they have their transponders off. They did it on Flight 11. It turned its transponder off and they put a separate tag on it and tracked it all the way into the valley.

Q: What do you do then with all the deficiencies of the official 9/11 report? There's not going to be another investigation or another commission.

A: Well, I don't think there will be that. I think our momentum would be to first of all try to deconstruct the report because it has the weight of an official government study. It's also got this popular weight and myth that this is a definitive thing and it's like the best thing that's come down the pike and it's one of the most bipartisan and objective reports that's ever been done and it really gets at the truth and it's going to be the standard for fifty years...And while there's a strata of people, of course, who are very critical of the report, that's not the case across America. It was nominated for a national book award! It's gotten a little bit of critical press, but not much. It also served then as this engine of a train that jammed itself through Congress carrying all these recommendations into law, consolidating the intelligence agencies. It didn't challenge at all the Pax Americana, or the attacks of the Bush administration. It gave more weight to the Homeland Security office and all of the interruptions of civil liberties. When they were considering their recommendations, we tried to get them to hear alternative witnesses. Just as an example, they had a whole panel on civil liberties versus security that did not include the American Civil Liberties Unions! It's that basic. Who do you want to talk to here? Primarily their staff was made up of people that came out of the National Security Council.

If you pick up the current issue of *New Republic* and read it, you will find Ernest May, one of the senior counsels of the commission, very tight with Phillip Zelikow, the director, tied into this Miller Center at the University of Virginia, which is a nest of these people that have ties to the intelligence agencies. It also promotes respect for the president and try to pretend that they are some sort of official repository for presidential statements. Ernest May and Phillip Zelikow, the director of the commission, co-authored a book on the tapes that came out at the Kennedy library as a result of the JFK Records Act on the Cuban Missile Crisis. They wrote a book

294

based on those tapes. The director of the library who had access to the tapes in the first place wrote an article in *Atlantic* saying that no student or scholar could rely on the transcriptions that these people had done. Those transcriptions came out of a recording and transcription section that was headed up by yet another 9/11 personage, Timothy Naftali, who has just written a book called *Blind Spot: The Secret History of American Counterterrorism*. He was commissioned to write the history of the "intelligence failure" and is really at least the intellectual author of the main theme of the report, that counter-intelligence fell apart. This person is in charge of this transcribing effort at the Miller Center that is a fraud, basically. It wasn't just sloppy transcription, it was politically motivated mis-transcription. At key points when Kennedy argued most forcefully against going to nuclear war, those are considered unintelligible in the transcript. They are quite intelligible and they're probably the most important parts of the transcript. So you've got these people that did such a sloppy job on that are now the authors of the 9/11 Commission report that's supposed to be the definitive history! If you read this article by May about how they formed the Commission you find that they formed it with people that were part of covert operations. They were part of the national security structure, and those are the people to be trusted.

That's in part what's wrong with doing any kind of investigation of the national security state is that the only people entrusted with enough security to look at it are already part of it! It's like investigating your own navel! "Well, you can't look because you're just an ordinary citizen. We're the only ones that know enough." But the way you get into those positions is that you already bought into the paradigm. You're supportive of the network. So of course it's in their interest to pose this as an "intelligence failure" rather than a break down of procedure, for which somebody would be held

accountable. Instead, those people are promoted. Even at the Pentagon, where you can get a court martial for turning over a jeep, its own building is smacked into by a plane and there's no line of duty inquiry. There's no court of inquiry. There's no court martial. Not a single head rolls.

The people who are responsible at the top are promoted, like Joint Chiefs chairman Richard Myers. The key people that should have been in place that day and responding, are just sitting there, according to their own reports! Myers said he knew about the first plane hitting, thought it was a small commercial accident, went into a private meeting with Max Cleland and didn't come out until after the Pentagon was hit, and then went over to the Pentagon. That's the acting head of the Joints Chiefs of Staff, OK? You have Donald Rumsfield, the secretary of defense, who says he was taking calls and doing papers in his office and didn't know anything was wrong until the plane hit. Isn't somebody going to come to the door and say, "Excuse me, sir? Secretary of Defense? Head of the Joint Chiefs? The country's under attack."

When people ask what did Bush know and when did he know, I say 9:05. Because at 9:05 the whole country knew that accident and coincidence no longer explained this, that this was a terrorist attack. By 9:05 everybody knew that who was paying any attention at all. No matter whether he was in a grade school, I'm sure somebody got him the message. But when they deliver the message to Bush there, he looks to me like a deer caught in the headlights. He doesn't look like somebody who knew what was going. He looks suddenly like, "Good heavens, what do I do now?" And he's basically kept out of the loop the rest of the day. He's left to finish his little jaunt to read to the students. Then he does a press statement and they get him on the plane and they take him further and further away from these command and control centers. When he goes up in Air Force One, he complains on

60 Minutes a year later that his secure line to the White House, his command and control phone on the plane, which gives him nuclear control, goes dead. For two hours his communication is dead. He's calling on non-secure cell phones. He's forcing the plane to land so that he can get a communication to somebody and he's insisting that he go back to DC and become the president. I even talked to a secret service agent here in DC who said that what actually happened was that Cheney didn't want him to come back and for security purposes and the secret service made Bush sign a waiver saying that they could not protect his life. They weren't responsible for his life. Then on that condition they brought him back to DC. He was a guy that to me was being pushed out of control.

The other person most responsible for the events would have been the commander in charge of the National Military Control Center, General Montague Winfield. He had been there for several years and he had made an arrangement the day before that between 8:00 and 10:30 he was going to be out of the office. So during the entire scenario, he's gone and a young Navy guy, now an admiral, who testified to the 9/11 commission but then I think he was like a lieutenant put in charge for the first time. He's put in charge during that period and he's not apparently responding in the way that he's supposed to. The Commission leaves the FAA holding the bag, saying that because they didn't declare it a hijacking until 9:24 no response was given. But that's not the response from NORAD. NORAD has given several different responses for what it did on that day, but its normal response is not dependent on a finding of hijacking from federal agencies on the ground. Also, in addition to the FAA, NORAD's standard procedure has a secondary level, as we now know in the news and has been there my whole life time, a restricted zone around the capital here in DC called P56. It has an outer zone, an identification zone of fifty miles out, and it has an inner

zone of a 16 to17 mile circle around the monument, which includes the Pentagon and the capital and all the main buildings around the Washington monument. That air space was guarded my entire life. When small planes came in, things went up, F16s and other things went up to intervene. Then you've got the defenses of the Pentagon itself and the White House itself, both of which have surface-to-air missile response.

At some point don't you have to ask, if they can't defend their own building, how can they defend the rest of us? Is that question in there somewhere subliminally in the American psyche?

John Judge remains an independent researcher and lecturer on political assassinations, covert operations, and hidden history. He can be reached at: P.O. Box 7147, Washington, D.C. 20044, copa@starpower.net.

The One True Alien Crash Site
by Kenn Thomas

My host and his brother grew up in Albuquerque, NM, exploring its surrounding desert areas. He went on to a long and successful career as a teacher and now lives in Northern California. At some point, he became briefly involved with the parapolitical underground press and did some important research that reversed many people's understanding of a famous bombing in that part of the world (northern CA). Certainly before that, however, he came to understand that nothing remains as settled as many seem to believe, even to those who accept that the world is rife with conspiracy.

With that ethic in mind, I accepted his invitation to travel to New Mexico to examine the One True Alien Crash Site. I regarded it as I might a piece of the True Cross, of course, doubtful as I am of the historical existence of a true Jesus. This story, however, also involved a review of parapolitical reportage from a knowledgeable source; it arose, actually, from a rejection of previous theories and research about the Roswell aliens.

My host (referred to hereafter as "Ed" to shade his identity) had picked up clues to this site in artifacts of obscure and eschewed publications and broadcast, and had combined them with his own experience with the desert canyons of New Mexico to advance the story in significant ways. Whether or not he had found the real site of the "Roswell" crash, it certainly represented a new adventure in understanding the cognitive dissonance that makes the legend endure.

I had just returned from a few days in Amsterdam, to support the opening of the new bricks and mortar storefront of Herman Hegge's Frontier Sciences, the bookstore that handles *Steamshovel*'s distribution in Europe. Amsterdam, of course, remains the most civilized city over there, and much of that trip was spent exchanging jokes at the local watering hole and arguing politics.

Part of my agenda included hyping the new issue of *Steamshovel*, which contains the interview I conducted with John Judge in DC earlier this year discussing the salient aspects of 9/11 conspiracy research. For the international crowd (which at various points included several people from Australia -- including the redoubtable publisher of *Nexus Magazine*, Duncan Roads -- France, the UK and pal and publisher David Hatcher Childress) assembled at the bar, I trotted out a comparison between al Qaeda and Nicaragua's

old Sandinistas to make a point about the current parapolitics of the earth: namely, that no such comparison exists, and that it is quite false to compare the *jihadists* with any group involved in a struggle for actual freedom. I think I got that point across, although I conceded that the global strategy of terror--state and stateless--has made this planet very alien indeed.

Shortly after this New Mexico adventure, I gave a lecture as a command performance before a small birthday party of a JFK assassination aficionado at the beautiful Clement Mansion in Joliet, IL. I had been set to retire this particular lecture, involving the Maury Island case and all the connections between JFK and the UFO subculture, and was happy to learn of enough interest out there to give it a last hurrah.

Some people hate it that I connect JFK to UFO, but the lecture includes only the sad facts of history, and the answers to many of America's conspiracy mysteries often lead back to one real science-fiction nightmare or another.

So I approached this examination of the One True Alien crash site, as ever, openly. As most people who know anything about it realize, the aliens didn't crash at Roswell. The bodies had been moved from the crash site to the military base and the mortuary at Roswell and then on to Wright Field in Ohio.

In *Crash At Corona*, for instance, by Stanton Friedman--a respected elder statesman of American parapolitics whether or not there has ever been a "cosmic Watergate" as he has maintained from the lecture podium now for decades--identified the Plains of St. Augustin as the probable location of the downed extraterrestrial craft. This came during a period when some credibility for the cause collapsed due to the claims of Gerry Anderson, a man whose uncle supposedly left directions to the craft in a diary. Unfortunately, tests

300

ultimately revealed that the diary was written in ink manufactured much later than 1947. Nevertheless, the savvy student of parapolitics, especially of the paranormal variety, takes into the account the corrupting commercial influences on the Roswell story, and holds open the possibility that down deep, Anderson did convey some sparse parcel of truth about the event.

That same non-attached approach to information about the Roswell incident guided Ed's interest and led to his discovery, southwest of Socorro, NM, near Nogal Canyon. After a long and successful career as a teacher and now in retirement, he had no monetary stake in making a wild claim for the discovery of a new crash site. As a lifelong student and teacher of science, he had no inclination to accept crazy, unsupportable assertions about the possibility either.

Our first stop that afternoon was the site in Socorro, NM where sheriff Lonnie Zamora claimed to have seen a sphere shaped craft on April 24, 1964. Ed handed me a photocopied first-hand account of a man-made craft called "the Bean" that the author claimed to have been flying around in the area at the time. As we drove from there to the One True Alien crash site, Ed and I conversationally reviewed the Friedman-Anderson story in detail, and concluded that Anderson may indeed have had an authentic connection to the reality at Roswell, but had spoiled it by hoaxing his proof. It was an important point, considering Ed's basis for taking me on the current expedition:

The directions we followed came from information supplied to several ufologists including Glenn Campbell and by Ray Santilli relaying specific details supplied via phone conversations and maps by the cameraman of the infamous alien autopsy film.

The time of the media circus about the alien autopsy had long since past. Ray Santilli, the UK film producer who surfaced the footage supposedly showing the surgical examination of the Roswell critters shortly after the crash, made his impact on UFOlogy eleven years ago, on May 5, 1995. Its authenticity had been endlessly debated ever since, but as Ed went over the details--such as the curled-cord phone in the film not being the anachronism that critics claimed--he underscored that its authenticity had never really been totally, unequivocally debunked. I recalled my own endless conversations with people about the film, all of whom had fashioned themselves as experts in photography who felt they could fake things just as well, none of whom had convincing critical arguments about what was actually on it.

It had been widely rejected, though, even among UFOlogists, and I chalked it up again to the enduring legend. Ed, however, had examined it quite closely and had written about it extensively on the web. He had rented a very large SUV for this journey, which began on a small road off Highway 60 southeast of Socorro. The need for such a monster vehicle became apparent as the small road withered into rough desert terrain. Ed had doggedly pursued a path he had taken many times, although I was certain that even this hummer-craft couldn't straddle some of the crevices he drove over and that we would eventually wind up stuck there. Ed was following a path described by the cameraman that ran along the now unused mining areas of the Magdalena mountains. We stopped at a point where the cameraman had placed a bridge in his description. A bridge certainly could have been here sixty years ago, but Ed expressed disappointment that he had never found any evidence of it. Before too much of my own kicking around in the dirt and sand, I actually found some old planks buried underneath that I imagined amounted to evidence that the bridge did exist there once. Ed assured me, however, that the chances of that debris being part of the

302

bridge were slim and none. The cameraman reported that when he revisited the site in 1980 the bridge was destroyed and he had to take the same route we did. In 1986, a 100 year flood occurred, washing away all signs. That's why the road was so rough.

We made two other stops, areas where another writer, Michael Hesseman, had wound up following the cameraman's directions and photographed for his book, *Beyond Roswell*. Ed held the book up against the landscape for comparison, but they were innocuous areas and not particularly distinguished as either the exact places Hesseman had photographed or as a possible place where a flying saucer crashed into the earth. Hesseman's book, however, also contained artwork that reproduced one of the cameraman's descriptions of the actual site, perhaps even taken from one of the cameraman's own photographs-and this would later comprise the last piece of uncanny indication that Ed may have discovered the One True Alien Crash Site.

We continued north another four miles, with Ed going over the deficiencies of Hesseman's search, that he had not really understood the local geography, stopping at the last posted mile marker, failing to follow along a certain arroyo. Ed told me of his years as a youngster coming out too this area and spending days exploring them with his brother. He went over again the words of the cameraman's descriptions and his story that he had been flown to Roswell from Washington, DC and then was driven out to this remote desert region to film the site and the autopsy. The day was otherwise quiet and still as the surface of the moon.

That comparison was just coming to me as we descended upon the site. Ed noted the singed tops of trees as drove into the canyon-only the tops and the sides facing us had been blackened by fire. The trunks were still alive. Could remnants

of such singe last a half-century? The thought was answered only by the desert silence. The singed areas grew bigger as we entered the canyon, however, and clearly ended at the canyon's base. The darkened areas pointed like an arrow to an area in the canyon of rocks with an odd, light bluish white covering. I climbed with Ed all over this little canyon, examining the rocks. The substance could only be found on the outward-facing sides, as if sprayed on from the front. The "spray" extended up the hills around the canyon, and less and less of it appeared as we climbed. We eventually came to where no more could be found. We saw none of this material anywhere else in the desert coming in, nor going out. Ed explained that he previously had collected a considerable amount of the material and had a well-known local chemical geologist and engineer do an X-Ray Diffraction test it. He identified it as Christobalite, a super heated silica that presence of which absolutely nothing could account for in this canyon.

The singed trees and the silica substance created a very distinguished, clear and very well defined area. When we returned to its base, Ed took out Hesseman's book and held up the art--which featured the saucer, alien bodies sprawled on the ground and the military response team--that had been taken from the cameraman's description. The geographic features matched perfectly.

It made a convincing picture. Ed had a lot more to say, about the silica, the alien autopsy and the story of its cameraman, and about the fact that he didn't actually believe in extraterrestrial travel, offering a notion that the aliens were actually highly evolved monotremes from earth, and basing his conclusions again on what he finds in the autopsy film. Pretty far-out, I concluded, but what else would I expect to find the One True Alien crash site?

Ed has taken only one or two UFO researchers to this site, as he rarely gets time these days to make the visit to New Mexico. That's quite a shame, really, considering that in the half-perceived, half-created world of UFOlogy, this canyon definitely falls into the half that actually can be perceived, and perhaps researched into some surprising realms of parapolitical history.

Kenn Thomas publishes the conspiracy magazine *Steamshovel Press* from POB 210553, St. Louis, MO 63121 USA. Sample issue: $7 ($10 overseas); four issue subscription, $25 ($35 overseas). The new edition of Thomas' book (originally co-authored with Jim Keith), *The Octopus: Secret Government and the Death of Danny Casolaro*, has just been released from Feral House. Adventures Unlimited Press has also published several titles by Mr. Thomas, including *NASA, Nazis & JFK, Mind Control, Oswald & JFK*, and the *Steamshovel Press* back issue anthology *Popular Paranoia*. A program of Mr. Thomas' recent television appearances, entitled *Parapolitics! The Video*, a companion video to this volume, is available on DVD and VHS for $25. All money orders payable to "Kenn Thomas" not "Steamshovel Press."

A MATTER OF INTELLIGENCE

PART I

NO SURPRISE

BY *KEVIN BELFORD*

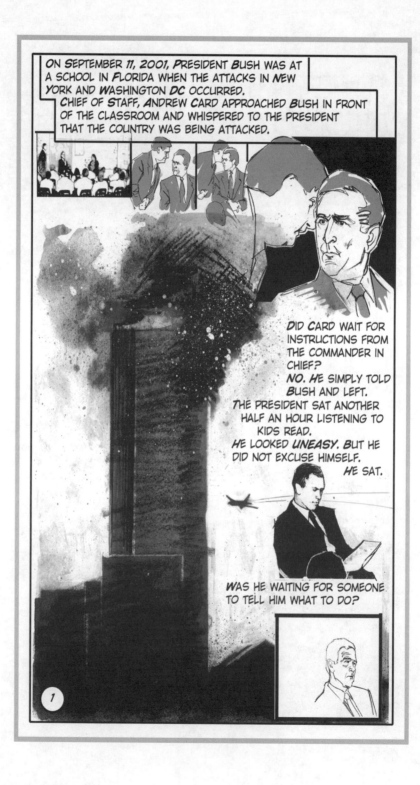

ON SEPTEMBER 11, 2001, PRESIDENT BUSH WAS AT A SCHOOL IN FLORIDA WHEN THE ATTACKS IN NEW YORK AND WASHINGTON DC OCCURRED.
CHIEF OF STAFF, ANDREW CARD APPROACHED BUSH IN FRONT OF THE CLASSROOM AND WHISPERED TO THE PRESIDENT THAT THE COUNTRY WAS BEING ATTACKED.

DID CARD WAIT FOR INSTRUCTIONS FROM THE COMMANDER IN CHIEF?
NO. HE SIMPLY TOLD BUSH AND LEFT.
THE PRESIDENT SAT ANOTHER HALF AN HOUR LISTENING TO KIDS READ.
HE LOOKED UNEASY. BUT HE DID NOT EXCUSE HIMSELF.
HE SAT.

WAS HE WAITING FOR SOMEONE TO TELL HIM WHAT TO DO?

1

WHOO! THESE ARE GREAT READERS! VERY IMPRESSIVE!

AFTER THE PLANNED EVENT ENDED, BUSH READ A STATEMENT ON LIVE TELEVISION AND BOARDED AIR FORCE ONE.

LOUISIANNA

NEBRASKA

THE PLANE LEFT FLORIDA AND WENT TO LOUISIANNA. THEN IT WENT TO NEBRASKA. HOPPING AIR FORCE BASES UNTIL IT FINALLY ARRIVED AT ANDREWS AIR FORCE BASE IN THE EVENING OF 9-11.

THE NEXT DAY, WHITE HOUSE SPOKESMAN ARI FLEISCHER SAID THAT THE PRESIDENT TOOK EVASIVE MEASURES BECAUSE A THREAT HAD BEEN RECEIVED.

THE CALLER SAID: "AIR FORCE ONE IS A TARGET"

ACCORDING TO A SGOSOCOA* THE CALLER KNEW THE AGENCY'S CODE WORDS RELATING TO AIR FORCE ONE PROCEDURES AND WHEREABOUTS.

AFTER MILITARY, SECRET SERVICE AND LAW ENFORCEMENT SOURCES SAID THAT NEITHER THE WHITE HOUSE NOR AF1 WERE TARGETS AND THE RADAR PATHS OF THE HIJACKED PLANES WERE RELEASED, REPORTERS QUESTIONED FLEISCHER AGAIN.

"THAT IS NOT THE RADAR DATA THAT WE HAVE SEEN," "THE PLANE WAS HEADED TOWARD THE WHITE HOUSE."

* "A SENIOR GOVERNMENT OFFICIAL, SPEAKING ON CONDITION OF ANONYMITY"

VICE PRESIDENT *DICK* CHENEY APPEARED ON "*MEET THE PRESS*" ON SEPTEMBER 16TH. IN THE INTERVIEW, CHENEY CLAIMED TO HAVE TAKEN CONTROL AT THE *WHITE HOUSE* ON *911.*

HE SAID THAT *HE* TOLD *BUSH* TO STAY AWAY AND THAT *HE* ORDERED CONGRESS EVACUATED AND THAT *HE* TALKED *BUSH* INTO GIVING THE SHOOT DOWN ORDER FOR ANY ROGUE AIRLINERS.

WHEN ASKED ABOUT THE PHONE THREAT, CHENEY PASSED THE BLAME.

THE SECRET SERVICE BROUGHT IT TO ME, SO I DIDN'T QUESTION IT.

BUT CHENEY DESCRIBED THE EVENTS AS IF BUSH WAS HIS PUPPET AND *THAT* WOULD NOT BE TOLERATED.

ADVISORS *KAREN HUGHES* AND *KARL ROVE* WERE NOT PLEASED.

HUGHES SCREAMED AT CHENEY'S STAFF,

ROVE TOOK CONTROL OVER ALL *TV* APPEARANCES BY OFFICIALS.

ON SEPTEMBER 25, "UNNAMED *WHITE HOUSE* SPOKESPERSONS" AND "ADMINISTRATION OFFICIALS" SAID THAT THEY 'DOUBTED' THAT THERE ACTUALLY WAS A THREAT.

WHO DOUBTED? WHO MISUNDERSTOOD?

?

ON THE 26TH, *THE BUSH* ADMINISTRATION BACKED AWAY FROM ITS STORY. *A* PRESS RELEASE SAID THAT *WHITE HOUSE* STAFFERS "APPARENTLY MISUNDERSTOOD COMMENTS MADE BY THEIR SECURITY DETAIL."

BUSH'S ACTIONS WERE IN CONTRAST TO THE *TV* VIEWER'S IMAGES OF *NEW YORK* MAYOR *GIULIANI* HANDLING THE EMERGENCY IN THE STREETS FILLED WITH RUBBLE AND DUST, AND FORMER *PRESIDENT BILL CLINTON* FLYING IN IMMEDIATELY FROM OVERSEAS AND RUSHING TO GROUND ZERO.

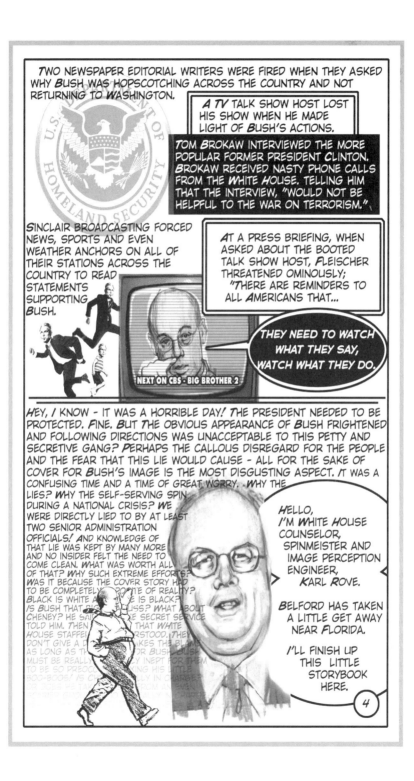

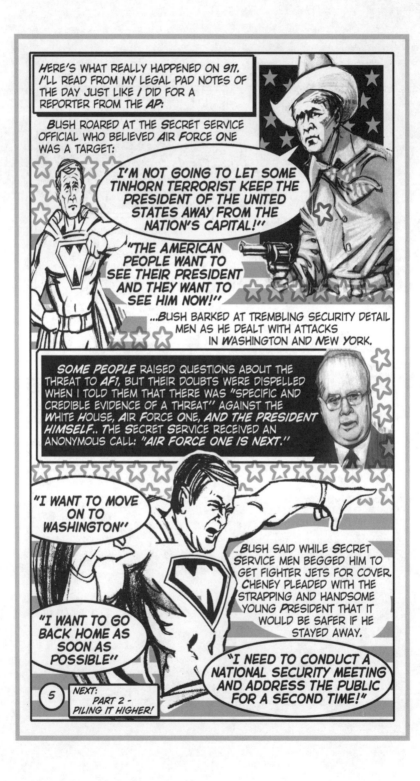

NASA, NAZIS & JFK:
The Torbitt Document & the JFK Assassination
introduction by Kenn Thomas

This book emphasizes the links between "Operation Paper Clip" Nazi scientists working for NASA, the assassination of JFK, and the secret Nevada air base Area 51. The Torbitt Document also talks about the roles played in the assassination by Division Five of the FBI, the Defense Industrial Security Command (DISC), the Las Vegas mob, and the shadow corporate entities Permindex and Centro-Mondiale Commerciale. The Torbitt Document claims that the same players planned the 1962 assassination attempt on Charles de Gaul, who ultimately pulled out of NATO because he traced the "Assassination Cabal" to Permindex in Switzerland and to NATO headquarters in Brussels. The Torbitt Document paints a dark picture of NASA, the military industrial complex, and the connections to Mercury, Nevada which headquarters the "secret space program."

258 PAGES. 5X8. PAPERBACK. ILLUSTRATED. $16.00. CODE: NNJ

INSIDE THE GEMSTONE FILE
Howard Hughes, Onassis & JFK
by Kenn Thomas & David Hatcher Childress

Steamshovel Press editor Thomas takes on the Gemstone File in this run-up and run-down of the most famous underground document ever circulated. Photocopied and distributed for over 20 years, the Gemstone File is the story of Bruce Roberts, the inventor of the synthetic ruby widely used in laser technology today, and his relationship with the Howard Hughes Company and ultimately with Aristotle Onassis, the Mafia, and the CIA. Hughes kidnapped and held a drugged-up prisoner for 10 years; Onassis and his role in the Kennedy Assassination; how the Mafia ran corporate America in the 1960s; the death of Onassis' son in the crash of a small private plane in Greece; Onassis as Ian Fleming's archvillain Ernst Stavro Blofeld; more.

320 PAGES. 6X9 PAPERBACK. ILLUSTRATED. $16.00. CODE: IGF

POPULAR PARANOIA
The Best of Steamshovel Press
edited by Kenn Thomas

The anthology exposes the biologocal warfare origins of AIDS; the Nazi/Nation of Islam link; the cult of Elizabeth Clare Prophet; the Oklahoma City bombing writings of the late Jim Keith, as well as an article on Keith's own strange death; the conspiratorial mind of John Judge; Marion Pettie and the shadowy Finders group in Washington, DC; demonic iconography; the death of Princess Diana, its connection to the Octopus and the Saudi aerospace contracts; spies among the Rajneeshis; scholarship on the historic Illuminati; and many other parapolitical topics. The book also includes the Steamshovel's last-ever interviews with the great Beat writers Allen Ginsberg and William S. Burroughs, and neuronaut Timothy Leary, and new views of the master Beat, Neal Cassady and Jack Kerouac's science fiction.

308 PAGES. 8X10 PAPERBACK. ILLUSTRATED. $19.95. CODE: POPA

MIND CONTROL, OSWALD & JFK:
Were We Controlled?
introduction by Kenn Thomas

Steamshovel Press editor Kenn Thomas examines the little-known book *Were We Controlled?*, first published in 1968. The book's author, the mysterious Lincoln Lawrence, maintained that Lee Harvey Oswald was a special agent who was a mind control subject, having received an implant in 1960 at a Russian hospital. Thomas examines the evidence for implant technology and the role it could have played in the Kennedy Assassination. Thomas also looks at the mind control aspects of the RFK assassination and details the history of implant technology. Looks at the case that the reporter Damon Runyon, Jr. was murdered because of this book.

256 PAGES. 6X9 PAPERBACK. ILLUSTRATED. NOTES. $16.00. CODE: MCOJ

THE SHADOW GOVERNMENT
9-11 and State Terror
by Len Bracken, introduction by Kenn Thomas

Bracken presents the alarming yet convincing theory that nation-states engage in or allow terror to be visited upon their citizens. It is not just liberation movements and radical groups that deploy terroristic tactics for offensive ends. States use terror defensively to directly intimidate their citizens and to indirectly attack themselves or harm their citizens under a false flag. Their motives? To provide pretexts for war or for increased police powers or both. This stratagem of indirectly using terrorism has been executed by statesmen in various ways but tends to involve the pretense of blind eyes, misdirection, and cover-ups that give statesmen plausible deniability. Lusitiania, Pearl Harbor, October Surprise, the first World Trade Center bombing, the Oklahoma City bombing and other well-known incidents suggest that terrorism is often and successfully used by states in an indirectly defensive way to take the offensive against enemies at home and abroad. Was 9-11 such an indirect defensive attack?

288 PAGES. 6X9 PAPERBACK. ILLUSTRATED. $16.00. CODE: SGOV

LIQUID CONSPIRACY
JFK, LSD, the CIA, Area 51 & UFOs
by George Piccard

Underground author George Piccard on the politics of LSD, mind control, and Kennedy's involvement with Area 51 and UFOs. Reveals JFK's LSD experiences with Mary Pinchot-Meyer. The plot thickens with an ever expanding web of CIA involvement, from underground bases with UFOs seen by JFK and Marilyn Monroe (among others) to a vaster conspiracy that affects every government agency from NASA to the Justice Department. This may have been the reason that Marilyn Monroe and actress-columnist Dorothy Kilgallen were both murdered. Focusing on the bizarre side of history, *Liquid Conspiracy* takes the reader on a psychedelic tour de force. This is your government on drugs!

264 PAGES. 6X9 PAPERBACK. ILLUSTRATED. $14.95. CODE: LIQC

THE ARCH CONSPIRATOR
Essays and Actions
by Len Bracken

Veteran conspiracy author Len Bracken's witty essays and articles lead us down the dark corridors of conspiracy, politics, murder and mayhem. In 12 chapters Bracken takes us through a maze of interwoven tales from the Russian Conspiracy (and a few "extra notes" on conspiracies) to his interview with Costa Rican novelist Joaquin Gutierrez and his Psychogeographic Map into the Third Millennium. Other chapters in the book are A General Theory of Civil War; A False Report Exposes the Dirty Truth About South African Intelligence Services; The New-Catiline Conspiracy for the Cancellation of Debt; Anti-Labor Day; 1997 with selected Aphorisms Against Work; Solar Economics; and more. Bracken's work has appeared in such pop-conspiracy publications as *Paranoia, Steamshovel Press* and the *Village Voice*. Len Bracken lives in Arlington, Virginia and haunts the back alleys of Washington D.C., keeping an eye on the predators who run our country. With a gun to his head, he cranks out his rants for fringe publications and is the editor of *Extraphile*, described by *New Yorker Magazine* as "fusion conspiracy theory."
256 PAGES. 6x9 PAPERBACK. ILLUSTRATED. BIBLIOGRAPHY. $14.95. CODE: ACON.

PIRATES & THE LOST TEMPLAR FLEET
The Secret Naval War Between the Templars & the Vatican
by David Hatcher Childress

Childress takes us into the fascinating world of maverick sea captains who were Knights Templar (and later Scottish Rite Free Masons) who battled the Vatican, and the Spanish and Italian ships that sailed for the Pope. The lost Templar fleet was originally based at La Rochelle in southern France, but fled to the deep fiords of Scotland upon the dissolution of the Order by King Phillip. This banned fleet of ships was later commanded by the St. Clair family of Rosslyn Chapel (birthplace of Free Masonry). St. Clair and his Templars made a voyage to Canada in the year 1298 AD, nearly 100 years before Columbus! Later, this fleet of ships and new ones to come, flew the Skull and Crossbones, the symbol of the Knights Templar. They preyed on the ships of the Vatican coming from the rich ports of the Americas and were ultimately known as the Pirates of the Caribbean. Chapters include: 10,000 Years of Seafaring; The Knights Templar & the Crusades; The Templars and the Assassins; The Lost Templar Fleet and the Jolly Roger; Maps of the Ancient Sea Kings; Pirates, Templars and the New World; Christopher Columbus—Secret Templar Pirate?; Later Day Pirates and the War with the Vatican; Pirate Utopias and the New Jerusalem; more.
320 PAGES. 6x9 PAPERBACK. ILLUSTRATED. BIBLIOGRAPHY. $16.95. CODE: PLTF

THE HISTORY OF THE KNIGHTS TEMPLARS
by Charles G. Addison, introduction by David Hatcher Childress

Chapters on the origin of the Templars, their popularity in Europe and their rivalry with the Knights of St. John, later to be known as the Knights of Malta. Detailed information on the activities of the Templars in the Holy Land, and the 1312 AD suppression of the Templars in France and other countries, which culminated in the execution of Jacques de Molay and the continuation of the Knights Templars in England and Scotland; the formation of the society of Knights Templars in London; and the rebuilding of the Temple in 1816. Plus a lengthy intro about the lost Templar fleet and its connections to the ancient North American sea routes.
395 PAGES. 6x9 PAPERBACK. ILLUSTRATED. $16.95. CODE: HKT

THE LUCID VIEW
Investigations in Occultism, Ufology & Paranoid Awareness
by Aeolus Kephas

An unorthodox analysis of conspiracy theory, ufology, extraterrestrialism and occultism. *The Lucid View* takes us on an impartial journey through secret history, including the Gnostics and Templars; Crowley and Hitler's occult alliance; the sorcery wars of Freemasonry and the Illuminati; "Alternative Three" covert space colonization; the JFK assassination; the Manson murders; Jonestown and 9/11. Also delves into UFOs and alien abductions, their relations to mind control technology and sorcery practices, with reference to inorganic beings and Kundalini energy. The book offers a balanced overview on religious, magical and paranoid beliefs pertaining to the 21st century, and their social, psychological, and spiritual implications for humanity, the leading game player in the grand mythic drama of Armageddon.
298 PAGES. 6x9 PAPERBACK. ILLUSTRATED. $16.95. CODE: LVEW

MIND CONTROL, WORLD CONTROL
by Jim Keith

Veteran author and investigator Jim Keith uncovers a surprising amount of information on the technology, experimentation and implementation of mind control. Various chapters in this shocking book are on early CIA experiments such as Project Artichoke and Project R.H.I.C.-EDOM, the methodology and technology of implants, mind control assassins and couriers, various famous Mind Control victims such as Sirhan Sirhan and Candy Jones. Also featured in this book are chapters on how mind control technology may be linked to some UFO activity and "UFO abductions."
256 PAGES. 6x9 PAPERBACK. ILLUSTRATED. FOOTNOTES. $14.95. CODE: MCWC

MASS CONTROL
Engineering Human Consciousness
by Jim Keith

Conspiracy expert Keith's final book on mind control, Project Monarch, and mass manipulation presents chilling evidence that we are indeed spinning a Matrix. Keith describes the New Man, where conception of reality is a dance of electronic images fired into his forebrain, a gossamer construction of his masters, designed so that he will not—under any circumstances—perceive the actual. His happiness is delivered to him through a tube or an electronic connection. His God lurks behind an electronic curtain; when the curtain is pulled away we find the CIA sorcerer, the media manipulatorÖ Chapters on the CIA, Tavistock, Jolly West and the Violence Center, Guerrilla Mindwar, Brice Taylor, other recent "victims," more.
256 PAGES. 6x9 PAPERBACK. ILLUSTRATED. INDEX. $16.95. CODE: MASC

PERPETUAL MOTION
The History of an Obsession
by Arthur W. J. G. Ord-Hume

Make a machine which gives out more work than the energy you put into it, and you have perpetual motion. The deceptively simple task of making a mechanism which would turn forever fascinated many an inventor, and a number of famous men and physicists applied themselves to the task. Despite the naivete and blatant trickery of many of the inventors, there are a handful of mechanisms which defy explanation. A vast canvas-covered wheel which turned by itself was erected in the Tower of London. Another wheel, equally surrounded by mystery and intrigue, turned endlessly in Germany. Chapters include: Elementary Physics and Perpetual Motion; Medieval Perpetual Motion; Self-moving Wheels and Overbalancing Weights; Lodestones, Electro-Magnetism and Steam; Capillary Attraction and Spongewheels; Cox's Perpetual Motion; Keely and his Amazing Motor; Odd Ideas about Vaporization and Liquefaction; The Astonishing Case of the Garabed Project; Ever-Ringing Bells and Radium Perpetual Motion; Perpetual Motion Inventors Barred from the US Patent Office; Rolling Ball Clocks; Perpetual Lamps; The Perpetuity of the Perpetual Motion Inventor; more.

260 PAGES. 6x9 PAPERBACK. ILLUSTRATED. BIBLIOGRAPHY. INDEX. $20.00. CODE: PPM

HIDDEN NATURE
The Startling Insights of Viktor Schauberger
by Alick Bartholomew, foreword by David Bellamy

Victor Schauberger (1885-1958) pioneered a new understanding of the Science of Nature, (re)discovering its primary laws and principles, unacknowledged by contemporary science. From studying the fast flowing streams of the unspoilt Alps, he gained insights into water as a living organism. He showed that water is like a magnetic tape; it can carry information that may either enhance or degrade the quality of organisms. Our failure to understand the need to protect the quality of water is the principle cause of environmental degradation on the planet. Schauberger warned of climatic chaos resulting from deforestation and called for work with free energy machines and energy generation. Chapters include: Schauberger's Vision; Different Kinds of Energy; Attraction & Repulsion of Opposites; Nature's Patterns & Shapes; Energy Production; Motion, Key to Balance; Atmosphere/Electricity; The Nature of Water; Hydrological Cycle; Formation of Springs; How Rivers Flow; Supplying Water; The Role of the Forests; Tree Metabolism; Soil Fertility and Cultivation; Organic Cultivation; The Energy Revolution; Harnessing Implosion Power; Viktor Schauberger & Society; more.

288 PAGES. 7x10 PAPERBACK. ILLUSTRATED. REFERENCES. INDEX. $22.95. CODE: HNAT

MIND CONTROL AND UFOS
Casebook on Alternative 3
by Jim Keith

Drawing on his diverse research and a wide variety of sources, Jim Keith delves into the bizarre story behind *Alternative 3*, including mind control programs, underground bases not only on the Earth but also on the Moon and Mars, the real origin of the UFO problem, the mysterious deaths of Marconi Electronics employees in Britain during the 1980s, top scientists around the world kidnapped to work at the secret government space bases, the Russian-American superpower arms race of the 50s, 60s and 70s as a massive hoax, and other startling arenas. Chapters include: Secret Societies and *Die Neuordning*; The Fourth Reich; UFOs and the Space Program; Government UFOs; Hot Jobs and Crop Circles; Missing Scientists and LGIBs; Ice Picks, Electrodes and LSD; Electronic Wars; Batch Consignments; The Depopulation Bomb; Veins and Tributaries; Lunar Base Alpha One; Disinfo; Other Alternatives; Noah's Ark II; *Das Marsprojekt*; more.

248 PAGES. 6x9 PAPERBACK. ILLUSTRATED. BIBLIOGRAPHY. $14.95. CODE: MCUF

UFOS, PSI AND SPIRITUAL EVOLUTION
A Journey through the Evolution of Interstellar Travel
by Christopher Humphries, Ph.D.

The modern era of UFOs began in May, 1947, one year and eight months after Hiroshima. This is no coincidence, and suggests there are beings in the universe with the ability to jump hundreds of light years in an instant. That is teleportation, a power of the mind. If it weren't for levitation and teleportation, star travel would not be possible at all, since physics rules out star travel by technology. So if we want to go to the stars, it is the mind and spirit we must study, not technology. The mind must be a dark matter object, since it is invisible and intangible and can freely pass through solid objects. A disembodied mind can see the de Broglie vibrations (the basis of quantum mechanics) radiated by both dark and ordinary matter during near-death or out-of-body experiences. Levitation requires warping the geodesics of space-time. The latest theory in physics is String Theory, which requires six extra spatial dimensions. The mind warps those higher geodesics to produce teleportation. We are a primitive and violent species. Our universities lack any sciences of mind, spirit or civilization. If we want to go to the stars, the first thing we must do is "grow up." That is the real Journey.

274 PAGES. 6x9 PAPERBACK. ILLUSTRATED. REFERENCES. $16.95. CODE: UPSE

INVISIBLE RESIDENTS
The Reality of Underwater UFOS
by Ivan T. Sanderson, Foreword by David Hatcher Childress

This book is a groundbreaking contribution to the study of the UFO enigma, originally published over 30 years ago. In this book, Sanderson, a renowned zoologist with a keen interest in the paranormal, puts forward the curious theory that "OINTS"—Other Intelligences—live under the Earth's oceans. This underwater, parallel, civilization may be twice as old as Homo sapiens, he proposes, and may have "developed what we call space flight." Sanderson postulates that the OINTS are behind many UFO sightings as well as the mysterious disappearances of aircraft and ships in the Bermuda Triangle. What better place to have an impenetrable base than deep within the oceans of the planet? Yet, if UFOs, or at least some of them, are coming from beneath our oceans or lakes, does it necessarily mean that there is another civilization besides our own that is responsible? In fact, could it be that since WWII a number of underwater UFO bases have been constructed by the very human governments of our planet? Whatever their source, Sanderson offers here an exhaustive study of USOs (Unidentified Submarine Objects) observed in nearly every part of the world. He presents many well-documented and exciting case studies of these unusual sightings.; more.

298 PAGES. 6x9 PAPERBACK. ILLUSTRATED. BIBLIOGRAPHY. INDEX. $16.95. CODE: INVS

THE WORLD CATACLYSM IN 2012
Maya Calendar Countdown
by Patrick Geryl
In his previous book, *The Orion Prophecy*, author Geryl theorized that the lost civilization of Atlantis was destroyed by a huge cataclysm engendered by changes in sunspot activity affecting Earth's magnetic poles and atmosphere. Having experienced earlier catastrophes, the Atlanteans had developed amazing astronomical and mathematical knowledge that enabled them to predict the date of their continent's demise. They devised a survival plan, and were able to pass along their knowledge to civilizations we know as the Maya and Old Egyptians. Here, Geryl shows that the mathematics and astronomy of the ancient Egyptians and Maya are related, and have similar predictive power which should be taken very seriously. He cracks their hidden codes that show definitively that the next earth-consuming cataclysm will occur in 2012, and calls urgently for the excavation of the Labyrinth of ancient Egypt, a storehouse of Atlantean knowledge which is linked in prophecy to the May predictions.
256 PAGES. 6x9 PAPERBACK. ILLUSTRATED. REFERENCES. $16.95. CODE: WC20

HAARP
The Ultimate Weapon of the Conspiracy
by Jerry Smith
The HAARP project in Alaska is one of the most controversial projects ever undertaken by the U.S. Government. Jerry Smith gives us the history of the HAARP project and explains how it works, in technically correct yet easy to understand language. At best, HAARP is science out-of-control; at worst, HAARP could be the most dangerous device ever created, a futuristic technology that is everything from super-beam weapon to world-wide mind control device. Topics include Over-the-Horizon Radar and HAARP; Mind Control, ELF and HAARP; The Telsa Connection; The Russian Woodpecker; GWEN & HAARP; Earth Penetrating Tomography; Weather Modification; Secret Science of the Conspiracy; more. Includes the complete 1987 Eastlund patent for his pulsed super-weapon that he claims was stolen by the HAARP Project.
256 PAGES. 6x9 PAPERBACK. ILLUSTRATED. $14.95. CODE: HARP

SECRETS OF THE HOLY LANCE
The Spear of Destiny in History & Legend
by Jerry E. Smith and George Piccard
As Jesus Christ hung on the cross a Roman centurion pierced the Savior's side with his spear. A legend has arisen that "whosoever possesses this Holy Lance and understands the powers it serves, holds in his hand the destiny of the world for good or evil." *Secrets of the Holy Lance* traces the Spear from its possession by Constantine, Rome's first Christian Caesar, to Charlemagne's claim that with it he ruled the Holy Roman Empire by Divine Right, and on through two thousand years of kings and emperors, until it came within Hitler's grasp—and beyond! Did it rest for a while in Antarctic ice? Is it now hidden in Europe, awaiting the next person to claim its awesome power? Neither debunking nor worshiping, *Secrets of the Holy Lance* seeks to pierce the veil of myth and mystery around the Spear. Mere belief that it was infused with magic by virtue of its shedding the Savior's blood has made men kings. But what if it's more? What are "the powers it serves"?
312 PAGES. 6x9 PAPERBACK. ILLUSTRATED. BIBLIOGRAPHY. $16.95. CODE: SOHL

FROM LIGHT INTO DARKNESS
The Evolution of Religion in Ancient Egypt
by Stephen S. Mehler
Building on the esoteric information first revealed in Land of Osiris, this exciting book presents more of Abd'El Hakim's oral traditions, with radical new interpretations of how religion evolved in prehistoric and dynastic Khemit, or Egypt. * Have popular modern religions developed out of practices in ancient Egypt? * Did religion in Egypt represent only a shadow of the spiritual practices of prehistoric people? * Have the Western Mystery Schools such as the Rosicrucian Order evolved from these ancient systems? * Author Mehler explores the teachings of the King Akhenaten and the real Moses, the true identity of the Hyksos, and Akhenaten's connections to The Exodus, Judaism and the Rosicrucian Order. Here for the first time in the West, are the spiritual teachings of the ancient Khemitians, the foundation for the coming new cycle of consciousness—The Awakening; more.
240 PAGES. 6x9 PAPERBACK. ILLUSTRATED. REFERENCES. $16.95. CODE: FLID

THE LAND OF OSIRIS
An Introduction to Khemitology
by Stephen S. Mehler
Was there an advanced prehistoric civilization in ancient Egypt who built the great pyramids and carved the Great Sphinx? Did the pyramids serve as energy devices and not as tombs for kings? Mehler has uncovered an indigenous oral tradition that still exists in Egypt, and has been fortunate to have studied with a living master of this tradition, Abd'El Hakim Awyan. Mehler has also been given permission to present these teachings to the Western world, teachings that unfold a whole new understanding of ancient Egypt . Chapters include: Egyptology and Its Paradigms; Asgat Nefer—The Harmony of Water; Khemit and the Myth of Atlantis; The Extraterrestrial Question; more.
272 PAGES. 6x9 PAPERBACK. ILLUSTRATED. COLOR SECTION. BIBLIOGRAPHY. $18.95. CODE: LOOS

ORACLE OF THE ILLUMINATI
Coincidence, Cocreation, Contact
By William Henry
Investigative mythologist William Henry follows up his best-selling Cloak of the Illuminati with this illustration-packed treatise on the secret codes, oracles and technology of ancient Illuminati. His primary expertise and mission is finding and interpreting ancient gateway stories which feature advanced technology for raising of spiritual vibration and increasing our body's innate healing ability. Chapters include: From Cloak to Oracle; The Return of Sophia; The Cosmic G-Spot Stimulator; The Reality of the Rulers; The Hymn of the Pearl; The Realm of the Illuminati; Francis Bacon: Oracle; Abydos and the Head of Sophia; Enki and the Flower of Light; The God Head and the Dodecahedron; The Star Walker; The Big Secret; more.
243 PAGES. 6X9 PAPERBACK. ILLUSTRATED. NOTES & REFERENCES. $16.95. CODE: ORIL

CLOAK OF THE ILLUMINATI
Secrets, Transformations, Crossing the Star Gate
by William Henry
Thousands of years ago the stargate technology of the gods was lost. Mayan Prophecy says it will return by 2012, along with our alignment with the center of our galaxy. In this book: Find examples of stargates and wormholes in the ancient world; Examine myths and scripture with hidden references to a stargate cloak worn by the Illuminati, including Mari, Nimrod, Elijah, and Jesus; See rare images of gods and goddesses wearing the Cloak of the illuminati; Learn about Saddam Hussein and the secret missing library of Jesus; Uncover the secret Roman-era eugenics experiments at the Temple of Hathor in Denderah, Egypt; Explore the duplicate of the Stargate Pillar of the Gods in the Illuminists' secret garden in Nashville, TN; Discover the secrets of manna, the food of the angels; Share the lost Peace Prayer posture of Osiris, Jesus and the Illuminati; more. Chapters include: Seven Stars Under Three Stars; The Long Walk; Squaring the Circle; The Mill of the Host; The Miracle Garment; The Fig; Nimrod: The Mighty Man; Nebuchadnezzar's Gate; The New Mighty Man; more.
238 PAGES. 6X9 PAPERBACK. ILLUSTRATED. BIBLIOGRAPHY. INDEX. $16.95. CODE: COIL

THE GIZA DEATH STAR
The Paleophysics of the Great Pyramid & the Military Complex at Giza
by Joseph P. Farrell
Was the Giza complex part of a military installation over 10,000 years ago? Chapters include:An Archaeology of Mass Destruction; Thoth and Theories; The Machine Hypothesis; Pythagoras, Plato, Planck, and the Pyramid; The Weapon Hypothesis; Encoded Harmonics of the Planck Units in the Great Pyramid; High Frequency Direct Current "Impulse"Technology; The Grand Gallery and its Crystals: Gravito-acoustic Resonators; The Other Two Large Pyramids, "Causeways," and the "Temples"; A Phase Conjugate Howitzer; Evidence of the Use of Weapons of Mass Destruction in Ancient Times; more.
290 PAGES. 6X9 PAPERBACK. ILLUSTRATED. $16.95. CODE: GDS

THE GIZA DEATH STAR DEPLOYED
The Physics & Engineering of the Great Pyramid
by Joseph P. Farrell
Farrell expands on his thesis that the Great Pyramid was a chemical maser, designed as a weapon and eventually deployed—with disastrous results to the solar system. Includes: Exploding Planets: The Movie, the Mirror, and the Model; Dating the Catastrophe and the Compound; A Brief History of the Exoteric and Esoteric Investigations of the Great Pyramid; No Machines, Please!; The Stargate Conspiracy; The Scalar Weapons; Message or Machine?; A Tesla Analysis of the Putative Physics and Engineering of the Giza Death Star; Cohering the Zero Point, Vacuum Energy, Flux: Synopsis of Scalar Physics and Paleophysics; Configuring the Scalar Pulse Wave; Inferred Applications in the Great Pyramid; Quantum Numerology, Feedback Loops and Tetrahedral Physics; and more.
290 PAGES. 6X9 PAPERBACK. ILLUSTRATED. BIBLIOGRAPHY. INDEX. $16.95. CODE: GDSD

THE GIZA DEATH STAR DESTROYED
The Ancient War For Future Science
by Joseph P. Farrell
This is the third and final volume in the popular Giza Death Star series, physicist Farrell looks at what eventually happened to the 10,000-year-old Giza Death Star after it was deployed—it was destroyed by an internal explosion. Recapping his earlier books, Farrell moves on to events of the final days of the Giza Death Star and its awesome power. These final events, eventually leading up to the destruction of this giant machine, are dissected one by one, leading us to the eventual abandonment of the Giza Military Complex—an event that hurled civilization back into the Stone Age. Chapters include: The Mars-Earth Connection; The Lost "Root Races" and the Moral Reasons for the Flood; The Destruction of Krypton: The Electrodynamic Solar System, Exploding Planets and Ancient Wars; Turning the Stream of the Flood: the Origin of Secret Societies and Esoteric Traditions; The Quest to Recover Ancient Mega-Technology; Non-Equilibrium Paleophysics; Monatomic Paleophysics; Frequencies, Vortices and Mass Particles: the Pyramid Power of Dr. Pat Flanagan and Joe Parr; The Topology of the Aether; A Final Physical Effect: "Acoustic" Intensity of Fields; The Pyramid of Crystals; tons more.
292 PAGES. 6X9 PAPERBACK. ILLUSTRATED. BIBLIOGRAPHY. $16.95. CODE: GDES

QUEST FOR ZERO-POINT ENERGY
Engineering Principles for "Free Energy"
by Moray B. King
King expands, with diagrams, on how free energy and anti-gravity are possible. The theories of zero point energy maintain there are tremendous fluctuations of electrical field energy embedded within the fabric of space. King explains the following topics: Tapping the Zero-Point Energy as an Energy Source; Fundamentals of a Zero-Point Energy Technology; Vacuum Energy Vortices; The Super Tube; Charge Clusters: The Basis of Zero-Point Energy Inventions; Vortex Filaments, Torsion Fields and the Zero-Point Energy; Transforming the Planet with a Zero-Point Energy Experiment; Dual Vortex Forms: The Key to a Large Zero-Point Energy Coherence. Packed with diagrams, patents and photos. With power shortages now a daily reality in many parts of the world, this book offers a fresh approach very rarely mentioned in the mainstream media.
224 PAGES. 6X9 PAPERBACK. ILLUSTRATED. $14.95. CODE: QZPE

TAPPING THE ZERO POINT ENERGY
Free Energy & Anti-Gravity in Today's Physics
by Moray B. King
King explains how free energy and anti-gravity are possible. The theories of the zero point energy maintain there are tremendous fluctuations of electrical field energy imbedded within the fabric of space. This book tells how, in the 1930s, inventor T. Henry Moray could produce a fifty kilowatt "free energy" machine; how an electrified plasma vortex creates anti-gravity; how the Pons/Fleischmann "cold fusion" experiment could produce tremendous heat without fusion; and how certain experiments might produce a gravitational anomaly.
180 PAGES. 5X8 PAPERBACK. ILLUSTRATED. $12.95. CODE: TAP

THE FREE-ENERGY DEVICE HANDBOOK
A Compilation of Patents and Reports
by David Hatcher Childress
A large-format compilation of various patents, papers, descriptions and diagrams concerning free-energy devices and systems. *The Free-Energy Device Handbook* is a visual tool for experimenters and researchers into magnetic motors and other "over-unity" devices. With chapters on the Adams Motor, the Hans Coler Generator, cold fusion, superconductors, "N" machines, space-energy generators, Nikola Tesla, T. Townsend Brown, and the latest in free-energy devices. Packed with photos, technical diagrams, patents and fascinating information, this book belongs on every science shelf. With energy and profit being a major political reason for fighting various wars, free-energy devices, if ever allowed to be mass distributed to consumers, could change the world! Get your copy now before the Department of Energy bans this book!
292 PAGES. 8X10 PAPERBACK. ILLUSTRATED. BIBLIOGRAPHY. $16.95. CODE: FEH

ETHER TECHNOLOGY
A Rational Approach to Gravity Control
by Rho Sigma
This classic book on anti-gravity and free energy is back in print and back in stock. Written by a well-known American scientist under the pseudonym of "Rho Sigma," this book delves into international efforts at gravity control and discoid craft propulsion. Before the Quantum Field, there was "Ether." This small, but informative book has chapters on John Searle and "Searle discs;" T. Townsend Brown and his work on anti-gravity and ether-vortex turbines. Includes a forward by former NASA astronaut Edgar Mitchell.
108 PAGES. 6X9 PAPERBACK. ILLUSTRATED. $12.95. CODE: ETT

THE TIME TRAVEL HANDBOOK
A Manual of Practical Teleportation & Time Travel
edited by David Hatcher Childress
In the tradition of *The Anti-Gravity Handbook* and *The Free-Energy Device Handbook*, science and UFO author David Hatcher Childress takes us into the weird world of time travel and teleportation. Not just a whacked-out look at science fiction, this book is an authoritative chronicling of real-life time travel experiments, teleportation devices and more. *The Time Travel Handbook* takes the reader beyond the government experiments and deep into the uncharted territory of early time travellers such as Nikola Tesla and Guglielmo Marconi and their alleged time travel experiments, as well as the Wilson Brothers of EMI and their connection to the Philadelphia Experiment—the U.S. Navy's forays into invisibility, time travel, and teleportation. Childress looks into the claims of time travelling individuals, and investigates the unusual claim that the pyramids on Mars were built in the future and sent back in time. A highly visual, large format book, with patents, photos and schematics. Be the first on your block to build your own time travel device!
316 PAGES. 7X10 PAPERBACK. ILLUSTRATED. $16.95. CODE: TTH

MAN-MADE UFOS 1944—1994
Fifty Years of Suppression
by Renato Vesco & David Hatcher Childress
A comprehensive look at the early "flying saucer" technology of Nazi Germany and the genesis of man-made UFOs. This book takes us from the work of captured German scientists to escaped battalions of Germans, secret communities in South America and Antarctica to todays state-of-the-art "Dreamland" flying machines. Heavily illustrated, this astonishing book blows the lid off the "government UFO conspiracy" and explains with technical diagrams the technology involved. Examined in detail are secret underground airfields and factories; German secret weapons; "suction" aircraft; the origin of NASA; gyroscopic stabilizers and engines; the secret Marconi aircraft factory in South America; and more. Introduction by W.A. Harbinson, author of the Dell novels *GENESIS* and *REVELATION*.
318 PAGES. 6X9 PAPERBACK. ILLUSTRATED. INDEX & FOOTNOTES. $18.95. CODE: MMU

THE A.T. FACTOR
A Scientists Encounter with UFOs: Piece For A Jigsaw Part 3
by Leonard Cramp

British aerospace engineer Cramp began much of the scientific anti-gravity and UFO propulsion analysis back in 1955 with his landmark book *Space, Gravity & the Flying Saucer* (out-of-print and rare). His next books (available from Adventures Unlimited) *UFOs & Anti-Gravity: Piece for a Jig-Saw* and *The Cosmic Matrix: Piece for a Jig-Saw Part 2* began Cramp's in depth look into gravity control, free-energy, and the interlocking web of energy that pervades the universe. In this final book, Cramp brings to a close his detailed and controversial study of UFOs and Anti-Gravity.
324 PAGES. 6x9 PAPERBACK. ILLUSTRATED. BIBLIOGRAPHY. INDEX. $16.95. CODE: ATF

COSMIC MATRIX
Piece for a Jig-Saw, Part Two
by Leonard G. Cramp

Leonard G. Cramp, a British aerospace engineer, wrote his first book *Space Gravity and the Flying Saucer* in 1954. Cosmic Matrix is the long-awaited sequel to his 1966 book *UFOs & Anti-Gravity: Piece for a Jig-Saw.* Cramp has had a long history of examining UFO phenomena and has concluded that UFOs use the highest possible aeronautic science to move in the way they do. Cramp examines anti-gravity effects and theorizes that this super-science used by the craft—described in detail in the book—can lift mankind into a new level of technology, transportation and understanding of the universe. The book takes a close look at gravity control, time travel, and the interlocking web of energy between all planets in our solar system with Leonard's unique technical diagrams. A fantastic voyage into the present and future!
364 PAGES. 6x9 PAPERBACK. ILLUSTRATED. BIBLIOGRAPHY. $16.00. CODE: CMX

UFOS AND ANTI-GRAVITY
Piece For A Jig-Saw
by Leonard G. Cramp

Leonard G. Cramp's 1966 classic book on flying saucer propulsion and suppressed technology is a highly technical look at the UFO phenomena by a trained scientist. Cramp first introduces the idea of 'anti-gravity' and introduces us to the various theories of gravitation. He then examines the technology necessary to build a flying saucer and examines in great detail the technical aspects of such a craft. Cramp's book is a wealth of material and diagrams on flying saucers, anti-gravity, suppressed technology, G-fields and UFOs. Chapters include Crossroads of Aerodymanics, Aerodynamic Saucers, Limitations of Rocketry, Gravitation and the Ether, Gravitational Spaceships, G-Field Lift Effects, The Bi-Field Theory, VTOL and Hovercraft, Analysis of UFO photos, more.
388 PAGES. 6x9 PAPERBACK. ILLUSTRATED. $16.95. CODE: UAG

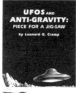

THE TESLA PAPERS
Nikola Tesla on Free Energy & Wireless Transmission of Power
by Nikola Tesla, edited by David Hatcher Childress

David Hatcher Childress takes us into the incredible world of Nikola Tesla and his amazing inventions. Tesla's rare article "The Problem of Increasing Human Energy with Special Reference to the Harnessing of the Sun's Energy" is included. This lengthy article was originally published in the June 1900 issue of *The Century Illustrated Monthly Magazine* and it was the outline for Tesla's master blueprint for the world. Tesla's fantastic vision of the future, including wireless power, anti-gravity, free energy and highly advanced solar power. Also included are some of the papers, patents and material collected on Tesla at the Colorado Springs Tesla Symposiums, including papers on: •The Secret History of Wireless Transmission •Tesla and the Magnifying Transmitter •Design and Construction of a Half-Wave Tesla Coil •Electrostatics: A Key to Free Energy •Progress in Zero-Point Energy Research •Electromagnetic Energy from Antennas to Atoms •Tesla's Particle Beam Technology •Fundamental Excitatory Modes of the Earth-Ionosphere Cavity
325 PAGES. 8X10 PAPERBACK. ILLUSTRATED. $16.95. CODE: TTP

THE FANTASTIC INVENTIONS OF NIKOLA TESLA
by Nikola Tesla with additional material by David Hatcher Childress

This book is a readable compendium of patents, diagrams, photos and explanations of the many incredible inventions of the originator of the modern era of electrification. In Tesla's own words are such topics as wireless transmission of power, death rays, and radio-controlled airships. In addition, rare material on German bases in Antarctica and South America, and a secret city built at a remote jungle site in South America by one of Tesla's students, Guglielmo Marconi. Marconi's secret group claims to have built flying saucers in the 1940s and to have gone to Mars in the early 1950s! Incredible photos of these Tesla craft are included. The Ancient Atlantean system of broadcasting energy through a grid system of obelisks and pyramids is discussed, and a fascinating concept comes out of one chapter: that Egyptian engineers had to wear protective metal head-shields while in these power plants, hence the Egyptian Pharoah's head covering as well as the Face on Mars! •His plan to transmit free electricity into the atmosphere. •How electrical devices would work using only small antennas. •Why unlimited power could be utilized anywhere on earth. •How radio and radar technology can be used as death-ray weapons in Star Wars.
342 PAGES. 6x9 PAPERBACK. ILLUSTRATED. $16.95. CODE: FINT

REICH OF THE BLACK SUN
Nazi Secret Weapons and the Cold War Allied Legend
by Joseph P. Farrell

Why were the Allies worried about an atom bomb attack by the Germans in 1944? Why did the Soviets threaten to use poison gas against the Germans? Why did Hitler in 1945 insist that holding Prague could win the war for the Third Reich? Why did US General George Patton's Third Army race for the Skoda works at Pilsen in Czechoslovakia instead of Berlin? Why did the US Army not test the uranium atom bomb it dropped on Hiroshima? Why did the Luftwaffe fly a non-stop round trip mission to within twenty miles of New York City in 1944? *Reich of the Black Sun* takes the reader on a scientific-historical journey in order to answer these questions. Arguing that Nazi Germany actually won the race for the atom bomb in late 1944, and then goes on to explore the even more secretive research the Nazis were conducting into the occult, alternative physics and new energy sources.

352 PAGES. 6x9 PAPERBACK. ILLUSTRATED. BIBLIOGRAPHY. $16.95. CODE: ROBS

SAUCERS OF THE ILLUMINATI
by Jim Keith, Foreword by Kenn Thomas

Seeking the truth behind stories of alien invasion, secret underground bases, and the secret plans of the New World Order, *Saucers of the Illuminati* offers ground breaking research, uncovering clues to the nature of UFOs and to forces even more sinister: the secret cabal behind planetary control! Includes mind control, saucer abductions, the MJ-12 documents, cattle mutilations, government anti-gravity testing, the Sirius Connection, science fiction author Philip K. Dick and his efforts to expose the Illuminati, plus more from veteran conspiracy and UFO author Keith. Conspiracy expert Keith's final book on UFOs and the highly secret group that manufactures them and uses them for their own purposes: the control and manipulation of the population of planet Earth.

148 PAGES. 6x9 PAPERBACK. ILLUSTRATED. $12.95. CODE: SOIL

THE ENERGY MACHINE OF T. HENRY MORAY
by Moray B. King

In the 1920s T. Henry Moray invented a "free energy" device that reportedly output 50 kilowatts of electricity. It could not be explained by standard science at that time. The electricity exhibited a strange "cold current" characteristic where thin wires could conduct appreciable power without heating. Moray suffered ruthless suppression, and in 1939 the device was destroyed. Frontier science lecturer and author Moray B. King explains the invention with today's science. Modern physics recognizes that the vacuum contains tremendous energy called the zero-point energy. A way to coherently activate it appears surprisingly simple: first create a glow plasma or corona, then abruptly pulse it. Other inventors have discovered this approach (sometimes unwittingly) to create novel energy devices, and they too were suppressed. The common pattern of their technologies clarified the fundamental operating principle. King hopes to inspire engineers and inventors so that a new energy source can become available to mankind.

192 PAGES. 6x8 PAPERBACK. ILLUSTRATED. $14.95. CODE: EMHM

THE ENERGY GRID
Harmonic 695, The Pulse of the Universe
by Captain Bruce Cathie.

This is the breakthrough book that explores the incredible potential of the Energy Grid and the Earth's Unified Field all around us. Cathie's first book, *Harmonic 33*, was published in 1968 when he was a commercial pilot in New Zealand. Since then, Captain Bruce Cathie has been the premier investigator into the amazing potential of the infinite energy that surrounds our planet every microsecond. Cathie investigates the Harmonics of Light and how the Energy Grid is created. In this amazing book are chapters on UFO Propulsion, Nikola Tesla, Unified Equations, the Mysterious Aerials, Pythagoras & the Grid, Nuclear Detonation and the Grid, Maps of the Ancients, an Australian Stonehenge examined, more.

255 PAGES. 6x9 TRADEPAPER. ILLUSTRATED. $15.95. CODE: TEG

THE BRIDGE TO INFINITY
Harmonic 371244
by Captain Bruce Cathie

Cathie has popularized the concept that the earth is crisscrossed by an electromagnetic grid system that can be used for anti-gravity, free energy, levitation and more. The book includes a new analysis of the harmonic nature of reality, acoustic levitation, pyramid power, harmonic receiver towers and UFO propulsion. It concludes that today's scientists have at their command a fantastic store of knowledge with which to advance the welfare of the human race.

204 PAGES. 6x9 TRADEPAPER. ILLUSTRATED. $14.95. CODE: BTF

THE HARMONIC CONQUEST OF SPACE
by Captain Bruce Cathie

Chapters include: Mathematics of the World Grid; the Harmonics of Hiroshima and Nagasaki; Harmonic Transmission and Receiving; the Link Between Human Brain Waves; the Cavity Resonance between the Earth; the Ionosphere and Gravity; Edgar Cayce—the Harmonics of the Subconscious; Stonehenge; the Harmonics of the Moon; the Pyramids of Mars; Nikola Tesla's Electric Car; the Robert Adams Pulsed Electric Motor Generator; Harmonic Clues to the Unified Field; and more. Also included are tables showing the harmonic relations between the earth's magnetic field, the speed of light, and anti-gravity/gravity acceleration at different points on the earth's surface. New chapters in this edition on the giant stone spheres of Costa Rica, Atomic Tests and Volcanic Activity, and a chapter on Ayers Rock analysed with Stone Mountain, Georgia.

248 PAGES. 6x9. PAPERBACK. ILLUSTRATED. BIBLIOGRAPHY. $16.95. CODE: HCS

THE ANTI-GRAVITY HANDBOOK
edited by David Hatcher Childress, with Nikola Tesla, T.B. Paulicki, Bruce Cathie, Albert Einstein and others

The new expanded compilation of material on Anti-Gravity, Free Energy, Flying Saucer Propulsion, UFOs, Suppressed Technology, NASA Cover-ups and more. Highly illustrated with patents, technical illustrations and photos. This revised and expanded edition has more material, including photos of Area 51, Nevada, the government's secret testing facility. This classic on weird science is back in a 90s format!
• **How to build a flying saucer.**
•**Arthur C. Clarke on Anti-Gravity.**
• **Crystals and their role in levitation.**
• **Secret government research and development.**
• **Nikola Tesla on how anti-gravity airships could draw power from the atmosphere.**
• **Bruce Cathie's Anti-Gravity Equation.**
• **NASA, the Moon and Anti-Gravity.**
230 PAGES. 7x10 PAPERBACK. ILLUSTRATED. $14.95. CODE: AGH

ANTI–GRAVITY & THE WORLD GRID

Is the earth surrounded by an intricate electromagnetic grid network offering free energy? This compilation of material on ley lines and world power points contains chapters on the geography, mathematics, and light harmonics of the earth grid. Learn the purpose of ley lines and ancient megalithic structures located on the grid. Discover how the grid made the Philadelphia Experiment possible. Explore the Coral Castle and many other mysteries, including acoustic levitation, Tesla Shields and scalar wave weaponry. Browse through the section on anti-gravity patents, and research resources.
274 PAGES. 7x10 PAPERBACK. ILLUSTRATED. $14.95. CODE: AGW

ANTI–GRAVITY & THE UNIFIED FIELD
edited by David Hatcher Childress

Is Einstein's Unified Field Theory the answer to all of our energy problems? Explored in this compilation of material is how gravity, electricity and magnetism manifest from a unified field around us. Why artificial gravity is possible; secrets of UFO propulsion; free energy; Nikola Tesla and anti-gravity airships of the 20s and 30s; flying saucers as superconducting whirls of plasma; anti-mass generators; vortex propulsion; suppressed technology; government cover-ups; gravitational pulse drive; spacecraft & more.
240 PAGES. 7x10 PAPERBACK. ILLUSTRATED. $14.95. CODE: AGU

THE GIZA DEATH STAR
The Paleophysics of the Great Pyramid & the Military Complex at Giza
by Joseph P. Farrell

Physicist Joseph Farrell's amazing book on the secrets of Great Pyramid of Giza. *The Giza Death Star* starts where British engineer Christopher Dunn leaves off in his 1998 book, *The Giza Power Plant*. Was the Giza complex part of a military installation over 10,000 years ago? Chapters include: An Archaeology of Mass Destruction, Thoth and Theories; The Machine Hypothesis; Pythagoras, Plato, Planck, and the Pyramid; The Weapon Hypothesis; Encoded Harmonics of the Planck Units in the Great Pyramid; High Freguency Direct Current "Impulse" Technology; The Grand Gallery and its Crystals: Gravito-acoustic Resonators; The Other Two Large Pyramids; the "Causeways," and the "Temples"; A Phase Conjugate Howitzer; Evidence of the Use of Weapons of Mass Destruction in Ancient Times; more.
290 PAGES. 6x9 PAPERBACK. ILLUSTRATED. $16.95. CODE: GDS

DARK MOON
Apollo and the Whistleblowers
by Mary Bennett and David Percy

•Was Neil Armstrong really the first man on the Moon?
•Did you know that a second craft was going to the Moon at the same time as Apollo 11?
•Do you know that potentially lethal radiation is prevalent throughout deep space?
•Do you know there are serious discrepancies in the account of the Apollo 13 'accident'?
•Did you know that 'live' color TV from the Moon was not actually live at all?
•Did you know that the Lunar Surface Camera had no viewfinder?
•Do you know that lighting was used in the Apollo photographs—yet no lighting equipment was taken to the Moon?
All these questions, and more, are discussed in great detail by British researchers Bennett and Percy in *Dark Moon*, the definitive book (nearly 600 pages) on the possible faking of the Apollo Moon missions. Bennett and Percy delve into every possible aspect of this beguiling theory, one that rocks the very foundation of our beliefs concerning NASA and the space program. Tons of NASA photos analyzed for possible deceptions.
568 PAGES. 6x9 PAPERBACK. ILLUSTRATED. BIBLIOGRAPHY. INDEX. $25.00. CODE: DMO

TECHNOLOGY OF THE GODS
The Incredible Sciences of the Ancients
by David Hatcher Childress
Popular *Lost Cities* author David Hatcher Childress takes us into the amazing world of ancient technology, from computers in antiquity to the "flying machines of the gods." Childress looks at the technology that was allegedly used in Atlantis and the theory that the Great Pyramid of Egypt was originally a gigantic power station. He examines tales of ancient flight and the technology that it involved; how the ancients used electricity; megalithic building techniques; the use of crystal lenses and the fire from the gods; evidence of various high tech weapons in the past, including atomic weapons; ancient metallurgy and heavy machinery; the role of modern inventors such as Nikola Tesla in bringing ancient technology back into modern use; impossible artifacts; and more.
356 PAGES. 6x9 PAPERBACK. ILLUSTRATED. BIBLIOGRAPHY. $16.95. CODE: TGOD

VIMANA AIRCRAFT OF ANCIENT INDIA & ATLANTIS
by David Hatcher Childress, introduction by Ivan T. Sanderson

Did the ancients have the technology of flight? In this incredible volume on ancient India, authentic Indian texts such as the *Ramayana* and the *Mahabharata* are used to prove that ancient aircraft were in use more than four thousand years ago. Included in this book is the entire Fourth Century BC manuscript *Vimaanika Shastra* by the ancient author Maharishi Bharadwaaja, translated into English by the Mysore Sanskrit professor G.R. Josyer. Also included are chapters on Atlantean technology, the incredible Rama Empire of India and the devastating wars that destroyed it. Also an entire chapter on mercury vortex propulsion and mercury gyros, the power source described in the ancient Indian texts. Not to be missed by those interested in ancient civilizations or the UFO enigma.
334 PAGES. 6x9 PAPERBACK. ILLUSTRATED. $15.95. CODE: VAA

LOST CONTINENTS & THE HOLLOW EARTH
I Remember Lemuria and the Shaver Mystery
by David Hatcher Childress & Richard Shaver

Lost Continents & the Hollow Earth is Childress' thorough examination of the early hollow earth stories of Richard Shaver and the fascination that fringe fantasy subjects such as lost continents and the hollow earth have had for the American public. Shaver's rare 1948 book *I Remember Lemuria* is reprinted in its entirety, and the book is packed with illustrations from Ray Palmer's *Amazing Stories* magazine of the 1940s. Palmer and Shaver told of tunnels running through the earth—tunnels inhabited by the Deros and Teros, humanoids from an ancient spacefaring race that had inhabited the earth, eventually going underground, hundreds of thousands of years ago. Childress discusses the famous hollow earth books and delves deep into whatever reality may be behind the stories of tunnels in the earth. Operation High Jump to Antarctica in 1947 and Admiral Byrd's bizarre statements, tunnel systems in South America and Tibet, the underground world of Agartha, the belief of UFOs coming from the South Pole, more.
344 PAGES. 6x9 PAPERBACK. ILLUSTRATED. $16.95. CODE: LCHE

ATLANTIS & THE POWER SYSTEM OF THE GODS
Mercury Vortex Generators & the Power System of Atlantis
by David Hatcher Childress and Bill Clendenon

Atlantis and the Power System of the Gods starts with a reprinting of the rare 1990 book *Mercury: UFO Messenger of the Gods* by Bill Clendenon. Clendenon takes on an unusual voyage into the world of ancient flying vehicles, strange personal UFO sightings, a meeting with a "Man In Black" and then to a centuries-old library in India where he got his ideas for the diagrams of mercury vortex engines. The second part of the book is Childress' fascinating analysis of Nikola Tesla's broadcast system in light of Edgar Cayce's "Terrible Crystal" and the obelisks of ancient Egypt and Ethiopia. Includes: Atlantis and its crystal power towers that broadcast energy; how these incredible power stations may still exist today; inventor Nikola Tesla's nearly identical system of power transmission; Mercury Proton Gyros and mercury vortex propulsion; more. Richly illustrated, and packed with evidence that Atlantis not only existed—it had a world-wide energy system more sophisticated than ours today.
246 PAGES. 6x9 PAPERBACK. ILLUSTRATED. $15.95. CODE: APSG

A HITCHHIKER'S GUIDE TO ARMAGEDDON
by David Hatcher Childress
With wit and humor, popular Lost Cities author David Hatcher Childress takes us around the world and back in his trippy finalé to the Lost Cities series. He's off on an adventure in search of the apocalypse and end times. Childress hits the road from the fortress of Megiddo, the legendary citadel in northern Israel where Armageddon is prophesied to start. Hitchhiking around the world, Childress takes us from one adventure to another, to ancient cities in the deserts and the legends of worlds before our own. Childress muses on the rise and fall of civilizations, and the forces that have shaped mankind over the millennia, including wars, invasions and cataclysms. He discusses the ancient Armageddons of the past, and chronicles recent Middle East developments and their ominous undertones. In the meantime, he becomes a cargo cult god on a remote island off New Guinea, gets dragged into the Kennedy Assassination by one of the "conspirators," investigates a strange power operating out of the Altai Mountains of Mongolia, and discovers how the Knights Templar and their off-shoots have driven the world toward an epic battle centered around Jerusalem and the Middle East.
320 PAGES. 6x9 PAPERBACK. ILLUSTRATED. BIBLIOGRAPHY. INDEX. $16.95. CODE: HGA

One Adventure Place
P.O. Box 74
Kempton, Illinois 60946
United States of America
Tel.: 815-253-6390 • Fax: 815-253-6300
Email: auphq@frontiernet.net
http://www.adventuresunlimitedpress.com
or www.adventuresunlimited.nl

ORDERING INSTRUCTIONS

➵ Remit by USD$ Check, Money Order or Credit Card

➵ Visa, Master Card, Discover & AmEx Accepted

➵ Prices May Change Without Notice

➵ 10% Discount for 3 or more Items

SHIPPING CHARGES

United States

➵ Postal Book Rate { $3.00 First Item
50¢ Each Additional Item

➵ Priority Mail { $4.50 First Item
$2.00 Each Additional Item

➵ UPS { $5.00 First Item
$1.50 Each Additional Item

NOTE: UPS Delivery Available to Mainland USA Only

Canada

➵ Postal Book Rate { $6.00 First Item
$2.00 Each Additional Item

➵ Postal Air Mail { $8.00 First Item
$2.50 Each Additional Item

➵ Personal Checks or Bank Drafts MUST BE

USD$ and Drawn on a US Bank

➵ Canadian Postal Money Orders OK

➵ Payment MUST BE USD$

All Other Countries

➵ Surface Delivery { $10.00 First Item
$4.00 Each Additional Item

➵ Postal Air Mail { $14.00 First Item
$5.00 Each Additional Item

➵ Payment MUST BE USD$

➵ Checks and Money Orders MUST BE USD$
and Drawn on a US Bank or branch.

➵ Add $5.00 for Air Mail Subscription to
Future *Adventures Unlimited* Catalogs

SPECIAL NOTES

➵ RETAILERS: Standard Discounts Available

➵ BACKORDERS: We Backorder all Out-of-

Stock Items Unless Otherwise Requested

➵ PRO FORMA INVOICES: Available on Request

➵ VIDEOS: NTSC Mode Only. Replacement only.

➵ For PAL mode videos contact our other offices:

Please check: ☑

☐ This is my first order ☐ I have ordered before

Name			
Address			
City			
State/Province		Postal Code	
Country			
Phone day		Evening	
Fax			

Item Code	Item Description	Qty	Total

Please check: ☑ Subtotal ➟

Less Discount-10% for 3 or more items ➟

☐ Postal-Surface Balance ➟

☐ Postal-Air Mail Illinois Residents 6.25% Sales Tax ➟
(Priority in USA) Previous Credit ➟

☐ UPS Shipping ➟

(Mainland USA only) Total (check/MO in USD$ only) ➟

☐ Visa/MasterCard/Discover/Amex

Card Number

Expiration Date

10% Discount When You Order 3 or More Items!

323